THE PRIMITIVE, THE AESTHETIC,
AND THE SAVAGE

The Primitive, the Aesthetic, and the Savage

. . . .

An Enlightenment Problematic

Tony C. Brown

University of Minnesota Press
Minneapolis
London

An earlier version of chapter 4 was previously published as "Joseph Addison and the Pleasures of *Sharawadgi*," *ELH* 74 (Spring 2007): 171–93; reprinted courtesy of The Johns Hopkins University Press. An earlier version of chapter 7 was previously published as "The Barrows of History," *Studies in Eighteenth-Century Culture* 37 (2008): 39–63; reprinted courtesy of The Johns Hopkins University Press.

Published by the University of Minnesota Press
111 Third Avenue South, Suite 290
Minneapolis, MN 55401-2520
http://www.upress.umn.edu

Library of Congress Cataloging-in-Publication Data

Brown, Tony C.
The primitive, the aesthetic, and the savage : an Enlightenment problematic / Tony C. Brown.
Includes bibliographical references and index.
ISBN 978-0-8166-7562-3 (hc : acid-free paper)
ISBN 978-0-8166-7563-0 (pb : acid-free paper)
1. Literature—18th century—History and criticism. 2. Primitivism in literature.
3. Enlightenment. 4. Aesthetics, European—18th century. 5. Noble savage in literature.
6. Literature and anthropology. 7. Primitive societies in literature. I. Title.
PN56.P7B76 2012
809'.9145—dc23
2012034547

For
VIOLET
and
ROY CALLAGHAN

Contents

Preface

The reader will quickly recognize this book's apparent dual nature. On the one hand, it pursues a subject matter we might call historical (roughly, eighteenth-century aesthetics), and on the other, it takes an approach we might call theoretical, or any number of lose synonyms (philosophical, abstract, conceptual, deconstructive). This all assumes a great deal, of course: that we know what we mean by *historical* and *theoretical;* that we are assured of their categorical separation (historical on the one hand, theoretical on the other); that we can pursue an historical subject matter and take a theoretical approach, as if both were not only separate to each other but external to ourselves (something to seek out or to adopt). Yet despite the misgivings these assumptions should no doubt prompt, history and theory are commonly sequestered, one from the other, in various, even essential, ways—so much so, in fact, that the fanciful reader may already be imagining me in the guise of Herman Melville's Tommo, who, having jumped ship in the Marquesas Islands with his companion, Toby, finds himself uneasily running the ridge between two valleys. He does not know on what side to descend because neither he nor Toby can tell which valley is home to the friendly Happar and which to the treacherous cannibals, the Typee. For Tommo as for us, it appears to be one or the other: Typee or Happar, theory or history.[1]

Now we know from the title of Melville's novel, *Typee: A Peep at Polynesian Life* (1846), that Tommo and Toby did make a decision and did go down one side of the ridge rather than the other. For my most historically inclined readers, this would be where the analogy proves most telling. Rather than remaining on the ridge, they would say, I made my decision early and descended—but on the wrong side. For in truth, while I am far from inattentive to the valley of history and the scholarship it yields, I do not treat history in the manner to which we are accustomed in the humanities. Historical context has become our most solid and unshakable habitual unity, that one level where everything may be, even ought to be, finally

explained. For this reason contemporary historicism, invested with the force of scholarly and moral obligations, can neither fathom nor accept history's potential restriction to just one valley among other valleys. It understands history as antithetical to such limitation, history as valley-ness itself, so to speak: insofar as something *is*, it *is historical*. Accordingly my book's emphasis will fall for many readers to the theoretical simply because it does not assume history's universal sovereignty. Caught as we seem to be between the one or the other (again, theory or history, Typee or Happar), the moment one questions history's explanatory power in and for all valleys one will be cast among the cannibals.

I must confess that if I do dwell among the cannibals, I find life with them to be rewarding. Yet given the contemporary academic context I am all too aware of the potential risks, if not to the integrity of my body then certainly to the consistency of my account. With history as the source of our most customary assurances, historical context and historical progression supply the default modes of coherence. Good common sense now suggests that properly knowing an object of human invention—like *Typee*, for example—depends upon one's ability to explain how and why it came into the existence it did when it did. The task becomes one of seeking those relevant sources of causation professed by the marriage of historicism and positivism contemporary to Melville. In the case of Melville's novel, those sources might include the author's biography up to the point of writing *Typee*; the history and discourse of European and Euro-American exploration, imperialism, whaling, and beachcombing in the South Pacific; the midcentury publishing industry in the United States and Great Britain; and whatever other sources of motivation may have made their effects felt before (but not after) Melville's writing of the novel. Not, then, the old metaphysical question of why something rather than nothing; today we ask why *this* something *then*, in *that* given context. We have no need for the "rather than nothing" because there is no longer any possible nothing beyond historical causation and explanation. Every valley is necessarily and entirely historical and is therefore properly the object of an historical investigation.[2]

One way of phrasing what I am trying to do in this book is to attempt to insert the outmoded nothing into the frame of historical reckoning, thereby recasting the latter as a necessarily limited and limiting mode of understanding. Now, recasting the frame of historical reckoning to include "nothing" (roughly, the primitive) does not mean no historical reckoning. I am

not professing a leap beyond the bounds of history and historical under-
standing. As the reader will soon see, the book includes historical claims
and contextual evidence. I simply do not proceed as if historical context
constituted the natural horizon of all valid explanation. "There is," Jacques
Derrida once noted, "nothing outside context." And he was surely right.
Crucially, his context does not usher into the relativism of historicized val-
leys. Context is, Derrida says, limitless, hence (like text) it has no outside.
It is always "differentiated and mobile," never limited to a completed,
transfixed self-identity.[3]

Of course, Derrida's understanding of context is at odds with our cus-
tomary rules of coherence. What cannot be adequately historicized has
arguably become almost unpresentable, at best just theoretical. Certainly
literary critics and theorists have long lamented the dominance of his-
torical studies—Cleanth Brooks did so in the 1940s, just as Paul de Man
did in the 1970s.[4] Today we face an added demand. One's work must not
just be historical; it must also be ordered by a comfortably historicized
unit, such as eighteenth-century England or eighteenth-century English
culture (whether one stays wholly with England or seeks to compare
and contrast it with other national units such as France or Spain). The
national and the national–cultural present apparently natural units for
recognizing and representing historical progression within a unified histor-
ical context, which no doubt helps explain why, with notable exceptions
in the Marxist tradition, modern historicism has long proved relentlessly
national in orientation.

I have tried to find other ways of proceeding, ways more attuned, if
anything, to my eighteenth-century object. After all, historically speaking,
the nineteenth-century canonization of European national traditions that
continues to order our work today sits between us and the eighteenth cen-
tury: it is a framework for producing and ordering knowledge that derives
from a particular nineteenth-century alignment of the modern research
university and its disciplinary formations with nationalist historicism.[5]
Accordingly, the structures governing our knowledge production may be
putting us at odds with the eighteenth century—not so much by blocking
our ability to identify with it, as by preventing our disidentification from
it. As I understand it, attunement to what we name the eighteenth century
will mean questioning the cumulative logic of an historicism that makes
the eighteenth century "us" at an earlier stage of development or existence.
At the very least, an encounter with the complexity of eighteenth-century

thinking should make us less comfortable with historicism's tendency to naturalize and universalize historical thought.

So what am I being all theoretical and hence not entirely historical about? What, as I understand it, calls for such an approach? Most simply, *The Primitive, the Aesthetic, and the Savage* addresses the role of exotic and especially savage figures in eighteenth-century aesthetics. I attend to cases where aesthetic theorists, faced with the difficulty of properly determining the aesthetic faculty and the experience it makes possible, call upon exotic figures to help delimit their object (Part II), and I take up cases where the savage presents a problem to understanding whose resolution is sought in an aesthetic framework or vocabulary (Part III). Less simply, the book grapples with a crucial and insistent problem in the encounter of the aesthetic and the exotic and the savage, the problem of our outmoded nothing. I suggest that there remains, in Enlightenment attempts to think the aesthetic and the savage, the inescapable yet infinitely troubling figure of the not-quite-nothing, the primitive: the absolutely first or, more significantly, what is before the first, beyond any temporal existence (Part I). The various texts I look at turn to exotic figures to delimit the aesthetic on the one hand, and concepts drawn from aesthetics to comprehend the savage on the other, yet they cannot get beyond the problem of thinking the primitive. As we will see, the primitive introduces into the aesthetic and the savage an element that proves necessary yet exceedingly difficult to think. At its most profound, that element engenders a loss of confidence in one's ability to understand the human's relation to itself and to the world. That loss of confidence—what I will refer to as a breach in anthropological security—I trace to Europe's inability to maintain itself in the face of the New World, primarily the Americas, but also China and the South Seas.

This is perhaps the moment to say something about my account's geographical reach. Just as I do not hold to any one national tradition, I do not hold to any one geographic region of focus, as one might, for example, focus on British or French North America, or even on the Americas as a hemispheric unit—what we typically call the New World.[6] Here, I generalize New World to indicate those newly encountered geographic zones that, in the eighteenth century, put particular pressure on European modes of understanding the human's relation to itself and to the world. Those zones include the Americas, of course, as well as China and the South Seas. I retain *New World* for two reasons: first, because the "Americas as

New World" presents a privileged figure for the pressure on thought with which I am concerned, *New World* already points us in the right direction; and second, because *New World* does not of itself necessarily name only the Americas, the title remains open to a generalization. There is a wider phenomenon we might call New Worldism, though I will be content to simply say the New World in general.

Much as my nonnational organization follows from a certain attunement to my object (the problem of thinking the aesthetic in the eighteenth century), I would suggest that my geographical roaming follows the material I deal with. Eighteenth-century writers who use exotic figures in theorizing the aesthetic do not limit themselves to examples culled from, say, British or French North America. Of course, the various zones I align under the heading of New World in general are not automatically interchangeable. One in particular stands apart. While eighteenth-century Europeans most consistently locate the savage in the Americas and the South Seas, they consider China as distinctly not savage. China presented a recognizably state-based society, which, recent scholarship suggests, was in many ways more developed than any particular state in Europe. Nonetheless, China bears the mark of a far-reaching exoticism. Most importantly, it plays a critical role in challenging the authority of European thought similar to the role played by the Americas and the South Seas. Its five-thousand-year-old tradition of written records, for example, challenged the dominant European understanding of world history, namely the biblical chronology.[7]

By situating eighteenth-century aesthetics in relation to the savage and the exotic, I can be said to be working within the recent global turn of the humanities in general and of literary studies in particular. Under the productive influence of a postcolonial studies shaped amid the major waves of decolonization in Africa, the Caribbean, Asia, and the South Pacific, the once obscured role of European global expansion in modern literary and intellectual history has become increasingly visible in humanities scholarship. In eighteenth-century studies the global turn has divided along two main pathways that roughly follow disciplinary lines. On the one hand, the global turn in the humanities has proved productive in intellectual history. There is, of course, a long-standing tradition of scholarship on primitivism and related ideas associated with the History of Ideas inaugurated in the North American context by Arthur O. Lovejoy. This work tended to approach its given unit-idea as an internal European intellectual

development.[8] However, in recent years some emphasis has fallen on the question of how the non-European world affected European thought, whether as a theme, as a motivating object for further thought, or as a force augmenting ignorance.[9]

On the other hand, the global turn has produced a significant body of work in literary studies. This work focuses largely on the representation of non-European peoples and places in European literary and nonliterary texts.[10] Taking its lead from Edward Said's *Orientalism* (1978), the text often thought to have inaugurated the field of colonial discourse analysis, it attends to European modes of representing areas of the earth that European merchants and states exploit for financial, military, or intellectual gain, suggesting that what is said about the far-off places of the earth forms part of a network of colonial techniques and strategies for dominating the non-European world.[11] Like Said—for whom the problem has been well documented—the scholarship on eighteenth-century colonial discourse encounters a problem in conceiving how various forms of representation, understood as originating and circulating within Europe, relate to acts of domination that necessarily are not exclusively European.[12] As Rodolphe Gasché shows in the case of Said himself, the problem follows from an adherence to the conventional Western critique of representation: that a representation is separate from what it represents, that there is a gap between sign and referent.[13] Accordingly, a representation and what it putatively represents belong to separate, incompatible orders of existence. Conceiving how the two orders might relate to one another becomes extremely difficult, with important consequences for how we understand the relation between the putatively European and non-European.

For our purposes, the most notable limitation that follows from separating representation into its own sphere concerns the Eurocentrism that colonial discourse analysis aims to put in question. As it turns out, by understanding representation as merely representation one tends in fact to legitimate a certain Eurocentric perspective in the sense that the colonial discourse framework, at least in its more naïve variants, provides an alibi for not taking into account anything beyond the (thus secured) bounds of Europe. As the representation finds its originating context and immediate sphere of circulation wholly within Europe, and as the representation has little to nothing to do with the non-European, one remains free to (continue) ignoring everything that is not European. One may well be attentive to mentions of Hottentots in eighteenth-century novels, yet

as long as one remains concerned exclusively with the representation of Hottentots, one limits one's perspective to that western peninsula of the Asian continent we call Europe. My point is not that Hottentots prove to be present in a novel like Samuel Richardson's *Clarissa* (1748), or that the novel offers an accurate portrait of Hottentots when Lovelace accuses his friend, John Belford, of taking refuge in "the palliating consolation of an Hottentot heart, determined rather to gluttonize on the garbage of other foul feeders, than to reform."[14] My point is that by conceiving representation as belonging to its own sphere of existence, one constitutes, by way of a circular logic, any possible mention of Hottentots as necessarily only (European) representation.

Noting a problem's existence does not, of course, resolve the problem. At best it warns us what not to do. The task is to turn that warning into a first step beyond the limitations entailed in the problem. For me this would mean taking a statement of the order "do not sequester what we call European texts and what we call non-European objects" and, in the space of negation it produces, setting about constructing a viable alternative approach. While the proof of viability will only be in the performance, at this point let me just signal some of the steps involved in making my approach by way of an example, namely the Maori facial tattooing I discuss in chapter 5. I work from the premise that a Maori facial tattoo can be represented because something in it allows itself to be represented, specifically a textual or inscriptive component that makes the conventional separation of European (textual) representation and non-European object questionable if not untenable. The relationship between a work like Immanuel Kant's *Critique of Judgment* (1790) and the Maori facial tattooing that Kant calls upon as an example is not exhausted by a logic of exclusivity (separate spheres), distortion (ideological misrepresentation), or contradiction (Kant is wrong). The relationship might include those elements, certainly, but there remains something else, a dynamic of a quite different order urging a shift in understanding. I will suggest that properly understanding the relationship in question—between what we would call a European text and a non-European object—requires moving beyond an exclusive focus on the tight circle of mere representation (on *what is said*) to a sense of representation as a modalization of substance (as *saying*), where the substance modalized is something like an inscriptive potential.

The term I most commonly use to name this modalization is *allegory*, the etymology of which suggests a speaking otherwise, or other-speech.

With it I hope to capture some of the force and energy of figural language (I am, after all, talking of exotic figures), while my emphasis on saying rather than just what is said highlights the performative and argumentative over the constative and thematic. The perspective I am proposing means taking a representation not as a completed functional expression of a given self or a culture, but, first and foremost, as an allegory of inscription—a proposal with far-ranging implications for our understanding of the relation between what we call European texts and what we call non-European objects. It means that a "European representation" does not find its possibility within itself; it is not the actualization of itself as European or as mere representation. It requires an alterity that does not belong to it, that makes it speak otherwise than itself. *Inscription* names the possibility of differential constitution—such as that which enables us to speak of "a European text and a non-European object" and eventually of historical context, progression, and intention.

Finally, let me make explicit what the reader may have begun to suspect: my approach to the eighteenth century is informed in significant ways by two remarkable works of scholarship, Derrida's *De la grammatologie* (1967) and Paul de Man's *Allegories of Reading* (1979). Though both works continue to receive little attention in eighteenth-century studies, the global turn I am most interested in extending is the one indicated by Derrida in his *Grammatologie,* where he explicitly and repeatedly situates the fate of writing in relation to European global expansion and imperialism. But whereas for Derrida what we call the eighteenth century is the place where Rousseau most vividly, "entre Descartes et Hegel," grapples with "le problème de l'écriture" as a breach "dans la sécurité logocentrique," for me it is (intellectually at least) where the problem of the primitive as almost nothing must be grappled with as a breach in anthropological security.[15]

What do I mean by anthropological security? For me, it entails a stable sense of the human's place in the world. Thus God's donation to the human alone of dominion "over the cattle, and over all the earth, and over every creeping thing that creepeth upon the earth" (Genesis 1:26) might be said to establish a certain anthropological security insofar as it clearly states the human's relation to the world. The human has dominion, and the one who has dominion is human. Historicism arguably works in an analogous, equally tautological manner: the human is the one who makes history, so the one who makes history is human. To be historical would be humanity's ever-present destiny on earth. However, I do not want to

suggest that outside the eighteenth century anthropological security was fully established: In fact, for reasons largely of space and focus, I leave as an open question whether or not we can say that it even presented a recognizable problem outside the eighteenth century.

What I am going to suggest is that certain eighteenth-century writers struggle with the human's place in the world due to a perceived breaching of secure knowledge of the human and the world. That is to say, I take the breaching in question as immanent to the demand for security: in a context we can call the Enlightenment, both for convenience and historical connotation, anthropological security is a recognizable problem because it is breached. The breach I have in mind occasions the difficulty of thinking the primitive in between the withdrawing of God and the arriving of a governing historicism that we tend to associate either with the organic pluralism of Herder's *Volksgeist* or the "expressive causality" of Hegel's *Geist*. The particular challenge is that of thinking the temporal and the atemporal on same plane, the otherworldy with the worldly, without the reassuring explanatory ground of God or History—again, "entre Descartes et Hegel," if we accept that for Descartes the *Cogito* is secured as a direct donation by God.[16]

It should be clear by now that the challenge to coherence I face in producing my account follows to some extent from my object. Or rather, the challenge follows from my object's uncertain status as an object. After all, if my "object" was indubitably object-like, things would be a lot easier. But I am not even dealing with a pseudo-object of the sort "the eighteenth-century British novel" or "the discourse on slavery in the French Enlightenment." I am dealing with a problem and its lines of force as they traverse and inscribe a nonnational, noncultural realm of thought-in-action. So if coherence of the order we expect today, coherence born from a national–cultural historicism, is unavailable to me for both historical and theoretical reasons, where is coherence to be found?

As I have indicated, this book relates the problem of thinking the primitive to connected, even consequent, attempts to think the aesthetic and the savage. It is the complex formed by those three terms—primitive, aesthetic, savage—that will constitute, for better or for worse, the framework for addressing what I have called the breach of anthropological security. Schematically, the difficulty of thinking the primitive occasions the breach, the attempt to theorize the aesthetic constitutes a central manifestation of the breach, and the savage puts it all in play—for as we will see, the breach

in question has much to do with the Old World's encounter with the New World. The reader may be surprised to find me speak here and elsewhere of "savage" and "primitive" as if the two were only kin rather than likenesses. However, the collapsing of primitive and savage into synonyms follows upon the coming to dominance of nineteenth-century historicism and the sinking of historicity into the primitive. In the eighteenth century, primitive and savage stand apart. The primitive, as intimated above, remains outside of history, or at best only minimally historical. It is almost nothing. *The Primitive, the Aesthetic, and the Savage* is my attempt to show how that not-quite-nothing proves crucial for the production of aesthetic theory in a context marked by Europe's encounter with the New World. Hence (as I hope is clear from this brief prefatory sketch) the somewhat conceptual organization of my account, as distinct from the more familiar empirical ordering of historical progression and historical context.

Acknowledgments

I wrote this book with the support of certain grants, fellowships, and institutions, and I would like to take this opportunity to extend my thanks to them. At the University of Minnesota, Twin Cities, I have been supported by a Faculty Summer Fellowship/McKnight Summer Fellowship from the Graduate School, a Residential Fellowship at the Institute for Advanced Studies, an Imagine Fund Grant, and a College of Liberal Arts Research Fellowship Supplement. When preparing the manuscript, the chair of the Department of English, Geoff Sirc, and associate deans of the College of Liberal Arts, Richa Nagar and Jo-Ida Hansen, provided me with the necessary research course releases. A National Endowment for the Humanities Fellowship at the Huntington Library, San Marino, California, for 2007–8 enabled me to conduct substantial research for this book. At the Huntington, Roy Richie and Juan Gomez made my time there both productive and rewarding. In addition to the staff at the Huntington, I also want to thank Jay Satterfield and his colleagues in the Regenstein Library's Special Collections at the University of Chicago, the staff at the John Ford Bell Library at the University of Minnesota, Twin Cities, and at the John Carter Brown Library in Providence, Rhode Island. The Eighteenth- and Nineteenth-Century Cultures Workshop at the University of Chicago, and the Theorizing Early Modern Studies Collaborative and the Nineteenth-Century Subfield Group at the University of Minnesota, Twin Cities, provided valuable forums for presenting earlier versions of my work.

There are many individuals to whom I owe my appreciation. My greatest intellectual and professional debts are to five individuals: James Chandler, Bill Brown, Qadri Ismail, Jonathan Lamb, and Sandra Macpherson. I have also been aided in the best possible ways by friends, colleagues, and students in Auckland, Canberra, Buffalo, Chicago, the Twin Cities (Minneapolis–St. Paul), Los Angeles, and elsewhere. To them all, I extend my sincere gratitude: Thomas Augst, Malcolm Baker, Ian Balfour, John Barrell, Adam Beach, Homi Bhabha, Daniel Brewer, Alex Calder, Emily

Capper, Juliette Cherbuliez, Maria Damon, Greg Dening, Bill Deverell, Andrew Elfenbein, Frances Ferguson, Rodolphe Gasché, Michael Gaudio, Brian Goldberg, Harriett Guest, Elaine Hadley, David Haley, Karen Hellekson, Elizabeth Helsinger, Gordon Hirsch, Jodhi Hoani, J. Paul Hunter, Shaun Irlam, Thomas Kim, Karen Kinoshita, Donna Landry, Seth Lerer, Pamela Leszczynski, Peter Mancall, Tony Maramarco, Robert Markely, Christine Marran, Susana Martens, Stuart McLean, Ellen Messer-Davidow, Keith Mikos, W. J. T. Mitchell, John Mowitt, Peter Nabokov, Michael Neil, Felicity Nussbaum, Elizabeth O'Conner Chandler, Frank Palmeri, John Pistelli, David Porter, Paula Rabinowitz, Max Rimoldi, Sarah Rivett, Jon Sachs, Arun Saldhanha, John Shanahan, J. B. Shank, Eric Slauter, Richard Squibbs, Richard Strier, Nicholas Thomas, Erin Warholm-Wohlenhaus, Elizabeth Wilson, and Patricia Zanski.

I wish to acknowledge my debts of a personal nature: Betty, Kathleen and Colin Brown, Janet and Jim Callaghan, Wayne, Lynette and Thelma Collins, Robyn, Craig and Abigail Cubitt, Ben and George Dibley, Rose Putt, and Ian and Melanie Walski.

Finally, I dedicate this book to my late grandparents, Violet and Roy Callaghan.

Note on Texts and Translations

All translations are my own except where indicated. When I use a published English translation of a work alongside an edition of the work in its original language, citations that follow the initial full references include only the author's name, the original-language title, and two sets of page numbers, the first set referencing the original-language edition and the second the translation, with a slash separating them. To give an example, "Rousseau, *Discours sur l'inégalité*, 123/54," points to page 123 of the French text and page 54 of the English translation. Any in-text citations will follow the same logic but will include only the two sets of page numbers.

This book ranges over several areas of specialization. For reasons of space it has proved impossible to provide full bibliographic information on the relevant critical literature for each area. When this problem presents itself, I cite in the endnotes the main works to be consulted and, where appropriate, those texts where full bibliographic coverage can be found.

An Enlightenment Problematic

THIS BOOK ADDRESSES THE OPERATIVE FORCE of exotic figures in eighteenth-century aesthetics. Taking the aesthetic as both object and modality of inquiry (something to think about and to think with), I will show how the exotic, and especially the savage, play a critical role in thinking on and with concepts like the sublime and the beautiful. My concern, then, is not (or at least not immediately) with the appearance of various savages and other exotics as objects of aestheticization—a level of analysis that too readily assumes the aesthetic (what it is and how one knows it) to be settled in advance. Eighteenth-century aesthetic theorists struggled to articulate their putative object. As Voltaire put it, if you ask *les philosophes* what beauty is, they will respond with an unintelligible discourse ("ils vous répondront par du galimatias").[1] I will suggest that the aesthetic's resistance to coherent exposition follows from the terms in which the aesthetic must be thought. Eighteenth-century aesthetic theory unfolds within a problematic that generates the central, unavoidable problem of conceiving a passage between two incommensurable orders, one atemporal (the almost nothing, or primitive), the other temporal (the occurrence of an aesthetic experience or the existence of savage populations). It is in the context of this problematic that we must look to discover the significance of the exotic figures that line eighteenth-century aesthetic thought, but also, as we shall see, to understand the role played by aesthetic concepts in producing knowledge of the exotic—and above all, the savage.

The particular form the problematic of concern to us takes, the form I would characterize as an Enlightenment problematic, is that of thinking the temporal and the non-, pre-, or atemporal on the same plane. This is what generates the problem or *aporie* that Louis Althusser finds, for example, in Montesquieu's typology of governments as formulated in *De l'esprit des lois* (1748): "how ever to think history in a category attached in essence to pure atemporal models *[à de purs modèles intemporels]*." We

should not miss the Kantian reference: with *pure*, Althusser points to what is not given by experience. The problem as Althusser locates it in Montesquieu is how to think the historical existence of a category of government that, determined by "la typologie pure," includes the essential attribute of being nonexperiential, nontemporal. I would suggest that the same problem orders eighteenth-century debates over the relation of mind and body, the existence of immortal souls in a world beyond theism, the possibility of innate ideas, and—most important for my purposes—the development of human capacities, whether societal or cognitive. Clearly, the problematic does not produce one problem among others. It generates a structuring problem, a problem that orders thinking. We are not dealing with something static that preexists a type of thought that the thought may subsequently discover and resolve; the model is not that of a subject who comes to an object that he or she then submits to controlled analysis. The problem presents, precisely, an aporia rather than a contradiction. One cannot think through the problem in its own terms, yet those are the only terms available. Or this, at least, is the case where neither God nor History provide a convincing third term by which to manage a higher-level reconciliation.[2]

We have as yet no detailed account of what I am calling an Enlightenment problematic, or, as it turns out, of the primitive as a concept or category, which proves to be quite different from the well-known discourse of primitivism.[3] The purpose of this Introduction will therefore be less to say what I will and will not do (the Preface should have made that much clear), than to give the necessary context for what I will be doing. I will elaborate on the problematic, and, insofar as my three main terms (primitive, aesthetic, savage) prove to be thought through it, I will then need to establish the scope and significance of each term, though for reasons of space and coherence I reserve the detailed exposition of my three terms for Part 1, "Primitive, Aesthetic, Savage." Here, my primary concern will be to set up the problematic, to explain what it is and how it relates most broadly to aesthetics. I will first establish the particular provenance of eighteenth-century aesthetics to show how it includes the problem of thinking the atemporal and temporal together. I will then address the appearance of exotic figures in attempts to confront that problem; the specific form the problematic takes in the eighteenth century under the impact of the New World on the Old World and the related secularization of thought; the problem's force as evidenced in the work of John Wilkins,

Julien Offroy de la Mettrie, and Jean-Jacques Rousseau; and, finally, how, late in the century, historicism first attempts to displace the problem by recasting the atemporal as necessarily historical.

The Aesthetic's Otherworldly Insistence

Let me first underscore that eighteenth-century aesthetic theory is not primarily concerned with what we might call art appreciation. Only in the nineteenth century will aesthetics name a discipline whose concern lies with the proper taste in art, a destiny Hegel signals when he stipulates that with the expression *aesthetics* "we at once exclude the beauty of nature": "the proper expression for our science is *Philosophy of Art* and, more definitely, *Philosophy of Fine Art.*" Still less does the "aesthetic" in eighteenth-century aesthetic theory correspond (as some mistakenly assume) to Aristotle's *ta aistheta,* which roughly translates as "sensible things," and which puts in the place of emphasis the objects that one perceives. In the notion of the aesthetic of concern to us, the emphasis falls primarily to the human faculty involved in an aesthetic experience, and only secondarily to things or objects.

Eighteenth-century aesthetic theory constitutes something closer to a critique of taste, which is to say, the analysis of taste's conditions of possibility. As such, it is often abstract and forcefully theoretical. The conditions of possibility in question do not lie in a given artwork's content or its formal qualities. The moral philosopher Francis Hutcheson, for example, in his *Inquiry into the Original of Our Ideas of Beauty and Virtue* (1725), argued "that by Absolute or Original Beauty, is not understood any Quality suppos'd to be in the Object, which should of itself be beautiful, without relation to any Mind which perceives it." Our ideas of beauty, he continues, originate in "these Sensations, which seem not so much any Pictures of Objects, as Modifications of the perceiving Mind." For Hutcheson, among others, taste's conditions of possibility reside in a supposed primitive human faculty and its potential expressions, paradigmatically revealed in the self's uninhibited viewing of nature's beauty or sublimity. The conditions are ordered, in short, by the Enlightenment problematic, as aesthetic theory aims to understand how the faculty engenders the expression, or more specifically, to comprehend as closely as possible the passage between a human faculty that verges on the limits of temporal existence (being primitive, it is before or at the beginning of time) and a

human experience that occurs in the world and that is characterized as free and immediate (the temporal, worldly encounter with, say, a beautiful object).[4]

The challenge of thinking the aesthetic in terms of, or in relation to, a passage between the atemporal and the temporal helps explain the widespread characterization of aesthetic experience as eluding, though with an instructive difference, what Leibniz calls in the *Monadologie* (1714) "l'aperception ou . . . la conscience" (apperception or . . . consciousness). Whereas Leibniz addresses the way we remain unaware of much that happens in our minds (our perceptions include much that we fail to apperceive—that is, what we fail to be conscious of), aesthetics attends to the way that something escapes apperception that we know is escaping our apperception, specifically the worldly occurrence of what is not quite of the world. What escapes apperception remains adjacent to the temporal unfolding of the experience. It does not disappear from the horizon of experience but abuts it as an otherworldly insistence that, in the eighteenth century, was first called aesthetic. The self undergoing an aesthetic experience is in some way opened to an uncertain shadow within itself.[5]

The otherworldly shadowing of the self manifests most vividly in the tendency for an aesthetic experience to include, as a necessary and not merely accidental component of the experience, a non- or minimally cognizable subjective element. That element is, for example, the *je ne sais quoi* Jean-Jacques Rousseau calls, in *Les Confessions* (1782), "quelque autre cause . . . plus secrette et plus forte" (some other cause . . . more secret and more potent) than the beauty of, and the memories he attaches to the sight of, Lake Geneva:

> The sight of Lake Geneva and its admirable shores has always held a particular charm for me, a charm I cannot explain [*que je ne saurois expliquer*], and which depends not only on the beauty of the scene, but on something, I do not know what [*je ne sais quoi*]—more interesting still [*de plus intéressant*], which moves and touches me [*qui m'affecte et m'attendrit*].[6]

Finding the *quelque autre cause* especially difficult to determine, Rousseau can just characterize it as *more than* ("plus intéressant . . . plus secrette et plus forte"). Inexplicable, it is not simply another cause but *some* other cause, a cause one cannot even gesture toward with certainty; it seems to

come from outside of mere temporal existence, as if from another world. Yet Rousseau's *autre cause* that gives itself beyond cognition nonetheless calls upon thinking, as the long history of aesthetics suggests. Removed from direct comprehension, it remains to be thought, if not by Rousseau in the *Confessions*, then by others before and after him. Rousseau himself remains oracular on the subject of his *je ne sais quoi*, pointing and moving on.

When an aesthetic theorist does look to move beyond the indicative to formulate the substantive makeup of an aesthetic experience (what it is and what causes it), exotic figures tend to crop up with some frequency. Edward Young, for example, in his *Conjectures on Original Composition* of 1759, calls on the Amerindian to help explain what it is that the sublime force of an original genius does to the reader's mind: "We read *Imitation* with somewhat of his languor, who listens to a twice-told tale: Our spirits rouze at an *Original;* that is a perfect stranger, and all throng to learn what news from a foreign land: And tho' it comes, like an *Indian* Prince, adorned with feathers only, having little of weight; yet of our attention it will rob the more Solid."[7] Young's near-naked Indian prince connotes the exotic nature of the specific kind of originality that Young uses him to figure, namely the most basic kind: it comes to us from beyond our habitual, repetitive existence, presenting nothing we have heard before. Though used thus figuratively, the Amerindian exhibits a clear literal import—an exotic, naked body with simple feather decoration. It is through that literal import that such exotic figures serve in Young to remark the form or contour of what remains in itself unconditioned. In Young's case, it indirectly presents what can never be directly presented: an original (or primitive) imagination. Unconditioned, originality "rises spontaneously from the vital root of Genius; it *grows,* it is not *made*" (12). A mere unfolding prior to education ("without the rules of the learned"), an original is not sophisticated in the sense of worked over or cultivated. Indeed, Young's eminent example, Homer, composes "by native force of mind" alone (28). If one were to properly imitate the great poet, one would not aim to imitate his work (the end product), but rather one would aim to achieve his capacity for expression (the poetic faculty) (20–21).

At such moments as we find in Young, the exotic provides a figure of great economy with which to think the excess of Rousseau's *quelque autre cause (plus ... plus ... plus)*. Coming from afar, the exotic brings with it a necessary principle of difference, most obviously geographical and typically

political but marked most immediately in the difference of appearance. What proves striking is that aesthetic theorists, often at crucial moments in their argument, turn the difference that inheres in the exotic to remark a difference of another order: the subjective order of aesthetic experience. That is to say, the forcefully clear order of difference instituted by the exotic figure tends to be deployed at moments when the theorist encounters the uncertainty that inheres in that shadowy lining of the self produced by the otherworldly insistence of a relation with something not quite temporal. As I will show, the exotic's allegorical energy—its turning to remark a difference of another order—means more than the mere illustration of a philosophical point or distinction. The exotic's role in aesthetic theory is perhaps better conceived as akin to that of a *motif*—an adornment certainly, but also dominant theme, even motivation for or basis of, an idea such as the aesthetic.

If I am right that an exotic motif constitutes the aesthetic in significant ways, we will need to rethink the common understanding of eighteenth-century aesthetics particularly, and Enlightenment thinking broadly, as internal European developments—though we should refrain from too quickly turning to the equally familiar dyadic logic of self-constitution. While my sense is that, in important ways, the New World inaugurates modern Europe and the modern European both economically and intellectually, what takes place is more involved than a dialectic of self-recognition whereby the European looks at the supposedly savage Amerindian to perceive itself as civilized. We need to understand not only that eighteenth-century Europeans turn to the exotic and the savage to think the aesthetic in the face of the difficult, even intractable problem of conceiving a passage between the atemporal and temporal, but that they do so in the midst of a profound challenge to the European's sense of anthropological security, a challenge that is at least partially engendered in Europe's encounter with the New World.

The New World's Challenge to Anthropological Security

Nearly forty years ago, the historian J. H. Elliott made his famous and still valid claim that, for a century and a half after Columbus's so-called discovery, the New World's impact on the Old was "uncertain."[8] Elliott's point, as I take it, was not that Europeans failed to accumulate knowledge about the New World between 1492 and, roughly, 1650. Rather, his point

was that only after 1650 did the New World become of great interest for a significant number of Europeans, an interest that both registered and produced a sustained challenge to existing canons of European thought. Phrased historically, the New World's intellectual impact on the Old is somewhat delayed. As Christian Marouby writes:

> In a strangely belated aftershock of the discovery, the mass of documentation and missionary relations which had for over two centuries been accumulated by explorers of the New World, and so largely ignored, seems finally to break through the defenses of Europe and elicit the kind of large-scale reaction one might have expected much earlier.[9]

The "large-scale reaction" that Marouby invokes finds Europe facing the New World (but also, I would add, though in differing ways, China, the East Indies, and, later, the South Seas), unable to turn away. Attempts to comprehend the structure and organization of human existence comes to include necessary reference to the far-off places of the earth. But the reference is not inert. Hence both Elliott and Marouby, despite the differences of their respective focuses (Elliott attends to early modern intellectual history, Marouby to the discourse of exoticism in the eighteenth century), characterize the intellectual effect of the New World as one of force, specifically of violent force ("impact" on the one hand, and "break[ing] through the defenses" on the other).

The necessary reference to the New World puts immeasurable pressure on the explanatory models provided by biblical history and classical cosmography. I would even be tempted to say that what we call the Enlightenment—*Aufklärung, Lumières, Illuminismo*—is the attempt to re-ground thinking in the context of the New World's dissolving of biblical and classical authority. On a more limited scale, when what we call Europe faces a suddenly revealed, almost sublime, human variety, it looks to secure what seems strikingly uncertain—the operation, even perhaps the existence, of universal and so primitive human forms or faculties, and the coherent origins of human institutions like language or civil society. The impact or breaking produced by the New World works to unhinge the human's supposed nature, producing a sense that one does not in fact know with much certainty what the human is. If we can isolate an interest in anthropology as characteristic of Enlightenment thought, this is less

the expression of a triumphal anthropocentrism and more the symptom of a certain insecurity: anthropological knowledge, namely knowledge of human physiology and psychology, is sought precisely because that knowledge is as yet unknown or at best uncertain.

The point to underline is that the problem of thinking the passage between atemporal and temporal, though not new to the eighteenth century, appears uniquely figured there, marked by a context in which the New World generates a certain anxiety about the human's place in the world. Bear in mind that if the New World puts God in question, then it also puts the idea of the human as made in God's image in question. Indeed, the secularization in thought commonly associated with the Enlightenment can be said to elevate the human to the place of truth insofar as true knowledge becomes true human knowledge, as distinct from knowledge revealed by the Word of God. Then, because knowledge of the human is no longer revealed to the human, it must be sought out and secured— though, of course, the object to be known is also the subject trying to know. Hence, once true knowledge more generally is no longer revealed but deducted or inducted by human reason or experience, it proves especially important to secure one's understanding of the subject who produces the knowledge. Anxiety over the human's place in the world appears, in other words, hand in hand with an elevation of the human to the place of most important object of knowledge. As the intellectual historian Michèle Duchet points out, anthropocentrism and anthropology form two sides of the same coin.[10]

What I am suggesting is that knowledge of the human is *to be* secured in a context where the nontemporal cannot be assigned, as a matter of course, to a transcendent sphere that belongs to an order separable from the earthly sphere. The problem is one of how to think the atemporal and temporal on the same plane of existence. Thinking the aesthetic, which includes a necessary passage between atemporal and temporal, will accordingly entail thinking the atemporal on the level of the human. *On a human level* means not only from a human perspective but also on the plane of human existence, actual as well as potential. Here the nontemporal takes on the names *primitive* or *original*—primitive or original not given and revealed by the Word of God, but approached through human understanding; primitive or original now lodged and even originating within the human (for example, the aesthetic as a primitive human faculty, akin to Rousseau's *quelque autre cause*), or broached within natural, civil, or

philosophic history (for example, chaos before order, isolated individuals before society or before language).

Encountering the Problem

To clarify my claims in this introductory context, let me offer an historical narrative of sorts—a narrative running through a series of examples to specify more closely the Enlightenment's encounter with our central problem. I will begin with Wilkins's seventeenth-century *Essay Towards a Real Character, And a Philosophical Language* (1668), then La Mettrie's *L'Homme-Machine* (1748) and Rousseau's unfinished *Essai sur l'origine des langues,* before bookending the narrative with some indication of how nineteenth-century historicism attempts to avoid the problem. Wilkins's attempt to produce a universal language (according to Umberto Eco, "the most complete . . . that the seventeenth century was ever to produce") registers an engagement with the New World in a context where the recourse to God helps Wilkins avoid the aporia that orders the Enlightenment problematic.[11] However, in the cases of La Mettrie and Rousseau, we see two central Enlightenment figures grapple with the problem of thinking the atemporal and temporal on the same plane, in the absence of God or History. Finally, we will note how the dominance of historicism in the nineteenth century works to disavow the problem.

Wilkins

With Wilkins we can best begin with his mention of the New World. Though commonly ignored in the scholarship, the New World's role in the *Essay* is decisive. It is the hinge upon which turn the major components of Wilkins's argument, which all partake in the problem of mediating the nontemporal and temporal: the Americas provide Wilkins an important empirical reference to secure his particular reading of scripture that will then underwrite both his attempt to produce a universal language and his sense that language is a primitive human capacity. Here is what Wilkins says of the New World:

> Some of the *American* Histories relate, that in every fourscore miles of the vast Country, and almost in every particular valley of *Peru,* the Inhabitants have a distinct Language. And one who for

several years traveled the Northern parts of *America* about *Florida,*
and could speak six several Languages of those people, doth
affirm, that he found, upon his enquiry and converse with them,
more than a thousand different Languages amongst them.

Wilkins calls upon the New World's astonishing linguistic diversity to sup-
port and further the claim "that no one Language is *natural* to mankind,
because the knowledge which is natural [that is, innate] would generally
remain amongst men, notwithstanding the superinduction of any other
particular Tongue, wherein they might be by *Art*." No original, underived
human language, then; if there were such a thing, knowledge of it must
always remain to some degree available to all humans, it being something
natural and so universal, innate and never quite forgettable. But one can
travel through the Americas and encounter "in every fourscore miles of
the vast Country . . . a distinct Language."[12]

The New World's linguistic variety also makes clear for Wilkins the
word of scripture, where "'tis evident enough that the first Language was
con-created with our first Parents, they immediately understanding the
voice of God speaking to them in the Garden" (2). That is to say, God
did not put into the human an essential language. God created the first
language alongside the first humans in an act of con-creation, with them
but not as part of them. The first language's relation to the human is acci-
dental rather than necessary. This means that unlike a supposed natural
language, whose specific words would be essential to the human and so
beyond alteration, a nonnecessary first language may, in its use over time,
change or even disappear. And this is exactly what the Americas show:
the existence there of so many distinct languages proves it impossible
that there ever was a single natural language, which is what the Bible says
anyway, if read properly.

The reader may wonder why Wilkins advances the reading of scripture
he does. It is, after all, a reading that needs the support of nonscriptural,
empirical evidence (the linguistic diversity of the New World), suggest-
ing a lack of clarity and even a lack of self-sufficiency in the Bible. Most
simply, Wilkins needs to establish his particular account of the creation
to secure the possibility of his ultimate project. Let me explain. Wilkins,
like a number of his contemporaries, wanted to produce a universal lan-
guage. For Wilkins that language must be able to exist outside of historical
change and the force of history's negative alterations, and yet, because of

the variety of languages on display in the world, it seems clear that all languages are subject to alteration, whether changing over time or developing through the consent of a given civil society (6). In fact, all human things, Wilkins says, prove subject to temporal processes and therefore to corruption, and the nonexistence of a single, let alone natural, language is in some sense symptomatic of the wider fallen state of all things human (2). The nonexistence of a natural language also means that there is no one perfect language to recover: insofar as a perfect language is possible, it is not something to be found but something to be made. Yet, as Wilkins notes, if something is produced historically—developed and altered over time through human interaction—then it is from the beginning tainted and therefore necessarily imperfect. For Wilkins it is critical that a nonhistorical yet nonnatural language be possible—which is exactly the possibility that he takes the Book of Genesis to evidence in the notion of con-creation.

Wilkins's reading of the Bible supports his separation of any actual language from the human's capacity for language. Doing so, Wilkins grounds his understanding of human linguistic potential in something that in the seventeenth century would be called primitive: while God created the first language as nonessential to the human being, what he did put inside the human was an original capacity for, or faculty of, language. Adam and Eve could speak the first language not only because God con-created the first language with them but because they were able to speak the language given them. God put inside them the capacity for language, to which he added, separately and as separable, an actual language. It is the primitive faculty for language that Wilkins believes can serve as a nonhistorical ground upon which to erect a nonhistorical language. Whereas particular languages are to some extent separate from the faculty of language, Wilkins's universal language will aim to reduce the distance between the language and the faculty so as to foreclose the possibility of distortion by temporal forces. Here we see Wilkins edging toward our problem—he wants to align the nontemporal with what is otherwise a worldly, temporal entity (that is, human language)—though he ultimately avoids it.

If the aporia that structures what I am calling the Enlightenment problematic was to manifest in Wilkins's *Essay*, it would be when he conceives the passage between a primitive capacity and the speaking of a language—that is, between a pregiven, underived faculty and a temporal action. However, by claiming that the first actual language was given by God, Wilkins needs not ask why anyone would have ever begun to speak in the first

place. There simply has always been language as long as there has been human beings. Eighteenth-century theorists will be most interested in the scenario Wilkins expressly repudiates: dispersed savages meeting and subsequently developing language, as if, in Wilkins's words, "men did spring out of the Earth, and after inhabit alone and dispersedly in Woods and Caves, [and] had at first no Articulate voice, but only such rude sounds as Beasts have" (2). The eighteenth-century interest lies less in how a particular language develops than in how human faculties could produce language. The essential scenario imagined by the likes of Adam Smith, Condillac, Rousseau, and Herder is not simply the appearance of a language; it is the appearing of a language at all when and where previously no language existed. The question they thus ask is, how does a human faculty generate something where there was a perceived nothing? The answer necessarily entails thinking the atemporal and temporal together: language not as given by God but as developed in the world out of a primitive human faculty that God may or may not have installed (which is to say, did not necessarily install) in the human.

Wilkins sidesteps the difficulties engendered by the Enlightenment problematic. His God answers in advance the problem of understanding the passage from atemporal to temporal. As the German philosopher J. G. Hamann writes nearly a century after Wilkins, "This decision of our prime originator [that is, to make possible the revealing of his creation to the senses by making the human in his own image] unravels the most complex knots of human nature and its destiny."[13] Hamann arrived at this position, broadly characteristic of his philosophy, because he could see no other way of solving the intransigent problems of philosophy. However, there is an important difference between Hamann and Wilkins. What Hamann arrives at through complex and often opaque argumentation, Wilkins begins with as established truth. Between Wilkins and Hamann, God moves from the position of departure for one's argument to that of arrival or recourse for one's argument. But how would one resolve the problem of thinking the nontemporal and temporal together without direct recourse to God as the absolute, transcendent point of causation? Many eighteenth-century theorists try to do exactly that as they search out a panacea from within the problematic—which is not to say they either resolve the problem or successfully evade God. I will now turn to the examples of La Mettrie and Rousseau to underscore the difficulty involved: first, to La Mettrie's *L'Homme-Machine*, where not only God but first

things return, even as they are dismissed as unfit for consideration; and second, to Rousseau's *Essai sur l'origine des langues*, where he attempts to comprehend the advent of language outside all theological models, as natural and not divine.

La Mettrie

La Mettrie expressly rejects all extranatural explanatory frameworks. Such frameworks cannot be warranted, he says, because they require going beyond what we can claim to directly know. La Mettrie extends the logic to first things. As "il nous est absolument impossible de remonter à l'origine des choses," he suggests it is folly to torment ourselves "pour ce qu'il est impossible de connaître"; we will only lose ourselves "dans l'infini," that is to say, in an abyss of what is not limited by temporal determination.[14] We must hold our interest to what clearly exists, limiting our attention to how something is organized and how it operates in its organization. For La Mettrie, approaching *l'homme* as he is means confronting a multifaceted mechanism engaged in assorted acts of mechanistic becoming—but whose original coming-into-being lies beyond our possible knowledge. The human-machine can be said to have "la disposition originaire & primitive des organes," though we cannot say how that disposition originated in its primitive form.[15]

La Mettrie acknowledges that many who confront our "ignorance absolument invincible" of nature's efficient cause take recourse to a God ("a fait recourir à un Dieu"). He contends, however, that when one says "God," one could just as easily say "Nature" or some such other term. Singling out the word *God* and adhering to all that comes with it is simply a recourse *of* ignorance *to* ignorance.[16] What La Mettrie is rejecting here is not ignorance itself, which simply cannot always be avoided, but the building of ignorance upon ignorance. We must realize the limits of our knowledge and cease projecting beyond those limits. God is something that lies well beyond our direct knowledge; unable to know whether or not there is a separate, transcendent creator, we ought to proceed as if there were not. "It is all the same for our peace of mind," La Mettrie points out, "whether matter is eternal or created; whether there is a God or none, we will lose no sleep over it."[17]

Yet when we look closely, La Mettrie proves unable to avoid recourse to a notion of first things—those things that he says we cannot know

and hence should not worry ourselves trying to know. Specifically, the problem returns in his account of the soul, which he insists on calling "l'ἐνορμῶν d'Hippocrate" (198). To see how the problem returns requires following the main lines of La Mettrie's repudiation of Descartes. La Mettrie's primary aim in addressing the soul is partly proleptic—to answer in advance certain Cartesian objections that will undoubtedly be put to his account, objections that will center on his attempt to resolve the mind–body problem by sinking mind into body.

Noting that the soul is typically taken, as it was by Descartes, to name an immaterial substance autonomous of the body, La Mettrie rejects that use of *l'âme* as a catachresis: "L'âme n'est donc qu'un vain terme dont on n'a point d'idée" (Soul is, therefore, only an empty word to which no idea corresponds).[18] The "ἐνορμῶν d'Hippocrate" (or *enormon,* an active force of the body) is, rather, concrete and material. It is a spring *(ressort)* lodged in the brain *(cerveau).* There, it causes feelings, thoughts, passions—even maladies of the imagination and what we would call aesthetic experience more widely. By claiming the soul to be a mechanism La Mettrie gives the lie to Descartes' well-known claim that the human differs from the animal because it possesses an immaterial and immortal soul, a discrimination that famously meant for Descartes that all animals must be mere automatons. But once one understands that the soul is itself a spring or *ressort,* then one realizes that "l'homme n'est qu'un animal, ou un assemblage de ressorts" (the human is only an animal, or an assemblage of springs).[19] In keeping with his emphasis on *l'homme* as he is, La Mettrie quickly notes that the soul takes its place in a continual process of natural oscillation whereby each spring activates the next, though we cannot, of course, tell where it all begins—at which "point du cercle humain la Nature a commencé" (198). What is certain is that if springs differ among themselves, they do so only because of their force and location. All springs are, in their nature, identical. Hence the soul as a spring is only a principle of movement (force) or a sensible material of the brain (location).

But precisely here everything will be called back into question. "On peut," La Mettrie writes, "sans craindre l'erreur, regarder [l'âme] comme un ressort principal de toute la machine, qui a une influence visible sur tous les autres, et même paraît avoir été fait le premier; en sorte que tous les autres n'en seraient qu'une émanation" (one can, without fear of being mistaken, regard [the soul] as a principle spring of the entire machine. It has a visible influence on all the others. It even appears to have been made

first so that all the others merely emanate from it). With what La Mettrie's modern editor calls "cette étonnante formule," the problem of knowing first things returns. La Mettrie reaches beyond his circular, already existing system of *oscillation naturelle* to posit a first-made spring, *l'âme*. While the spring itself is supposedly of the same nature as all other springs (meaning that it is of an origin we cannot know, and that it operates within an endless causal chain whose originating link we cannot know) "l'ἐνορμῶν d'Hippocrate" nonetheless appears to have been made first and made causally preeminent.[20]

What could compel La Mettrie to reintroduce a genetic understanding of the soul and of all human springs *(ressorts)* which now "merely emanate from it *[l'âme]*," an understanding so at odds with the dominant, extensively argued principles of his own account? Why would he return to his account the problem of knowing first things, bringing himself before the abyss *(l'infini)* he warns against? There is no clear answer to these questions. What they point to and what I want to underscore is the difficultly of avoiding the aporia I am suggesting recurs in much Enlightenment thinking, notably the unpassable pass between the atemporal and temporal.

Rousseau

Rousseau is perhaps more successful than La Mettrie in avoiding, or at least thinking outside, the model of God as absolute Creator. However, this is the case less because Rousseau has no need for God than because he is unable to seamlessly integrate the biblical and the natural frameworks he deploys. That Rousseau considers the two frameworks as separable is clear from the *Discours sur l'origine et les fondements de l'inégalité* (1755), where he begins by arguing the need to divest *l'homme sauvage* "of all the supernatural gifts *[tous les dons surnaturels]* that he could have received, and of all the artificial faculties *[toutes les facultés artificielles]* that he could have acquired only through long progress."[21] As for what Rousseau calls *les primitives langues* (and he insists on the plural), in both the *Discours sur l'inégalité* and the undated *Essai sur l'origine des langues,* he wants to conceive the languages' advent not supernaturally but naturally. On the one hand, specific local circumstances create conditions that make a language necessary, and on the other, "une faculté propre à la homme" ensures that a language is able to be produced.[22]

Nonetheless, Rousseau only finds the room to conceive the development of *les primitives langues* by forcing open a gap in Genesis. Like Wilkins, Rousseau maintains that God gave Adam the first, subsequently lost language. Rousseau then goes on to align the existence of dispersed savages in the world with the biblical chronology by suggesting they derive from the wandering children of Noah (94, 96). Dispersed, Noah's descendants forget their forefathers' language and enter the solitary state of *l'homme sauvage*. At this point Rousseau then steps beyond the biblical account, opening a time of worldly existence unmarked by human or natural development, "un temps avant le temps," as Derrida puts it.[23] With his abyssal time before time Rousseau prepares the grounds upon which he aims to think the advent of human language and society, the passage he now seeks to comprehend being that whereby humanity departs from its equilibrial existence to enter *l'état social*.

However, Rousseau encounters a problem. While he speculates freely on the time of humanity's dispersal *avant le temps,* when *l'homme sauvage* lived, he says, in isolation and indolence amidst plenty, Rousseau has difficulty conceiving how that existence could have come to end: "I cannot imagine how they would ever have renounced their primitive freedom *[leur liberté primitive]* and left the isolated and pastoral existence *[la vie isolée et pastorale]* that so well suits their natural indolence, in order to impose on themselves without any necessity the slavery, the labors, and the miseries that are inseparable from the social state *[l'état social]*."[24] Not only can Rousseau find no answer in the Bible, but he can also find no telos in the first phase (a time before time) that would point to or necessarily engender the second. Nothing in the first phase suggests to him its end and subsequent substitution by a further phase. The time before time leads him out of the Bible and into a dead end.

Facing the unimaginable passage from freedom to *l'état social*, Rousseau recurs to the figure of a Deity, or rather, to the finger of one. Rousseau proposes a *surnaturelle* tipping of the earth's axis, in an act that expresses the will and power of a transcendent Deity: "Celui qui voulut que l'homme fut sociable toucha du doigt l'axe du globe et l'inclina sur l'axe de l'univers" (He who willed man to be sociable inclined the globe's axis at an angle to the axis of the universe with the touch of the finger) (99/273). Simply put, the earth's being tipped onto its current axis changes nature, a change that then naturally forces humans into groups. For with the earth on its new axis, nature inaugurates the variety of climates we now find across the

globe. Hence the double import of Derrida's *un temps avant le temps,* translatable as either "a time before time" or "a time before weather." The earth's new alignment occasions seasonal variations, which, adding to the force of nature's continual accidents (particular floods, volcanic eruptions, earthquakes), brings about periods of scarcity, and isolates certain resources in particular areas and not others.[25] Whether to combat resulting hardships or to access geographically limited resources, once dispersed people are now drawn together. As they form into societies, they also begin formalizing means of communicating with one another.

Rousseau proves unable to directly banish a supernatural God from the *Essai.* When he faces what Hamann might call a "complex knot of human nature and its destiny," Rousseau freely calls upon an understanding, willful, and powerful Deity. But once the transcendent finger tips the earth and humanity enters time, Rousseau no longer requires God as an explanatory principle. Henceforth things proceed *naturellement* as humans interact with a changed natural environment: Rousseau needs no extraterrestrial agency to explain the complex of processes and developments entailed by human beings acting in the world (upon nature and upon one another) and the world of nature acting upon them. It is, in other words, something like history to which Rousseau turns as an explanatory principle. So while historical understanding faces limits it cannot surpass—the passage from *l'homme sauvage* to *les hommes sauvages* cannot be explained historically—human history nonetheless becomes the principle by which to understand the particular actuating of a language by the latent linguistic faculty "propre à la homme." Hence the advent of specific groups in specific local circumstances who engender primitive languages.

The Disavowal of History

One might be tempted to see in Rousseau's turn to history as explanatory principle a foreshadowing of attempts to resolve the problematic by way of a third term. The notion of history, particularly in the historicism we associate with Herder, will appear to supply not simply the missing answer to the initial question (how to think the atemporal and temporal on the same plane?), but also the missing answer whose absence had itself caused the initial problem. Without an adequate concept of history, in a context marked by God's withdrawal, one would be condemned to endlessly repeat the problematic's structuring problem. Insofar as historicism appears

to get us beyond the problem, its rise to dominance would become the sign of intellectual progress. I will suggest a different scenario.

Rather than understanding historicism as the triumphant overcoming or resolving of the problem, we can better understand it as a sophisticated disavowal of the problem—a disavowal whose virtue lies in its apparent ability to hide the problem more effectively than Enlightenment thought did. At its most effective, historicism avoids Montesquieu's *aporie* by displacing the *intemporel*. Recall that the problem Montesquieu faced was how to mediate the nonexperiential, only intelligible order of "la typologie pure," and its corresponding yet incommensurate temporal instantiation. From the historicist perspective, Montesquieu's inability to articulate typology and history would follow from his primary term's lack of causal agency, the category of pure typology being, for Montesquieu, essentially (as opposed to accidentally) *intemporel*—hence the problem of comprehending how the nonexperiential attribute of a type of government could instantiate a particular, temporally bound government. A properly historical understanding cannot accept the implication that follows: that because the typological founds the historical yet contains no clear causal connection to what it founds, the typological paradoxically leaves the historical unanchored and so apparently accidental. To secure the authority of a proper historical understanding, one thus needs to displace the nonexperiential, atemporal force of a category that renders history itself (and not simply historical events) merely contingent.

Historicism works by sinking the accidental into the categorical, reducing to an apparent single order what remained in Montesquieu two separate, incompatible orders. It does so, first, by restricting its focus to human actions understood as historically determined actions.[26] Second, it secures and even extends its own scope and power by making history both subject and object of knowledge: a given human-inaugurated event (the object "history") becomes the effect made possible by a given, human-made historical context (the subject "history"). History becomes the essential category whose putative accidents (historical events) merely instantiate the categorical. Once dominant, historical thought "[makes] history the condition of human life at all points."[27] History becomes beginning and end, cause and effect—as if a new Deity.

For my purposes the point to underscore would be that historicism's apparent ability to avoid the problem that concerns us also works to recast the primitive, insofar as it exists in the world, as historical. Whereas

Rousseau held primitive and savage apart, under a dominant historicism the concept of the primitive becomes substitutable with that of the savage, available for use in an ethnological sense more familiar to us today, as a predicate for certain nations, races, and eventually cultures. One way to phrase the shift in question is to say that the definite article gives way to the indefinite and to an attendant pluralism. A people would be called primitive not because they are the one, original human group, but because they live and reproduce under certain basic—perhaps the most basic—conditions. Insofar as historicism, with its global pretensions, posits an internally unlimited field of human action where everything proves subject to its logic, it makes everything out as containing and being contained by historicity. Accordingly it affords no place within the sphere of human activity to what is prior to temporal alteration. The use of *primitive* to name a form of human society would thus reference nothing outside of history. The word would name the most simple form of human society, one that exists in time even if it barely alters over time.

What I find remarkable and endlessly fascinating about the eighteenth century is the particular attempt then to try and think through the problem of conceiving a passage between atemporal and temporal without God or *Geist* to guarantee in advance the terms of an answer. Having, in this Introduction, set up the scope of the problem, I will turn, in Part I, "Primitive, Aesthetic, Savage," to establish the respective scope and significance of my three main terms. I dedicate one chapter to each. Ordering the terms as I do—with *aesthetic* in between *primitive* and *savage*—serves to underscore the difference that persists throughout the eighteenth century between primitive and savage. In addition, the order of terms enables us to follow a certain trajectory that works its way from one term to the next. The primitive puts to the fore the intellectual interest in origins, specifically in worldly origins; the aesthetic presents the narrowing of that focus toward a primitive human faculty and the problem of thinking its worldly articulation; and the savage provides eighteenth-century theorists the means to try and delimit something primitive like the aesthetic faculty.

The chapters of Part II, "Delimiting the Aesthetic," look at how two influential aesthetic theorists constitute their object. In chapter 4, "Joseph Addison's China," we will see how Addison's particular avowal of the imagination lead him to found his aesthetics on the model of a fundamentally

incomplete self. What holds the self open is the problem of thinking the primitive. Addison characterizes aesthetic experience as immediate, pre-cognitive, and largely irrational, engendered by a faculty (the imagination) that remains outside historical development—a characterization that constitutes his object as something that precludes direct description, something primitive, prior to any defined temporal alteration. With his aesthetic theory, then, Addison conceives a primitive human faculty that opens an unconditioned gap at once necessary for understanding aesthetic experience and yet difficult to properly determine. How does Addison respond to the problem of determination? His response involves present-ing an ideal aesthetic experience as incarnated by a certain Chinese taste in landscape. What becomes clear from a close attention to Addison's argumentation (to what he is *saying*) is that the example's exoticism, its geographical and cultural difference, supplies him a literal limit that he turns to figure a limit of another, subjective order: the difference between one type of experience (aesthetic) and another (not aesthetic). However, Addison's own "saying" encounters, with notable effects, the example's own uncertain articulation of self and world, with instructive consequences for our understanding of eighteenth-century aesthetic theory's dependence on exotic figures.

Like Addison, Immanuel Kant insists that something unconditioned holds a central place in aesthetics. However, unlike Addison, Kant builds an elaborate critical architecture to set the conditions of possibility for aesthetic experience according to which he can then determine the role of what remains unconditioned and free from any determination by the understanding. Even so, this does not mean Kant can determine the un-conditioned itself, making his task one of setting its conceivable limits. As I show in chapter 5, "Kant's Tattooed New Zealanders," Kant calls upon exotics figures to delimit the unconditioned aspect of the aesthetic. In a decisive articulation, he turns to Maori facial tattooing, binding what Jacques Derrida calls Kant's "recours anthropologiste" to a largely unrec-ognized ethnological component underwriting the *Critique of Judgment*. Kant's casual mention of the New Zealanders and their tattooing carries the most important consequences, signaled by its appearance in what has become one of the most contested sections of the third *Critique,* in which Kant attempts to distinguish the concepts of free beauty and merely adher-ent beauty. For Kant's aesthetics hinges on his ability to coherently sepa-rate free or unconditioned beauty from adherent or conditioned beauty,

and it is this distinction that Kant calls upon the tattooed New Zealanders to indicate, placing them at the heart of Kant's aesthetic theory. Part III, "Aesthetic Formations of History," also consists of two chapters. But here I address efforts to link or to separate the primitive and the savage in the face of pressure put upon existing modes of comprehension by the New World. In chapter 6, "Adding History to a Footprint in *Robinson Crusoe*," I examine Crusoe's attempt to read a singular, Cratylic footprint as a mark made by a savage and thus as a temporal event. I begin with a curious yet seldom acknowledged feature of Defoe's novel: the assuaging role it affords actual savages. Though for much of the novel Crusoe anxiously reiterates his fear that cannibal hordes will descend upon him, when such savages finally do arrive on his island, they help relieve him of anxiety. How are we to understand the stakes and the logic of this relief that at moments borders on delight? Because it occurs shortly after Crusoe's discovery, to his great fright, of a lone footprint in the sand, the relief that the savages facilitate would appear to have to something to do with their ability to palliate the fears Crusoe derives from this discovery. What I suggest is that between Crusoe's encounter with the footprint and his subsequent response to the savages, Defoe dramatizes the advent of a certain aesthetic self. That self takes shape through an active overcoming of the perceived threat to its continuance that the singular footprint appears to pose. In lessening the pain that the footprint causes him, this overcoming produces in Crusoe a sense of relief. The savages facilitate that sensation and thus get the aesthetic self going.

What happens when Crusoe's problems find a wider canvas, a nation or new body of thought, rather than an individual? I take up this question in chapter 7, "Indian Mounds in the End-of-the-Line Mode." Late in the eighteenth century, Euro-Americans suddenly realized that for the waves of settlers heading into the Ohio Valley, the earth might not be all that was before them. Not only were there the bands of Indians still surviving disease and displacement, but there were things in and of the earth itself, such as the often immense mounds of earth that A. J. Conant, in the nineteenth century, would call "the Foot-prints of vanished races in the Mississippi Valley." The encounter with the mounds produced effects that could not be contained within the limits of the encounter itself. The closed logic of cause and effect was cast open. Instead, the encounter with the mounds elaborates the logic of what Horace Walpole, in 1754, coined *serendipity*. Not unlike the word *Sharawadgi* that I address in chapter 4,

serendipity is a word of exotic derivation (Serendip being an ancient Persian name for present-day Sri Lanka) used to conceive a certain aesthetic experience. For us, Walpole's concept comprehends both the disruptive energy of the mounds (their ability to transform one's relationship to the land and its past) and the surprise, felt so strongly in the late eighteenth century, of suddenly realizing something (an Indian mound) where one had expected nothing (undifferentiated nature). It seemed impossible that monumental earthworks could exist in a land populated only by itinerant savages, yet here they were, thousands upon thousands of them. As it turns out, what most early archaeologists claimed to find in the mounds were not the remnants of earlier Indian societies. The discipline of archaeology in the United States took shape as early nineteenth-century writers separated what they called the savage races of Indians and the primitive race of true first Americans, the Mound Builders, whose civilization was supposed to have been extinguished by the subsequent arrival of marauding bands of savage Indians. In this case, the surprise of serendipity ushers in not an aligning of primitive and savage, but their separation, producing a vision of human history that supplied the young United States with its own sublime, immemorial past.

 The Primitive, the Aesthetic, and the Savage examines the primitive's critical place in eighteenth-century thought and expression; how its formulation leads early aesthetic theorists to conceive the aesthetic by way of the exotic and savage; and, conversely, how writers like Defoe and the early writers on the mounds use aesthetic concepts to articulate the savage within an historical framework. In the Conclusion, I take up the question of what all this means for our understanding of the Old World's relation with the New World.

I

PRIMITIVE, AESTHETIC, SAVAGE

· CHAPTER 1 ·

The Primitive

HISTORICALLY SPEAKING, THE TERM *primitive* carries considerable weight in the eighteenth century. Understood as designating the first or original of something, it proves centrally important in a context marked by the keen interest origins. A point of origin was, broadly put, understood to present a point prior to contradiction and contingency, hence revealing something in its original state meant revealing that thing in its essential, true state. As Jean Starobinski notes, among "les hommes de sciences et les philosophes de l'époque," few believe they have demonstrated anything unless they have "revealed the simple and necessary sources of all phenomena [*de tous les phénomènes*]: they therefore made themselves historians of the origins of the earth, of life, of the soul's faculties, of societies." Knowledge of the primitive, understood as first or original, would thus offer knowledge of worldly origins ("de tous les phénomènes") at a point prior to possible confusion. However, as I hope to make clear, *primitive* is not limited to the sense of first or original— and this has implications of great import not only for our understanding of eighteenth-century attempts to think the primitive, but also for its attempts to theorize the aesthetic and to comprehend the savage.[1]

As yet, we have no account of the primitive's fortune in the Enlightenment, nor of the ways that it presented the pressing problems to comprehension that it did.[2] My immediate aim in this chapter is to supply that missing account. Doing so will enable me to show more closely the central problem generated by the problematic that demands knowledge of the nontemporal and the temporal. As we will see, in its weak sense the primitive is what upsets the ordering of time, while in its strong sense it is what occurs outside of time. However, the primitive must also be rejoined with the worldly (or temporal) order of existence. After addressing the various ways *primitive* might be used in the eighteenth century, I will show how the problem of thinking the primitive *in* the world attends a certain secularization of thought, whence origins are conceived no longer in terms of

a transcendent Deity but in terms of principles of human knowledge. Jean-Jacques Rousseau's famous attempt to formulate humanity's *l'état primitif* will provide us a vivid example of thinking the primitive from principles, after which we will be in a position to address, in chapter 2, the theorization of aesthetic experience as originating in a primitive human faculty.

The Primitive's Complexity

Margaret T. Hodgen, in her classic study of early modern anthropology, notes that *primitive* carries "a heavy semantic burden of confused implications and intimations."[3] Hodgen does not elaborate the word's burden. Few critics or historians of ideas have, tending, like Hodgen, only to augment the confusion by assuming *primitive* and *savage* to be mutually substitutable. Certainly *primitive* is, as Hodgen suggests, a complex word, condensing an array of meanings, doctrines, and propositions, as well as hosting a variety of linguistic and conceptual difficulties. Yet before the nineteenth century, the term does not serve as a predicate of actually existing people. Rather, it is used to posit an original instance, moment, thing, or condition.

Let me give some examples. Certain colors could be called *primitive*, or later *primary* (Voltaire's Micromégas knew an astonishing "trente-neuf couleurs primitives"), just as certain words could be (James Macpherson, author of the famous poems of Ossian, claiming the Celtic dialect of northern Scotland to abound "with primitives," by which he means words not derived from another language, but original, "antient and unmixed"). The Restoration poet, John Wilmot, earl of Rochester, in his "Upon Nothinge" (1679), called the void before creation a "primitive nothinge":

Ere tyme and place were, tyme and place were not,
When primitive nothinge somethinge straite begot,
Then all proceeded from the greate united *what.*

In addition, an event occurring at any date might be called *primitive* if it was, from a given perspective, the first such event: one could have, for example, a "primitive impression" of London.[4]

When *primitive* was used to predicate a given social form, it denoted an original institution or custom, as in the following passage from John Bulwer's popular work *Anthropometamorphosis* (1653), which seeks to

compare the various conditions of the earth's human populations: "Paint-ing and black-Patches are notoriously known to have been the primi-tive Invention of the barbarous Painter-stainers of *India.*" Interest in determining an institution's primitive form followed mainly from the claim that one could thereby locate the institution's most authoritative instantiation, as in the so-called Primitive Church (the one true original church), or, recalling Jonathan Swift's satire on the question in *Gulliver's Travels* (1726), as in the Big-Endians' and Little-Endians' respective claims to observe "the primitive Way of breaking Eggs before we eat them." However, a "primitive Invention" of whatever sort does not make a society itself primitive—or even savage. After all, if Adam and Eve in the Garden of Eden spoke the primitive language, it was not because they were savages.[5]

Now, as a complex word *primitive* is atypical. Unlike many such words (*art, history, literature*), its connotations are characteristically at odds with complexity. *Primitive,* as evocative of a natural priority or simplicity, should easily point to its putative object, but it does not—a lack of referential confidence deriving not only from its semantic instability (which is Hod-gen's claim), but also from its positional force. The primitive's ordinal potential gives it a complicated temporal reference. Most obviously, the ordinal potential entails a structural compromise. As the word's etymol-ogy suggests, *primitive* denotes or at least connotes the first or original (*primus*), yet there can be no first without a second remarking its ordi-nal priority. Otherwise the so-called first *of* something is simply the only instance of that thing. We can even say that insofar as the first requires the advent of the second, the first comes after the second—though we would have to add that at the same time the inaugurating second must be signed in advance by a supposed first, without which the second could not come into existence, and which it thus can never properly exceed and leave behind. The same logic would extend to the pairs *primary–secondary* and *original–derivative.*

What proves so remarkable about the primitive's positional force is that it does not simply engender confusion. It ensures that as the concept shifts into and out of differing contexts it retains a certain formal con-sistency. Despite the structural compromise, *primitive* points toward the first or original that most commonly appears as if prior to any temporal alteration or corruption—hence the authority granted the primitive ver-sion of something. It is the true, unadulterated version. Viewed from the

perspective of its formal consistency, the concept gathers a legibility stretching back to the ancients and forward to the moderns of our own recent past and present. It makes thinking the primitive a variation on the problem of thinking first things found as readily in Plato's *Theaetetus* and Plutarch's *Lives* as in Ferdinand de Saussure's *Course in General Linguistics* and Martin Heidegger's *Being and Time,* and most recently in Steven Pinker's *The Stuff of Thought* and Quentin Meillassoux's *After Finitude.* Phrased in the temporal terms so important in the late seventeenth and eighteenth centuries, it is the problem Milton explores in *Paradise Lost* when both Adam and Satan confront the impossibility of knowing an original act of creation when one is a product of that act and hence always after it in existence (one is the effect of the cause) and in knowledge (one is able to approach it only a posteriori and in the terms given by the creation). As Aquinas puts it, "We cannot demonstrate by the world itself how the world originates."[6]

The problem of comprehending the primitive is especially acute when positing the appearance of something where there had previously been nothing of the same order. This usage differs a great deal from naming an earlier version of humanity or one's first impression of London. With the latter, the impression may well be striking, but presumably it is not one's first impression at all, merely one's first impression *of London.* But *primitive,* used in the stronger sense, could also suggest the experience of having a first impression where previously one has had no impressions at all.[7] It is a sense that intimates an event or condition beyond or tangential to either direct knowledge or direct eyewitnessing. Certainly it lies beyond empirical knowledge, being, like the creation for Adam, known only secondhand or (as we shall see in Part III, "Aesthetic Formations of History") by its effects or remnants.

But there remains a still stronger sense, one that names what is before the possibility of a first, or indeed before the possibility of differentiation. Although this stronger sense does not escape the structural compromise of primary and secondary, it adds a further degree of complexity by making the prior and anterior incommensurable. In its stronger sense—closer to Rochester's "primitive nothinge"—the concept can even suggest the barely conceivable. Up to now I have been using the *or* in "first or original" inclusively. Yet it also has an exclusive sense. In the example of one's very first impression, *primitive* carries a clear ordinal reference and necessarily suggests subsequent impressions (a second impression, a third, and

so forth). However, the term can also name the condition prior to the occurrence of the first. Here we could place one's original condition prior to any impression at all. This sense of primitive names what comes before any possible ordinal differentiation—what, in other words, comes before the first, and often proves incompatible with a serial logic. The preordinal condition may need to give way for the first of something to occur. While one could have a primitive impression alongside a second, third, or fourth impression, it is harder to see how one could maintain an original, pre-impression condition alongside a second, third, or fourth impression. And this means that it also becomes harder to comprehend how the original, preordinal condition could lead, of itself, to ordination or the first of something.

Begetting Something from Nothing

Let me elaborate the problem by looking more closely at Rochester's claim in "Upon Nothinge" that "somethinge . . . begot" itself immediately out of the original "primitive nothinge."[8] The transition would entail, most precisely, movement from a preordinal to an ordinal condition. In the context of the poem, Rochester attempts to ground the difficult passage from nontemporal void to temporal world, or preordinal to ordinal, by recasting the abyssal "Nothinge" as elder brother, as monarch, and as deity—which is to say, dialectically, that he shows how nothing qua nothing cannot supply the means to think the passage from void to existence. Rochester figures Nothinge as able to give rise to Somethinge only by endowing it with various attributes of existence. The move is clearly paradoxical, as Rochester acknowledges with the oxymoron lodged in the biting satire of "thy fruitefull Emptinesses hand" (11): presumably "primitive nothinge" means no causal agency, hence from "nothinge" nothing can come—that is, something cannot come from nothing.

Yet the action Rochester denotes with "When primitive nothing somethinge straite begot" (5) remains one of begetting. Possibly *begot* serves to mark our (human) perspective, with its necessarily limited view on the Creation; because suddenly and immediately ("straite"—that is, without intermediary) there was something where there had been nothing, it looks like the something came from that nothing. According to the logic of ex nihilo nihil fit, however, that human perspective must be inadequate. But rather than call upon the familiar Christian God, Rochester

responds to the limits of human understanding by personifying and deify-
ing Nothinge. On the one hand, Rochester personifies Nothinge. The
"elder brother, even to shade," Nothinge possesses the attribute of exis-
tence ("Thou had'st a beinge ere the world was made") and of primogen-
iture (the "well fixt" "elder brother") (1–3). Personified, Nothinge becomes
Somethinge's ordinal reference, the first installing as it is installed by the
latter's second. On the other hand, Rochester deifies Nothinge, making it
out as God to Somethinge's Satan:

4
Yett somethinge did thy mighty power Command
And from thy fruitefull Emptinesses hand
Snatch'd men, Beasts, birds, fyre, water, Aire, and Land.
5
Matter, the wickedst ofspringe of thy Race,
By forme asisted, flew from thy Embrace
And Rebell Light, obscured thy Reverend dusky face.
6
With forme and matter, tyme and place did Joyne,
Body thy foe, with these did Leagues Combyne
To spoyle thy peacefull Realme and ruine all thy Lyne. (10–18)

As "Rebell Light," Somethinge possesses clear agency. While all that
Somethinge ever "sever'd" from "thee [that is, Nothinge] its sole origi-
nall" will eventually return, "undistinguish'd," "Into thy boundless selfe"
(9; see also 19–21), Somethinge nonetheless managed to command "thy
mighty power" (10). Here, Somethinge is able to draw power off from
Nothinge.
 At best, Rochester only displaces the deeper problem with his figur-
ative formulations. On the one hand, in personifying Nothinge as elder
brother, Rochester posits it as at once the original abyss or "boundless
selfe" where all distinctions disappear (9), and the first generated, a posi-
tion that requires it be distinguishable from what generated it, as from the
second, third, fourth generated. On the other hand, in deifying Nothinge
as God against "Rebell" Somethinge, Rochester fails to account for the lat-
ter's apparent ability to exercise will over Nothinge's power, leaving us to
wonder where enough difference could be found from "the greate united
what" to enable Somethinge's move out of the abyss of Nothinge's *quod* to

the thatness of its own quiddity. The difficulty that neither formulation is able to overcome is that the possibility of Somethinge requires, a priori, the possibility of a difference whose source remains unclear: if there is only nothing how could something have generated Nothinge, and how could Somethinge snatch anything at all from Nothinge, which presupposes a not-nothing (that is, something) that is separable from nothing?

Models of Transcendence

The problem of thinking ordination *out of* a preordinal condition proves most difficult when one places both on the same plane. In fact, this is Rochester's problem, played out as an attempt to establish difference in an abyss without limits. Because neither Nothinge nor Somethinge clearly transcends the other term, he needs to conceive Somethinge coming out of an apparently absolute Nothinge. Beyond Rochester's metaphysical concerns, the particular logic of the difficulty that he faces is shared by those thinking the primitive from a human perspective, where the demand is that one understand, from a worldly, temporal perspective, something that edges beyond the temporal—but which is crucially outside or at least beside the available models that would anchor it in a state of transcendence. It means binding the temporal and nontemporal, making the abyssal touch on our existence at every point.

Previously dominant models of transcendence, whether theological or adapted from the ancients, allowed one to separate things temporal and nontemporal either by locating a transcendent term that authorizes and governs their distribution or by assigning them to categorically distinct realms, with one transcending earthly existence. Aristotle provides a vivid example of the latter in the well-known passage from his *On the Parts of Animals:*

> Of things [Τῶν οὐσιῶν] constituted by nature some are
> ungenerated [ἀγενήτους], imperishable, and eternal, while others
> are subject to generation and decay. The former are excellent
> beyond compare and divine, but less accessible to knowledge.
> The evidence that might throw light on them, and on the
> problems which we long to solve respecting them, is furnished but
> scantily by sensation [αἴσθησιν]; whereas respecting perishable
> plants and animals we have abundant information, living as we do

in their midst, and ample data may be collected concerning all
their various kinds, if only we are willing to take sufficient pains.[9]

With "ungenerated, imperishable, and eternal" Aristotle alludes "to the
incorruptible ether from which the planets, stars, and orbs are made."[10]
Barely knowable from "sensation," the celestial realm of "substances" (to
specify Aristotle's "Τῶν οὐσιῶν" more closely) remain beyond us, divine,
transcendent. But while the heavens present problems for our knowledge,
which proceeds from sensation (αἴσθησιν) and so follows from a certain
proximity to what is to be known, those problems do not negatively affect
our ability to understand the temporal things around us. In fact, any
knowledge of what lies beyond the terrestrial region only enhances our
existence here and now: "The scanty conceptions to which we can attain
of celestial things give us, from their excellence, more pleasure than all our
knowledge of the world in which we live" (644b, p. 656).

Likewise, Christian theology, in its various post- and counter-
Reformation branches, anchored the nontemporal in a preestablished
global framework (the consideration of which also tended to give pleasure
or at least reassurance). Whether one thought God created the earth in
a single act alone (deistic) or in an original act with subsequent acts of
intervention (theistic), one could explain how something thought primi-
tive either heeded to or marked the first of something without having
to address the problems found to inhere in what we might call a more
worldly genesis. God framed nature and its laws in an act of pure creation
ex nihilo that places them and their origins outside of temporal becoming
and rational understanding.

Readers of Rousseau will recall the difficultly Rousseau had in deter-
mining the temporal origin of language. He suggests, on the one hand,
that the advent of languages enabled human beings to form societies, and
on the other hand, that the advent of societies enabled human beings
to form languages. Rousseau never resolves the problem.[11] However, as
we saw in the case of John Wilkins, those who adhere to a theological
model sidestep such problems in advance. God gave Adam the primitive
language; hence, one need not ask the question of when and how human
language first came into existence. Yet the primitive language continued
to exist beyond God's initial act of donation, at least until the dispersal of
tongues upon the collapse of Babel—and here the problem of thinking
the nontemporal and temporal together returns.

Writers wanting to hold onto a fully theological origin of language try to resolve, in various ways, the challenge of understanding the continued worldly existence, before and even after Babel, of the primitive and non-temporally derived language. One of the more significant attempts for our purposes is John Webb's *An Historical Essay Endeavoring a Probability That the Language of the Empire of China is the Primitive Language* (1669). Published a year after Wilkins's *Essay Towards a Real Character,* Webb's *Historical Essay* presented the first full treatment of the so-called Chinese language published in Europe. A concept of the primitive as what is original and unchanged, an ordination from God, is extremely important for Webb. Insofar as he maintains a certain theological plan, he finds little difficulty in positing what he calls the primitive language. Fitting his account to an established version of the biblical narrative, Webb guarantees both the prior existence of his object (the primitive language) and a governing order that determines its place in the world. But what Webb understands by primitive is all but unrecognizable to us today and will prove, if not unrecognizable then at least unwarranted, to the likes of Rousseau and others in the eighteenth century.

Webb's basic claim is that the Chinese still speak the language God gave Adam as an original dispensation, fully formed. He finds this evidenced, for example, in the fact that "their books are free from all errata's." Webb's China is a linguistic Utopia. Along with the books, the language of China remains free of error, accidental or intentional, to the point where it does not allow for deception in either speech or writing—qualities characteristic of the long-lost primitive language. Chinese even imparts in its singular purity the linguistic equivalent of an Edenic fig leaf: "they have no Letters whereby to express the *Privy parts* . . . which cannot be said of any Language under the concave of Heaven, besides." But how did the language of Adam end up in China? Citing much historical evidence from available written sources (his account is, Rachel Ramsey says, "an authority-driven, quotation-filled argument"), Webb contends, first, that the language spoken by Noah was still the original language of Eden, and second, that it was in China that Noah settled after the deluge. His descendants retained the original language and hence their innocence by choosing not to go to the Valley of Shinaar, where they would have succumbed to the confusion of tongues at Babel; by remaining isolated and thereby free from any change that follows from the conquest of or by, and the commerce with, foreign parts; and by possessing a stable, well-ordered

polis. The first two present historical outcomes preventing the loss of the primitive language. The third relates particularly to Chinese society's organization, which at once supports its linguistic purity and is that purity's direct effect. The primitive language, securing social order, has effects not wholly linguistic.[12]

That the Chinese language establishes both a linguistic and a political ideal in no way makes Chinese society a primitive, undeveloped society. Webb certainly articulates an ideal that contrasts sharply with the upheavals and apparent broken promises of England's recent history.[13] However, he bases his criticism on a fundamental resemblance between China and England, as of other European countries. Chinese society is ordered on a tributary mode of production whereby subjects pay fealty to the emperor in a social formation resembling the postfeudal European monarchies. That is to say, most basically, the empire of China is state based. As such, it presents European leaders with a model of economic and social organization to be emulated because structurally analogous (86, 97, 115). Also worth emulating is Chinese civil society, for it is as well developed as it is extensive. Mathematics, astrology, and astronomy; agriculture and planting; "physick," poetry, and moral philosophy—the main arts and sciences proliferate under Chinese conditions, carrying forth the true Adamic inheritance ("*Adam* . . . was, by his Creation learned in all manner of Arts") (7–8, 97–102).

Yet while Webb's China exhibits what we might call organizational intricacy, it shows no analogous temporal composition. As Webb sees it, the Chinese empire is wholly determined—not just in its state formation but also in its extensive civil society—by a language called *primitive*. As such, it has existed largely in a state of stasis for over five thousand years. What complexity China has follows from the fact that its language and society was and is generated by the Word of God, or at least the word closest to God, producing a social order Webb claims as the most advanced and most perfect, well ordered, and smooth running. Much of Webb's account of China thus concerns how it was able to remain outside of historical development. In this sense, only Chinese society might be called primitive or undeveloped. While Webb acknowledges that societies can and typically do change over time (primarily through conquest and commerce), he sees such change as the falling further away from the original, ideal condition. Webb effectively holds that primitive condition and the flow of history on separate planes. It is precisely because China has

remained outside of history that it has been able to preserve the revealed language. Otherwise, when the planes touch, the primitive falls away from itself, becoming subject to temporal corruption.

If Webb's aim is exactly opposite to understanding the primitive language as historical (which would bring him before our problematic), what would be the *historical* aspect of his *Historical Essay?* It lies in the attempt to reconcile the history of China and the known biblical chronology, specifically by fitting China to the existing biblical account of world history. This is his historical analysis. In venturing it, Webb aims to resolve a profound difficulty: he may sidestep our problematic, but he does not avoid hard questions. Contemporary estimates dated the earth's creation to no more (and often less) than six thousand years previous, placing all the major events of world history recorded in scripture within that time frame. However, in 1658 the Jesuit Martino Martini made clear that the Chinese had detailed written records reaching back five thousand years. The problem was that while the Chinese had records predating the destruction of Babel, and possibly even the universal deluge itself, those records contained no apparent mention of these events.[14]

Webb responds to the challenge China poses by aligning what history tells us of the Chinese with what scripture reveals. This entails his shoring up of scripture by finding veiled references in the Chinese writings to the flood as an ancient, past event, as something that occurred before the Chinese begin their record keeping. Then Webb can move on to his full rapprochement, claiming that the Chinese did not go to the Valley of Shinaar:

> Scripture *teacheth, that the* whole Earth *was of one* Language *until the* Conspiracy *at* BABEL; History *informs that* CHINA *was peopled, whilst the* Earth *was so of one* Language, *and before that* Conspiracy. Scripture *teacheth that the Judgment of* Confusion *of* Tongues, *fell upon those only that were at* BABEL; History *informs, that the* CHINOIS *being fully setled before, were not there; And moreover that the same* LANGUAGE *and* CHARACTERS *which long preceding that* Confusion *they used, are in use with them at this very* DAY; *whether the* Hebrew, *or Greek* Chronology *be consulted.* (A3r–A3v)

The effect of an attempted reconciliation like Webb's is that through it China forces a glimpse of history's potential for separation from the sacred

narrative. After all, Webb's account is ultimately premised on the Bible's being incomplete, needing to be supplemented by a profane history that can tell us where Noah settled and who retains the primitive language. But more than this, in aligning the biblical account with the available Chinese historical record, Webb articulates a chronology that can be abstracted from the Bible: if the medium that links sacred narrative and historical record is chronology, then chronology does not belong to the Bible alone and can therefore be conceived as separable.

The Primitive in the World

Webb derives a clear advantage by adhering to a theological plan. It settles in advance questions concerning the origination of things—how there came to be something rather than nothing, the world rather than not, language rather than not. God gave language to Adam, and it was so. Webb needs give no account of linguistic development prior to the institution of the Chinese empire; the fabled meeting of two savages common to eighteenth-century accounts of the origins of language has no place in his *Historical Essay*. All is given preformed, which means that he is in no way obliged to conceive the primitive as constituted in relation to historically determined models of existence—that he can avoid the problem that informs our Enlightenment aporia.

Webb's contemporary, Spinoza, would suggest that such recourse to an anthropomorphic transcendent authority who originates and governs the world serves as an unwarranted ideological and epistemological support. It grounds an explanatory framework whose own grounding is therefore assumed to require neither reasoned proof nor examination. More specifically, Spinoza would object that Webb's account of how the primitive language came to be that of the Chinese rests on his positing unknowable external causes due to limitations in his own understanding. It is the state of Webb's understanding that leads him to see what Spinoza would call *fortune* as responsible for China having the primitive language, *fortune* naming what Webb casts as God's will and understanding. For Spinoza Webb's use of a concept of fortune would sign Webb's ignorance: Spinoza defines *fortune* as an external, unknown cause, and he considers recourse to such causes as indicative of a failure of knowledge following upon a deficient understanding. If Webb's understanding was not limited in the way it is, he would be able to comprehend how his perfect society, if it

existed and was therefore possible, could only be established by internal acts of human understanding, and he would be able to do so because he could recognize the potential of human understanding to achieve and maintain such a society. That Webb does not suggests that he is unable to think that far.[15]

Refusing to posit first things as worldly in origination and hence potentially conceivable in origination is certainly not idiosyncratic. Among those who sought to keep worldly existence and preworldly nonexistence separate were central figures of what we call the Scientific Revolution, including Robert Boyle and Isaac Newton. As Paolo Rossi makes clear, Boyle and Newton argued their position against what they saw as the grave error committed by certain "atheistic mechanists," namely Epicureans and Cartesians, whose casting of Creation as the making of nature out of a previous chaos carried the dire implication that one could hope to comprehend the transition from chaos to order according to existing laws of nature. Boyle and Newton themselves restrict the scope of human understanding to the temporal, postcreation world. For them, "the process of the formation of the world did not constitute a possible object of science. . . . That process was narrated in the Bible, and the laws of nature are helpless to explain the world's way out of chaos. The physical world, just as it now exists, between its creation and its final dissolution, is the only object of rational investigation." Beyond the beginning, then, before the creation, human understanding cannot (in fact, should not) hope to reach.[16]

Now, if Boyle and Newton recapitulate a theologically driven version of Aristotle's separation of spheres, they also share with Aristotle a less theologically governed emphasis on knowledge following from experience, or what Aristotle called sensation (αἴσθησιν). Having put something considered unknowable beyond the scope of their own concerns, they have nonetheless laid open an immense field for human understanding. The world that we have before us, which includes all of nature's current, characteristically regular laws, still remains to be known. In this way Boyle and Newton end up in a roughly analogous position to those they criticize, particularly the Cartesians, emphasizing the central role played by human understanding. They place great authority in the human. Whether or not one retains a providential Deity, it becomes especially important to understand crucial sources of causality thought to reside not in an anthropomorphized God but in the world, as disclosed by human understanding.

The demand is that one frame the primitive as "ungenerated, imperishable, and eternal" and existing amid things "subject to generation and decay." The idea is to bring the primitive into a worldly order of positional, ordinal logic, leaving the "primitive nothinge" free, beyond human reason.

From *Princeps* to *Principium*

To say that the Enlightenment placed great stock in reason is of course a truism. As such, the statement is subject to major drawbacks. Because it is so easily repeatable, it can be invoked with apparent authority even as one's understanding of what is being named remains minimal. However, when I say the likes of Newton and Boyle give a central role to human understanding, I intend something quite specific, at least vis-à-vis the primitive. When they conceive the primitive, they tend to proceed by understanding first things according to principles. At the beginning of understanding (in the principal place, we might say), one does not find God or even the object. One finds principles of reason posited by human understanding. As the philosopher and theologian Jean-Luc Marion puts it, "God is now a term in a demonstration."[17]

To clarify what I mean, let me recall Reiner Schürmann's account of the turn in philosophy at the end of the Latin epoch. For Schürmann a fundamental change occurred in comprehending the ordination of things once the Medieval concept of *princeps* gave way to the modern one of *principium:* "At the medieval apogee of Latin thought in Scotus, the order derived from a first is an order of entities receiving their cohesion from the divine substance; at the close of the Latin epoch in Leibniz, it is an order of propositions receiving their coherence from human subjectivity." As Schürmann explains, both *princeps* and *principium* translate Aristotle's concept of *arche.* The medieval version revised Aristotle's concept to mean an authoritative Deity who originates and governs the world, who, as absolute *arche,* creates the world ex nihilo and, in the singular force of His act of creation, determines and intervenes in its subsequent existence. The modern version, in contrast, recasts Aristotle's *arche* as a series of principles posited by human reason—principles that themselves cannot be further reduced to a prior derivation and that establish the terms by which one can establish certain knowledge of the world.[18]

Schürmann's reference to Leibniz is crucial. It has been argued that Leibniz devoted much of his mature metaphysics to refuting the perceived

atheism of Spinoza, "who leave[s] only an infinite power to God, without admitting either perfection or wisdom in his [God's] consideration [*à son égard*]."[19] Certainly Leibniz asserts a creative, providential God, prior to and separable from the world, possessing and exercising understanding and will in addition to *une puissance infinie*. However, the significance of Leibniz's claim lies less in its content than in its argumentation. Leibniz does not proceed by comparing historical sources or by detailed biblical exegesis. His approach bares little resemblance to Webb's "authority-driven, quotation-filled argument," or to Spinoza's hermeneutics in the *Tractatus Theologico-Politicus* (1670). What Leibniz's approach does resemble is a different feature of Spinoza's work, the emphasis (in the *Tractatus* but most forcefully in the later *Ethics*) on reason's necessary role in determining what is and is not true. If one is to understand the world and know how to act in it, one must follow reason. For Leibniz, reason will prove, against Spinoza, the necessity of a willing, intelligent First Cause. That First Cause is, of course, God, or, as Leibniz puts it in the *Monadologie* (1714), "l'Unité primitive . . . la substance simple originaire."[20]

Most specifically (and here lies the importance of Leibniz for Schürmann), Leibniz grounds reasoning in certain principles of human understanding:

> 31. Our acts of reasoning [*nos raisonnements*] are founded on *two grand principles* [*sont fondés sur deux grands principes*], *that of contradiction*, in virtue of which we judge false whatever includes [*ce qui enveloppe*], and true whatever is opposed or contradictory to, the false.
>
> 32. And *that of sufficient reason*, in virtue of which we consider that no fact can be found [*ne saurait se trouver*] true or existing, no Proposition true [*Énonciation véritable*], without there being a sufficient reason why it is thus and not otherwise [*une raison suffisante pourquoi il en soit ainsi et non pas autrement*].[21]

Both principles enable us to distinguish the true from the false while they themselves lie beyond the possibility of error. Leibniz's *deux grands principes* can themselves never be wrong because they do not follow from anything else. They lie at the beginning of any legitimate act of reasoning. Thus God's existence, the existence of *l'Unité primitive*, is confirmed because only the concept of an existing God—one that wills, acts, and

knows—can provide a sufficient reason for why the world is as it is and not otherwise (§45, pp. 230–31).

So when I suggest that the Enlightenment conceives the primitive according to principles, we need to keep this in mind: the conception follows from human understanding's perceived positioning vis-à-vis the world. It is axiomatic for the likes of Leibniz that what the understanding relates to (the world and its particular contents) must have had a first instantiation of some sort. Its first instance would constitute its primitive appearance or type—though as we have seen, when something appears to have come from nothing (most notably the world's appearance where previously there had been mere void), one could also call that void primitive in the sense that it presents the original state prior to the thing's advent. In both cases (ordinal or preordinal) one typically has no direct access to the primitive moment or condition, but one must, according the demands of reason, presume its existence. Which leads to my basic point: because the primitive is difficult to directly observe, its existence is not only posited by human understanding, but its deduction, as is clear in the case of Leibniz, follows from that understanding's principles.

The Perpetually Receding Primitive

Let me conclude my account of the primitive by closing in on the way that its eighteenth-century formulation, which aims at understanding what is thought to be primitive in light of human and thus worldly models, gets bound up in an especially strong version of the aporia generated by the Enlightenment problematic. Eighteenth-century writers who try to align or at least conjoin the nontemporal and the temporal encounter the problem of thinking something in its primitive purity when that thing is, on the one hand, the first or original *of* something, and so never isolated, bound unto itself; and on the other, always distanced from one's necessarily belated, secondary vantage point.

Obviously any representational epistemology such as that commonly associated with the Enlightenment assumes a distance between idea or concept and object.[22] One is necessarily, vis-à-vis the object, in a secondary position. Moreover, one as it were re-presents the object but in a form, and according to an order, that do not belong to the object itself. Condillac, the *philosophe* whose work represents a major attempt to rethink Lockean empiricism in midcentury France, states the implications clearly:

But it is evident that these ideas do not enable us to know what existing things are in themselves [*ce que les êtres sont en eux-mêmes*]; they present things only [*ne les peignent que*] in the relations they have to us, and this alone demonstrates how superfluous are the efforts of philosophers, who claim to penetrate into the nature of things [*la nature des choses*].[23]

Still, the distancing entailed in representing, say, a beautiful flower, or even a vastly more complex object like a beautiful landscape, would seem of an entirely different order from that entailed in representing what one cannot see let alone actually know, what is in the world and yet not exactly of the world. This is the problem the primitive presents. One would be trying to represent something existing at the level of what Condillac calls "the nature of things," something that one can neither see nor possibly know with any certainty because it exists at a remove from us—and hence the claim to penetrate, to go beyond the veil of the merely secondary, apparent domain of relations, to know an actual being in itself.

The problem appears in Rousseau's well-known account of *l'état primitif* in the *Discours sur l'origine et les fondements de l'inégalité* (1755). There, Rousseau casts the primitive in an earthly context. He aims to comprehend the human in *l'état primitif* without recourse to "all the supernatural gifts [*les dons surnaturels*] he may have received, and of all the artificial faculties [*les facultés artificielles*] he could only have acquired by prolonged progress."[24] The primitive state is entirely natural, a state of human existence conceived without recourse to an absolute creator or the alterations wrought upon the human by humanity's own historical progress. What is primitive can therefore be characterized as immanent to the human in its natural condition. Yet in comprehending that immanence, Rousseau encounters a fundamental difficulty, which, instructively for us, he indicates and, unable to proceed further, ultimately obscures.

Before proceeding let me note that for Rousseau, *l'état primitif* is not revealed. It is something to be pursued or discovered by human understanding. If it was a case of revelation Rousseau would not face the difficult task of comprehending the temporal and nontemporal at once; the passage from nothing to something (or, for Rousseau, equality to inequality, dispersed existence to social organization) would be guaranteed in advance by a God, for example, who transcends the two terms and governs the passage between them. Rousseau's problem is how to conceive that same

passage when it occurs within the world, where "nothing" and "something" would appear in a relation of immanence.

Rousseau freely claimed, of course, that indubitable knowledge of *l'état primitif* may be impossible. However, the source of impossibility does not reside within the concept of the primitive. It is because we are too far gone from the simplicity of that first age. The problem of knowing the primitive is one of knowing it only belatedly. Rousseau observes that if it is true that the more advanced *l'Espèce humaine* becomes, the further it stands from any simple, original state, then the facility with which it can exert knowledge of the primitive may only remark, if not in fact augment, its structural ignorance of *son état primitif*:

> What is more cruel still, is that, since every progress of the human
> Species removes it ever farther from its primitive state *[l'éloignant
> sans cesse de son état primitif]*, the more new knowledge we
> accumulate, the more we deprive ourselves of the means of
> acquiring the most important knowledge of all, and that in a sense
> it is by dint of studying man *[à force d'étudier l'homme]* that we
> have made it impossible for us to know him *[que nous nous sommes
> mis hors d'état de le connaître]*. (122–23/124)

In Rousseau's estimate, learning's advancement effects a detrimental reordering of human existence to the point that the removals *sans cesse* of so-called progress make the most important kind of knowledge (that is, knowledge of the human's primitive condition) increasingly difficult, perhaps even impossible.

Even when in the primitive state, however, the human is unable to gain knowledge of the state. Rousseau suggests that the human in the primitive state of nature exhibits something of a corresponding structural ignorance to that of civilized humanity's. Whereas *les nations sauvages* live already beyond *l'état primitif* because each member of a savage nation lives in relation to its other members, *l'homme sauvage*, who does live in the primitive state, lives alone and in absolute immediacy with nature. The single savage exists, as Jean Starobinski notes, *"dans l'immédiat"*:

> Nothing inserting itself between his "limited desires" and their
> object, the intercession of language is scarcely necessary; sensation
> opens directly onto the world to the degree that *l'homme* scarcely

distinguishes himself from what surrounds him. *L'homme* knows only a perfectly transparent contact [*un contact limpide*] with things, and thus error still does not trouble him: the senses, limited to themselves, not contaminated by judgment or reflection, are subjected to no distortion.[25]

Being open to nature but lacking judgment and reflection implies that the human in the state of nature cannot know that state, or at least cannot know that state rationally. Nor can he formulate knowledge of nature in nature's potential absence (through language, ideas, concepts, or writing). *L'homme sauvage* cannot be considered an eyewitness to the original condition. The fate of falling out of nature would entail, among other things, the fate of knowing—and of knowing that, for example, one has lost something one had not really known one had. But at no point, either inside or outside *l'état primitif,* does anyone gain both direct access to the primitive and the ability to know it as such—that is, as something one could both call primitive and know in its actual attributes, as one might point to a stone and determine it as a "stone" (that is to say, in its mineralogical composition).[26]

Rousseau does not resolve the problem of the *as such.* He inscribes it throughout his account such that it might be said to be the structuring principle of his historical understanding. If *l'homme sauvage* has no access to the *as such, les hommes policées,* who apparently do, have no access to the primitive state *in itself* (having long ago departed from it) and hence *as such.* It remains nothing that one can directly describe in its constituent parts, as one might a stone. The moment one might be able to properly achieve the required knowledge would at once be the moment where one is fully open to nature in such a way that the ability to gain and the need to articulate that knowledge are unavailable. But then, in having fallen away from the condition of immediacy (what we might call an abyss of sensation prior to all reflection and hence differentiation), *les hommes policées* stand on the wrong side of another abyss, an ever-widening and potentially unbridgeable abyss between itself and the primitive state.

Succinctly put, the problem Rousseau puts to the fore is the difficulty, if not impossibility, of joining the primitive with the worldly or temporal existence that it inaugurates yet with which it remains incompatible. I hope to have made clear my sense that the problem is, in this form, a common one in the eighteenth century. In the wake of humanity's separation

from God and prior to the dominance of historicism there remains no easy way forward; the passage from primitive to nonprimitive proves extremely hard to divine, let alone successfully formulate. There is no third term, whether it be God or History, to guarantee the passage from one order to the other. It remains for us now to turn to the particular instantiation of the problem in eighteenth-century aesthetic theory.

· CHAPTER 2 ·

The Aesthetic

A s I understand it, eighteenth-century aesthetics emerges between the withdrawal of God and the advent of Hegel's immense and systematic Historicism. Neither God nor *Geist* directly occasion or govern aesthetic experience. It is a natural human experience. Such a construal helps disclose aesthetics' relation to the Enlightenment problematic. For aesthetic theory aims to think the aesthetic itself, understood as the conjoining of a universal human faculty and an experience productive of pleasure or delight. As such the aesthetic itself comprehends a passage from primitive faculty to derived experience, but as a movement that cannot cancel or leave behind the former, nontemporal faculty. It is a pass that cannot quite be passed through, an unpassable pass or aporia.

Understanding the workings of aesthetic judgment as entailing nontemporal and temporal aspects will be familiar to readers of Alexander Pope's *Essay on Criticism* (1711).[1] Pope begins by setting up as a problem for proper judgment the human's tendency to exceed essential nature. Nature herself generously affords most people "the *Seeds* of Judgment in their Mind" (20). Almost all have an innate capacity to judge. Yet human beings readily pervert nature's donation through *"false Learning"* (25). Going beyond nature's proper limits, which are constant, unerring, and just, the human readily succumbs to inconstancy, judging according to the individual's own taste alone. For Pope, elevating one's own judgment above nature means vainly following mere personal taste, whereas "True *Taste*" derives only from the "One *clear, unchang'd,* and *Universal* Light" of nature (12, 71). The problem Pope poses, then, is how to hold a debased and debasing human existence within fit limits set by nontemporal (unerring and unchanging) nature.

Pope's solution to the problem is, famously, adherence to "Those RULES of old *discover'd,* not *devis'd,*" the rules of the ancients that "Are *Nature* still, but *Nature Methodiz'd*" (88–89). One may wonder why Pope asks us to follow the authority of example when presumably we could just

look again at nature and copy her directly. Pope seems to be suggesting that we look to temporal productions, albeit those undertaken within nature's limits, to avoid judging according to merely temporal standards of personal taste. The crucial point for Pope, however, is that the ancients successfully discovered and followed the rules of nature, and as there is only one nature, following their rules means exactly following nature. Nature cannot have two sets of rules. Moreover, we should gladly follow the ancients because they save us a great deal of hard work. Those rules of nature are exceptionally difficult to discover because, at least when producing art, one can see only the effects of the making, not the agency of the making. Pope points out that art itself can be properly produced only when supplied by the funds of nature, which he likens to the soul as itself unseen, known only in its effects:

> In some fair Body thus th' informing Soul
> With Spirits feeds, with Vigour fills the whole,
> Each Motion guides, and ev'ry Nerve sustains;
> *It self unseen*, but in th' *Effects*, remains. (76–79)

Extended to aesthetic judgment guided by nature, Pope's logic suggests that its occurrence will be marked only a posteriori, in its effect, never its cause. In being closest to nature we follow nature—postlapsarian as post-natural, so to speak, leaving the human in the predicament of being perpetually belated in relation to what it ought to know best, namely nature and its laws.

The aesthetic's aporetic structure engenders varied formulations of aesthetic experience. The formulations coalesce as attempts to conceive aesthetic experience as both natural and human, with the natural and the human being parsed out, incompletely and unevenly, into nontemporal and temporal qualities. In other words, we have the vertiginous situation whereby an aporia generates another version of itself. As God no longer automatically or absolutely underwrites either the natural or the human, the narrowing of his authority opens a gap yet to be filled by the logic of a determinant Zeitgeist. In the absence of reasonably predictable outcomes offered by an absolute God or all-determining *Geist*, the problem becomes one of finding a solid enough support for otherwise apparently temporal, even ephemeral, phenomenon. This is precisely the problem of

eighteenth-century aesthetics: how to ground the experience itself in the absence of a clear and absolute final cause.

In this chapter I aim to introduce in some detail exactly what it is that eighteenth-century aesthetic theory produces as its object of theorization. Doing so, I will explain what comprises an aesthetic experience, and what the aesthetic faculty and the imagination are thought to be. As we will see, between the faculty and the experience, aesthetic theory runs into the problem of thinking the atemporal and temporal in articulation. In the second half of the chapter I will move on to examine several examples where exotic figures are deployed in an effort to lend a certain contour to what is an otherwise poorly shaped object of theorization. The examples I address lead us directly to the vitally important issue of the exotic figure's allegorical force.

Aesthetic Experience

The first thing we will need to establish is what, in the eighteenth century, would be understood as a specifically *aesthetic* experience. Most simply, it would comprise a sensation of pleasure undergone by a subject in perceiving a beautiful (picturesque, sublime, agreeable) object. The object may be actual or imagined. Although Alexander Baumgarten, a central figure in the Leibniz–Wolffian school dominant in German-language philosophy for much of the eighteenth century, had coined the term *aesthetics* in his *Meditationes philosophicae de nonnullis ad poema pertinentibus* (1735) by recasting the Greek *aisthesis* to specify the study of an extensive, sensuous reason, his insistence on aesthetics as a science of reason's lower faculties is unusual for the eighteenth century. More characteristically, theorists consider the aesthetic as distinct from reason, a discrete domain in itself, and one that is rationally inaccessible. Certainly the likes of Joseph Addison, Edmund Burke, and Immanuel Kant share with Baumgarten the sense that beauty does not manifest itself in "Cartesian clear *and* distinct ideas," as critics William K. Wimsatt Jr. and Cleanth Brooks put it, "but in ideas that are clear though *confused*, that is, in 'sensuous' ideas (images)." Still, they do not stop there. Insofar as aesthetics deals with sensuous ideas, these ideas appear, in the words of Wimsatt and Brooks, at best "distinguishable from one another but not internally analyzable." Thus Immanuel Kant, in the *Critique of Pure Reason*, finds futility

in Baumgarten's efforts to consider the beautiful critically "under the prin-
ciples of reason, and . . . elevate its rules to a science": "the putative rules
and criteria [of the critique of taste, or 'aesthetics' as understood by Baum-
garten] are merely empirical as far as their sources are concerned, and can
therefore never serve as *a priori* rules according to which our judgment of
taste must be directed."[2]

The reader may object that an experience is by definition evanescent
and nothing that needs fall under the purview of reason. The reader would
thus find redundant my emphasizing exactly these features of specifically
aesthetic experience. But *experience* as I use it here does not correspond
to what we might call sensual experience. Aesthetic experience includes
some element of judgment, conscious or unconscious, and hence even in
the case of an empiricist aesthetics, the sensual experience is not all there
is. Kant helps bring out the difference with particular force in the *Prole-
gomena to Any Future Metaphysics* (1783), where he rejects the "long habit
of taking experience to be a mere empirical combining of perceptions."
Distinguishing judgments of perception and judgments of experience,
Kant gives the following example:

> If the sun shines on the stone, it becomes warm. This judgment
> is a mere judgment of perception and contains no necessity, how-
> ever often I and others also have perceived this; the perceptions
> are only usually found so conjoined. But if I say: the sun *warms* the
> stone, then beyond the perception is added the understanding's
> concept of cause, which connects *necessarily* the concept of
> sunshine with that of heat, and the synthetic judgment becomes
> necessarily universally valid, hence objective, and changes from a
> perception into experience.

Transforming a judgment of perception (the stone becomes warm in the
sunshine) into one of experience (the sun warms the stone) means add-
ing a pure concept of understanding (in Kant's example, *cause:* the sun
causes the stone to become warm) to the intuition or perception. Doing
so grounds the judgment in objective validity. The stone necessarily be-
comes warm in the sunshine because sunshine is an agent of heat that
makes things like stones warm. This judgment is universally valid. Who-
ever considers the matter properly must agree. However, the judgment
remains one of experience and not simply of understanding as the concept

does not erase the intuition but is added to it. Experience includes, as it goes beyond, mere "sensual experience," to occur in between an intuition and the understanding.[3]

Aesthetic experience too takes place somewhere between the sense and the understanding. It is never merely sensual. And yet—or this at least is how Kant will put it in the *Critique of Judgment* (1790)—to be an *aesthetic* experience, the intuition must not be bound with a determinate concept of understanding, such as *sunshine* or *heat,* or even explicitly ordered by a pure concept of understanding like *cause.* An aesthetic experience would be something like an objectively valid experience occurring in the absence of what, for other forms of experience, grounds that validity: the concept that determines necessity. But crucially it is the lack of a determinate concept in aesthetic experience that not only ensures aesthetic experience its highly mobile and unsettled operation, but also constitutes aesthetic experience itself as a mobile and unsettled object for analysis.

In his classic account of Enlightenment aesthetics, Ernst Cassirer emphasized the twofold form Wimsatt and Brooks identify—"in addition to the aesthetic ideal of correctness and precision there is the other, diametrically opposed ideal of *inexactness*"—but drew out the form's further implications. He locates as the "decisive factor" a profound change in emphasis; what counts is not the result of thinking, the arrival at a constative content, but the manner of thinking as a performative expression. As the idiomatic je ne sais quoi suggests, the aesthetic response cannot simply and directly be stated. Thus—and here we start to see the aesthetic's vertiginous aspect—the expressive aspect of aesthetic experience that, as a way of representing nature or of relating it to oneself by an apparently natural judgment, takes the form of an apparently natural turning away from nature. Aesthetic experience would thus constitute a figurative relation of sorts (the turning away) that introduces a certain heterogeneity, making what is natural depart from itself.[4]

The claim is not, then, that aesthetics simply concerns the unfathomable or irrational. Rather, it is that aesthetic theory attempts to think through what occurs, productively, in between the literal and the figural, or alternatively, the content and the expression, the rational and the imaginative, the nonaccidental and the accidental. So while Cassirer underscores the trope's turning, not its end, he advances a tropic model that does not erase the literal (276). An aesthetic experience is not equivalent to a statement made up entirely of figural language—what Aristotle would

call either a riddle or a barbarism, a catachresis or an utterance using only "strange words."[5] The trope requires the compromise of the literal to ensure two things: first, to maintain it as incomplete, for if the trope reached its end and so stopped turning, it would no longer present an act of expression but rather a content that could itself be restated literally; and second, to remark the double import of clarity and confusion separated out into the literal and figural respectively. The difference of the indefinite proves necessary. As Cassirer puts it, "The aesthetic as such does not originate and flourish in the pure and colorless light of thought; it requires a contrast, a distribution of light and shade" (302). By binding with the unresolved figurative movement, the insistence of the literal secures the difference that, if reduced, would entail the aesthetic's annulment.

The Aesthetic Faculty

Despite the absence of a transcendent final cause aesthetic theorists look to ground aesthetic experience in something beyond the experience itself. An aesthetic experience is, in all its dizzying ambiguity, an experience; it is something that happens, and that happens for a human subject. While an aesthetic experience is something one can have, it is not something one can be.[6] The experience has no existence prior to itself, and it cannot be said to exist outside its happening. Beyond the question of *what* happens in an aesthetic experience, there is something, some substratum, that makes an aesthetic experience able to happen. That substratum can be found, in principle, in each individual. While a given individual can have a discrete aesthetic experience that happens for her at *that* particular time and not for another, the potential to have such an experience belongs to each individual (whether or not a given person is able to actualize her *potentia*). As Pope put it, "Most have the Seeds of Judgment in their Mind": most have the potential or faculty for judgment ("the Seeds"), and that potential exists "in [the] Mind."

Aesthetic theory puts the agency for possible pleasure in the self, not in the object. An object may allow for (if beautiful) or prevent (if monstrous) the occurring of pleasure, certainly, yet this is not what causes the sensation. Aesthetics thus contrasts with poetics and rhetoric, which concern how one can make an object (such as a poem or an address) to affect a reader or listener in a specific manner. Of interest in poetics and rhetoric is the means by which one can produce a work that will *cause* an effect

in another person. Although an aesthetic experience may occur as an individual looks upon an object, the attendant pleasure is primarily consequent not upon that object, but upon something within the individual. To underscore the difference, we can say that poetics and rhetoric advance a model of self-alienation and aesthetics of world-alienation: whereas with poetics and rhetoric the self is, to varying degrees, overtaken by an external object (the poem, the speech) driven by an external force, with aesthetics the self's relation to the world is secondary and even unnecessary for the self's internal experience of the pleasure. It is in this sense that one begins to see how aesthetics gets caught up in the problem of anthropological security. In addition to its vertiginous formulations, it does not guarantee one's relation to the world. That relation proves one *to be* established.

For eighteenth-century theorists, the force or agency that generates an aesthetic experience remains separable from the occurring of the experience. An individual's experience of pleasure in viewing a beautiful object requires, in the individual, an agency not only beyond the sensation of pleasure but qualitatively distinct from the sensory faculties. Specifically, the agency resides in the imagination understood as an aesthetic faculty. Here "aesthetic faculty" must be recognized to carry over from Aristotle the twofold sense of *faculty* as power and as potentiality: "an ability or power to achieve an end . . . [and] a potential for change which would be actualized through *energeia*."[7] A faculty is, in Ephraim Chambers's definition of it in his widely read *Cyclopedia: Or, an Universal Dictionary of Arts and Sciences* (1728), "a *Power,* or Ability of performing and Action." As commonly understood, the power or ability remains exactly that even when not in use. A faculty *is able to* make something happen. It is in this sense that a faculty edges outside of time. In his *Essai sur l'origine des langues,* for example, Rousseau speaks of a human capacity for *pitié* that remains "éternellement inactive" until activated by a separate faculty, the imagination. The faculty of pity remains outside temporal finitude (*éternellement*) and yet is always there, always potentially able to be put in play and have its effects.[8]

The aesthetic faculty is commonly thought to be universally human. It may remain undeveloped or it may be developed in barbarous ways (as evidenced in a depraved taste). Either way, the faculty itself exists, at the very least a virtual capacity in each individual person. It is an original and thus primitive human faculty, something pregiven, standing outside

temporal becoming. Of course, an individual's aesthetic faculty might change circumstances (proper education, for example, can enhance one's taste), but the subject of changed circumstances—that is, the faculty itself—remains necessarily unchanged. The aesthetic faculty can never be anachronistic or anatopic: akin to Montesquieu's *pur modèle intemporel* in being neither momentary nor localized, neither time nor place enter into its determination.

Yet an aesthetic faculty cannot be seen. It is not an object one can look at and into, then describe. As Chambers noted in the entry on "Faculty" in his *Cyclopedia,* the "antient Philosophers" tendency to use the term "to explain the Actions of natural Bodies by" is often "only a substituting of one Name of an unknown Phenomenon for another" (1:5). One may posit the imagination, for example, as an a priori human faculty outside of historical becoming, but one can only indicate it a posteriori, in its apparent moments of occurrence. The aesthetic faculty's existence and workings are marked only through events that take place temporally. Moreover, the confused aspect of aesthetic experience, which calls for the faculty's positing, only adds to the challenge of determining what it calls for. An aesthetic experience, after all, carries something of the je ne sais quoi that often stands in to mark its occurrence. How, then, might one reasonably determine a faculty that cannot be directly described when what is available to describe, the a posteriori, proves un-reasonable, or at least minimally reasonable? How can one establish its determining characteristics and so be able to distinguish it from other things?

Determining the Imagination

Eighteenth-century theorists inherited *imagination* as a name for what lay between sense and reason, and they extended it to name what also lies between the object and the affect in an aesthetic experience. But when framed as an aesthetic faculty, the imagination undergoes a reconfiguration; something of the singularity of eighteenth-century aesthetics hinges on the particular role it affords the imagination. Among the faculties commonly perceived as universally human (if often unevenly active or distributed), those of the senses and reason were familiar from the work of both ancients and moderns. Likewise, the role of the imagination vis-à-vis poetics and rhetoric—that is, as an agency of making or persuading. However, aesthetics is not concerned to explain how one is to deploy certain words to

produce certain effects in a reader's or listener's imagination. Aesthetics asks how and why one experiences a certain pleasure when perceiving or imagining a beautiful object, or when reading or hearing certain words. Thus as Montesquieu puts it in his *Essai sur le goût* (1757): "The sources of the beautiful, of the good, of the agreeable, etc., are therefore in ourselves [*dans nous-mêmes*]; and to try and discover their reasons, is to try to discover the causes of the pleasures of our soul [*les causes des plaisirs de notre âme*]."[9]

By locating the pleasure's source in the human, aesthetic theorists introduce a complex temporality into an experience one would call aesthetic, a complexity that directly recalls the temporal problem structuring the concept of the primitive. We can begin to make clear the complexity in question by considering the way eighteenth-century aesthetics can be said to reject the model "a beautiful object gives one pleasure." That model appears fundamentally insufficient because it fails to ask *why* a given object would produce a certain affect, and *how* that affect could occur. "A beautiful object gives one pleasure" implies the affect of pure response associated, for example, with the animal, whereas aesthetic experience is characteristically human; it is consequent on the human ability not merely to respond to the surrounding world but to reflect on that world as on one's response to it—even to reflect on one's own reflections.

In asking the why and how one abandons the straightforward temporal organization of the model "a beautiful object gives one pleasure." In that model, temporality presents few problems. As one looks at the object one feels the affect. One thing leads directly, and in a unidirectional fashion, to the other thing (Figure 1). However, once the object and affect appear mediated by the aesthetic faculty, the temporality of the experience becomes complex. The claim that the human experiences pleasure (the effect) when viewing a beautiful object (the cause) *because* she has an aesthetic faculty reorders causality. We see this in the consequent reordering of the initial questions of why and how (Why does one see the object as beautiful? How does one come to feel that affect?). The questions must be rephrased: What causes her to see the object as beautiful? What inside her causes her to experience pleasure? Right away the language of cause and effect comes under stress. We no longer have a straight cause-and-effect outcome but rather two causes and two effects leading in two directions (Figure 2).

Crucially, we cannot tell to what degree these causes and effects may or may not have sunk into the substance, so to speak—that is, into the

"A beautiful object gives one pleasure." (Object ⇌ Affect.)

FIGURE 1. The unidirectional model according to which "a beautiful object gives one pleasure."

Beautiful object ↰ Human aesthetic faculty ↳ Pleasure

FIGURE 2. The bidirectional model where pleasure in a beautiful object is mediated by the aesthetic faculty.

aesthetic faculty. For, making the problem acute, there is this: if we find a variability in causes and effects (depending on context: what one looks at and who looks) yet cannot tell where the causes and effects begin and end vis-à-vis the substance, what guarantees the conceptual identity of any such universal, primitive faculty?

The problem of how to determine the aesthetic faculty is usefully seen to recapitulate Locke's gloss on substance in the *Essay concerning Human Understanding* (1690) as "but a supposed, I know not what," which ironically introduces the je ne sais quoi into the attempt at divining any substance at all. For Locke that introduction entails the fact of our ignorance before what he calls the nonaccidental. We do not know, and seem unable to know, the substratum or support of our (therefore) accidental ideas:

> The *Idea* then we have, to which we give the general name
> Substance, being nothing, but the supposed, but unknown support
> of those Qualities, we find existing, which we imagine cannot
> subsist, *sine re substante,* without something to support them, we
> call that Support *Substantia;* which, according to the true import
> of the Word, is in plain *English, standing under,* or *upholding.*

Of particular importance for us is the way Locke brings out, as the American literary critic and philosopher Kenneth Burke observes with great insight, the pun that lurks in the Latin roots of *substance:*

> But returning to the pun as it figures in . . . Locke, we might point
> up the pattern as sharply as possible by observing that the word
> "substance," used to designate what a thing *is,* derives from a word
> designating something that a thing *is not.* That is, though used to
> designate something *within* the thing, *intrinsic* to it, the word

etymologically refers to something *outside* the thing, *extrinsic* to it.
Or otherwise put: the word in its etymological origins would refer
to an attribute of the thing's *context,* since that which supports or
underlies a thing would be a part of the thing's context. And a
thing's context, being outside or beyond the thing, would be
something that the thing is *not.*

Burke goes on to note that with the pun in substance "the intrinsic and
the extrinsic can change places": "To tell what a thing is, you place it in
terms of something else. This idea of locating, or placing, is implicit in our
very word for definition itself: to *define,* or *determine* a thing, is to mark its
boundaries, hence to use terms that possess, implicitly at least, contextual
reference."[10]

Given the dialectic that Burke locates in *substance* (and it will help to
recall that for Burke dialectic substitutes as the literal application for the
trope of irony), we are left with the question, vis-à-vis the aesthetic faculty,
of what will supply the *not* to shore up its definition or determination.
With the aesthetic faculty, pressure to supply a *not* is especially strong. For
how can one determine where the accidental ends and nonaccidental
begins when the latter is unknown and perhaps unknowable? How would
one know that one was in fact not at the nonaccidental when one does not
seem able to recognize it?[11]

Locke himself suggests a way. Each time he wants to show why, when
we use the word *substance,* we do so in the absence of any corresponding
"clear and distinct idea," Locke calls upon a fabled Indian philosopher.
That is, to de-fine the unknown aspect of substance he turns to the exotic:

> They who first ran into the notion of *Accidents,* as a sort of real
> Beings, that needed something to inhere in, were forced to find
> out the word *Substance,* to support them. Had the poor *Indian*
> Philosopher (who imagined that the Earth also wanted something
> to bear it up) but thought of this word *Substance,* he needed not to
> have been at the trouble to find an Elephant to support it, and a
> Tortoise to support his Elephant: The word *Substance* would have
> done it effectually.[12]

Substance does mean anything, or at least it names nothing we directly
know. It only does something, serves some purpose. To make the absence

of meaning clear, to give some sort of definition to the word without meaning, the Indian philosopher supplies something of a *not*. Indeed, the trope is irony: he says Tortoise but he means substance (as an "I know not what"), which is to say, nothing at all—a simple placeholder for our ignorance. For the remainder of this chapter I will look at several examples where the exotic is called upon to delimit the aesthetic.

The Exotic

In the Enlightenment and beyond, the exotic commonly serves to formulate various forms of identity. Most simply, the exotic supplies thinking with generalized figures for differentiation. In eighteenth-century aesthetics we find examples of exotic adornment placed in explicit or implicit contrast to European norms to show how human taste must be relative, how universal taste must degenerate the further one falls from Eden, how civilized taste must be superior (more highly developed) or inferior (a descent into mere luxury) to such simple forms of aesthetic appreciation. Through the exotic, one can formulate difference and therefore the identity of something one can therefore in some way claim to know.

The motif of the exotic that I am pointing to is fundamentally different in intent from, say, modernist primitivism, which sought to break from tradition by basing a practice on incorporating so-called primitive forms.[13] In eighteenth-century European literature we often see the exotic's difference used to provide a reference through which to know oneself and one's world, to shore up things as they are, or in the case of satire, to show things up as they are. Here one can think of texts as varied as Montesquieu's *Lettres persanes* (1721), Swift's *Gulliver's Travels* (1726), Eliza Heywood's *Adventures of Eovaai* (1736), Samuel Johnson's *Rasselas* (1759), Oliver Goldsmith's *Citizen of the World* (1760–61), Voltaire's *L'ingénu* (1763), Denis Diderot's *Supplément au Voyage de Bougainville* (1773), Robert Bage's *Hermsprong* (1796), and Elizabeth Hamilton's *Translations of the Letters of a Hindoo Rajah* (1796). In each case, the exotic provides a difference of perspective turned upon European life either to aid the European in developing adequate self-awareness and self-knowledge, or, in a more Juvenalian vein, to mock the European in his or her degraded existence.[14]

My own interest lies with a less obvious exoticism. I will not be dealing with the sustained exoticism of extended narratives like the *Lettres persanes* but with texts where certain exotic figures appear as a kind of detour,

whether or not they extend or depart from the main argument or narrative focus. In the case of aesthetic theorists, they use exotic figures much as Baumgarten formulated his notion of "the example" in the text where he first introduced the term *aesthetic:* "By *example* we mean a representation of something more determined which is supplied to clarify the representation of something less determined."[15] In particular, aesthetic theorists tend to look to the exotic and the savage to provide a solidity of reference unavailable in the aesthetic's unconditioned aspect. The exotic's presumed stability acts to border and delimit the indistinct. We can phrase this either in Wimsatt's and Brooks's terms, or in Cassirer's. For the former, the borders marking one image from another provide the only cognitive purchase available; sensuous ideas, they say, "are distinguishable from one another but not internally analyzable." Here the exotic comes in to designate a limit; bordering the ineffable, it sets up a formal check where there is little distinction. The motif of the exotic serves a similar purpose in Cassirer's terms: by upholding the aesthetic in its inexactness it in turn provides a literal marker securing taste's expression. Simple savages, in short, lend a vivid clarity to complex relations. They provide, in Cassirer's terms, a certain light to illuminate the present darkness, even if they do not remove the darkness.

Exotic human figures do not present a new substance for eighteenth-century thinking. They present, as Roland Barthes points out, new limits. The new ways of being that "l'humanité allogène" reveal (Barthes refers to Voltaire's Chinese and Persians) still belong to humanity as attributes: "de nouveaux habitacles sont attribués à l'essence humain."[16] While the substance, *l'essence humain,* remains the same, its known modalities are extended into radically different forms. Along these lines, Gotthold Ephraim Lessing presents, in his *Laocoön* (1766), a pair of Hottentots who share the common human propensity toward love and aesthetic appreciation:

We know how dirty the Hottentots are and how many things that awaken disgust and loathing in us are beautiful *[schön]*, comely, and sacred to them. A piece of flattened cartilage for a nose, flabby breasts which hang down to the navel, the whole body covered with a layer of goat's fat and soot and tanned by the sun, the hair dripping with grease, feet and arms entwined with fresh entrails—think of all this in the object of a fiery, worshipping, tender love; hear this expressed *[ausgedrückt]* in the noble language *[edeln*

Sprache] of sincerity and admiration, and try to keep from laughing.

The point Lessing himself wants to make with his example is that the Hottentots show, in their absurdity, how adding dignity to the disgusting softens the latter to produce an image ridiculous and humorous. We should note too that they reckon this aesthetic combination with great economy. Exotic and faraway, they are turned to stand for what Lessing wants them to stand for without demanding an extensive explanation. "We know [*Man weiß*]," Lessing writes, "how dirty the Hottentots are [*wie schmutzig die Hottentotten sind].*"[17]

Now the use of absurd figures that we find in Lessing is not unfamiliar. It recalls, for example, the opening lines of Horace's *Art of Poetry,* the source of the famous dictum *ut pictura poesis* that Lessing argues against in the *Laocoön:* "Supposing a painter chose to put a human head on a horse's neck, or to spread feathers of various colours over the limbs of several different creatures, or to make what in the upper part is a beautiful woman tail off into a hideous fish, could you help laughing when he showed you his efforts?"[18] What both Horace and Lessing evince is the use of an absurd, laughable mixed form that in turn testifies to an artistic or poetic limit.

Yet the two—Horace and Lessing—differ. Horace presents figures marked as riddles, the fanciful product of a violent yoking of alien terms. Lessing uses figures whose intentional structure appears referential, deriving their force from the assumption that a group of people are being described. Horace's wit pokes fun at painters and his fellow poets, aiming to reform their practice and judgment. Lessing's humor depends on the Hottentots' apparent hilarity as he calls up a group of people who themselves, according to his own depiction, have little to do with the arts in question. This suggests that although Lessing has recourse to supposedly realistic and thus probable figures, he nonetheless has no necessary reason for turning to the Hottentots specifically. But does this mean they are merely superfluous, rhetorical ornaments?

Let me elaborate by pursing a further case: Sir Joshua Reynolds's seventh discourse on art, delivered as the presidential address to the Royal Academy of Art in December 1776.[19] There Reynolds calls upon Cherokee Indians and then Tahitians in formulating the classical relation between nature and custom, specifically customs of ornamentation. Over-against "the uniform, eternal and immutable laws of nature," he posits the accidents

of habits: "beside this one immutable variety there are likewise what we have called apparent or secondary truths, proceeding from local and temporary prejudices, fancies, fashions, or accidental connexion of ideas" (141). Reynolds will go on to specify this adjacent domain by citing the exotic savage in a comparison whose purpose is to specify a difference. The point itself that he makes is not new. Among precursor texts we could include 1 Corinthians 14:11 ("Therefore if I know not the meaning of the voice, I shall be unto him that speaketh a barbarian, and he that speaketh shall be a barbarian unto me") and the following passage from Montaigne's "Des cannibales": "chacun appelle barbarie ce qui n'est pas de son usage" (each man calls barbarism whatever is not his own practice).[20]

Reynolds may, however, take his lead most directly from a passage in David Hume's "The Standard of Taste" (1757): "We are apt to call *barbarous* whatever departs widely from out own taste and apprehension: But soon find the epithet of reproach retorted on us." What Hume states free of exempla, though still issuing a division between civil and barbarous, Reynolds adorns with illuminative figures in a rhetorical gesture that recalls Lessing's combination of dignity and the disgusting to produce the humorous:

> If an European, when he has cut off his beard, and put false hair on his head, or bound up his own natural hair in regular hard knots, as unlike nature as he can possibly make it; and after having rendered them immoveable by the help of the fat of hogs, has covered the whole with flour, laid on by a machine with the utmost regularity; if, when thus attired he issues forth, and meets a Cherokee Indian, who has bestowed as much time at his toilet, and laid on with equal care and attention his yellow and red oker on particular parts of his forehead or cheeks, as he judges most becoming; whoever of these two despises the other for this attention to the fashion of his country, which ever first feels himself provoked to laugh, is the barbarian.

"All these fashions are very innocent," Reynolds continues. They do not impinge upon nature but are at a remove from it, taking the place of external supplements that in no way alter nature itself.[21]

There are cases, though, when relative customs of adornment cannot appear innocent. They demand, Reynolds says, a different kind of judgment, one no longer founded on an ethic that determines taste as relative

but on natural laws. The laws of nature being universal, their transgression is the same the world over. Therefore, whenever and wherever such an abuse occurs, one will recognize, with appropriate disgust, a custom-authorized contravention of nature's laws: "a false or depraved taste is a thing as well known, as easily discovered, as any thing that is deformed, mis-shapen, or wrong" (141). Thus it is with adornments agonizing in their application or destructive of bodily health. At this point Reynolds cites "some of the practices at Otaheite," namely their tattooing, and "the straight-lacing of the English ladies." What places these kinds of adornment beyond all good taste is their failure to remain purely external supplements (137). Tattoos and the crimping lines of too-tight laces, literally marking the natural body by cutting into and disfiguring it, figuratively re-mark the boundary of the aesthetic, as one limit is crossed to observe another. One cannot truly be said to appreciate tattoos and tight corsets aesthetically.[22]

In Reynolds's own terms, his exempla border on the "merely arbitrary": "though eloquence has undoubtedly an essential and instrinsick excellence, and immovable principles common to all languages, founded in the nature of our passions and affections; yet it has its ornaments and modes of address, which are merely arbitrary" (136). The Tahitian and the Englishwoman come close to the folds of the arbitrary not because they fail to locate a limit to the aesthetic. We know that they are beyond the pale of good taste. What signals their potential superfluity is that they themselves could readily be substituted by any number of other figures, including the Cherokee Indian or the European man. No necessary reason governs Reynolds's alignment of the Tahitian with pain and the Cherokee with the pleasures of taste rather than vice versa. In the late eighteenth century, each could and did stand for the other. Further, one could as easily invoke the proper Englishwoman as a paragon of beauty and the European man as bearer of pain, or at least of the sublime. Reynolds's figures carry no "essential and intrinsick" relation to what he asks them to stand for. For this reason, the significance of the respective exotic figures does not reside in their content. It resides, rather, in their repetition.

Certainly Reynolds could have stated his point more or less literally, as Hume had done, which for a dominant tropology indicates the trope itself teaches us nothing and is therefore only decorative. But as Paul Ricœur points out, by proceeding from an "initial decision to treat metaphor as an unusual way of naming things," such an approach obscures metaphor's

discursive level of operation: metaphor is also a way of organizing thought and orienting thinking.[23] What form of thought, then, would be constituted through the particular use of words characterized by the prevalence of exotic figures in eighteenth-century aesthetics, in Reynolds as in Lessing, Young, and Locke? I could have provided myriad other examples much like Reynolds's or Lessing's. What is remarkable is the recurrence of a gesture that, calling upon the exotic to mark an external limit—supplying the contextual *not* to delimit the aesthetic—ensures its repetition *in* the enunciation of the aesthetic. The exotic sits inside and outside the aesthetic, something external that supplies an interior lack.

To conclude, my sense is that the repetition of exotic figures in eighteenth-century aesthetics is less metaphoric than allegoric. They work to produce something like an allegory-effect. In part the effect implies the sense of pointing to some prior existent, as was clear with Lessing's Hottentots. But it largely serves to delimit or mark something otherwise lacking in distinct boundaries. And this is why I am reluctant to talk simply of metaphor; it remains unclear, most obviously in trying to formulate the aesthetic faculty, what the metaphor would reduce to beyond simply another metaphor in the absence of a more concrete tenor. Thus Reynolds's exotic figures, for example, work allegorically insofar as, in a bid to delimit the bounds of possible aesthetic experience, Reynolds negotiates bodies of knowledge different in structure and even diametrically opposite. By using a series of geopolitically distributed figures to formulate a nongeopolitical relation, he turns the literal marks of the tattooed Tahitian and corseted Englishwoman to stand for something else: a depraved taste. He adds to his text these apparently tropic adornments that illuminate something they are not. It is that particular movement or gesture that interests me most, and that proves to be of great importance in attempts to think the aesthetic. However, we first need to have some sense of the particular fate of the exotic savage in Enlightenment thought, and that is the topic of my next chapter.

· CHAPTER 3 ·

The Savage

I HAVE SUGGESTED THAT AESTHETIC THEORISTS deploy exotic figures
to determine the aesthetic and that they do so because their object
(aesthetic experience and its agent, the aesthetic faculty) lacks in the dis-
tinct, and thus differentiating, characteristics required for a direct descrip-
tion. Crucially, by calling upon the exotic to mark various limits (here
good taste turns to its opposite), theorists ensure the exotic's repetition in
the aesthetic's enunciation. The exotic appears not just at the level of the
said but at the level of the saying. It helps, even pushes, thinking along—
though its provenance introduces something foreign that arguably never
quite settles down into a full domestication. This, at least, is most forcibly
the case with the exotic savage qua savage. My aim in this chapter will be
to isolate and explain the particular force the savage exerts for Enlighten-
ment thought. Because the critical literature on the New World is already
extensive and freely available, I will limit myself here to addressing what
thinking the savage means in the context of our problematic.[1]

Let me note first that the exotic broadly conceived need present few
difficulties to understanding. Exotic fruits, animals, places, and peoples
present readily repeatable figures of novelty and difference, and in citing
an exotic figure one need not know especially much about the figure's
putative referent. As with Edward Young's Indian prince, it is enough that
the figure capture the imagination and indicate a certain difference. The
importance of such straightforward difference is, of course, its ability to
produce identity. By determining a point of difference between two enti-
ties, one also determines a quality of identity on each side of the differ-
ence. If, for example, Hottentots differ from Lessing's fellow Europeans
because, unlike the latter, they smear animal fat on their naked bodies,
then one attribute of Hottentot-ness will be a naked body smeared with
animal fat, and one attribute of European-ness will be a clothed body not
smeared with animal fat. Here the exotic facilitates clear understanding,

whether or not the gained understanding is insightful or free of preju-
dice. However, things prove less clear when it comes to the exotic savage
approached *as a savage*—that is, as something much more than an exotic
ornament to argumentation.

Viewed historically, the problems that attend thinking the savage come
to the fore in the late seventeenth century. The problems tend to follow
from the savage's apparent possession, so to speak, of few, if any, apparent
qualities. Though eighteenth-century Europeans inherit a long tradition
of talk about things wild and savage, and though they believe savages exist
and can be observed in various parts of the world, there is a strong sense
that the savage presents something of an unconditioned aspect. Recog-
nizing the New World savage's unconditioned aspect accompanied a
breakdown in the authority of the traditional analogies because drawing
likenesses between Amerindians and ancient Greeks and Romans, as well
as Persians, Egyptians, and Babylonians, proved less and less convincing.[2]
Amerindians were now to be described as they are. And yet the New World
savage appears lacking in positive qualities, with the lack suggesting less
a moral judgment (the savage as possessing bad qualities) and more the
absence of determinable qualities (the savage has no government, no writ-
ing, and so on). Bear in mind that the claim that Amerindians possessed a
bad quality would be a positive claim in the sense that it names a property
or characteristic belonging to certain savages; it names something they
have. Aside from the notable example of cannibalism, often attributed to
the savage as a positive quality (indeed, one conceived as quite bad), the
problem of accounting for the savage proved to be akin to describing some-
thing without qualities.

The savage's lack of definition tends to mean that the "exotic savage"
gets conceived through a supplementary logic of the exotic. We have, that
is, an abyssal logic—the exotic illuminated by the exotic. Over the next
several pages, I will make clear the savage's unconditioned aspect and its
paradoxical abyssal delimitation before moving on to examine the pecu-
liar role of the savage as agent of European self-constitution, which holds
direct implications for attempts to determine a primitive human capacity
such as the aesthetic faculty. What will become apparent is that as much
as the savage exerts a certain force of attraction—Europeans cannot stop
talking about Amerindians and South Sea Islanders—its force proves nec-
essarily difficult to control.

The Savage's Minimal Difference

As with the aesthetic, eighteenth-century attempts to comprehend the savage discover a privileged shaping motif in the exotic. Not, though, through the revealing of a particular content that we might mark as essentially exotic. The motif's force is effectively formal. In the exotic, the aesthetic theorist finds a control of sorts. It serves to mark a limit, an outside to the inside for which the exotic is exactly that: exotic (*exo-*, "out from").

What arguably made the savage so attractive to eighteenth-century theorists of the aesthetic is that it comes, like Young's Indian prince or Lessing's Hottentots, bearing the unmistakable mark of exoticism to introduce a limit, even if what the supposed savage was in itself proved less certain. For despite Young's noble Indian, it is an as it were exotic aspect that the savage, when considered in itself, seems to lack; the savage appears to be what is not quite "out from" nature—though less because it embodies the harmonious nature authorized by God and more because it appears unformed into recognizable, complex social bodies. Hence Young's Indian prince might well be figurative in a second sense, suggested in his being "adorned with feathers only, having little of weight." He does not carry a weighty authority derived from a solid monarchical social structure but rather a certain noble status with little heft behind it.

The point I am making is that the New World savage appears exotic from the perspective of European civilized life not only geographically but also, as it were, socially, being from the perspective of nature nonexotic, not *out from*. The latter proves especially important for two reasons. First, it marks a crucial difference between the savage as exotic and the East as exotic. The two Orients (one near, one far) certainly proved to be loci of exotica for seventeenth- and eighteenth-century Europeans. However, Europeans like John Webb, among many others, saw state-based societies in the East. Even when they thought they saw only despotism, that too meant state-based civilization, one comprising, like the European states, rulers (monarch, despot, electors, republican and parliamentary government) and the ruled (in all cases, subjects). What this means is that the East does not force Europeans to fundamentally rethink the individual's possible modes of existence—or at least it does not present the far-reaching problems for self-understanding that the stateless savage will. *L'homme sauvage* forces the European to consider at length and in depth the self in utter isolation. To be a savage was precisely not to be a subject.

Second, the savage's presumed proximity to nature sinks it into a vague condition of minimal differentiation. A band or assemblage of savages existing in an apparently unformed social condition do not appear to give forth particular characteristics or traits that, once pointed out, would separate them clearly from nature or even from other groups of savages. A clear separation would require something like categorical difference as opposed to differentiation, which can occur within a category. The word *savage* itself signals the lack of separation. As a predicate it can be attached to a person, to a scene, or to a product of nature. In each use the category remains *savage*; differentiation takes place only within the limits of that category (a savage human or a savage scene of nature). In *Candide* (1759), for example, Voltaire puts two such uses adjacent to one another, in one referring to people *(sauvages)* and in the other to wild nature *(fruits sauvages)*.[3] While *civilized* can work in a similar way, predicating a person, a way of behaving, or a condition, it insists upon its categorical difference from wild nature. Either the civilized stands over-against a nature understood as wild and beyond any governing human order, or it is, for Deists like Pope, a kind of heightened, rational nature, a nature ordered by God, providing the model for a proper, orderly human conduct with which one must seek rapprochement. In either case, nature as wild—*sauvage, Wild*—remains apart.[4]

The lack of distinct categorical difference between *savage* and *nature* means that even when Enlightenment thinkers deny that savages live in the state of nature, they can only minimally differentiate the two. For example, Buffon, writing midcentury, argues strenuously against the idea that the savages of the New World lived in the state of nature, but he nonetheless insists that they live in a vague state of minimal society, with the implication that the appropriate unit of consideration would have to be the individual savage rather than any supposed savage society. As he writes, discussing the "coutumes de ces nations sauvages":

> any nation where there is neither rule, nor law, nor master, nor
> customary society [*société habituelle*], is less a nation than a
> tumultuous assemblage of barbarous and independent men, who
> obey only their own particular passions [*leurs passions particu-
> lières*], and who can have no common interest [*intérêt commun*],
> being incapable of directing themselves towards a shared end [*un
> même but*] and of submitting themselves to persistent customs
> [*usages constants*], which always suppose an ordered and ordering

combination of deliberate rational ends [*une suite de desseins raisonnés*] approved by the greatest number.[5]

Buffon's comments also suggest how the savage, like the primitive and the aesthetic, edges onto what we might call the otherworldly. As witness to a division between social values and natural values, the savage resembles the European by being in the world and (more or less) human, existing and persisting within minimal social forms, yet it also connotes the atemporal condition of a natural ordering. The savage, in its otherworldly dimension, lays bare a potentially natural human outside of institutional authority, whether of church, of state, or of reason. Grouped together, Buffon's savages present not so much nations—understood as discrete, self-contained social organizations—but tumultuous assemblages of largely independent, individual beings. The natural order that the savage reveals, unloosed of social structures or even strictures, appears a force of ungoverned energies, "passions particulières" ordered by no "intérêt commun." Here Buffon plays into the more common view of the savage as lacking self-restraint, manifesting strong passions that remain merely particular and aimed toward no common end that would structure and limit the savage's actions in advance of their occurrence. Savages never look before or behind themselves, to the past or to the future. Living in a condition of apparent unhistorical immanence, they belong to the present alone.

The Exotic Logic of the Savage

We find the logic of the exotic commonly at work in attempts to comprehend this otherworldly thing, the savage. As with the aesthetic, with the savage the exotic can provide a certain contour, if not a positive content. Consider the enduring mode of identifying the savage made famous by Michel de Montaigne in "Des cannibales" (1580). Rather than describe the Brazilian Tupi directly, Montaigne offers a list of qualities, none of which he suggests are "out from" nature, and none of which he can phrase as positive possessions:

This is a nation . . . in which there is no [*il n'y a aucune*] sort of traffic, no [*nulle*] knowledge of letters, no [*nulle*] science of numbers, no [*nul*] name for a magistrate or [*ni*] for political superiority, no [*nul*] custom of servitude, no riches or poverty, no

[*nuls*] contracts, no [*nulles*] successions, no [*nuls*] partitions, no [*nulles*] occupations but leisure ones, no [*nul*] care for any but common kinship, no [*nuls*] clothes, no [*nulle*] agriculture, no [*nul*] metal, no [*nul*] use of wine or wheat. The very words that signify lying, treachery, dissimulation, avarice, envy, belittling, pardon— unheard of [*inouïes*].[6]

Here Montaigne establishes a contour to his object by way of a series of negations—of what we have but that is not there in the New World ("nulle ... nulle ... nul ... ni ... nul"), which is accordingly "out from" us, *ex-otic*.

Montaigne's list was often recited (by Buffon as well as Shakespeare and Hobbes, among others), though already with Montaigne it was a recitation, both within the *essai* (Montaigne is reporting the account of a servant who had traveled to Brazil) and outside it, the list having appeared as early as 1503 in Amerigo Vespucci's *Mundus Novus*. Importantly, while each incarnation of the list offers little in the way of positive knowledge, it also posits the savage Amerindian as an object *to be* represented. Marked by negation, having no writing or means of abstracted representation in the form of government, the Amerindians possess no apparent means to represent themselves apart from themselves. This is the context in which emerges what we might call a New World imperative in Enlightenment thinking: the unavoidable need to acknowledge and account for the existence of large numbers of apparently unaccountable stateless peoples. Recall John Webb's mid-seventeenth-century attempt to write an historical essay explaining the descent and current location of the primitive language. Webb could and did ignore all non-state-based Amerindians, mentioning only (and briefly) "*Peru* and *Mexico*" (the Incas and the Aztecs). But in the eighteenth century, if one were to attempt such an account, one could not bypass the New World savage. The savage must be taken into account.[7]

If I am right that the Enlightenment registers a New World imperative, what is it that makes thinking the savage so inescapable? A quick glance at the relevant literature shows us that talk about the savage commonly appears where Europeans seek what Kant called *Weltkenntniß* or *"knowledge of the world"*—that is, knowledge of "the human being according to his species as an earthly being endowed with reason," which Kant claims constitutes "the most important object in the world to which [the human being] can apply" his "acquired knowledge and skill."[8] Observing only

contemporary commercial Europe and the civilizations of the Orient, writers throughout Europe (Kant along with Herder, Rousseau, Diderot, Kames, Ferguson, and others) find that something important remains hidden from view. That something is sought in the savage populations of the New Worlds—primarily the Americas and the South Pacific, along with the Hottentots of southern Africa. The inhabitants of the New Worlds show humanity's possible natural state or illuminate the historical origination of language; they supply the empirical evidence necessary to support or counter ideas such as the four stages of human development; they are readily and widely cited, often in an offhand manner, as immediately illustrative of idolatry or superstition, of a carefree idyllic, noncommercial existence, or any number of supposed noncivilized states. In this way we might say that the savage proves necessary for what Kant advocates as systematic world comprehension.

Now, achieving world comprehension by including the savage within one's systematic thinking presents problems. Eighteenth-century attempts to produce a global understanding arguably tend to intensify rather than reduce the known world's uncertainty, the attempt to produce a systematic understanding through the savage often leading to an epistemological undoing of systematization. In a formulation advanced hypothetically by J. G. A. Pocock, the obsessive Enlightenment interest in savagery succeeded in making "half the planet . . . an alien and alienated universe." The point is not that knowledge of far-off places lessens. Quite the contrary. Throughout eighteenth-century Europe, there is a massive quantitative and qualitative extension of interest in, knowledge of, and material relations with the far-off places of the earth and its inhabitants. But this does not automatically signal a concomitant rise in synthesizable knowledge. In this context, the seemingly savage inhabitants of far-off lands are called upon as European writers try to resolve problems of knowledge that are made both more urgent and more difficult by the proliferating signs of exotic others. We might say that for a newly unified subject "Europe," the coherence of its *res cogitans* becomes evermore difficult to maintain as the *res extensa* became evermore extensive in scope.[9]

Self-comprehension

The ever-extending *res extensa* also questions the coherence of the individual self's *res cogitans*. Commentators commonly observe that with the

Enlightenment the self tends to get configured in a characteristically unique way. Tzvetan Todorov, for example, argues that Hobbes, writing in the mid-seventeenth century, formalized a new, modern sense of the self as dependent on others. For the ancients, "others are necessary as a natural environment for the individual, not in order to assume any particular function."[10] Along with an anthropological emphasis central to the Enlightenment came an understanding of the self's others as serving a particular function for the self such that it now maintains an unavoidable relation to those others. This thinking, Todorov suggests, reaches its apogee in the work of Rousseau, where "the other no longer occupies a position comparable to mine [that is, as merely another 'I' over there] but contiguous and complementary; he is necessary to my own completeness."[11]

Rousseau himself (much, in fact, like Hobbes before him) found especially instructive those others he called *les nations sauvages*.[12] In the *Discours sur l'inégalité*, Rousseau famously argued that if civilized humanity is to fulfill the Delphic command, "know thyself," it will need to know its origins. Further, though contemporary Caribs and Hottentots do not present *l'homme sauvage* in a pure state of nature, or *l'état primitive*, they do, unlike civil societies, show humanity before the advent of commodities, property relations, and the division of labor, among civil society's other characteristic developments. By knowing *les nations sauvages*—the Caribs and the Hottentots—humanity will not thereby know its most remote origins, but it will be able to know something more about itself, namely the trajectory taken after its unknown origin that has led to its contemporary instantiation. In this way Rousseau posits the savage as an anterior form of the European, giving each a certain autonomy. The savage presents an external category of identity different to that of the European.

Comprehended as a dyadic model, Rousseau's approach would be seen to maintain that the savage, through its exterior position, closes the circle of European self-constitution. The savage points both to the European self and away from that self; it presents, precisely, the not- or pre-European. However, Rousseau makes clear that any such necessary supplement points to an insufficiency or lack in the self. As he puts it so economically in *Émile ou de l'éducation* (1762), "Tout attachement est un signe d'insuffisance."[13] It is that insufficiency which ensures the circle's closure will remain unsecured. One cannot locate the savage clearly on the outside, in the place of a *non-* or *pre-*, precisely because it is sought to make up for an internal

insufficiency. In this way the savage does not form a solidly positioned difference but rather a differing figure of uncertain position within a system of positioning.

Conclusion

What I hope is clear from this brief discussion of the savage is that what I have called the New World imperative does not issue into the familiar dyadic model of self-recognition. It suggests that any European self-comprehension in relation to the savage does not proceed from a straightforward act of self-though-other recognition. The identities in question remain insecure, indeed in question, always in relation and so never complete or self-identical. We are not dealing with a static model whose opposing terms may be successfully described by a constative use of language. Once again we cross from the said to the saying, to acts of positioning whose success cannot be guaranteed in advance, whose failure may, in fact, structure the relation.

Given the exotic savage's important role in aesthetic theory, which is itself an attempt to formulate the self in a certain way, it should also be clear the extent to which understanding eighteenth-century aesthetics will be necessarily challenging. It is only through the most attentive reading that we will be able to make our way through the interplay of primitive, aesthetic, and savage, thinking the three together in a context where each present distinct yet related concepts: typically, a nonderived or nonhistorical state; a universal human faculty engaging the self in clear yet confused experiences; and a temporal yet noncivil (that is, stateless, even minimal) being. As Enlightenment philosophers as varied as Leibniz, Rousseau, Hume, and Kant realized, insistent difficulties inhere in trying to understand something human that is unconditioned and without derivation—something all three terms share to varying degrees in varying contexts. The difficulties take two related forms. First, one has to comprehend something that is closer to nothing, that is to say, something that exhibits no perceivable difference within itself or between subsequent versions of itself by which one could identify it. Second, one has to explain, in a version of the mind–body problem, how something seemingly spiritual and undetermined temporally—the faculty being given outside of time—nonetheless interfaces with the temporal world to produce concrete feelings of pleasure. Both difficulties resolve into versions of the

same problem, namely that of negotiating one's way forward between two discrete orders: the nothing and the something, the nontemporal and the temporal. As we will see in some detail over the course of the next two chapters that make up Part II, "Delimiting the Aesthetic," it is this problem, whose intractability helps shape thought, that issues into that aporia where the exotic takes on a crucial importance in determining the aesthetic.

II

Delimiting the Aesthetic

Joseph Addison's China

THIS CHAPTER AND THE NEXT address the respective attempts of two notable aesthetic theorists to delimit their object. We will see how both Joseph Addison and Immanuel Kant proceed by way of the problematic that requires them to determine a relation between an atemporal faculty and a temporal experience, and how both deploy exotic examples in trying to conceive the passage between atemporal and temporal. The reader may wonder why I put together these two more commonly distanced writers, one an early eighteenth-century English man of letters and the other a late eighteenth-century Prussian philosopher's philosopher. By way of initial explanation I should say that the Addison I present is a bit different from the one to whom we have long become accustomed, one whose work is seen either as a polished blending of Aristotelian teleology and Lockean empiricism, or as a representative organ of rational discussion promulgated in a burgeoning coffeehouse culture. The Addison I present is more of a serious philosopher, closer, in this way, to Kant. Moreover, my Addison performs a complex expansion of thinking that takes place in relation to (rather than following blindly) Aristotle and Locke, as well as to certain traditions we would now call Continental—all in the context of an impulse to think the primitive, the aesthetic, and the exotic and savage.

With his aesthetic theory Addison aims to comprehend a particular order of human experience and the primitive faculty that makes it possible. An experience called *aesthetic* in Addison's terms occurs through a subject's immediate and precognitive engagement with an object. The object can manifest physically or mentally. Either way, the experience will center on an unconditioned instant that yields no temporal order of discrete, unfolding moments. It happens prior to certain knowledge and without delay. Moreover, it is engendered by an aesthetic faculty that itself, crucially, does not alter temporally or spatially. Hence Addison's encounter with difficulties characteristic of the Enlightenment problematic: How to determine something that appears to be merely prescriptive, or at best

accessible only a posteriori? Further, how to represent the agency of aesthetic experience, the aesthetic faculty, when, as an original, primitive faculty, it itself exhibits no difference over time or space?

We find these difficulties entailed in the main lines of Addison's aesthetic theory, as elaborated most closely in his *Spectator* papers "on the Pleasures of the Imagination" (1712).[1] There he radically expands taste by making an "infinite variety" central to aesthetic experience; elevates the imagination over the senses and the understanding (albeit an imagination with a fatal flaw); and formulates the pleasures of the imagination less as governed by divine final cause than as operating via the efficient cause considered as a primitive, universal human faculty. I will begin by elaborating each line's particular entailment of the noted difficulties, to present, as precisely as possible, Addison's instantiation of our problematic. Only then will we be able to fully recognize his attempt at resolving the problem of conceiving the temporal and nontemporal at once, and the central part played there by the exotic in its allegorical operation.

"Infinite Variety"

Addison gives variety a vital role in his aesthetics. By it, he apportions a noticeable freedom to aesthetic experience on the level of both subject and object. When one faces a scene conducive to the pleasures, one's eyes must be able to roam over it at will, wearied by no labor, directed or otherwise impinged upon by no obvious force. The object being favorable, the imagination is able to roam where it pleases, as when one views appropriate scenes of nature: "in the wide Fields of Nature, the Sight wanders up and down without Confinement, and is fed with an infinite variety of Images, without any certain Stint or Number."[2] And in the moment of viewing, the subject also needs to share in the independence from restraint or direction exhibited by the object. Absent any necessary determinate cognitive relation to the object, the subject needs no specific instruction or understanding to experience a pleasure of the imagination. The subject should, in fact, be free of such regulation.

Addison's understanding of variety puts at the heart of aesthetic experience a liberty so far-reaching that it ascribes few explicit determinants to the experience itself. It follows that Addison will need to delimit the aesthetic by recurring to what remains, properly speaking, outside it, for in itself, an aesthetic experience offers few conditioning constituents to be

isolated and elaborated. Crucially, Addison will not determine the aesthetic by calling upon a transcendent, authorizing agency. In concluding the "Pleasures," he writes: "We have now discovered the several Originals of these Pleasures that gratifie the Fancy" (3:579). Those originals are sourced primarily in the human faculties rather than in the direct expression of God's will. Here Addison departs from notable contemporaries like Shaftesbury and Francis Hutcheson, who predetermine the aesthetic's extent by marrying Platonic idealism to an emphasis on final cause. Addison radically reduces the role and significance of such preconditioning frameworks by introducing variety into taste at the two levels of subject and of object.

Addison's divergence from Shaftesbury becomes most apparent in the way he revises and extends Shaftesbury's Neoplatonic aesthetics on two fronts, basing good taste on more open principles and complicating Shaftesbury's strict opposition of beauty and deformity. In *The Moralists*, published in 1709 and then collected in his *Characteristics of Men, Manners, Opinions, Times* (1711/13), Shaftesbury argues that to know true beauty one must go further than "the rest of the unthinking world" who only appreciate things as they appear "on the first view." It is not enough, he is suggesting, to perceive exterior form alone. Thus the gentleman virtuoso, who by "natural good genius or the force of a good education" looks beneath an object's surface to identify an internal, innate kernel, can truly judge an object beautiful if he perceives an harmonious alignment of external and internal form. If, however, he finds harmony lacking, he reckons the object monstrous, "as in an idiot or savage." A distinguishing cognitive relation to the object and a proper use of understanding prove thereby essential. Even if an object's exterior form is flawless, only those of "the unthinking world" would mistake it as beautiful if it were not truly so.[3]

Shaftesbury does hold out the prospect of a sublime enjoyment of the wild or what would seem lacking in harmonious form. His aesthetics allows for one to see as "beauteous" objects "how terrible soever or how contrary to human nature" (315). "The wildness pleases," says Theocles in the *Moralists*. "We view [nature] in her inmost recesses, and contemplate her with more delight in these original wilds than in the artificial labyrinths and feigned wildernesses of the palace" (315). However, it is not the disorder and mayhem of nature's wildness, the wild's thrusting freedom from restraint, that gives delight. It is the wild's ironic testimony to a higher harmonious unity, for "the wildness" can

raise our thoughts in admiration of that divine wisdom, so far
superior to our short views. Unable to declare the use or service
of all things in this universe, we are yet assured of the perfection
of all and of the justice of that economy to which all things are
subservient and in respect of which things seemingly deformed are
amiable, disorder becomes regular, corruption wholesome and
poisons . . . prove healing and beneficial. (315)

As if a poison that heals, the wild reveals what it is not and thus negatively
indexes the sublime, overarching final cause. The harmony that the wild-
ness indicates beyond the merely visible is a harmony that remains only
cognizable.

Addison, on the other hand, widens the jurisdiction of those who can
experience imagination's pleasures. For him, the variety central to aes-
thetic experience dissociates taste from understanding. "The Pleasures of
the Imagination," he says, "have this Advantage, above those of the Under-
standing, that they are more obvious, and more easie to be acquired. It is
but opening the Eye, and the Scene enters. The Colours paint themselves
on the Fancy, with very little Attention of Thought or Application of Mind
in the Beholder" (3:538). Addison likewise gives a greater license at the
level of object, where he supplants Shaftesbury's "fair, beautiful and good"
(321) with a tripartite configuration of great, uncommon, and beautiful.
Greatness corresponds to what will widely be called the sublime and is a
pleasure produced by "that rude kind of Magnificence which appears in
many . . . stupendous Works of Nature"; novelty "recommends Variety"
by filling "the Soul with an agreeable Surprise" so as to refresh and divert
our minds from "our usual and ordinary Entertainments"; and beauty is a
positive quality determined by customary experience such that in viewing
an arrangement of "Matter" that one finds beautiful, "a secret Satisfaction"
is immediately diffused through the imagination (3:540–42). Contrary to
Shaftesbury's restricted version of flawless harmony and sublime enthusi-
asm for an harmonious creation, Addison permits an aesthetic apprecia-
tion by potentially anyone of potentially any form. An uncommon object
can lack harmonious form yet readily be appreciated aesthetically; novelty
even "bestows charms on a Monster, and makes even the Imperfections of
Nature please us" (3:541).

By licensing greater flexibility at the level of form, Addison might be
said to give greater scope to Shaftesbury's own notion of disinterested

pleasure. This would be ironic insofar as the notion of disinterest is typically considered Shaftesbury's main contribution to aesthetics. For Shaftesbury, one must not want to possess the object viewed.[4] Yet as we have seen, because the subject must achieve a moral position proper to aesthetic appreciation, it is not a case of what merely appears to the eye. Rather, on the basis of an understanding given at birth or attained through good education, one secures a propriety of position from which to apprehend an object. Addison, however, opens wide the extent of an individual's potential disinterest. It extends so far as to include not only objects without purpose or utility for the properly positioned subject, but also objects without any potential interest or virtue at all. A novel object strikes the eye and gives pleasure independent of the understanding or of cognition more generally.

Now I am not suggesting that Addison offers no criteria for value. He insists that some pleasures are base while others are proper. However, distinguishing one sort from the other does not form *part of* a judgment of taste. In *Spectator* 412 Addison writes that "we find by Experience, that there are several Modifications of Matter which the Mind, without any previous Consideration, *pronounces at first sight* Beautiful or Deformed" (3:542; my emphasis). The beautiful and the deformed are each identified instantly and automatically. A pleasure of the imagination arising from beauty, therefore, would always be a proper one or it would not be a pleasure of the imagination but something else (3:538). Whereas Shaftesbury gives the understanding an essential role (the "unthinking world" cannot recognize the truly beautiful), Addison finds an object's beauty or deformity set in advance. If that prior division does require a cognitive judgment it remains, crucially, unacknowledged in the aesthetic experience itself.

The Imagination as Human Faculty

Addison formulates the occurrence of an aesthetic experience as an event whose circumstances one does not distinctly think through. Neither the subject nor the object introduces restraints into the experience that would limit the relevant pleasurable sensations, including restraints that could follow from any determinate act of understanding; the experience happens as if in between thoughts. Still, just as Addison dissociates aesthetic experience from express acts of intellectual judgment, he distinguishes it from merely sensual activity. Entailing a certain aspect of mental perception,

though one that fails to yield clear and distinct ideas, aesthetic experience proves to be something more than simply sensual perception. It is an experience that belongs neither to the faculty of understanding nor to the faculty of the senses. Producing a concept of the imagination as a third, discrete faculty, positioned alongside the other primitive human faculties, constitutes a major gambit in the "Pleasures." Through it, Addison attempts to comprehend what it is that makes one able to have an aesthetic experience.

Addison frames his general undertaking as original. However, the frame quickly becomes opaque, stated twice in a way that makes it difficult to tell whether the undertaking itself constitutes a primary or secondary action. In *Spectator* 409, the paper that introduces the "Pleasures" to the public ("I shall next *Saturday* enter upon an Essay *on the Pleasures of the Imagination*"), Addison says he will embark on "an Undertaking . . . entirely new" (3:530–31). The epigraph to *Spectator* 411, the first paper proper of the "Pleasures," restates the claim to newness: "Avia Pieridum peragro loca, nullius ante / Triata solo; juvat integros accedere fonteis; / Atque haurire" (I traverse pathless tracts of the Pierides never yet trodden by any foot. I love to approach virgin springs and there to drink) (3:535).[5] Citing Lucretius's claim to be a pioneer in poetry, Addison presents his "essay," his *try* or *attempt,* as a first exploration of uncharted territory. However, the two formulations conflict. Addison's "Undertaking . . . entirely new" suggests a wholly inventive action missing in the pathbreaking claim, where one comes after, following upon given, if unexplored, ground. We could reconcile the two positions by taking Addison's "Undertaking" that is "entirely new" as the action of exploring a new territory: his originality lies in exploring *this* territory. Yet such an inference cannot be drawn from the statement itself, which indicates only an inventive action. Moreover, the tension between original and secondary persists as Addison figures the pathbreaking action through a repetition, citing Lucretius. His claim to newness is forked, made in words not his own.

Commentators have largely ignored the tension Addison sows into his claims to newness. Often and without apparent irony, they claim newness for Addison by reiterating Addison's repetition of Lucretius. Hugh Blair, writing in the eighteenth century of Addison's achievement, suggests "he has the merit of having opened a track, which was before unbeaten." As it turns out, evoking Lucretius's saying to suggest newness is itself nothing new—not to Addison, or for that matter to Lucretius, who himself repeats

his own use of the phrase. My point is not that Addison is unoriginal but that a too-earnest endorsement of his claim to innovation loses sight of something important: if newness is a ruse in the "Pleasures," it is a staged ruse, a rhetorical gambit.[6]

The straight-faced reading is perhaps partly responsible for (or at least fully symptomatic of) the tendency in the critical literature to minimize the role of rhetoric in Addison's aesthetic theory—or more accurately, the tendency to approach Addison's *Spectator* papers as largely free of rhetorical language proceeds hand in hand with the tendency to see Addison as having dealt institutional rhetoric "its deathblow."[7] This reading takes its modern lead from Samuel Holt Monk, who made a strong claim for the originality of the "Pleasures." It is, he says, "the first sustained piece of writing on aesthetic in eighteenth-century England," and "the first effort in the century to build up a real aesthetic." What Monk means by this is that with Addison, "the sublime [and the aesthetic generally] became an important idea in the philosophy of taste and in an investigation of the pleasures of *imagination,* not of rhetoric."[8]

Monk is not simply wrong. Although I would suggest that Addison continues to embrace rhetoric, he does foreground a move toward what is for him the more *primary* domain of the imagination. *This* is either what he is out to invent, or it is the as yet trackless territory over which he is to wander. Even so, Addison finds the imagination limited and somewhat defective:

> Our imagination . . . is confined to a very small Quantity of Space, and immediately stopt in its Operations, when it endeavours to take in any thing that is very great, or very little. Let a Man try to conceive the Bulk of an Animal, which is twenty, from another which is a hundred times less than a Mite, or to compare, in his Thoughts, a length of a thousand Diameters of the Earth, with that of a Million, and he will quickly find that he has no different Measures in his Mind, adjusted to such extraordinary Degrees of Grandeur or Minuteness. The Understanding, indeed, opens an infinite Space on every side of us, but the Imagination, after a few faint Efforts, is immediately at a stand, and finds herself swallowed up in the Immensity of the Void that surrounds it: Our Reason can pursue a Particle of Matter through an infinite variety of Divisions, but the Fancy soon loses sight of it, and feels in it self

a kind of Chasm, that wants to be filled with Matter of a more
sensible Bulk. (3:576)

Here Addison defines the imagination negatively, marking its farthest ex-
tent by its failure. The imagination proves limited to a simple view. If one
wants to "take in" a complex, multipart object, one will need to proceed
rationally. The understanding's capacity for logical extension means it is
able to go beyond the simple view afforded by the imagination and supply
what would be missing in the latter.

Addison's modern editor, Donald F. Bond, has suggested that in defin-
ing the imagination as limited Addison pursues a traditional account of
the imagination. It is, says Bond, like the account Descartes presents in
considering the impossibility of imagining a chiliagon, or thousand-sided
figure (3:576n1). Thus Descartes writes in the *Meditations on First Philos-
ophy* (1641) that though one can understand what a chiliagon is, one
cannot picture it in one's "mind's eye" owing to the figure's complexity: "I
may construct in my mind a confused representation of some figure; but
it is clear that this is not a chiliagon." It follows for Descartes that the imag-
ination cannot match the "clear and distinct" knowledge afforded by the
understanding. At best, the imagination presents an imperfect "applica-
tion of the cognitive faculty."[9]

Yet Addison substantially revises the traditional account. He does not
stop, as Descartes does, with separating an act of imagination from one of
understanding. He goes further. He conceives *the* imagination as a human
faculty—established on grounds of its own and operating according to
principles of its own. That the imagination need not require or offer a
determinate cognitive grasp of an object is partly what makes it the imag-
ination (rather than, say, a failed or weak version of the understanding).
For Addison the imagination is not a derived, superfluous supplement but
a specific primitive faculty alongside that of the understanding. Addison
does not conclude, again as Descartes does, that because "this power of
imagining which is in me . . . [differs] from the power of understanding,
[it] is not a necessary constituent of my own essence" (51).

Although Addison acknowledges the tenuous nature of the imagina-
tion owing to its limited capacity, he does not reduce the imagination to
cognition. It should be clear that Addison's concern is not to determine
a wholly rationalized world-engagement. In his discussion of the imagi-
nation's deficiency he advances a model of aesthetic experience founded

on the simultaneous positing and delimiting of something like an abyss. What appears without impingement (the imagination roams over the scene and is itself unknown territory) must nonetheless be delimited so it will not succumb to its own "Defectiveness" and be swallowed up in the surrounding "Void" or be left feeling a "Chasm" within.

One could object that Addison also says the opposite: that the imagination is not defective but expansive. Earlier in the "Pleasures," he invests the imagination's incapacity with a positive sense evidently at odds with his negative definition. Moreover, he posits not as disparate but as analogous the imagination's and the understanding's relation to what is "too big":

> Our imagination loves to be filled with an Object, or to graspe at any thing that is too big for its Capacity. We are flung into a pleasing Astonishment at such unbounded Views, and feel a delightful Stillness and Amazement in the soul at the Apprehension of them. . . . Such wide and undetermined Prospects are as pleasing to the Fancy, as the Speculations of Eternity or Infinitude are to the Understanding. (3:540–41)

However, Addison presents, with his respective negative and positive formulations, two fundamentally different approaches by the subject to an object. In the negative version the imagination tries to extend itself and dominate an object ("when it endeavours to take in any thing that is very great, or very little"), whereas in the positive version it tries to grasp after what is clearly too big for it and thus ungraspable. It grasps as it were ironically, aware it cannot succeed. And what the imagination shares with the understanding is pleasure rather than a specific act, a pleasure that, for the imagination, lies in *giving itself up to* the "too big" object and the freedom it embodies with its "unbounded Views" and "undetermined Prospects." As Addison continues: "a spacious Horison is an Image of Liberty, where the Eye has Room to range abroad, to expatiate at large on the Immensity of its View, and to lose it self amidst the Variety of Objects that offer themselves to its Observation" (3:541).

Both versions, defective and expansive, join in presenting the imagination as a faculty and as edging onto an abyss. If Addison makes this most obvious in the negative version, he makes it clear enough in the positive version. "Our imagination loves" does not simply personify the imagination but also underscores Addison's sense that the imagination is something

with capacity. It is *able to* do something—here, figured as "love." The love in question is for the pleasure that obtains in the faculty's subjection to the object (it is "filled with [the] Object" and "flung into . . . a delightful Stillness"). This does not follow a Platonic logic of desire. The imagination does not seek a lost object whose attainment would ensure self-completion. Rather, it opens itself to something foreign, something that alienates the faculty by filling it up, taking its place. Addison presents in both versions, then, an imagination perpetually in danger of succumbing to its own annihilation because it possesses in itself no internal limits. In this it recalls Addison's notion of "infinite variety" and, as with that notion, suggests the need to call upon a delimiting reference outside itself—a need that goes deep, to the very structure of the imagination's activity.

How the Imagination Works

Addison first drafted the "Pleasures" in 1704, the year John Dennis published his major work, *The Grounds of Criticism in Poetry*. Regarding Addison's aesthetics as a response to Dennis serves to highlight the particularity of Addison's account of the imagination. Dennis himself, of course, had written the *Grounds of Criticism* to defend poetry against the attacks of Jeremy Collier and others on artistic representation. Advancing a positive notion of "poetic enthusiasm," he proposes two ends for poetry: to reform manners and to please. Though he finds the latter end subordinate, it nevertheless facilitates a program of reform based on religious tenets by moving the passions. By so ordering enthusiasm as to further religious virtue and quash vice, Dennis sought to bring order and beauty to civil society ("to bring Mankind from Irregularity, Extravagance, and Confusion, to Rule and Order"). He advocates what Albert O. Hirschman famously called a "principle of countervailing passions," here a rhetoric of persuasion arousing esteemed passions to in turn control regrettable ones. But to use poetry in this way, its affective rhetoric must be formalized in a set of replicable rules; only by establishing "the Rules" in advance can one be sure of affective rhetoric's effect and hence be confident in its deployment. Dennis's is not an attempt to explore uncharted lands but to guard against such wild places—to banish rather than engage inexactness.[10]

In contrast, Addison directs the effects of enthusiasm away from heavy religious control toward palliative gratification. This is not to say that Addison denies a reforming motive for his *Spectator* papers; clearly he does

when he writes in one of his papers on wit that "as the great and only End of these my Speculations is to banish Vice and Ignorance out of the Territories of *Great Britain,* I shall endeavour as much as possible to establish among us a Taste of polite Writing" (1:245). Unlike Dennis, however, Addison accentuates the ease and gratification of aesthetic pleasure. Most important, he also goes beyond what remains in Dennis the mere fact *that* an individual is affected in certain ways to frame the pleasures of the imagination according to the Aristotelian causes. In order, the *causa materialis* corresponds to the primacy of vision, "the subtle Matter on the Organ of Sight" (3:547); the *causa formalis* to the differing essences of objects that render them appreciable as novel, great, or beautiful; the *causa efficiens* to what effects a change in the viewer to give rise to aesthetic appreciation; and the *causa finalis* to the reasons for the pleasure. Addison phrases these reasons as a series of hypotheses (for example, God gives pleasure to the idea of anything new or uncommon to encourage the pursuit of knowledge) (3:546).

If Dennis can be said to favor any of the four causes, it would be, almost exclusively, the final cause. This is not surprising given his emphasis on the religious ends of poetry, but his dependence on the final cause produces problems. Thus, when he explains why terror affects us so strongly, Dennis succumbs to a tautology wholly inadequate in light of later developments in aesthetic theory. "The Ideas which produce Terror ['perhaps the violentest of all the Passions'], are necessarily accompany'd with Admiration, because ev'ry thing that is terrible, is great to him whom it is terrible." Dennis's circular argument—that a terrible object is sublime because it excites admiration in those to whom the object is terrible—cannot address *why* one finds a terrible object admirable or even terrible and so *how* an individual reacts to such an object.[11]

Addison's approach is markedly different. He opens a place for the *how* of aesthetic experience by formulating the pleasures' efficient causes as able to figure an individual's affective alteration in aesthetic experience. By claiming the importance of the efficient causes for Addison, I am arguing against a dominant reading of the "Pleasures." "It is," Ernst Lee Tuveson writes in his influential account, "in the final causes that [Addison] is most interested. . . . The 'efficient causes' . . . do not interest him."[12] Addison would seem to encourage this reading when he notes in *Spectator* 421 that the final causes are *"more known and more useful"* than the efficient causes, which remain unknown and hence presumably less useful. We

want, he says, "such a Light" as would enable us know them in themselves
(3:580). Yet several aspects of his account should prevent us from too
quickly dismissing these unknowable causes that he also calls "necessary"
and "occasional" (as in what occasions, what brings about or causes to
happen).

Of the four causes, the final cause is the one that can most readily be
stated in commonsense propositions. When Aristotle first outlines the
causes, he gives a notably commonsensical example for a final cause: "'Why
is he walking about?' we say. 'To be healthy.'"[13] Addison himself exhi-
bits an affinity with a widespread tendency to align final causes of human
affections and motives with the goodness of God's will. In explaining why
there are pleasures of the imagination, he suggests that God "has annexed
a secret Pleasure to the Idea of any thing that is *new* or *uncommon*, that
he might encourage us in the Pursuit after Knowledge, and engage us to
search into the Wonders of his Creation" (3:545). Addison also associates
final cause with what we might call ideological illusion. They produce
quixotic chimera. While entranced by the pleasures' "annexed" final cause,
we feel as if under "some secret spell," but once "the fantastick Scene
breaks up . . . the disconsolate Knight finds himself on a barren Heath,
or in a solitary Desart" (3:547). Here Addison uses the language of a satire
on medieval romance to describe the worldly operation (or better, appari-
tion) of final cause, calling into question the seriousness, and hence the
authority, of God-given causes.

Addison further implies that his aim is to diminish the authority of final
cause when he concludes the paper on causes by directing the reader to
"the Eighth Chapter of the Second Book of Mr. *Lock*'s Essay on Human
Understanding" (3:547). Following Addison's direction the reader will
find Locke explaining why aspects of an object's appearance, "as appre-
hended by the Imagination," do not belong to the object itself but "are
only Ideas in the Mind." It is in following Locke that Addison separates
the "Supernumary Ornaments to the Universe" from an object's essential
existence. The supplementary adornments that present the delights of
"the fantastick Scene," which include its "Light and Colours," have the
end of attracting one's attention to the object. That is, Addison presents
them as final causes. But they are not all there is; nor are they essentially
what is. As "Ideas which are different from any thing that exists in the
Objects themselves," they do not form the "proper Figures and Motions"
of "Things" (3:546). The final causes, as "Supernumary" supplements,

simply do not go deep enough into an object to be part of its substantial form. If Addison is as influenced by Locke as he says he is, then we should take note that when Locke describes *cause* as such, he does so in terms of efficient causes. As we understand the world, the efficient causes make things happen: "Finding, that in that Substance which we call Wax, Fluidity, which is a simple *Idea,* that was not in it before, is constantly produced by the Application of a certain degree of Heat, we call the simple *Idea* of Heat, in relation to Fluidity in Wax, the Cause of it, and Fluidity the Effect."[14]

In Addison, what Locke names *heat* corresponds to what produces the pleasures of the imagination in an individual, with the difference that the efficient causes remain unknowable in themselves. This is why Tuveson denies their importance; he assumes that because efficient causes cannot be known, they hold no place in Addison's aesthetics. Now we have seen that Addison dissociates the pleasures of the imagination from understanding, and Tuveson himself emphasizes this, repeating his subject's adopted terms: "It was only when Addison considered the imagination as a thing in itself that he was led into new paths" (93). Moreover, Tuveson notes that "Nowhere do we find the traditional hitherto inescapable warnings that imagination must remain the faithful servant of reason. . . . On the contrary, the very absence of rational activity becomes a virtue of the imagination" (94). Yet by allowing no place in Addison's aesthetics for something that resists comprehension, Tuveson bars the imagination from any role in the aesthetic's formulation. He fails to see that what one cannot know maintains an active, indeed critical, position in Addison's aesthetic theory. There, what lies beyond understanding helps frame aesthetic appreciation; indeed, it marks the possibility of a pleasure of the imagination where the imagination itself lacks determinate internal limits. This helps explain why Addison, far from abandoning the efficient cause, articulates it with—even elevates it over—the final cause, to advance an aesthetic theory that hinges on both cognitive and noncognitive elements.

The Primitive Within

With the double structure of his aesthetics (both cognitive and noncognitive), Addison insists that an aesthetic experience includes something immediate and unconditioned that remains beyond personal or institutional controls. Yet Addison is not merely advocating a freedom to imagine. It should be clear by now that for Addison, *imagination* does not mean

the capacity to fantasize. His understanding of the concept remains incompatible with the following definition, perhaps more familiar to us today:

> Imagination, as the ability to make what is absent present and to present it both in its absence and as absent, remains a distinct kind of activity. . . . [The] distinctive feature of [imagined experience] is to give us what is unreal, to connect up with something nonexistent which we see as nonexistent.[15]

Certainly Addison suggests that the imagination can call upon absent objects and ideas, and that it can combine absent objects and ideas to form new images. It can "make what is absent present" while implying the remark of absence Maurice Blanchot underscores ("to present it both in its absence and *as* absent"). But for Addison any such reflective component would fail to cancel or even render marginal the nonreflective, noncognitive aspect of an aesthetic experience. There will always remain the essential experience that would be, in the context of Blanchot's definition, the pleasure that resides in the act of fantasizing itself.

Crucially, Addison does not limit the imagination's noncognitive aspect by locating a higher control. He places the freedom it implies beyond personal and institutional controls, beyond either a transcendent controlling agent such as God or a determining agency such as historical development (though such development may limit its flowering). Addison, through his emphasis on the efficient cause, insists on understanding the imagination as a human faculty. The occasioning cause introduces into his aesthetics an unconditioned, noncognitive component that resides inside, and only inside, each of us as a capacity. Put simply, the source of the uncontrolled lies within the human.

Addison's position—that the imagination is a human faculty characterized by an unconditioned element with no external control—has certain consequences that can best be brought out by once again positioning his account as a response to Dennis's. The relevant difference between Addison and Dennis follows from their respective poetics, which bear out markedly different understandings of the primitive. To begin with Dennis, he proves a strong advocate of the neoclassical emphasis on rules. His aim in writing the *Grounds of Criticism* was, he says, "to fix the Rules both of Writing and of Judging."[16] Dennis's concern is that without the guiding principles supplied by an ordered and ordering system, something

unknowable and thus unscriptable would enter into poetry and pervert it. To ensure against poetry's diversion for unseemly purposes, one needs, he argues, to obey the principles of a strict formalization. In a starkly all-or-nothing manner, everything must be calculable. Without order, all falls to chaos. And to Dennis's mind, the threat of an overwhelming chaos is ever present in our secondary, postlapsarian world.

Dennis binds his poetics to a social vision that explicitly takes the form of a totalizing primitivism. It is poetry, he agues, that supplies the best means for restoring the order lost to us with our parents' fall from Eden. The universe in its primitive state was, he says, perfectly ordered and beautiful. In it, everything is for the best. Unfortunately, humanity fell into disorder:

> The Universe is regular in all its Parts, and it is to that exact Regularity that it owes its admirable Beauty. The Microcosm owes Beauty and Health both of its Body and Soul to Order, and the Deformity and Distempers of both to nothing but the want of Order. Man was created, like the rest of the Creatures, regular, and as long as he remain'd so, he continu'd happy; but as soon as he fell from his Primitive State, by transgressing Order, Weakness and Misery was the immediate Consequence of that universal Disorder that immediately follow'd in his Conceptions, and his Passions and Actions. (335–36)

It is by way of the arts, and above all poetry (which "comprehends the Force of all [other] Arts"), that humanity can return to order and so to a happy primitive condition. "The great Design of Arts," he says, "is to restore the Decays that happen'd to human Nature by the Fall, by restoring Order" (336). Yet this requires the arts themselves to be harmonious, for "how should these Arts re-establish Order, unless they themselves were regular?" (336). From the regularity of poetry derived from the rules there should follow, Dennis argues, a return to the primitive state. But the efficiency of that return rests on its ability to be complete and absolute.

Turning to Addison, he certainly does not reject the rules. But whereas Dennis argues the need to observe decorum through exacting adherence to them, Addison contends that by staying too close to the rules one runs the risk of producing poor literature.[17] As Addison puts it in his paper on "Genius," following the rules does not as a matter of course negate a poet's

brilliance but it will ensure that such an annulment persists in the poet's work as a "great Danger" (2:130). By contrast, there is a sort of genius not subject to this hazard: "nobly wild," "extravagant," and "natural," this other talent was "never disciplined and broken by Rules of Art" (2:127). Though Pindar stands as the paragon of such a poet, Addison approximates natural genius to climate. The farther east one goes into "warmer Climates," the stronger such genius, with Homer exhibiting more qualities of natural genius than Virgil, the Old Testament more than Homer (2:128). The elaborate rules of propriety governing poetry's *Bel Esprit* and *Bienseance* do not direct these wild geniuses. Forging new figures that strike, even surprise, the imagination, their genius bursts forth in bold similitudes and allusions that do not observe "the Decency of Comparison" (2:127). Though notably, Addison does not suggest that the poet of unbroken genius produces dark conceits that hold out yet withdraw significance. Presumably this poet's figures are both fresh and clear. Moreover, it does not follow for Addison—as it does for Dennis—that the figures so produced pervert reason.

Precisely because Addison separates the imagination and the understanding, the ungoverned strength of the former does not necessarily corrupt the latter. When Addison does look "to lay down Rules" in *Spectator* 409, they are rules to determine "whether we are possessed of . . . that fine Taste of Writing which is so much talked of among the Polite World" (3:527). Addison's interest in rules extends to conventions for diagnosing whether or not one has fine taste, not for producing fine literature. Even here he wishes critics to go beyond "Mechanical Rules" and "enter into the very Spirit and Soul of fine writing." A rule-bound approach, he says, misses "something essential" that affects the reader (3:530). Unlike Dennis, Addison introduces an important dimension reserved from formal replication: the efficient cause, which alters the self yet presents no definitively cognizable content.

For Addison society needs no reordering along primitivist lines. A taste for Pindaric wildness comes from within a civil existence; indeed, such taste forms part of a civil existence. Moreover, wildness is radically disordered; antithetical to regularity, this primary unconditioned state is annihilated by rules. So Addison neither consigns the primitive to a prelapsarian past nor sets stringent parameters governing its accessibility. It is present in the nonrational pleasures that constitute part of quotidian existence. Framing civil taste, this secret something cannot be cognized, but

it nonetheless must be posited as pleasure's cause to render the pleasures knowable in their effects—as recognizable novelty, vastness, or beauty.

Returning to Addison's aesthetic theory, Addison obliquely yet fundamentally writes his dynamic understanding of the primitive into his account when separating the pleasures into primary and secondary. Doing so, he isolates by predication pleasures of the imagination produced, on the one hand, by looking at an object, and on the other, by recalling, imagining, or reading about an object. Addison invokes Locke's division of sense perception and the perception of ideas, asking his readers "to remember that by the Pleasures of the Imagination, I mean only such Pleasures as arise originally from Sight, and that I divide these Pleasures in two Kinds":

> those Primary Pleasures of the Imagination, which entirely
> proceed from such Objects as are before our Eyes; and . . . those
> Secondary Pleasures of the Imagination which flow from the
> Ideas of visible Objects, when the Objects are not actually before
> the Eye, but are called up into our Memories, or formed into
> agreeable Visions of Things that are either Absent or Fictitious.[18]

An important consequence attends Addison's categorical separation of the pleasures. Their common origin remains inaccessible. Both pleasures "arise originally from Sight," but whereas the secondary pleasures add a certain difference—a delay ("called up") or alteration ("formed into agreeable Visions of Things")—the primary pleasures add nothing. As pleasures that arise only from sight, the exclusive condition of the primary pleasures corresponds to the common condition of any pleasure of the imagination. While the primary pleasures therefore illuminate what gets hidden in the secondary pleasures due to the latter's detachment from the moment of sight, at the same time the secondary pleasures produce the need for the predicative identification of primary pleasures. Otherwise the primary pleasures would merely be *the* pleasures. Rather than show the common origin of both categories, then, the primary pleasures mark the aftereffect of a categorical separation. For this reason, if the division of primary and secondary introduces a certain specificity, it is a displacement of the problem not its solution: *the* pleasures themselves remain unaccounted for, the absent cause of a mutually constitutive play of primary and secondary.

Addison's Exempla

The aesthetic faculty—the common, primitive origin beyond the plea-
sures' division into primary and secondary—will remain an inaccessible
horizon within Addison's account of the imagination. Profoundly oblique,
the faculty persists within the logic of Addison's aesthetic theory as at
once inaccessible yet necessary, indefinable yet demanding definition.
Addison responds to the demand for definition with examples. Through-
out the "Pleasures," Addison calls upon a wide variety of exempla to aid
him in focusing his oblique object, from the courtship and music of birds,
to vast uncultivated deserts and the contemplation of God's Being, to
ancient Eastern architecture (the Great Wall of China, the Tower of Babel,
the Gardens and Temple of Babylon, the pyramids of Egypt), Gothic
cathedrals and the Pantheon in Rome, to the arts of pre-Columbian Mex-
ico, and to Virgil, Ovid, Milton, and Shakespeare. Examples serve Addison
as delimiting agents.

One example proves more exemplary than others. More than fifty
years ago, Arthur O. Lovejoy pointed out that in the "Pleasures," Addison
"expressly sets up the Chinese as the actual exemplars of the ideals which he
is preaching."[19] In the way they appreciate a well-laid garden, the Chinese
uphold a principle of variety without end, make apparent the immediacy of
aesthetic pleasure, and exhibit a positive use of an imagination not beholden
to the dictates of reason. Though what the Chinese therefore illustrate is
a largely unconditioned state—of perpetual novelty, immediacy, and free-
dom from reason's rule—this is not because Addison thinks they belong
to such a state historically or culturally. As I have pointed out in previous
chapters, many late seventeenth- and early eighteenth-century Europeans
consider China a site of competing civilization, and Addison certainly
shares this view. The China Addison presents in the "Pleasures" is neither
a figure of primitivism nor a predicate of simplicity prior to state and com-
mercial development. China does not stand in for an unconditioned state
due to its supposed condition of negation (no government, no letters, no
architecture, and so on). Rather, Addison finds in the figure of Chinese
landscape appreciation something that exemplifies aesthetic experience in
such a way as to enable him to delimit the aesthetic as such—something he
does not find available at home in Europe. The Chinese present in the aes-
thetic realm what a wild genius in civil society presents in the poetic realm.

Despite Lovejoy's observation, few have picked up on the significance

of Addison's reference to the Chinese. This neglect has two main sources worth noting. The first is Addison's evident literary bent. As Hugh Blair made clear in his *Lectures on Rhetoric and Belles Lettres* (1785), Addison's use of figurative language is pervasive in the "Pleasures."[20] Addison's literary style has perhaps not only helped to obscure his significance in the history of aesthetic thought—his frequent and at times elaborate use of figures distancing him from supposedly more rigorous and plain-speaking inquiry—but it has led critics to underestimate the significance of the Chinese for his aesthetic theory. China appears as one figure among many. Contrary to such an understanding, I suggest not only that we should take Addison's aesthetic thought seriously, but that to do so, we need to account for the important and active role of figural language in that thought, and in particular the figure of China.

The second source for the lack of recognition afforded the Chinese taste is its having been siphoned off into the realm of garden theory, where it receives wide notice. Along with Alexander Pope's *Epistle to Burlington* of 1731, Addison's writings on landscape gardening are credited as among the most influential early eighteenth-century formulations of a natural taste in gardening, written at a time dominated by the artificial *parterres* and ornate hedge design of French gardening and to a lesser extent the orderly Dutch influence carried to England by William. About that current taste Addison is unenthused. British gardeners fail to humor nature and "love to deviate from it as much as possible." As if misplaced Cartesians perturbed by nature's exuberance, they cut and trim trees into "Mathematical Figure[s]," making "Trees rise in Cones, Globes, and Pyramids" and making us "see the Marks of the Scissars upon every Plant and Bush." Addison does not like to see upon the purer plants and bushes of nature the violent marks of a gardener's cut and thrust.[21]

They order the matter better in China. Like good rhetoric, Chinese gardening effaces the figurativeness of its figure. As Addison's source, the English essayist and statesman Sir William Temple, put it in his essay "Upon the Gardens of Epicurus; or of Gardening in the Year 1685": "their ['the *Chineses*'] greatest Reach of Imagination is employed in contriving Figures, where the Beauty shall be great, and strike the Eye but without any Order or Disposition of Parts, that shall be commonly or easily observ'd."[22] Addison slightly alters Temple's terms to keep things in line with the aesthetic's undetermined aspect. He suggests a garden not less obviously ordered but one where the ordering is impossible to detect:

Writers, who have given us an Account of *China,* tell us, the
Inhabitants of the Country laugh at the Plantations of our *Euro-*
peans, which are laid by Rule and Line; because, they say, any one
may place Trees in equal Rows and uniform Figures. They chuse
rather to shew a Genius in Works of this Nature, and therefore
always conceal the Art by which they direct themselves. They have
a word, it seems, in their Language, by which they express the
particular Beauty of a Plantation that thus strikes the Imagination
at first Sight, without discovering what it is that has so agreeable
an Effect. (3:552)

As if to repeat rhetorically the "without discovering" of Chinese garden-
ing, Addison draws a veil over the word that "they have." Temple is more
forthcoming: "though we have hardly any Notion of this Sort of Beauty,
yet they have a particular Word to express it; and, where they find it hit
their Eye at first Sight, they say the *Sharawadgi* is fine or is admirable, or
any such expression of Esteem."[23]

Temple and Addison each give radically divergent scope to Chinese
taste and gardening practice. Temple finds Chinese gardening one "sort of
Beauty" amid a host of globally differentiated garden practices, from the
Dutch in Cape Town, to other parts of Africa and Mexico (132–34). Fur-
thermore, it is founded in thought thoroughly different from European
thought: "the *Chineses,*" he writes, are "a People, whose way of Thinking
seems to lie as wide of ours in *Europe,* as their Country does" (131). Thus
the beauty of *Sharawadgi* appears as one kind among many and is marked
by a thoroughgoing cognitive difference from Europe figured by geograph-
ical distance. This beauty is relative, objective, and foreign. Addison re-
peats Temple's geographic distancing of China, referring to "the remote
parts of China" (by which he does not mean the remote parts *in* China, its
rural areas, but China *as* parts remote) (3:557). He does not, however,
reproduce Temple's relative objective taste.

For Addison the exercise of Chinese taste presents an ideal aesthetic
experience. Neither one sort of taste among others nor marked as essentially
incompatible with European taste, it crystallizes the practice of aesthetic
appreciation by dramatizing a beauty "that thus strikes the Imagination at
first Sight, without discovering what it is that has so agreeable an Effect."
In other words, Chinese landscape appreciation exemplifies aesthetic ex-
perience in its immediacy and indifference to cognition. Moreover, it is

not an appreciation of beauty alone. Exhibiting the important "infinite variety," the Chinese garden allows for an impression of novelty or of vastness, imposing no confinement on where the spectator can look (3:549). It is absolute and subjective, and thus intimate and felt; it is not merely sited in a far-off object defined by the absence of visible order—indeed, by its absence from the European.

Addison's Aesthetic Allegory

I have outlined what Addison said of Chinese gardening. But how are we to read Addison's reference to Chinese gardening—what, in other words, is Addison *saying*? He himself ends the "Pleasures" with a remarkable discussion of figural language that suggests we ought to take his Chinese reference to contain an explicit and necessary figural aspect. "The Pleasures of the Imagination," he writes, "are not wholly confined to such particular Authors as are conversant with material Objects, but are often to be met with among the Polite Masters of Morality, Criticism, and other Speculations abstracted from Matter; who, though they do not directly treat of the visible Parts of Nature, often draw from them their Similitudes, Metaphors, and Allegories." "Transcribing Ideas out of the Intellectual World into the Material" so that "we are able . . . to discover a Scheme of Thoughts traced out upon Matter," these writers present an idea of reason artistically and so simultaneously gratify two faculties, the understanding and the imagination (3:577). When used to determine the aesthetic itself, such allusions would present something obvious to illuminate something that cannot be directly presented. They would work to establish a hinge between the unknown and the apparent, providing a stability of reference otherwise unavailable. And this is what the reference to the Chinese does: it delimits the aesthetic by way of an exemplary exercise of taste in landscape gardening. One might object that Addison draws "the *Chineses*" not from the material but from the intellectual world, and therefore it does not fit his figurative model. However, we must keep in mind that his mention of the Chinese allows him to describe first of all a particular landscape gardening practice, a certain distribution of nature's products.

As Addison articulates the aesthetic itself—what an aesthetic experience is as well as what its cause is—through the figure of Chinese gardening, we can call the figure allegoric rather than, say, metaphoric. Whereas the latter, to maintain its coherence, would bracket any incompatibility

between tenor and vehicle, for Addison Chinese gardening designates something—the aesthetic—that *in effect* exhibits a qualitative nonequivalence with its vehicle or fable. As William Empson puts it,

> Part of the function of an allegory is to make you feel that two levels of being correspond to each other in detail and indeed that there is some underlying reality, something in the nature of things, which makes this happen. . . . But the effect of allegory is to keep the two levels of being very distinct in your mind though they interpenetrate each other in so many details.[24]

Of course the stillness and isolated aspect of Addison's figure looks more like metaphor than it does those extended narratives of wonderful events so readily called allegories. Importantly, Addison's own understanding of allegory does not belong to the medieval or Renaissance Christian tradition. It partakes of a neoclassical remodeling of allegory that brings it closer to metaphor by controlling and limiting its operation, though a marked divergence persists between the two as allegory maintains its constitutive schism. Thus Gordon Teskey notes that neoclassicism requires allegory to maintain a "coherence on the literal plane." No longer praised for a numinous energy of signification, with its "magical correspondences" and "cosmographic view of the world," allegory must hold to "the rhetorical standard of consistency in metaphor." That standard demands a linguistic decorum. Inasmuch as allegory serves understanding, telling us something about things, it should shed light, not dissemble meaning in baggy folds of darkness.[25]

Dovetailing with the empiricist emphasis on the epistemological significance of plain speaking, the neoclassical account of allegory suggests that obscure figures may not only get in the way of reflection but may also pervert it.[26] Allegory should be clear-cut, neither confused nor confusing. "Those Fables and Allegories . . . which are very proper for Instruction," Addison writes in *Spectator* 391, need "but little Explanation . . . the Interpretation is obvious enough" (3:467). In like fashion, Addison's close friend and sometime contributor to the *Spectator*, John Hughes, argues that allegory should be divorced from baroque excess. Hughes, in the most sustained consideration of the topic contemporary to Addison, argues that "the Allegory [ought to] be clear and intelligible: the Fable being design'd

only to clothe and adorn the Moral, but not to hide it, should methinks resemble the Draperies we admire in some of the antient Statues; in which the Folds are not too many, nor too thick, but so judiciously order'd, that the Shape and Beauty of the Limbs may be seen thro them." The need to speak plainly itself speaks a desire to avoid a perversion of words: "An Allegory," Hughes says, "which is not clear, is a Riddle, and the Sense of it lies at the Mercy of every fanciful Interpreter."[27] By speaking as precisely as one can in this indirect mode, one guards against the subsequent disfiguration of one's words by the will of another. That Addison's own thinking on figural language is governed by a desire for stability is apparent in the cognitive benefit of what he calls "a Scheme of Thoughts traced out upon Matter." Despite the figural aspect of the relation being named, the linguistic sign disappears; thought and matter meet without intervention or relay. Importantly, an analogous immediacy makes the Chinese reaction to landscape an aesthetic ideal. They experience beauty as it "strikes the Imagination at first Sight."

The Chinese dispense with delay, enabling them to allegorize the aesthetic in a good way—or more specifically, to speak otherwise, as if emblematically and so without the temporal unfolding inherent in narrative. Neoclassical critics tend to reject traditional allegory's narrative mode as a font of semantic instability; its temporal form, they fear, makes it hard to control figural language. Of this, Hughes's use of the figure of a statue is symptomatic, and Addison's own allegories, in various *Spectator* papers, are vivid examples. His dream of the Bank of England (1:14–17), his exotic Amerindian and Oriental allegories, the visions of Marraton and Mirzah (1:236–40; 2:121–26), and his "Continued Allegory [of] the several Schemes of Wit," to which he appends as epigraph Horace's denunciation of a rhetorical mermaid's impropriety (1:270–74)—all these are virtually *ekphrastic* in technique, describing a settled and visible tableau. But we find no extended journey whereby the protagonist encounters great dangers and temptations, or even undergoes radical transformation, proving incompatible with the tradition of allegory extending from Apuleius's second-century narrative, *The Golden Ass,* to William Langland's fourteenth-century narrative poem *Piers Plowman,* and even up to the largely self-sufficient, literal narrative of John Bunyan's *Pilgrim's Progress* (1678). Addison detaches the protagonist from the scene; she remains largely untouched by things. His understanding of allegory, then, like neoclassicism's more broadly,

would be at home in a world of stillness and completion. More or less atemporal, allegory describes, and itself becomes, an immobile object of knowledge that can be stated literally.[28]

But as we saw in chapter 2, eighteenth-century aesthetic theory insists on the central importance of something clear and confused. Arguably it is this departure that calls for the figural supplement of allegory such as Addison's use of the Chinese, his turn to an allegoric figure testifying to a prior loss of certainty. Addison deploys a figure of human understanding to shed light on something that he insists is separate from understanding, presenting a lacuna to sure cognition. Consider in this light how the *typosis* of Chinese aesthetic experience as Addison conceives it suggests an attenuation of temporality more radical than any achieved by Addison in his schematic allegories. Viewing the Chinese garden one is struck, suddenly and immediately, by the scene. What makes possible the subjective experience of this instant striking force of inscription is what Addison's aesthetic allegory allegorizes. Addressing the understanding, it presents to cognition what cannot directly be cognized: the imagination, the faculty whose provenance is the aesthetic. The striking of the scene shows how the aesthetic faculty operates, namely in an event-like way that cannot be the subject of a putatively mimetic narration.

An allegory for Addison, though, appeals not only to the understanding but also to the imagination, a double appeal that gives it its pedagogic utility. Allegories can dress up difficult ideas in pleasing attire, though that attire must fit well. This is what Addison wants to achieve with the figure of Chinese taste. For this reason, the allegory partakes of what it articulates. It presents the imagination to the understanding by way of the imagination—what the understanding cannot directly grasp. Hence Addison paradoxically replicates the noncognizable gap of the aesthetic in making it cognizable. Yet he produces an object for aesthetics in doing so, clearing a space for the aesthetic. He rejects the imagination's reduction by those following too closely empiricism's rationalization of subjective experience. If, as Tuveson suggests, Lockean epistemology closes out the imagination by narrowing "the gap between the impression and the 'intellectible,' which it had been one function of poetry to fill," then Addison wedges that gap open.[29] In this view, Addison, who directly follows Locke in so many respects, supplements the Lockean account by disclosing a major and irreducible place for the imagination. The exotic allegory serves to open up a space for thinking the aesthetic faculty in its operation, and hence for thinking the aesthetic itself.

China

The Chinese garden does not confine the spectator's imagination. It offers the spectator a pleasing, automatically imbibed variety. The "particular Beauty" the garden offers "strikes the Imagination at first Sight," calling forth the instant pronouncement ("Sharawadgi") that prior to any reflection proclaims the scene pleasurable. The pronouncement would be metaleptic: it leaps from an open structure of "infinite variety" to a structure named with a single word. Paul de Man locates an analogous gesture in Rousseau's use of "love" in La Nouvelle Héloïse (1761): "'love' is a figure that disfigures, a metaphor that confers the illusion of proper meaning to a suspended, open semantic structure." Addison shares with Rousseau the recourse to "the naïvely referential language of the affections"—and also like Rousseau, Addison's recourse is not itself naive.[30]

In Addison's case, he sophisticates what might otherwise remain a metaphorical use of the absent term, Sharawadgi, by recasting it as allegorical. Claiming the term as a metaphor of aesthetic experience—the "naïve" reading of the statement "They have a word . . . by which they express the particular Beauty of a Plantation"—would entail the further claim that Addison takes the aesthetic itself as an object of a potentially literal restatement according to the common logic of metaphoricity. In this view, Addison's turn to the Chinese pronouncement would appear an attempt to reinstate a referential model of language to delimit what is beyond direct statement—that is, the aesthetic. However, as suggested, the exemplary Chinese do not present a metaphor but an allegory of the aesthetic, an allegory that includes the metaphoric naming of what will not take a metaphor. Accordingly, we can call Addison's allegory (to use de Man's terms) an allegory of metaphor.[31]

So while Addison says "They have a word . . . by which they express the particular Beauty of a Plantation that thus strikes the Imagination at first Sight," he is saying something else. There is, in his account, the insistence that in the act of determining the aesthetic one needs a figural language that cannot be restated to yield a literal designation. To this end, the Chinese prove invaluable. Exotic (exotikos, "from the outside") as they are, or are thought to be, they remark, through their iteration, a border. That border brings to what the Chinese name (that is, the aesthetic) a differentiation otherwise lacking. So although Chinese taste exemplifies the extended form of variety without set limits, the Chinese themselves nonetheless

introduce a perceptible difference. Brought as if from faraway shores to
figure as it were shoreless, the figure of Chinese taste iterates, in its itera-
tion, a certain crossing and therefore limit.

Addison's view of Chinese taste might be called an hallucination. Cer-
tainly the "they have" seems to be an unwarranted projection: there is no
known Chinese equivalent for *Sharawadgi*.[32] More significant (at least for
our understanding of aesthetics) is the disfiguring action central to Addi-
son's allegory. Though Addison praises the Chinese artistry in imitating
nature, he says very little as to what that artistry includes. As he puts it,
again repeating rhetorically the action he describes, "they express the par-
ticular Beauty of a Plantation that thus strikes the Imagination at first Sight,
without discovering what it is that has so agreeable an Effect." In short,
Addison's Chinese are detached from any putative context, unhinged at
its outer edge to form a kind of floating framework. What the frame bor-
ders is the mirror image of what ought to belong to any given aesthetic ex-
perience, including that of a European. The return of the projected image
would complete an economy that, we might say, economizes on the abyss
of the imagination. China would thereby define the self by bordering the
internal, primary void of the imagination, making a Chinese aesthetic expe-
rience the principle of European self-fulfillment.

This understanding is incomplete, however. Addison references not
China but other texts, which means that it is by reciting other accounts,
namely Temple's, that he figures aesthetic primacy. Addison (again, as de
Man writes of Rousseau's use of allegory) "does not even pretend to be
observing" the Chinese.[33] Of Chinese gardening, Addison himself had no
firsthand experience; the "prettiest landskip" he says he ever saw was one
projected by a camera obscura in London (3:550–51). As with Lucretius,
Addison designates something primary by an act marked as secondary, a
gesture that at once opens and presupposes a place or moment of the pri-
mary. As he puts it, "Writers, who have given us an Account of *China,* tell
us, the Inhabitants of the Country laugh at the Plantations of our *Euro-
peans.*" Given the importance Addison attaches to the primary, as well as
his subtle, ironic play between it and the secondary, it is significant that he
presents the Chinese, who exemplify the primary pleasures, by reciting
previous accounts, especially as it recalls the allegorical import of his men-
tion of China; he is literally speaking otherwise, in words not his own. Yet
whereas his aesthetic allegory appears to work semantically—China shows
something other than what it literally shows—we can call the medium of

his allegorical citation syntactic. As such, it bears a temporal aspect at odds with the emblematic model of neoclassical allegory. "Writers . . . *tell us*," Addison says, pointing up what eighteenth-century writers commonly called a *relation* to underscore the allegory's basis in narration, marking his dependence on a mode whose temporal unfolding is incompatible with its putative object. *Sharawadgi,* which is instantaneous, offers no narrative potential.

By foregrounding the allegory's temporal form Addison pressures its referential function. *China* appears less the synchronic embrace of a referent than the effect of a diachronic repetition of other accounts, making its alignment with what it is allegorical of uncertain. The implications for Addison's spectatorial self—bordered by what is now a doubly ungrounded figure, expressly detached from context and now from referent—are far-reaching. The self necessarily remains incomplete, constituted through a sign structured disjunctively, so that China countersigns a European self that it at once denies, or at least delays. This last point might appear to go against the grain of Addison's statements that seem to favor self-completion with no remainder. In *Spectator* 409, for example, he says he will consider "how we may acquire that fine Taste in Writing, which is so much talked of among the Polite World," having introduced the issue of *"the fine Taste"* by invoking the ancient Roman emperor Gratian's urging it "as the utmost Perfection of an accomplished Man" (3:527). As I read him, Addison does not say he recommends taste as Gratian does, but that Gratian recommends it as he (Gratian) does. What he does say is that it is a taste *to be* acquired.[34]

Contra Gratian, Addison presents a dynamic if troubled self reaching after taste. Pivotal to this action is the self's need to border the chasm introduced by the aesthetic. However, the self-supplementation China imparts does not produce completion. The temporal bearing of the allegorical sign extends rather than resolves the gap in the self such that the self can never quite be present to itself; the self's incompletion cannot be transcended. For this reason, the recuperative economy of the self–other reflection proposed above (the self arriving at itself by way of a delimiting detour through China) becomes an inadequate explanatory model.

We can best begin to see the significance of Addison's formulating the self as necessary incompletion by considering its relation to what political theorist and philosopher Claude Lefort calls bourgeois *vertige*. A major consequence of the "modern democratic revolution," as Lefort sees it, is

the "désincorporation" of both individual and society. In the older monarchies, the state is "consubstantial with the body of the king."[35] With the rise of bourgeois democracy, however, a vital change occurs. "Democracy inaugurates the experience of an ungraspable, uncontrollable *[insaisissable, immaîtrisable]* society in which the people will be said to be sovereign . . . but whose identity will constantly be open to question" (172–73/303–4). For Lefort it follows that the "bourgeois cult of order" (and here we might recall Dennis) proves less the rational organization of social relations than the response "to the loss of the substance of society, to the disintegration *[la défaite]* of the body": in its attempts to promote order, the bourgeoisie "testifies to a certain vertigo *[vertige]* in the face of the void *[la béance]* created by an indeterminate society *[une société indéfinie]*" (173/304). Addison's incomplete, disinterested subject of aesthetic appreciation might itself be taken to express a certain disincorporation. Most important, Addison faces up to the vertiginous void by formulating an aesthetic self engaged with the dizzying and irrational conditions presented by an emergent democratic state. And he tries to face the void with China.

Having said this, the allegorical sign *China* does not sit comfortably with Lefort's "whole cult" of order, which is extensive with society itself. Allegory "establishes its language in the void of [its] temporal difference."[36] The language of allegory is one of unrelieved disjunction. Hence its incompatibility with Lefort's perverse synecdoche, the people, composed by the conjoining of integrally related parts that presupposes this category to be the whole that they add up to, but that cannot contain them because no one corresponds to the people as such. The allegorical sign suspends such a representative relation: the uncertainty that China presents does not consist in its standing over-against the bourgeois as its dialectical other. In the action of self-identification, it intrudes as much on the inside as on the outside, putting in doubt any easy separation of the two domains. To use the figure of the mirror, China shows the *tain*—the dull, nonreflective tinfoil bordering the back of a mirror that at once enables and escapes the circular economy of reflection. In other words, taking our cue from the etymology of reflection (*re-flectere*, "to turn back" or "to bring back," but also "to bend"), we can say that Addison not only shows us the self's shaping through the image of the other, but also its bending out of shape through something entirely other, something that does not hold to a restricted model of self–other reflection.[37]

This leads to a final question. What does China's pointing to the tain reveal about Addison's allegorical reference itself? Most immediate, it underscores how the allegorical sign does not simply repeat previous content. While the nonmimetic factor clearly appears in the subtle alterations Addison makes to Temple's account, and in his including a reference to the previous account that that account does not carry, it goes deeper. Addison's citation of the Chinese taste leads away from itself, encrypting within itself its own dispersal and thus what does not fit within a seamless economy of reflection or exchange. Something intrudes that is aneconomic. In the text but not fully reducible to it, China leads out from the text's edge to open a dialectic of identification, yet it remains on the inside too, remarking an internal lack and constitutive nonequivalence. What this suggests is that in Addison's formulation, the aesthetic proves less the expression of public sphere rationality and more the disclosure of a certain problematic that places the European self in a rather different spherical context—a globalizing perspective that simultaneously reveals the self's incompletion, promises it completion, and denies it any sense of self-equivalence.

Kant's Tattooed New Zealanders

WE HAVE SEEN HOW JOSEPH ADDISON formulates the aesthetic faculty as a primitive human capacity, and how in doing so he opens an unconditioned gap in the self at once necessary for aesthetic experience and yet potentially hazardous for an experiencing self if the gap is not in some way stabilized. Immanuel Kant, like Addison, conceives the aesthetic faculty as primitive and unconditioned. However, unlike Addison, he includes it within the elaborate architecture of a Critical Philosophy that aims to determine the conditions of possibility that afford a pure judgment of taste, a judgment that is expressly nonempirical. A significant constituent of Kant's Critical Philosophy is his notion of reflection *(Reflexion)*. Reflection, of course, proved important in Addison, though its importance there did not follow from Addison's own theorization of it. Reflection's importance in Addison might even be said to result from his failure to theorize it, as the unlimiting force of the Chinese exemplar institutes, within the assumed economy of a self–other reflection, an ungovernable *vertige* of non-self-identity. With Kant, the importance of a concept of reflection is explicit. In question, though, is not one's reflecting upon an object as one might think about an object one sees or has seen. Reflection is not empirical in this way. It occurs within the subject and involves the referral of a representation *(Vorstellung)* to the proper cognitive faculty, to understanding, judgment, or reason.

In Kant's Critical aesthetic theory the human subject refers the representation (and again not the object) to her feeling of pleasure or displeasure. Crucially, the referral or reflecting does not entail a determinate judgment (where the representation would be subjected to a concept of the understanding) but a pure reflective judgment (where the representation is neither constrained by, nor in conflict with, the understanding). In other words, the reflection here is reflective. This is not a mere play on words. As with Addison, with Kant we end up with something like an abyss structure, for Kant's concept of reflection tends to leave us with a

hollow subject. Thus Howard Caygill observes more generally that "the relation between reflection and the subject of reflection is . . . extremely nuanced—it is by no means clear whether reflection is an act of a subject or whether the subject is nothing but a mode of reflection." While Philippe Lacoue-Labarthe and Jean-Luc Nancy suggest that in the third *Critique* particularly, reflection "connotes only a pure referral or reflecting back." It does not substantialize a subject or even require a substantial subject. The Critical Philosophy, put most simply, would then be Kant's attempt to set the self-grounding conditions of possibility for a subject whose grounds remain unclear.[1]

The subject is self-grounding, of course, because Kant had made it so. That was the outcome of the so-called Copernican Revolution in philosophy inaugurated by the first *Critique*—where Kant had, he says, in language we are familiar with, "set forth" on the only as yet unexplored path.[2] Henceforth the human subject is centered upon itself. Kant locates within the subject not just all thinking and all knowledge but the conditions of possibility for any thinking and any knowledge at all. Recall that Descartes, who might be thought to have inaugurated the turn to subject-centered knowledge, still required a God to guarantee reliable knowledge of the world outside to the subject. Kant, claiming that our faculties of cognition, of pleasure and displeasure, and of desire, originate and operate within us, seeks to avoid theological recourse to a God as guarantor of our link with the material world. The universe circles around us, each of us, with nothing behind us. We ground ourselves and direct ourselves to what is outside us.[3]

Pursuing the subject's self-grounding as far as he did, Kant feared that with the first two Critiques he had opened *eine unübersehbare Kluft,* "an incalculable gulf."[4] A chasm without measure now appears to separate cognition and desire, understanding and reason. The third *Critique* is Kant's attempt to throw a bridge across the abyss—not, then, to fill or reduce the abyss, which is, properly speaking, impossible; one cannot fill or reduce what is without limit or size. Kant wants to throw a bridge—or better yet, to build the subject out over the abyss—by grounding reflection itself in the subject's capacity for judgment. In this sense the *Critique of Judgment* tries to ground judgment and hence the aesthetic where there is no possible ground. Which perhaps explains why Kant, as he builds out over the great gulf, makes what Jacques Derrida calls "une recours anthropologiste." Kant's recourse is to a pragmatic understanding of the human,

which in turn brings into Kant's theory of the beautiful "une théorie de la culture." The pragmatic anthropology of the third *Critique* means that Kant will paradoxically use particularized acts of culturally constituted judgment in formulating pure judgment as a capacity or power—that is, a faculty.[5]

Kant's settling of the subject's capacity or power of judgment in the context of his anthropological (and specifically ethnological) recourse returns us to our problematic. Aiming to determine aesthetic judgment's conditions of possibility, with the aesthetic faculty itself remaining unconditioned and free of particular determination, Kant's task becomes one of setting the faculty's conceivable limits. Put differently, Kant will need to comprehend what is without condition in light of a certain finitude (the faculty's conceivable limits). In setting these limits, Kant turns to exotic examples. I will suggest that Kant's casual mention of tattooed New Zealanders is especially consequential, signaled by its appearance in what is now one of the most debated sections in the third *Critique,* where Kant attempts to distinguish free or unconditioned beauty and merely adherent or conditioned beauty. The tattooed New Zealanders appear in a context where Kant wants, on the one hand, to determine the temporal operations of the primitive faculty of judgment, and on the other, to categorically separate unconditioned beauty from conditioned beauty. As we will see, when Kant, in a decisive articulation, turns to Maori facial tattooing, he binds his "recours anthropologiste" with an ethnological constituent that underwrites the third *Critique* and Kant's attempt there to ground the subject's capacity for reflexive judgment.

Armchair Exoticism?

Kant's mention of Maori facial tattooing is brief:

> One would be able to add much to a building that would be pleasing in the intuition of it if only it were not supposed to be a church; a figure *[eine Gestalt]* could be beautified *[verschönern können]* with all sorts of curlicues and light but regular lines *[Zügen]*, as the New Zealanders do with their tattooing *[mit ihrem Tettawiren thun]*, if only it were not a human being *[es nur nicht ein Mensch]*; and the latter could have much finer features *[viel feinere Züge]* and a more pleasing, softer outline to its facial structure *[der*

Gesichtsbildung] if only it were not supposed to represent a man,
or even a warrior *[wenn er nur nicht einen Mann, oder gar einen
kriegerischen vorstellen sollte].*[6]

Despite its brevity Kant's mention presents great difficulties to interpreta-
tion. As one critic recently put it, "It is not at all clear what Kant's claim
is."[7] The problems tend to derive from the unclear relation of face and tat-
too in the example. Is Kant suggesting that the tattoos are beautiful, but
not on the human face? Or that the tattoos could never be beautiful
because they could never be without the human face? Kant seems to imply
that they are both separable and inextricably bound together. This is
remarkable given that the New Zealanders and their tattooing illustrate
a certain form of ornamentation. To ornament something, one adds to it
a separate component, which remains an ornament insofar as it remains
separable, nonessential. Yet here the difference of object and ornament,
and thus the relation of one to the other, is unclear.

One could dismiss the complexity of Kant's mention of the New
Zealanders as armchair exoticism. As exotic figures, they present a com-
mon enough kind of reference. Kant's turn to them is almost too obvious.
And yet this does not, perhaps cannot, explain why Kant goes so far as
to inscribe doubt directly into his mention of the New Zealanders and so
draw particular attention to the reference. Three examples make clear the
extent to which Kant sows uncertainty into his mention:

1. *Figure.* Kant immediately courts hesitation by beginning with
 the word *Gestalt* ("a figure *[eine Gestalt]* could be beautified").
 As we read the passage we cannot yet tell that the figure marked
 with these patterns is a human one. If Kant had instead used,
 say, *Gesicht* ("face"), we would know at once that we are deal-
 ing with a face embellished with various marks—an objective
 correlative, as it were, of savagery. Additionally, in light of a
 notable previous use Kant had made of *Gestalt,* the reader
 would justified in assuming that the term is not referencing a
 face. In §14 he used it to specify, along with *Spiel* ("play"), the
 Form of objects as they appear to the senses in a state of *mere
 form,* the state necessary for a pure judgment on the beautiful.[8]
2. *Physiognomy.* Because Kant is referring to a face one might be
 tempted to posit his reference as an entry into contemporary

debates on physiognomy. However, his use of *Gestalt* and the uncertain relation of object and ornament already mentioned means that such debates, which would position Kant's reference with some certainty, do not provide an adequate explanatory framework. More precisely, Kant's mention of the New Zealanders at once approaches and retreats from *phusiognō-monia*. The point of reference for physiognomy, the face as a discrete, characteristic-bearing ontological entity, hovers on the margins of Kant's talk of facial tattooing and then disappears. Thus Kant freely uses the familiar terms of physiognomy in the passage of concern to us, namely *Gestalt* (figure, shape, form), *Züge, Zügen* (features or characteristic lines) and *Gesichtsbildung* (literally, face formation). But crucially, Kant recasts the terms of physiognomy to draw them away from any physiognomic valence. *Gesichtsbildung,* for example, is a central term in contemporary physiognomy that Kant uses in an explicitly nonphysiognomic way. With it, Kant does not designate the pregiven facial characteristics by which one can know a person's or race's interior characteristics. In Kant's usage the word references the facial shape of the tattoos, underscoring the representational significance of *Bildung* to evoke the act of giving form. That is, it suggests a face-like *forming* that marks instead a certain aesthetic intention. What proves important for Kant in the case of Maori tattooing is the interpenetrated form of face and tattoo following on from an act of beautification ("could be beautified").[9]

3. *Beautification.* The notion of an act of beautification as a particular mode of ornamentation does not, however, provide much clarity. What Kant believes the act to entail is uncertain. We know that Kant had a dim view of the darker races, particularly of those he called *die Negers.* One might therefore assume, as have critics who note Kant's mention of Maori facial tattooing, that he merely dismisses them as obviously not beautiful. But consider Kant's use of *verschönern* ("beautified"). Now commonly aligned in meaning to *schöner machen,* the word retains an older, discrete import. Grimms' *Wörterbuch* indicates that while *schöner machen* names a raising *(erhöhen)* in beauty *(Schönheit)* of what is beautiful, *verschönern* can also suggest

the enhancement of what is unattractive *(unschönen Gegen-stand)*. Here the object in question would be turned *(würde)* toward beauty, a deviance making the thing different to itself and the act of beautification itself ironic. In this sense, to say of something that it *verschönern können* (could be beautified) appears a backhanded compliment—a more subtle version of Gotthold Ephraim Lessing's laughable Hottentots discussed in Chapter 2. Again, we cannot be certain. *Verschönern* remains ambiguous enough, in Kant's text and philologically, to cut either way, toward serious or ironic beautification.[10]

Beyond the uncertainty that inheres in Kant's mention of Maori facial tattooing, the mention itself appears in perhaps the most critically contested section of the Analytic of the Beautiful, §16, "The judgment of taste through which an object is declared to be beautiful under the condition of a determinate concept *[bestimmten Begriffs]* is not pure." As is well known, a central claim of Kant's aesthetic theory is that a pure judgment of taste *(reines Geschmacksurtheil)* occurs in the absence of any determinate end or purpose *(Zweck)*. If in the representation of an object to oneself one attaches a concept of cognition to the object (that is, a concept that determines the object in light a some cognizable end), then that object is adherent to a predetermined end or purpose and is thus unable to give rise to a pure judgment of taste. In §16 Kant formalizes the distinction in the discrete categories "free beauty *[freie Schönheit]*" and "merely adherent beauty *[bloß anhängende Schönheit]*," on the premise that the latter retains a concept whereas the former does not. However, critics disagree widely on what Kant intends by each category, as well as (even to the point that some question the foundation of his aesthetics) whether the difference between the two types of beauty is tenable.[11]

The interpretive disagreement over §16 pivots on the examples Kant uses to point up his distinction. Generally speaking, Kant's examples tend to prove disconcertingly vague, supporting quite different readings, and certainly within the third *Critique* Kant will often put an example to quite different ends. The problems follow partly because Kant tends to employ his examples in a closely contextual manner, according to the specific demands posed by the claim he wants to illustrate. The result is that the use he makes of a specific example to illustrate one claim sometimes conflicts noticeably with the use he makes of the same example to illustrate a

different claim. So in §14, "Elucidation by means of examples," Kant refers to colonnades around buildings as examples of *parerga* (224), meaning that they are objects of mere form *like* the object they adorn, yet in §16 he cites buildings, along with horses and humans, as a kind of object that can never have mere form only (230). On the one hand, then, Kant implies that buildings can be free beauties, and on the other, he states that they cannot.

In the case of the New Zealanders—where, as we have seen, Kant makes the example exceptionally hard to read—I would suggest that Kant makes them stand out so that they break from the closely contextual way that he tends to use his examples. If "a building" means one thing in one context and another thing in a different context, the New Zealanders do not quite settle in any context. We face two questions, then. Why does it matter that *this* example remains vague? And what implications does that vagueness hold for the third *Critique* more widely? Most simply, from the perspective of the third *Critique* the New Zealanders' importance lies in the way they help Kant determine certain limits. Specifically, they mark a difference between free beauty and adherent beauty. In presenting a merely adherent beauty, they also give shape to free beauty and hence to the pure judgment of taste or the aesthetic per se. So even if Kant gives them a freedom belying fixity, they must hold on one point. And it is, perhaps, in looking to hold the New Zealanders in place that Kant insists on the nondetachability of the tattoos from the face (hence his particular use of *Gesichtsbildung*). That attachment serves, in other words, to guarantee their nondetachment on this point from the terms of his Critical Philosophy.

Aesthetics, Ethnology, and the Kantian Wild

Kant likely became aware of Maori facial tattooing through his extensive reading in travel literature. The New Zealanders and their tattooing are certainly exotic for late eighteenth-century Europeans, but they find their way into European consciousness via a commonplace archive: travel literature, specifically the then-fashionable subgenre of South Seas voyage narratives. An exotic example from an existent archive of exotic examples, Kant's use of the tattooed New Zealand warrior would seem an attempt to explain the theoretical by popular public means. Yet as we have seen, something makes them stand out. Recalling the etymological import of

example (from the Latin *exemplum,* literally, "that which is taken out," from *eximere,* "take out, remove"), the New Zealanders maintain a singularity that makes the movement from particular to general or vice versa problematical. If Kant's intent is to make his philosophy accessible to a wider public through his popular examples, the case of the tattooed New Zealanders suggests that an example may only reinforce a sense of his Critical Philosophy's detachment and obscurity. At the very least, his popular examples appear incongruous with his dense theoretical speculations—a little too everyday to be in the midst of the uncommon and inaccessible.[12]

However, we start to perceive a deliberate and wider role for the tattooed New Zealanders within the third *Critique* by disclosing their relation to a certain ethnological thought that runs through Kant's account of aesthetic judgment. That ethnology is lodged discretely in Kant's valorizing of the wild, which for him presents a kind of utmost nature. As Rodolphe Gasché points out, "Although Kant amply clarifies that pure judgments of taste—which occur only if no determined concept is available for the object under consideration, so that the object is unknown— concern exclusively 'free beauty,' commentators have scarcely noticed that such beauty is encountered in the wild." Kant's distinction between free and adherent beauty, and thus the role afforded the New Zealanders, has something to do with his understanding of the wild and free beauty's proximity to it. Kant signals this proximity quickly in the Latin gloss he gives "free beauty": *pulchritudo vaga.* As Derrida suggests, the reason for Kant's use of a Latin gloss here is not directly apparent. Kant gives no context to comprehend its inclusion. It just appears. One is faced with "ces mots latins dont on ne comprend pas tout de suite (ni parfois jamais) la nécessité," so that *vaga* is aligned with *vague* not only etymologically but, in Kant's use, rhetorically. *Vaga* turns out vague. Left to wander *(vague)* into a wasteland *(terrain vague)* without fixed or apparent limit, it associates free beauty with the errant and, above all, the wild.[13]

Let me bring out and clarify the ethnological aspect of Kant's Critical aesthetics by following the figure of the wild through four examples.

Landscape Gardening

The first example, landscape gardening, recalls Addison's emphasis on a paradoxically cultivated wild, or wild cultivation. Like Addison, Kant speaks highly of landscape gardening (though he does not favor a perceived

Chinese taste). He places *"the art of pleasure gardens"* in the category of painterly arts, which present *"sensible illusion"* by either "the beautiful *depiction* of nature" or "the beautiful *arrangement* of its *products.*" The pleasure garden's art corresponds to the latter. "In the viewing of its forms *[ihrer Formen]*," the garden appears as "nothing other than the decoration of the ground with the same variety (grasses, flowers, bushes and trees, even water hills and valleys) with which nature presents it to intuition *[Anschauen darstellt]*, only arranged differently and suited to certain ideas." Taking from nature its way of appearing to the subject *(Anschauen darstellt)* and its forms *(ihrer Formen)*, the *Lustgärtnerei* present "no concept *[Begriff]* of the object and its end *[Zwecke]* . . . as the condition of its arrangement."[14]

A botanist taking a turn in such a garden might be presumed to have a cognitive relation to the flowers he sees. As Kant puts it, "the botanist knows what sort of thing a flower is supposed to be." However, botanic knowledge can be bracketed: "the botanist, who recognizes in it the reproductive organ of the plant, pays no attention to this natural end *[Naturzweck]* if he judges *[urteilt]* the flower by means of taste *[Geschmack]*" (§16, p. 229). By such judgment, the plants of the *Lustgärtnerei* are "only the forms *[die Formen]* (without regard to an end *[einen Zweck]*) as they are offered to the eye" (§51, p. 324). They cannot become the objects of a determinate knowledge. At this point, nature's beautiful arrangement dovetails with its beautiful depiction, such as Kant finds on "wallpaper, moldings, and all kinds of beautiful furnishings"; they "merely serve to be viewed." A pleasure garden produces "merely the free play of the imagination *[bloß das freie Spiel der Einbildungskraft]* in the contemplation, [and] to that extent it coincides with merely aesthetic painting *[bloß ästhetischen Malerei]*, which has no determinate *[bestimmtes]* theme" (323).

In valorizing the garden that strikes the eye, appears as nature, and is not oriented by an end, Kant's account echoes Addison's. But the echo sounds deeper. The luxuriant, free face of nature that Addison finds embodied in Chinese garden taste forms for him an exemplary instance of aesthetic appreciation; it figures the ideal aesthetic itself. Kant too gives free nature this central role. Nature, he says, concluding the Critique of Aesthetic Judgment, "constitutes the correct standard, not to be given by any universal rule *[allgemeinen Regeln]*, for taste *[Geschmack]* as a universal human sense *[als allgemeinen Menschensinn]*" (§60, p. 356). Yet he will not pin it down to a taste one could call Chinese or any other particular

name. In fact he does not quite pin it down at all, which would no doubt be to give it a concept before judgment, to de-*fine* it. No knowledge can appear on offer in an aesthetic judgment. What Kant does do, as we shall see in the next example, is attribute to merely formal nature an ability to strike one without end: it has immense variety *(Mannigfaltigkeit)* but no governing purpose or end *(Zweck)*. Merely formal nature has only a pre-adaptedness to the subjective faculties, "a purposiveness *[zweckmäßig]*, in its form, through which the object seems as it were to be predetermined for our power of judgment" (§23, p. 245).

Sumatra

The second example comes from the General Remark that concludes the Analytic of the Beautiful. Kant illustrates his point that "all stiff regularity . . . is of itself contrary to taste" (242) by refuting a particular claim concerning the beauty of a pepper garden made by William Marsden in his *History of Sumatra,* first published in English in 1783 and translated into German in 1785 as *Natürliche und bürgerliche Beschreibung der Insel Sumatra in Ostindien.* Marsden mentions the pepper garden's beauty in a section of his book headed "Productions of the island considered as articles of commerce." In the midst of detailing the pepper plant's commercial properties, manner of cultivation, and suggested means of increasing crop uniformity and quality, Marsden digresses to exclaim over the pepper garden's aesthetic properties. While Marsden remarks in his Preface that Sumatra is "surpassed by few [other islands] in the bountiful indulgences of nature," he finds, as he states in his account of the pepper plant, that in the absolutely wild jungle of Sumatra there is so much free beauty that soon there is no beauty at all. One needs a break from nature's unceasing beauties. Marsden finds that break in the order presented by *ein Pfeffergarten* lodged deep in the jungle. The relief that Marsden attributes to the garden, and that makes it for him so beautiful, follows from its marked contrast from its surrounds. Drawing an analogy with recent English garden history, he suggests that if one "raise[d] up, amidst these magnificent wilds, one of the antiquated parterres, with its canals and fountains, whose symmetry [the English have] learned to despise [due to 'the modern, or irregular style of laying out grounds']; his work would produce admiration and delight."[15]

Marsden's understanding, Kant argues, is fundamentally mistaken:

In his description of Sumatra, *Marsden* remarks that the free beauties of nature [*die freien Schönheiten der Natur*] everywhere surround the observer there and hence have little attraction for him any more; by contrast, a pepper garden where the stakes on which the plants were trained formed parallel rows had much charm for him when he encountered it in the middle of a forest [*einem Walde*]; and from this he infers that wild [*wilde*], to all appearances irregular beauty [*nach regellose Schönheit*] is pleasing only as a change for one who has had enough of the regular kind. But he needed only to have made the experiment of spending one day in his pepper garden to realize that once the understanding has been disposed by means of the regularity to the order that it always requires the object would no longer entertain him, but would rather impose upon the imagination a burdensome constraint, whereas nature, which is there extravagant in its varieties [*Mannigfaltigkeit*] to the point of opulence, subject to no coercion from artificial rules, could provide his taste [*Geschmacke*] with lasting nourishment.[16]

Kant finds the wild jungle to be a source of perpetual variety. It inherently counters "boredom" induced by "stiff regularity": "that with which the imagination can play [*spielen*] in an unstudied and purposive [*zweckmäßig*] way is always new for us, and we are never tired of looking at it" (242–43). In contrast, a purpose-built, geometrically organized pepper garden imparts a conceptual force preventing the imagination's free play. It would constrain the imagination, making it follow along the determined lines of a concept. The wild necessarily remains free from such constraints.

The Tulip

Commentators have said little about the role of Sumatran vegetation in the third *Critique*. Kant's mentions of the tulip, however, have received wide notice. Such attention is not itself unwarranted. As Gasché notes, "the figure of a flower whose species one does not know, is perhaps the paradigm of beautiful form," and Kant's preeminent example of such a flower is the tulip that merely appears to the view. Yet the attention paid to the tulip tends to disavow, consciously or not, the flower's wildness. Perhaps this is

an effect of its calling up images of ordered gardens alongside dykes and windmills, part and parcel of the ordered, indeed extremely contrived, belabored, even literally fabricated, Dutch landscape. However, not only was Kant skeptical of Dutch aesthetic sense—"*Holland* can be regarded as the land where this finer taste is fairly unnoticeable"—but in the late eighteenth century the tulip remains still something of an exotic flower. The tulip, in eighteenth-century Königsberg, is a flower with exotic, even wild, associations.[17]

The tulip was first brought to Europe in the sixteenth century from Turkey, where the wildflower had been highly appreciated since its arrival from the Tien Shan Mountains in the eleventh century. Although the tulip is not wild simply because its origins lie in Turkey and farther east, this fact would no doubt only aid its figuring as wild for Kant, and it appears to retain for him some kind of mingled exotic and wild signature. Of course, Kant himself could have seen a tulip in Königsberg, and it would thus not have been a wild flower such as that he invokes in the third *Critique*. Even so, Kant's tulip arguably does not come from nature anyway, but, as Derrida suggests, from another text: "there is every reason for presuming that it does not come [directly] from nature. From another text, rather." As a likely source, Derrida cites a passage from *Voyages dans les Alpes* (1779–86) by Horace-Bénédict de Saussure (whom Kant cites approvingly elsewhere in the third *Critique*): "I found, in the woods above the hermitage, the wild tulip [*la tulipe sauvage*], which I had never seen before." Whether or not the tulip found by Saussure was wild—there were in fact two anomalous wild varieties known to exist in the area of Savoy; indeed, whether or not Kant's tulip comes from nature or from another text—what remains crucial for Kant is the figure of the wild as exotic and unknown: "it is extremely important," Derrida notes, "that Kant's tulip should nevertheless be natural, absolutely wild [*naturelle, absolument sauvage*]. . . . Kant always seeks in it the index of a natural beauty, utterly wild [*l'indice d'une beauté naturelle, toute sauvage*], in which the *without-end* or the *without-concept* of finality is revealed."[18]

Savage Ornamentation

With the fourth example, Kant articulates his recurring interest in wild flora (what Derrida calls his "paradigmatique de la fleur") with an ethnological understanding of the savage:

For himself alone a human being abandoned on a desert island
would not adorn either his hut or himself, nor seek out or still less
plant flowers in order to decorate himself; rather, only in society
does it occur to him to be not merely a human being [nicht bloß
Mensch] but also, in his own way, a refined human being [ein
feiner Mensch zu sein] (the beginning of civilization): for this is
how we judge someone who is inclined to communicate his
pleasure to others [andern mitzutheilen geneigt] and is skilled at it,
and who is not content with an object if he cannot feel his satisfac-
tion in it in community with others [in Gemeinschaft mit andern].
Further, each expects and requires of everyone else a regard to
universal communication, as if from an original contract [einem
ursprünglichen Vertrage] dictated by humanity itself; and thus, at
first to be sure only charms, e.g., colors for painting oneself
(roucou among the Caribs and cinnabar among the Iroquois), or
flowers, mussel shells, beautifully colored birds' feather, but with
time also beautiful forms [mit der Zeit aber auch schöne Formen]
(as on canoes, clothes, etc.) that do not in themselves provide any
gratification, i.e., satisfaction of enjoyment, become important in
society and combined with great interest, until finally civilization
that has reached the highest point makes of this almost the chief
work of refined inclination [der verfeinerten Neigung], and sensa-
tions have value only to the extent that they may be universally
communicated; at that point, even though the pleasure that each
has in such an object is merely inconsiderable and has in itself
no noticeable interest, nevertheless the idea of its universal
communicability [die Idee von ihrer allgemeinen Mittheilbarkeit]
almost infinitely increases its value.[19]

The example of body decoration differs from that of the Sumatran jungle
and the tulip as it illustrates the first stages of socialization, not the abso-
lutely wild. Recalling eighteenth-century theories on the origins of lan-
guage—decoration entails being inclined (geneigt) to communicate or
share with others (andern mitzutheilen)—Kant situates bodily adornment
on the cusp of the wild and the social. It occurs once a relation to others is
established.[20]

Most important, Kant's reference to Carib and Iroquois body painting
reframes his earlier mention of the tattooed New Zealanders. It places

them within an ethnological, developmental structure, as Kant aligns the initial act of decorating oneself with "the beginning [*der Anfang*] of civilization," when one wants "to be not merely a human being [*nicht bloß Mensch*] but also . . . a refined human being [*ein feiner Mensch zu sein*]." The wider literature on tattooing commonly views the advent of permanent skin marking as subsequent to that of body painting. Placed on a progressive scale, it represents a further stage of development. Accordingly, those who have addressed the origins of Maori facial tattooing locate the reason for its first use in a desire to make indelible the designs once only painted on the face, a desire whose fulfillment required a technology not previously needed.[21] In Kant's terms, tattooing would be on level with direct bodily ornamentation (body painting, flowers, shells), although the intricacy of Maori facial tattooing presents the explicit manipulating of forms that he associates with nondirect decorative practices. The New Zealanders would therefore be situated between what Kant considers civilization's first attempts at articulation and the developments "with time [*mit der Zeit*]" leading to beautiful forms applied to separable, constructed body decorations such as clothes. For Kant, once adornment upon detachable objects becomes possible civilization can begin heading toward its "highest point." Yet an insistent, dominant quality binds tattooing and body painting, making them symptomatic of early social forms: their nondetachability from the human. They remain between wildness and civility.

The New Zealanders' Tattooing

I have established, on the one hand, the uncertainty that inheres in Kant's mention of the tattooed New Zealanders, and, on the other hand, the central role of the wild in Kant's Critical aesthetics. The latter highlighted a certain ethnological understanding at work in the third *Critique*, within which the New Zealanders with their tattooing appear to be departing from an absolutely savage condition. However, while the tattoos' permanence would indicate that the New Zealanders are moving out of the savage state, the tattoos' lack of detachability from the human would suggest that they are not moving far from that state. As we will see, the question of detachability proves central to understanding the full force of Kant's reference to Maori facial tattooing. First we will have to consider the New Zealanders and their tattooing more closely. It will help, before moving on to examine the force of this particular example in the third *Critique*, to ask

why this example is chosen, rather than any number of other possible fig-
ures of savage adornment.

Perhaps the first thing to note about the tattooed New Zealanders is
that, historically speaking, Kant's example could claim a certain novelty.
Only after Cook's first voyage (1768–71) does specific knowledge of New
Zealand Maori and their tattooing become available in Europe. H. G.
Robley, in his foundational work *Moko; or Maori Tattooing* of 1896, puts
the development in quasi-biblical terms: "Captain Cook and the *Endeav-
our* returned to England in June, 1771, and then it was that the subject of
this book became known." Also after Cook's return, images of the South
Pacific and its inhabitants began to circulate widely in Europe. One image
occupied a privileged position: *Portrait of a New Zealand Man* by Syd-
ney Parkinson, the artist on Cook's first voyage. Parkinson produced two
versions of the *Portrait,* the most famous portraying a facial tattoo with a
puhoro design, the other with a *moko* design (Figures 3 and 4 respectively).
Bernard Smith notes of them, "Engraved and re-engraved, published and
re-published from Cook's time to our own day, they have become the
visual archetypes of the Maori warrior." Anthropologist Nicholas Thomas
goes further, suggesting that the puhoro version is "probably the single most
extensively reproduced image from the entire visual archive of eighteenth-
century exploration." Both are included in John Hawkesworth's *An Account
of the Voyages Undertaken by the Order of his Present Majesty for making
Discoveries in the Southern Hemisphere* (1773), which Kant may have read
in one of several German translations.[22]

The exemplary status of Parkinson's images goes some way toward
suggesting why Kant cites Maori tattooing rather than, say, Tahitian or
Marquesan—or even Amerindian tattooing, images of which, including
facial tattooing, had been available in Europe for some time.[23] However,
something else helps explain why Kant situates them, as he does, in rela-
tion to beauty ("could be beautified . . ."). Of all Pacific tattooing, that of
the Maori was most typically cited as beautiful or at least in some way
artistic, and precisely for the reasons Kant refers to it: the fine, curved
lines. Georg Forster, for example, in his 1777 account of his travels on
Cook's second voyage (1772–75), *A Voyage Round the World,* refers to
most Polynesian tattooing as "blotches" and "black strips," in marked con-
trast to his description of Maori tattooing as "spirals and curve lines." The
first European to write of the beauty of Maori tattooing, Joseph Banks, the
botanist on Cook's first voyage and the first English aristocrat to bear a

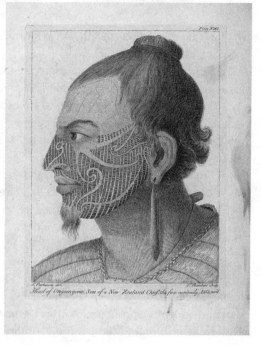

FIGURE 3. "Head of Otegoongoon, son of a New Zealand Chief, the face curiously tataow'd." An engraving from Sydney Parkinson's drawing of a Maori chief's son with *puhoro* design tattooing, as included in John Hawkesworth's *An Account of the Voyages Undertaken by the Order of his Present Majesty for making Discoveries in the Southern Hemisphere* (1773). From the James Ford Bell Library, University of Minnesota, Minneapolis.

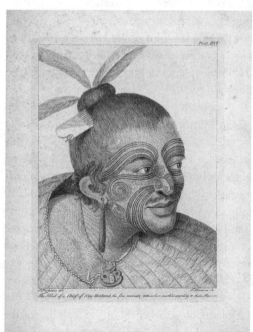

FIGURE 4. "The Head of a Chief of New Zealand, the face curiously tataowd, or mark'd, according to their Manner." An engraving from Sydney Parkinson's drawing of a Maori chief with moko (facial tattooing), as included in Hawkesworth's *Account of the Voyages.* From the James Ford Bell Library, University of Minnesota, Minneapolis.

Polynesian tattoo (Tahitian), notes the discrepancy Kant would invoke between the perceived beauty of the lines and their lack of beauty in being on the face:

> Both sexes stain themselves with the colour of black in the same manner and som[e]thing in the same method as the South Sea Islanders, introducing it under the skin by a sharp instrument furnish'd with many teeth. . . . The men . . . seem to add to their quantity every Year of their lives so that some of the Elder were almost covered with it. There [sic] faces are the most remarkable, on them they by some art unknown to me dig furrows in their faces a line deep at least and as broad, the edges of which are often again indented and most perfectly black. . . . Yet ugly as this certainly looks it is impossible to avoid admiring the immence Elegance and Justness of the figures in which it is form'd, which in the face is always different spirals, upon the body generaly different figures resembling something the foliages of old Chasing upon gold or silver; all these finished with a masterly taste and execution.

Clearly Banks is not making a judgment on the beautiful in Kant's terms; he does not have a disinterested relation to the object in question. His statement shows the two worlds of thought that Bernard Smith suggests Banks inhabits throughout his life. First is "the world of science," exhibiting the naturalist's eye by implicitly viewing the process of tattoo accumulation as akin to the adding of rings in a tree's growth ("The men . . . seem to add to their quantity every Year of their lives"); and second is "the world of taste," expressing a connoisseur's appreciation of figure and technique. Importantly, Banks's comments indicate that Kant ties into the third *Critique* a topical example in terms roughly similar to those with which it was first recorded by a European, that is, as lines potentially beautiful, though not so on the human face.[24]

Somewhat unique is Kant's use of a German equivalent for *tattooing* ("wie die Neuseeländer mit ihrem Tettawiren thun"). The word is new to Europe. Of the many things collected on Cook's several South Seas voyages was the word *tattoo*, from the Tahitian *tattow* (also rendered *tattaw* and *tatu*), thought to be an onomatopoeic rendering of the tapping of the tattooing implements. Variants were common throughout much of the

South Pacific, yet despite the previous voyages of Dampier, Anson, and Wallis, among others, Cook and Banks were the first Europeans to note the term that would become the generalized one used to name the phenomenon. The newness of this word to European languages is apparent in its unsettled orthography. In German, for example, *tättowirten, tätuieren,* and *tatuieren,* among other variations, were used until *tätowieren* became the standardized term. Moreover, throughout the late eighteenth century and into the nineteenth, *tattoo* in any form remains an uncommon word. *Punctures, holes,* or simply *marks,* and their various European-language equivalents, were the terms typically used. Georg Forster, for example, used *punctirt* in the 1784 German version of his *Voyage Round the World.*[25]

So we might say that Kant opens his text to the foreign. He translates a Polynesian word still recognized as such into the text of philosophy. This may indicate a greater sensitivity or desire for accuracy on his part, naming a Polynesian phenomenon with the appropriate Polynesian word. As it happens, *tattow* and its variants are not found in the Maori language. Thus George Lillie Craik observes in an early book-length account of New Zealand, "The term tattoo is not known in New Zealand, the name given to the marks, which are elsewhere so called, being in this country *Moko.*"[26] As Craik points out, moko refers to what we would call tattooing generally, though we should note that it can be used to name facial tattooing specifically or a certain style of tattoo design. In any case, tattoo was not used. It is in this way ironic that New Zealand will become, in the nineteenth century, most closely associated with tattooing tout court.[27] Yet Banks for one had immediately noted the different Maori term, writing in his *Endeavour Journal* that the New Zealanders call their facial markings *Amoco.*[28]

Both Banks and Craik were aware that the misapplication in question was not simply a case of using a different name to designate the same practice. Banks signals moko's uniqueness in the passage cited above from his *Journal.* Banks clearly comprehends conventional tattooing methods ("introducing [pigment] under the skin by a sharp instrument furnish'd with many teeth") and sees that Maori use such techniques in their bodily tattooing. But when it comes to facial tattooing, Banks is confounded: "they by some art unknown to me dig furrows in their faces." What escapes Banks's understanding was the use of a different kind of implement. Rather than what is sometimes referred to as a pricker (what Banks calls an "instrument furnish'd with teeth"), to get the furrow effect, a chisel-like

implement *(uhi)* is used. Driving the difference of facial moko home, Craik notes that the "chisel is sometimes nearly a quarter of an inch broad." Using a chisel involves techniques, and produces results, radically different to those of the skin puncturing tattoo practices common throughout Polynesia. As H. Ling Roth describes the contrasting outcomes, "instead of the series of fine holes, dots under a smooth skin, the result was a series of continuous shallow grooves said to have been deep enough to bed a pin in. In this operation, therefore, in which pigment was likewise used, the margins of the wounds inflicted did not heal evenly with the surface of the skin."[29]

Kant's no doubt inadvertent misuse of terms yokes this foreign (albeit Germanized) word, *Tettawiren,* to a context to which it is foreign. The act of context-breaking conflation, of course, connects the third *Critique* to a wider history of exoticism and European aesthetics. As Bernard Smith writes, "A central function of the exotic [in aesthetics] is to conflate and reduce those diversities [of the non-European] into an exotic polarity that may be conveniently opposed, in a geographical sense, to the beautiful. The exotic is thus the spatial antinome of the beautiful."[30] We might say that Kant's yoking of a foreign word to a doubly foreign context sets up a "spatial antinome" in the third *Critique.* The exotic New Zealanders and their tattooing come to mark a limit to free beauty so that a geographical difference countersigns an aesthetic demarcation. Yet Smith himself quickly complicates the polarity he identifies, noting that the exotic in aesthetics is not simply the foreign:

> The sense in which exotic, as when we speak of an exotic plant
> or animal, simply means foreign is not helpful in understanding it
> as an aesthetic category or an aesthetic genre. An exotic plant
> originates in a non-European place. The exotic as aesthetic
> category or aesthetic genre originates in Europe, or at least in the
> European mind when it is seeking to perceive and understand
> the non-European. In this sense the exotic is an essential part of
> the parent culture: a hybrid construction from a vision of the
> non-European. Consider Chinoiserie, Japanisme, orientalism.
> It is a fantasy bridge between the homely and the foreign. (10)

Smith's sense of an exoticism on the inside that leads out as a bridge to the foreign posits the exotic as at once an "essential part of the parent culture"

that nonetheless extends out from the culture. The exotic is a paradoxi-
cally excessive "essential part" of the parent culture's boundaries.

Smith suggests one way we could establish a certain contextual dimen-
sion to Kant's mention of Maori facial tattooing, a way that shows how
aesthetics, in citing exotic figures, betrays a common ambivalence of place-
ment. We can begin to see the particular pertinence of Smith's formula-
tion for our understanding of Kant by attending to the important role
the notion of a bridge plays in the third *Critique*. Although Kant does not
call upon the idea of the bridge directly in Smith's terms, he uses it, like
Smith, to figure the linking of two disjointed entities. The task Kant sets
himself in writing the third *Critique* is, he says, "to throw a bridge" over
(eine Brücke . . . hinüberzuschlagen) "the great chasm" or "incalculable gulf"
(die große Kluft, unübersehbare Kluft) that, as noted above, he believed
the first two Critiques had opened in philosophy.[31] By way of the faculty
of judgment and the correspondent idea of a regulative purposiveness,
the third *Critique* is to complete Kant's Critical system by providing the
means of transition *(Übergang)* between the two divided and as yet un-
aligned faculties of cognition and of desire. Kant contends that pure judg-
ments of taste, judgments founded on an a priori "purposiveness with-
out purpose," provide the grounds of transition between the theoretical
and the practical. Kant is speaking here at the broadest level, that of the
architectonics not only of the third *Critique* but of his entire Critical Phi-
losophy, which indicates the crucial importance for him of establishing
the coherence of what he calls a pure judgment of taste. Hence the signifi-
cance of the tattooed New Zealanders, whom Kant cites to determine a
limit to pure judgment by isolating it from impure judgment.

Like "a fantasy bridge between the homely and the foreign," Kant
deploys the New Zealanders to exceed and remark a boundary. Unlike
Smith's bridge, at home in an apparently stable "parent culture," Kant's
bridge attempts to span an abyss—an abyss, moreover, whose edges are as
yet unaligned. The New Zealanders are called upon, as it were, to cut a
limit in the void and thereby establish a platform for certain rules that, as
Derrida puts it, "contraignent la logique de l'abîme."[32] It is here that Kant's
ethnology returns. As figures whose existence is set by the ineluctable pro-
cedures of humanity's development, the New Zealanders provide a stabil-
ity of reference otherwise missing in the abyssal aspect of mere form and
pure judgment. Now we know this example has proved obscure and recal-
citrant to interpretation, and that Kant even seems to inscribe a certain

ambiguity into his presentation of the New Zealanders. If Kant really was looking to do what I am suggesting, might he not have found a less ambiguous example? The answer to this question resides in the fact that the stability they supply hinges more or less on one quality thought to belong to them: that their tattoos are nondetachable. The tattooed New Zealanders mean what they do for Kant because their tattoos are *on*—or even *in*—the human face.

Tattoos, Detachable and Nondetachable

European accounts of Maori facial tattooing suggest a common impression of inscrutability. The tattoos, taken to harbor some deeper significance, turn and retreat from comprehension. As we have seen, *Amoco* clearly impressed and perplexed Joseph Banks ("There [sic] faces are the most remarkable, on them they by some art unknown to me dig furrows in their faces a line deep at least and as broad, the edges of which are often again indented and most perfectly black"). Those following Banks describe moko in similar terms, though with an emphasis less on technique than on the lines' possible significance or meaning. Thus Edward Tregear, cofounder of the Polynesian Society and author of the important *Maori–Polynesian Comparative Dictionary* (1891), writes late in the nineteenth century: "I do not think there is any mark distinguishing tribes, still we do not know everything (probably never will) about the full significance of tattau."[33]

The purpose of Maori facial adornment does not confound Kant—or rather, he knows what it means vis-à-vis a judgment on the beautiful. That meaning requires one to see the tattooing as inseparable from the context of the face. As we have seen, for Kant the tattooed face forms a kind of second-order faciality that includes the face itself as grounds and ends of inscription. Common sense suggests he is not wrong: with their holes for the eyes and mouth and their symmetrical arrangement on a facial distribution, moko designs clearly remark the face. Moreover, tattoos of any kind become part of the skin. To remove a tattoo one would need to flay the flesh, taking the skin with the tattoo in an act that only reinforces our awareness of its nondetachability.

However, one might be tempted, contra Kant, to insist that a tattoo is structured by a potential detachability. One might, for example, claim tattooing as a mode of mythographic writing following Rousseau's suggestion, in the *Essai sur l'origine des langues*, that "La première manière

d'écrire" is the depicting (*peindre*) of "les objets même" directly (Mexican) or "par des figures allégoriques" (Egyptian).[34] As mythographic writing a tattoo would remark a detachment from an object or concept to which it in some way referred—a face, a person, a tribe, a cosmology. Historically, we find early nineteenth-century cases of Maori chiefs signing documents by copying the respective pattern of their moko. Samuel Marsden, the influential early missionary to New Zealand, describes one such example, from a land sale at Rangee Ho in February 1815: "The chief has signed the grant in a manner extremely curious and perfectly original. He has displayed the ingenuity which is characteristic of his countrymen, in a minute and laborious copy of the tattooed lines upon his own face." Here a Maori facial tattoo does, as Kant says, represent a man, but it does so precisely in its capacity as re-mark, detached and repeatable in the absence of the respective signatory. Less verifiably, Richard Taylor, who served in the Church Missionary Society under Samuel Marsden, tells of a use of moko as writing in a highly conventional sense:

> The Maori used a kind of hieroglyphic or symbolical way of communication. Thus a chief inviting another to join in a war party sent a tattooed potato and a fig of tobacco bound up together; which was interpreted to mean by the tattoo that the enemy was a Maori, and not European, and by the tobacco that it represented smoke; the other chief, on receiving the missive, roasted the one (the potato) and ate it, and smoked the other (the tobacco) to show he accepted the invitation and would join him with his guns and powder.

What Taylor describes is possible in the sense that one could carve a moko pattern into a potato and have it look like its original in its furrowed quality—and in a way that one could not using conventional tattooing techniques, which involve a puncturing and inking action difficult to perform on a potato. While tattooing requires the elastic qualities of human skin that leave it intact, moko treats the skin in a radically different way. Indeed, as technique, moko's carving brings it close to late eighteenth-century engraving techniques: by inking its groves and pressing a sheet of paper to it, one could replicate the very technique used to disseminate the image of the tattooed New Zealanders throughout late eighteenth-century Europe ("engraved and re-engraved," as Smith put it). Samuel

Johnson beings all this close to writing, too, when, in his *Dictionary* (1755), he defines *to write* as "To express by means of letters," but also "To engrave; to impress."[35]

And yet if one hopes to question Kant's insistence on a tattoo's non-detachability, and therefore his confidence in knowing what Maori facial adornment means for a judgment on the beautiful, treating a tattoo as something that has been written—whether as mythographic (representational) or as technique (engraved)—will not get one very far. Kant effectively answers such an objection in advance. By aligning tattooing with the written we would simply align it with what Kant calls the *mechanical* as opposed to the *beautiful* arts: a tattoo is the product of a *doing* with a purpose (which he glosses *facere*, while he calls the beautiful arts a *making* or *agere*).[36] Understood as being written, a tattoo would present as one aspect of its end precisely its *having been written* on the body. In addition, as marked by the intentionality of a deliberately written work, one would suppose it to posses a legible meaning, even if no meaning was readily apparent. Clearly not of the order of a natural patterning, tattooing gives itself to be read more like hieroglyphics than coffee grounds.[37] All this holds moko right where Kant put it when he said the tattooed New Zealanders could not give rise to a judgment of pure taste on the grounds that such a judgment must involve no perception of an end *(Zweck)*. We have just switched that end from a concept of the human to a concept of writing as a mechanical art.

What we need to do is return to the context in which Kant considers the tattoos. Because Kant does not address tattooing in the context of the mechanical arts, it does not help to try and put it there for him. Kant's concern lies with a judgment on the beautiful, and a judgment on the beautiful includes no reference to an object's conditions of production: "In order to decide whether or not something is beautiful, we do not relate the representation *[Vorstellung]* by means of understanding to the object for cognition, but rather relate it by means of the imagination . . . to the subject and its feeling *[Gefühl]* of pleasure or displeasure."[38] The context, then, in which Kant considers tattooing is one that assumes a face-to-face, and thus subjective, engagement with tattoos.

As such, the context recalls less a mechanical art like writing and more the ethnographic understanding of its object's speech that Michel de Certeau traces from Jean de Léry in the sixteenth century to Lévi-Strauss in the twentieth: "speech does not part from the place of its production *[le lieu*

de sa production]. In other words, *the signifier is not detachable* [n'est pas détachable] *from the body*, individual or collective. It is therefore not exportable." Moreover, de Certeau notes a complementary understanding of writing which suggests enough of a difference between it and tattooing to align the latter with speech: "So that writing can function at a great distance [*au loin*], it is necessary that, from its distance, it maintain intact its relation to the place of production [*son rapport au lieu producteur*]." As *au lieu producteur* can suggest not simply a "place of production" but a "producing place or agent," de Certeau implies that writing's intentional structure requires that a written mark reference an originating source or moment. Without this referral, the written mark points up no characteristic gain and expansion in space or time ("To this writing that invades space and capitalizes time, is opposed the speech which does not go far and which retains nothing"). Accordingly, tattooing would not in fact operate as writing; it is not detachable from its origin, being always stuck in place. It would be closer to that speech which, in the absence of writing, constitutes, for Léry, Rousseau, and Lévi-Strauss, among others, *l'espace de l'autre* as one of *oralité*.[39]

However, once we turn to properly consider tattooing within the context in which Kant engages it, another possibility presents itself. Tattooing will appear not as something that has been written but something that presents, in the midst of the speech situation, an active force of writing. Alfred Gell points the way in his history of Polynesian tattooing when, in unacknowledged Kantian terms, he suggests that moko means nothing at all. Unlike much Polynesian tattooing, which tends to have strong political and cosmological elements, moko, he says, "affords few such easy insights into deeper meanings." "The problem, or non-problem, of Maori moko is that here we seem to be confronted by an art which is nothing but art, and which only succeeds in impressing, terrifying, or seducing the onlooker by the unmediated presentation of sheer form. The strategy of moko rejects metaphorical allusiveness in favour of a direct, almost physiological, assault on sensibility."[40] Belying a greater semantic content, moko's "sheer form" works to *impress, terrify, seduce*; it operates an overwhelming force such that the subject (viewer) no longer exhibits intentionality toward the object (moko) but the reverse. The reversal draws moko closer to aesthetic than rational judgment, presenting an intentional structure that forecloses any cognitive relation of representation to object; instead, the representation works on the subject and her imagination.

I am suggesting, then, that moko crucially displaces rather than reduces an inscriptive moment. It inserts writing into the face-to-face situation (Gell's "unmediated presentation") characteristic of speech: moko appears as an impression upon the onlooker, as if itself a stylus writing on the sensorium. Yet by turning to the figure of *the act of writing*, we disavow the very displacement we name. The trope of conventional writing posits a cognizability that returns moko to a judgment on the object, one conceived again as the product of the mechanical arts. More properly, moko—in its reception historically and, as I will show, in Kant's text—presents a singular force that escapes attributions of meaning (failing, for example, to take the figure of the act of writing) and troubling cognition such that what de Certeau points to as the necessary "rapport au lieu producteur" is lost—or perhaps worse, threatens to become a relation of alterity in place of (*au lieu*) the *producteur*. Formulated thus, moko does not present a form of speech's extension, as if a modal supplement to the latter (either inside or outside the speech situation). Neither invading space nor capitalizing time, it would instead force a rethinking of the anchoring place of production that provides the measure for expansion or gain. Though moko puts the producing place in abeyance, it neither becomes static nor absolutely does away with what it undermines: it maintains the producing place in a certain way, and in so doing alters it. The question becomes whether this plays out in the third *Critique*. I suggest it does, and the answer brings us to the parergonal. The latter articulates a doubled logic that illuminates the role of moko in the *Critique of Judgment*, with notable implications for our understanding of the text.

The Parergonal Tendency

Kant adds the word *parerga* to the second edition of the *Critique of Judgment*, published in 1793. The word serves as a gloss on *"ornaments* [Zierathen]*,"* conferring to that common term what Derrida calls "une dignité quasi conceptuelle."[41] Kant defines a parergon as "that which is not internal to the entire representation *[Vorstellung]* of the object as a constituent *[Bestandstück innerlich]*, but only belongs to it externally *[äußerlich]* as an addendum and augments the satisfaction of taste *[Wohlgefallen des Geschmacks]*."[42] A parergon is beside the work *(ergon)*, with the work defined as the object of a subjective representation capable of giving rise to a pure judgment of taste. For a particular sensation to remain pure and thus a judgment on the

beautiful to remain possible, the uniformity of that particular sensation must not be "disturbed and interrupted by any foreign sensation [*fremdartige Empfindung*]" (224). Keeping its distance from the work's interior, a parergon presents no force of insurgency such that it would introduce a "foreign sensation." The three examples Kant gives of parerga—"the borders of paintings, draperies on statues, or colonnades around magnificent buildings"—touch but do not cross into the work proper (226). The point where work and paragon touch is as much a holding apart that preserves the work's integrity as it is a bringing together.

Parerga are not the only kind of ornamentation that Kant considers. They are, though, the good kind of ornamentation: they introduce no "foreign sensation" and thus only augment the satisfaction of taste. Over-against parerga Kant cites "charms [*Reize*]," whose very name connotes a gratification at odds with disinterestedness. A taste dependent on charms remains, Kant says, *barbarisch* (§13, p. 223). Those of such taste, satisfied simply with the pleasant (*das Angenehme*), would include the Caribs and Iroquois who decorate themselves directly and who are yet to reach civilization's highest point, with its higher appreciation of the beautiful. But more than this, charms themselves are hazardous. To suppose that charms merely heighten beauty is, Kant suggests, a common mistake. Certainly charms can be useful, Kant notes, when it is a case of presenting the beautiful to a taste "still crude and unpracticed [*roh und ungeübt*]." Charms can help to draw the viewer's attention to what is properly beautiful. But charms necessarily present a sensation alien to pure judgment, a sensation that poses a grave danger to true beauty, for rather than just stand beside the work, charms can threaten to displace it. As Kant puts it, charms cause injury to judgment "if they attract [*ziehen*] attention to themselves as grounds for the judging of beauty [*als Beurtheilungsgründe der Schönheit*]." By distracting the subject, such upstart charms pervert judgment. They take the place of the work in an act of substitution that for Kant carries injurious force (*Abbruch thun*). Hence one must be cautious of charms and admit them "as foreigners [*als Fremdlinge*], only to the extent that they do not disturb that beautiful form [*schöne Form nicht stören*]" (§14, p. 225). Charms must be permitted, as it were, only with an authorized visa that remarks at all times their alien status and that can be revoked leading to their expulsion if they threaten usurpation of the work's domestic domain.

Parerga present no such problems. Giving rise to no pleasure (*Lust*), arousing no particular interest, they do not lead the subject away from but

only toward what is properly beautiful. A parergon works, Kant says, by "awakening and sustaining attention to the object itself... *only through its form*" (§14, p. 226; my emphasis). Elsewhere Kant expressly aligns parerga with a certainty that belies any deception. In *The Metaphysics of Morals* (1797), he introduces the qualities of reciprocity that one must cultivate—"agreeableness, tolerance, mutual love and respect"—and says of them: "These are, indeed, only *externals* [Außenwerke] or by-products [*Beiwerke*] (*parerga*), which give a beautiful [*schönen*] illusion resembling virtue that is also not deceptive since everyone knows how it must to [*sic*] be taken."[43] However, in the third *Critique* certainty gives way. There, parerga are contiguous with and thus outside the work ("not internal to the entire representation of the object as a constituent"), yet nonetheless continuous with it, having mere form only. Accordingly, it will become difficult to determine where the work ends and adornment begins. If parerga are on the outside and yet of the same condition as the work, how do we generate enough difference to tell them apart and so mark the inside from the outside? What stops us from mistaking the one for the other? And if we cannot tell the one from the other, how can the parergon lead us toward the work?

The difficulty of isolating where the work ends and the by-work begins proves especially unsettling in light of the parergon's supposed subordinate status. Standing beside the work, framing, touching, and thus marking the work's beginning and end, the parergon is in the service of the work. And it must keep to its place. It is what the work must not become and vice versa: the work must not become marginal to the place of the work, just as the marginal must not take the place of the work. As we have seen, the unsettling of center–periphery relations is the danger posed by charms. But whereas charms are qualitatively different to the work (that is, they arouse interest and so are not merely formal), the difference of parerga remains unmarked. Moreover, parerga are harder to do without. While charms may or may not be near a work, the *par*-ergonal is always close by: the work requires the by-the-work in order to take (its) place as the work, *in order to be the work*.[44] Ironically, the work's need for a proximate by-work renders the work dependent upon what it must divide itself from. Arriving at itself by way of the parergon's difference, the work becomes adherent to its own subaltern. So parerga start to look like usurping charms incognito. Figured, like charms, as aliens (a parergon is not a constituent, *Bestandstück*), parerga quietly take shape as a potentially far more

dangerous foreign force than charms. Having mere form only they are able to pass as domestic, not quite alien enough for a distinct demarcation as nonconstituent, yet paradoxically, the moment they do appear as non-constituents, they become clearly constitutive in other ways.

Kant turns to the tattooed New Zealanders to illustrate adherent beauty. Right away Kant's use of *adherent* suggests a relation to the parergonal. The subaltern parergon and the merely adherent beauty: with both, it is a question of subordination. There are further connections. Kant discusses both parergon and adherent beauty in the Third Moment of the Analytic of the Beautiful. Recall that Kant imports into the Analytic of the Beautiful the framework of the four moments—quality, quantity, relation, and modality—from his account of logical judgment in the first *Critique*.[45] The Third Moment attends specifically to the relation to ends or purposes (*der Relation der Zwecke*) in judgments of taste. It is here that Kant sets out to show pure taste grounded in what he calls *zweckmäßig ohne Zweck*, "purposiveness without purpose." The Third Moment, he says, leads us to the following definition of the beautiful: "*Schönheit* ist Form der *Zweckmäßigkeit* eines Gegenstandes, sofern sie *ohne Vorstellung eines Zwecks* an ihm wahrgenommen wird" (*Beauty* is the form of the *purposiveness* of an object, insofar as it is perceived in it *without representation of an end*).[46] Kant has in mind two types of end: that supplied either by gratification (as in charms) or by a concept of what an object ought to be (as in the botanist with a concept of "flower"). So on the one hand, we have a pleasure (*Lust*) that draws one into an interested relation, and on the other, we have a moral judgment on the good that also results in an interested relation (one realizes a desire to know what the object is or is not). Parerga are addressed in the context of the former and the tattooed New Zealanders the latter.

The two—parerga and the New Zealanders' tattooing—form opposites of sorts; while parerga do not manifest a purpose, facial tattoos, Kant argues, necessarily do. The tattooed New Zealanders, in this sense, having a purpose, would come closer to charms than parerga. And yet Kant does not invoke the tattooed New Zealanders because they are charming, or even because they might suggest charm. If Kant were to relate them to charms, he would perhaps do so in figuring an apparent rejection of charm as facial tattooing tends to be thought productive of shock rather than attraction. However, Kant summons the New Zealanders and their tattooing to mark adherent beauty because they in fact come so close to free

beauty. His referencing them in this sense a prolepsis. They serve to ward against the misconstruing or even collapsing of an important distinction.

What Kant is warding against is this: the New Zealanders with their ornamental facial tattoos might be thought potentially parergonal—or rather, their tattoos would be: prosthetic, added on ("a figure could *be beautified [verschönern können]*"), and, to the extent they are mere design, could be said to have in themselves form only. Kant's mention of the tattooed New Zealanders follows a series of examples of free beauties to which they bear a striking resemblance. The black lines of the tattoos recall the drawing or design Kant contrasts to the charm of auxiliary colors. "The *charm* of colors . . . can be added, but *drawing [die* Zeichnung] . . . constitute[s] the proper object of the pure judgment of taste *[Geschmacksurtheils].*" What is essential is the drawing "in which what constitutes the ground of all arrangements for taste is not what gratifies in sensation but merely *[bloß]* what pleases through its form *[seine Form gefällt]*" (§14, p. 225). Moreover, the New Zealanders' tattoos come close to such "free beauties" as the "foliage for borders or on wallpaper, etc." that "signify nothing by themselves: they do not represent *[stellen]* anything, no object under a determinate concept *[bestimmten Begriffe]*" (§16, p. 229). Let us not forget too that the visual image of the tattooed New Zealanders circulating in Europe in the form of engravings (à la moko) present the variety *(allerlei)* of their "curlicues and light but regular lines" in a way that looks like foliage design. The New Zealanders' difference needs remarking.

What makes the difference for Kant is that the object adorned is a human being. Having established in §14 that a pure judgment of taste cannot be combined with the pleasant, here, in §16, Kant argues that a judgment of free beauty occurs only in the absence of the damage *(Abbruch)* that would be done it if the object was found to "stand under the concept of a particular end." Thus Kant suggests there can be no free human, equine, or architectural beauty, for they each "setzt einen Begriff vom Zwecke voraus, welcher bestimmt, was das Ding sein soll, mithin einen Begriff seiner Vollkommenheit, und ist also bloß adhärirende Schönheit" (put in advance a concept of the end that determines what the thing is or should be, hence a concept of its perfection, and is thus merely adherent beauty).[47] One may wonder why Kant decides that these three objects in particular—humans, horses, and buildings—put a concept of their own end in advance of a subjective judgment upon them. The answer is that, as with the tulip, Kant does not seem to be proceeding on the basis of any

empirical encounter with humans, horses, and buildings—not because he is especially wrong about either, but because the examples and what they exemplify come from another text: "For what each thing is when fully developed, we call its nature, whether we are speaking of a man, a horse, or a building [ἄνθρωπος ἵππος οἰκία]. Besides, the final cause and end of a thing is the best."[48]

Kant's concern in §16 is not, as is Aristotle's in the *Politics,* with the nature of human political organization as embodied in the state. Nor is it with teleological judgment. Kant is trying to think through a properly aesthetic judgment which for him requires that one differentiate free from adherent beauty on the grounds that the later has a relation to a concept that has an unavoidable reference to an end *(Zwecke).* The adherent beauty exists, as it were, in relation *au lieu producteur:*

> There are two kinds of beauty: free beauty *(pulchritudo vaga)* or merely adherent beauty *(pulchritudo adhaerens).* The first puts in advance no concept of what the object ought to be *[setzt keinen Begriff von dem voraus, was der Gegenstand sein soll];* the second does put in advance such a concept and the perfection of the object in accordance with it *[setzt einen solchen und die Vollkommenheit des Gegenstandes nach demselben voraus].* The first are called (self-subsisting) beauties of this or that thing; the latter, as adhering to a concept (conditioned beauty), are ascribed to objects that stand under the concept of a particular end *[die unter dem Begriffe eines besondern Zwecks stehen].*[49]

A "self-subsisting" beauty *(für sich bestehende,* "existing for itself") has a unity missing in a conditioned or qualified beauty *(bedingte Schönheit).* The latter is not only itself. Standing under (that is, subject to) a concept of perfection *(Vollkommenheit),* the conditioned beauty bears a necessary reference beyond itself to "the concept of a particular end *[eines besondern Zwecks]."* For Kant, the adherent beauty's necessary reference beyond itself introduces a "foreign sensation" into the judgment of that object. The judgment is no longer a pure judgment. Specifically, the "foreign sensation" displaces the grounds of a reflexive subjective judgment because it establishes a corollary cognitive relation that forecloses on the free play of the imagination and the understanding. The understanding comes to fix the imagination in relation to a determinate cognition: this is what the

object ought to be. In the case of any subjective judgment upon a human being, then, the human will be marked by its deferral to a concept, "put in advance," of "what the object ought to be."

A point of clarification is required. If the object's standing under a concept results in a damage that prevents a judgment of free beauty, how do we know when a beauty is not damaged? By requiring an absence of damage *(Abbruch)*, such as results from an object's adherence to a concept, a free beauty would itself assume in advance the decision that there has been no such infraction. Supposedly subject to no determinate judgment and so beyond law, the beautiful will have had posed first of all a question of law; that is, has a damage been done? Yet for Kant, a judgment of free beauty takes place beyond moral law.

The required clarification initially follows from Kant's claim that something adheres to objects like the human, the horse, and the building that gets in the way of a judgment beyond law. Whereas one *can* go straight to a judgment of free beauty without recognizing a judgment of law, such a judgment will always get in the way when dealing with *these* types of objects. For that reason they can never give rise to a judgment of free beauty; they are at best merely adherent beauties. Each pushes to the forefront its respective attachment to a concept of perfection so that one cannot look at the object without facing the need for a decision of law, the mere fact of which necessities that one come down every time in favor of a negative judgment: this is not a free beauty. To the human, the horse, and the building, the law adheres, and one must always meet with its mediating mark in viewing one of these objects. Because the concept's presence is always put in advance *(setzt . . . voraus)*, a damage will have already been done. A free beauty, in turn, appears a remarkably fragile thing, lost as simply and as quickly as an identification of belonging. Recall that in viewing a tulip one would negate its pure beauty by saying "this is a beautiful *flower,*" an utterance that gives it a generic designation and so sets or puts *(setzt)* it in relation to a concept.

We arrive at a full clarification when we realize that for a free beauty to remain as such the relation to a decision of law must itself remain unknown and unrecognized, as if a decision has taken place without leaving a mark.[50] We should take this "as if" in terms of Kant's purposiveness. That is to say, an object that gives rise to a judgment of pure taste is purposive in its particular preadaptedness to the subjective faculties: a judgment on the beautiful can occur because the object of a representation

disfigures the mark of law that would tie it to an unavoidable determination; a free beauty presents itself immediately *(Anschauen darstellt)*, having no qualifying mark, and so allows "merely the free play of the imagination *[bloß das freie Spiel der Einbildungskraft]*." Kant underscores this formulation in an example-based prolepsis footnoting his definition of the beautiful according to the Third Moment ("Beauty is the form of the purposiveness of an object, insofar as it is perceived in it without representation of an end"):

> It might be adduced as a counterexample to this definition that there are things in which one can see a purposive form *[eine zweckmäßige Form]* without cognizing an end in them *[ohne an ihnen einen Zweck zu erkennen]*, e.g., the stone utensils often excavated from ancient burial mounds, which are equipped with a hole, as if for a handle, which, although they clearly betray by their shape *[ihrer Gestalt]* a purposiveness the end of which one does not know *[eine Zweckmäßigkeit deutlich verrathen, für die man den Zweck nicht kennt]*, are nevertheless not declared to be beautiful on that account. Yet the fact that they are regarded as a work of art *[ein Kunstwerk]* is already enough to require one to admit that one relates their shape *[ihre Figur]* to some sort of intention and to a determinate purpose *[einen bestimmten Zweck]*. Hence there is also no immediate satisfaction at all in their intuition. A flower, by contrast, e.g., a tulip, is held to be beautiful because a certain purposiveness *[eine gewisse Zweckmäßigkeit]* is encountered in our perception of it which, as we judge it, is not related to any end *[keinen Zweck]* at all.[51]

Now, Kant says that the spirals and curved lines of Maori facial tattooing *could (können)* lead to a judgment of beauty "if only *[wenn ... nur]*" the figure so adorned were not a human being. Even worse, if the tattoos were not themselves "supposed to represent *[vorstellen sollte]* a man, or even a warrior [that is, an idealized man]"—and, we might add, if the patterns of moko were not "equipped," like the ancient utensils and their absent handles, with holes that remark the human face. Yet as we have seen, tattooing and moko are repeatable in other contexts, a potential detachability that structures the mark of the tattoo itself. So we might well still ask, given this, why is moko so stuck on the face for Kant, this literal attachment that

precludes their disfiguring of this other mark, that of law? Why are the New Zealanders' tattoos handled, so to speak, in this way? Why can they not simply be bracketed?

The remark of the "handle" Kant assumes for moko is a bracket of sorts, or more specifically a frame. By framing the human face, moko is articulated to a purpose. This frame is one that cannot, it seems, be avoided; the botanist's bracketing of knowledge does not work here. But then the botanist does not merely have one set of brackets. If a botanist came across a tulip and judged it a free beauty, holding in abeyance her knowledge of "what sort of thing a flower is supposed to be," she would behold it bracketed not only from a concept but from an awareness of that bracketing. As the initial brackets themselves testify to the separation they make possible, like the holes in the unearthed utensils, in the moment of a judgment of free beauty one must be, as it were, blind to one's blindness, open only to an immediate intuition. Looking at the flower one must not recognize one's own cognitive bracketing, which would make one see that a logical judgment is structuring one's perception. Given this, it is striking that in his *Logic* (1800) Kant formulates a kind of savage-vision blind to purpose. A wildman or savage , he says, knowing no concept of a house, cannot judge it according to rules of logic that enable a "clear representation *[klaren Vorstellungen]*." The savage returns here to exemplify a purely formal apprehension:

> If a savage *[ein Wilder]* sees a house from a distance, for example, with whose use he is not acquainted *[nicht kennt]*, he admittedly has before him in his representation *[in der Vorstellung vor sich]* the very same object as someone else who is acquainted with it determinately as a dwelling established for men. But as to form, this cognition of one and the same object is different in the two. With the one it is *mere intuition* [bloße Anschauung], with the other it is *intuition* and *concept* at the same time [Anschauung *und* Begriff *zugleich*]. The difference in the form of the cognition rests on a condition that accompanies all cognition, on *consciousness* [Bewußtsein]. If I am conscious of the representation *[der Vorstellung]*, it is *clear* [klar]; if I am not conscious of it, *obscure* [dunkel].[52]

The question becomes why the pattern of a quintessentially savage form of decoration, facial tattooing, cannot be viewed double-blind. The short

answer is that for Kant the human being is nature's ultimate end: "we have sufficient cause to judge [*beurtheilen*] the human being not merely, like any organized being, as a natural end [*als Naturzweck*], but also as the *ultimate end* of nature [letzten *Zweck der Natur*] here on earth, in relation to which all other natural things constitute a system of ends [*ein System von Zwecken*] in accordance with fundamental principles of reason, not, to be sure, for the determining [*bestimmende*] power of judgment, yet for the reflecting power of judgment [*die reflectirende Urtheilskraft*]."⁵³ It would therefore be difficult—Kant says impossible—to detach from a concept of an end something that carries a necessary relation to the human. Yet with the New Zealanders and their tattoos I think we do glimpse a potential concept-detachment, a potential Kant at once signals and closes out. If Maori moko, like the ancient utensils, lack a handle but in some way remark its absence, we might say that the potential I am suggesting results from the difficulty Kant has in getting a good grip on his example. As we will see, in conclusion, the tattooed New Zealanders lead the third *Critique* out from itself, opening it up beyond itself—a *recours anthropologiste* that troubles the logical grounds upon which Kant erects reflexive subjective judgment. What Kant wants to say cannot control his saying. Put differently, the tattooed New Zealanders form an ungoverned repetition in Kant's text, defacing the third *Critique* by re-writing (in) it.

Irony and the Exotic Example

Kant calls upon the tattooed New Zealanders to illustrate a philosophical point about ornamentation: *this* is not beautiful because it violates a certain precept. Like Addison's China, Kant's exotic figure shows something other than what it literally shows. It is, once again, allegorical. More specifically, the tattooed New Zealanders constitute in more than one way a disfigured figure. Kant deploys facial tattooing, itself commonly considered a disfiguration or defacing, as a trope (Maori moko as synecdoche) that is further turned or disfigured as the lines of the tattoos are made to mark both the possibility of a pure judgment of taste (they could be free beauties) and its limits (they are not). But if, as Hegel suggests, figural language possesses a force that works a disturbing magic, interrupting and dispersing ideas by drawing the mind into "something akin and foreign [*Verwandtem und Fremdartigem*]," what does the mobile, turning figure of facial tattooing do to the unifying text of philosophy that is the third *Critique*?⁵⁴

I assume that Kant would want to ensure that his exotic figure properly represents what he wants it to represent. After all, by setting certain limits to aesthetic judgment through the example of the tattooed New Zealanders, Kant is making an apparently superfluous figure central to aesthetic judgment's delimitation. A deviation from purpose by the exotic figure would likewise occasion a deviation from purpose for Kant's argument. Kant may have been aware of the danger—or this at least is the implication that follows from the sense that Kant appears to have been drawn to Maori facial tattooing because it suggests a foreclosure of movement. As permanent markings that form part of the skin and that do not alter over time, the tattoos bar movement both spatially and temporally. Bear in mind that Kant could have furnished his text with numerous other examples, theoretically any decoration of human form but more simply any number of figures from the vast literature on savage adornment familiar to him. He himself cited a couple with his mention of Carib and Iroquois body painting. Yet for Kant's argument, permanent skin markings have an advantage over other forms of bodily decoration. They allow him to pass quietly over the issue of possible detachment in space or alteration over time. It follows that one thing this particular example appears to let him do is pass over the question of writing, even as, ambivalently, moko visibly recalls writing.

Remember that in the ethnographic tradition discussed above, writing was understood as a mechanical art able to invade space and capitalize time. Necessarily separable from its origin or place of production, it is able to work at a distance (it can be read wherever) at various different times (it can be read whenever). Speech, in contrast, manifests in one place and one time, bound to an individual who is speaking, there and then. Tattoos may resemble writing in several ways (visibly, technically), but they too are bound to an individual, this time one who is tattooed. Accordingly, even the savage who leaves the raw, isolated state of nature, and produces permanent decorative markings in a social setting, remains without writing if those markings prove nondetachable, as do tattoos. Hence Kant's ethnographic frame for understanding savage ornamentation binds with the wider ethnographic tradition to secure the tattoos' nondetachability and associated lack of potential movement in space or time. The tattooed savage *sans écriture* exists only here and now—or, viewed with the distance manufactured in writing, there and then. Unable to produce a surplus of time that could generate a sense of time-unfolding as history, he proves barely able to economize on the abyss of mere existence.

Yet Kant cannot strike out beyond the question of writing. What I am calling the tattoos' potential turning, their disfiguring, accompanies the return of a certain writing within the third *Critique*, a writing I would characterize as an ungoverned repetition. This repetition appears on two levels, one empirical, the other theoretical. On the empirical level, the exotic savage, the savage from beyond, from over there, necessarily foregrounds, perhaps even embodies, a certain textual form. The claim is, of course, based on a paradox central to the ethnographic tradition that presumes the savage to have no detachable signs. The savage cannot therefore represent itself at a distance or across time. It has no textual agency. The savage's lack of any long distance or temporally extendable semiotic intention renders the savage repeatable beyond itself only in a necessarily foreign writing predicated on its absence—or better, occlusion—from the scene of writing. The savage is paradoxically marked *in and by* writing because it cannot present itself *in or by* writing. Hence the paradox that an ethnographic tradition that posits the exotic savage as something *to be* represented necessarily never quite arrives at its object: the savage recedes into an order of existence marked as radically distinct from the order of representation bringing the savage into view. To write of the savage, who cannot supply its own detachable signs, means being neither savage nor presenting anything savage as such.

My claim is not that Maori, for example, do not exist or that they have no means of writing. What I am saying is that talk of the savage, such as we find in Kant and the wider ethnographic tradition, operates a temporal and spatial disarticulation of its putative object that disavows an intentional structure of "savage" self-representation—and this disavowal occasions certain problems. The implicit distance that makes the figure of the exotic savage so readily, even essentially, repeatable, gives it a license leaving it difficult to govern. Insofar as a depiction of a savage works apart from direct contradiction by a referent, it also works apart from any guarantee of its own accuracy. The figure of the exotic savage might of necessity have to be taken with a grain of salt.

On the theoretical level, as it turns out, things will start to taste a little salty. First let me make the obvious point that Kant's mention of the tattooed New Zealanders does not reference anyone he saw in Königsberg on one of his famous afternoon walks. We are not dealing with an eyewitness account. As with Kant's mention of the wild tulip, here he recites previous accounts, visual or verbal, and, we might add, anticipates subsequent

ones. Kant's reference to the New Zealanders, like Addison's to *Shara-wadgi*, is structured allegorically in the sense that it refers to something marked as belonging to an entirely incompatible representative order. Kant recites what can never be coterminous with the written sign of its representation; he speaks otherwise of the savage as the savage cannot speak directly, remaining structurally disjoint to the sign that represents it. More clearly than Addison's reference, however, Kant's reference allegorizes not simply specific previous accounts (in Addison's case, Sir William Temple's) but other figurations of savage adornment—that is, a certain diction of invocation. Allegory here involves not only a reciting or referring at the level of content. It includes, even foregrounds, the diction of invocation as a form of repetition: this is how one cites an exotic example. Allegory proves to be a way of reciting that harbors a peculiar force of disfiguration and tropic complexity. Kant's use of the New Zealanders belongs to a mode of address that posits the savage both as a putatively specific ethnic or historical entity and as a trope that undergoes a further turning to remark a certain limit.

Kant himself had argued for a strict control of figural language in philosophy. Once a word goes in two directions (as we saw above with *ver-schönern*), uncertainty can too easily set in and confound cognition. The desire to exclude, as far as is possible, metaphor and other tropes is almost itself a generic trait of philosophical discourse. Kant sets out his own position in a critical assessment of his one-time student Johann Gottfried Herder. There, Kant suggests his one-time student's penchant for figural language may put "allegories" in the place of "truths": "instead of neighbourly excursions from the region of philosophic language into that of poetic language," Herder may be mistakenly disregarding "the limits and provinces of both." Kant then wonders, rhetorically in a discourse against rhetoric, saying yet not saying, "whether the fabric of bold metaphors, poetic images, and mythological allusions does not serve in some instances to conceal the body of thought as under a *farthingale,* instead of making it agreeably visible as if through a transparent garment." The question becomes: does Kant's own use of the exotic savage constitute a farthingale whose concealing action has an attraction akin to that of charms, or a transparent garment that does not divert attention to itself but leads us on to the proper object of consideration?[55]

To grasp the question's force we must first recall the specifically allegorical aspect of Kant's exotic figure. As with Addison, with Kant we are

obviously not dealing with a conventional allegory along the lines of *Piers Plowman* or the *Pilgrim's Progress*. We are dealing with an exotic figure structured by its distance from a referent that, as savage, it can never coalesce with, drawing upon the authority of an ethnographic tradition that asserts the savage's incapacity to represent-at-a-distance. The savage has yet to reach that "highest point" at which the human intentionally produces detachable signs. Crucially, what we are calling the allegorical sign does not form from a split between two separate and respectively homogeneous levels, literal statement and figural meaning. The singularity of Kant's exotic example follows from the temporal disjunction it introduces into the sign itself and that is characteristic of a kind of language we might call literary. More specifically—and here we can recognize the depth of our question as to the role of figural language in the third *Critique*—the allegorical aspect we have located in Kant's tattooed New Zealanders quickly crosses into the register of irony.

The crossing of allegory into the register of irony is not an unusual proposition. Theorists of rhetoric from Quintilian to Northrop Frye note that under certain conditions allegory slides into the salty marshes of irony. When this occurs, the narrative surface is broken. "The whole point of allegory," Angus Fletcher suggests, "is that it does not *need* to be read exegetically; it often has a literal level that makes good enough sense all by itself." Irony shatters that apparent literal level from within. The broken ironic form retains a common allegorical element—it is still a case of saying one thing and meaning another—but the doubled meaning is inscribed in the narration as a breaking within that narration. As Quintilian put it, "it is apparent [in irony] that the intention is different from the expression." The disjunctive relation of statement and intent is somehow marked in the utterance itself. Now, qualitatively, the ironic utterance is like the allegorical sign in being structured by a disarticulation. It is not entirely present to itself. But irony's disjunction is not organized between the allegorical sign and the sign anterior to it that it cannot join. It does not need this spaced-out-time. Irony occurs *as* a breaking of narrative that, putting forth a sudden movement from what one says to what one is saying, opens up what de Man calls a "temporal void." In the place of allegory's "temporal difference"—as de Man says, allegory "establishes its language in the void of [its] temporal difference," that void of perpetual noncoalescence— irony forces open a voiding of temporal unfolding, but not simply to bar time; rather, to shatter it.[56]

With Kant's exotic example the allegorical gives way to an initially inverted version of Friedrich Schlegel's *romantische Ironie*. What intrudes is not the author upon the narration as in a traditional *parabasis,* a direct authorial address within the space of a literary work. The philosophical text already assumes an equivalence of author and narration. Rather, the literary (allegorical) aspect of Kant's example stands out in such a way as to upset the confluence of author and narration. The "rhetorical register," as de Man would say, has been shifted by the interruption of parabasis. Most immediately, the shift is from transcendental deduction to induction by example, but most importantly, from serious philosophical language to figural language.[57]

In Schlegel's terms, the kind of a shift in register I am suggesting that we find in Kant dislocates judgment to produce a strong sense of becoming dizzy *(schwindlicht)*. One loses one's bearings, as one does trying to read Schlegel's ironic definition of irony as a permanent parabasis *(eine permanente Parekbase)*.[58] What does Schlegel mean by putting these two terms together, when the latter *(Parekbase)* suggests a sudden interruption at odds with permanence *(permanente)*? It is precisely such a tension that Schlegel wants to formulate as irony—the tension that arises from not being able to decide between two senses radically at odds. The entailed indecision produces the permanence of an interruption that nonetheless never proves stable enough to be identifiable as only permanent. Irony has, says Schlegel, "incredibly long-lasting aftereffects," a statement he makes in a context that renders it potentially ironic, though one cannot tell for sure: Schlegel injects uncertainty into the statement itself so that it performs what he is saying. The "shift in rhetorical register" does not settle down into a new consistency to form a smooth surface on another level. In de Man's phrase, Schlegel's irony "is unrelieved *vertige.*"[59]

The philosophical text's dependence on the literary has far-reaching implications. The text turns out to be authorized by what Kant argues is only supposed to supplement the proper work and thought of philosophy. In his example of the tattooed New Zealanders, a superfluous figure usurps philosophy's place as a trope delimits aesthetic judgment in a work that is an attempt to delimit aesthetic judgment. Inside the third *Critique,* called to mark a limit, Maori facial tattooing crosses the literary and the philosophical to take the place *(au lieu)* of the *producteur*. Put differently, in the void opened by irony and marked by this chiasmus (the crossing of the literary and the philosophical), the figure of the tattooed savage

introduces a relation of alterity—not, that is, a piece of alterity, an alterity as content or as object (having been written), but an opening, a singular and undetermined relation of (writing without beginning or end).

Let me conclude by underscoring that it is the ironic status of Kant's mention of the tattooed New Zealanders that leads us to recognize their wider parergonal status in the text of the third *Critique*. To delimit the aesthetic Kant turns to this figure as a marker of what cannot give rise to a pure judgment of taste. The figure is literally part of the text, underwriting it, appearing within it, although a little foreign in skirting the properly philosophical, marking an outer limit. At once continuous and discontinuous with the work, the New Zealanders and their tattooing points to an exterior never quite on the outside only, but not wholly inside either—not "a constituent" of pure aesthetic judgment, but nonetheless constitutive in its foreignness. Kant articulates the conditions of possibility for a pure aesthetic judgment through the savage who, silent and occluded, nonetheless addresses us directly, within writing, to give rise to a certain utterance, though only on the basis (or parabasis) of dislocating the authority of the philosopher's voice. In short, the parergonal savage introduces a singularity that prevents its coming to stand only in a restricted economy of synecdochic relations. *It writes.*

III

AESTHETIC FORMATIONS
OF HISTORY

· CHAPTER 6 ·

Adding History to a Footprint in
Robinson Crusoe

W E HAVE SEEN HOW JOSEPH ADDISON and Immanuel Kant each allot
a central place in aesthetic experience to certain unconditioned ele-
ments. For both, the faculty of the imagination is in some sense primitive,
which is to say, original and without predetermined content. To clarify
and delineate what must nonetheless remain unconditioned, to give con-
tour to what is by definition without shape, Addison and Kant call upon
the exotic—a Chinese taste in landscape and Maori facial tattooing
respectively. With this chapter and the next I turn from such attempts to
theorize the aesthetic by way of the exotic, to focus instead on how the
language and logic of aesthetics is used to theorize certain temporal pro-
cesses. We will see the aesthetic deployed to articulate the savage and the
primitive as each are drawn into the sphere of history and its particular
representational requirements, which, among other things, indicates that
the problems that inhere in coherently formulating the aesthetic do not
prevent the use of aesthetic concepts in thinking through other problems.

More concretely, the present chapter addresses Robinson Crusoe's
famous encounter with the solitary footprint of unknown origin, while the
next focuses on the late eighteenth-century and early nineteenth-century
encounter with North American Indian mounds, also of unknown origin.
In each case, the encounter proves to be with something that appears
to push beyond time. At their extreme, each case dramatizes the poten-
tial unhinging of the human and the world as one approaches it through
the senses, the understanding, and the temporal frameworks of historical
knowledge. The respective attempts to suture the human and the world
call upon an aesthetic vocabulary, which ironically, as we have seen, does
not itself necessarily guarantee anthropological security, with crucial im-
plications for our own understanding of the encounter between the Euro-
pean and the New World savage.

To begin this chapter proper, let me recall a curious yet seldom ac-
knowledged aspect of Daniel Defoe's *Life and Strange Surprizing Adventures*

of Robinson Crusoe (1719): the assuaging role it affords actual savages. For much of the novel Crusoe reiterates his fear that cannibal hordes will descend upon him, and yet when such savages finally do arrive on his island, they help relieve him of anxiety. How are we to understand the stakes and the logic of this relief that at moments borders on delight? Insofar as the relief that the savages facilitate occurs shortly after Crusoe's discovery, to his great fright, of a lone footprint in the sand, it would appear to have to something to do with their ability to palliate the fears Crusoe derives from this singular discovery. What I will suggest is that between them, these two episodes—Crusoe's encounter with the footprint and his subsequent response to the arrival of savages—dramatize the advent of what we might call an aesthetic self. That self takes shape through an active overcoming of the perceived threat to its continuance posed by the singular footprint. This overcoming, in lessening the pain that the footprint causes him, produces in Crusoe a sense of relief. As we shall see, the savages enable that sensation and get the aesthetic self going.

As one would expect, the quantity of commentary on Defoe's novel is immense, and a significant measure of that commentary situates the footprint in various contexts. There is no critical consensus on the footprint's provenance. The footprint is also notable for being invoked in the absence of direct discussion of the novel: it continues to turn up unexpectedly, as it does, for example, in Herman Melville's *Typee,* as Tommo and Toby search for the valley of the friendly Happar.[1] The footprint has a certain currency. Able to function widely inside and outside the novel that introduced it, the print is, simply put, iterable, able to be cited and recited much like any other mark. At the same time, as the print of a foot, it would be, strictly speaking, a mark of the order that Peircean semiotics would call indexical. It results directly from and points directly to what made it and of which it is a sign: the foot that pressed into the earth. Accordingly, the footprint would retain a nonarbitrary relation to the sign maker—that is, the foot. Put differently, the footprint would be what seventeenth-century theories of language termed a primitive sign, possessing "the Adamic unity of word and world."[2] Still, there remains in any footprint that potential for iteration and the insertion of a difference that doubles the mark, splitting it at its putative origin: as the foot presses the earth there is already the possibility that the print can be cited and recited. That possibility structures the mark making. Hence one cannot easily tell by looking at any given footprint which foot made it—or indeed, whether it was really the

print of a foot, or a counterfeit. The print may be indexical and it may be primitive but that does not mean that it bears within itself its own indubitable origin. The provenance of a footprint cannot be bound within a secure unity.

Commentary on the novel has tended to assume that the cannibals' arrival provides Crusoe (and so us) with an alibi for the single footprint's otherwise obscure origin. The assumption is that the savages present earthly agents who could have left, and so apparently did leave, the uncertain mark on the shore. The novel itself says nothing of the sort, going beyond any such straightforward explanation to stage a paradigm of sublimity that raises the stakes considerably. Defoe's novel articulates an especially complex logic of the sublime that hinges on the footprint's insistent singularity, that is, its apparent lack of derivation, it nonrepresentational force. For us, comprehending the sublime's complex logic while maintaining the necessary sense of the footprint's singularity will entail recognizing more than one version of sublimity. The novel translates into itself, or makes itself out of, two distinct accounts of the sublime, the first that of Longinus and the second that of Edmund Burke. By recognizing the operation of both versions in the novel we begin to understand the peculiar dynamic involved in Crusoe's attempts to link the primitive print with the local savages. Specifically, we are able to see that Crusoe's transition from a preaesthetic (Longinian) to an aesthetic (Burkean) sublime enables him to regain his firm footing in a temporal world that the singular footprint had put in question.[3]

Strictly speaking, the footprint would appear within the framework of a classic eighteenth-century understanding of the sublime only after Crusoe lessens or at least brackets his anxiety. Otherwise he would experience fear or terror, but not sublimity. Useful here is Thomas Weiskel's well-known analytic of the sublime's three phases. Weiskel aligns the first stage with the "habitual" relation of subject and object that we might call the modern subject's default quotidian existence. If the habitual relation is interrupted or broken up (as happens to Crusoe in encountering the footprint), one then enters upon a second stage wherein conventional relations of subject and object are put in question, a situation resembling what I have been calling a loss of anthropological security. Weiskel's third stage is the one that retroactively constitutes the first two stages as belonging specifically to a sublime experience and not simply to a terrible or disturbing experience. In the third, "reactive" stage, "the mind recovers the balance

of outer and inner by constituting a fresh relation between itself and the object" in a particular way: it establishes a transcendent symbol with which to mediate its relation to the indeterminacy presented in phase two.[4]

As Weiskel indicates by staggering the sublime into three stages, the sublime takes place in time—or perhaps, rather, over time: stage two after stage one, stage three after stage two, with the three stages bound together in close proximity. One, two, three: the sublime. However, things do not follow so readily for Crusoe. Thrown into utter confusion by the footprint, Crusoe does not seem to reach anything like stage three (and therefore sublimity) near the time of his encounter with the footprint. Proximate to his troubling encounter, Crusoe fails to establish the necessary transcendent symbol. So why would I suggest that the sublime plays an important role in the footprint episode? Put simply, what we find in Defoe's novel is a distended sublime, a sublime that takes its time. And it is the distended nature of the sublime in *Robinson Crusoe* ultimately links the footprint and the advent of Crusoe's assuaging savages.

The Untimely Footprint

One could say that the footprint lies at the center of *Robinson Crusoe*. Appearing midway through the novel as well as midway through Crusoe's time on the island, the narrative as it were folds around the print. Here, at the novel's center, is this singular insistence that presents an immense challenge to Crusoe's faculties and his ability to maintain an alignment with the world as he knows it. "It happen'd one Day about Noon," he says,

> going towards my Boat, I was exceedingly surpriz'd with the
> Print of a Man's naked Foot on the Shore, which was very plain
> to be seen in the Sand: I stood like one Thunder-struck, or as if
> I had seen an Apparition; I listen'd, I look'd round me, I could
> hear nothing, nor see any Thing, I went up to a rising Ground to
> look farther, I went up the Shore and down the Shore, but it was
> all one, I could see no other Impression but that one, I went to it
> again to see if there were any more, and to observe if it might not
> be my Fancy; but there was no Room for that, for there was
> exactly the very Print of a Foot, Toes, Heel, and every Part of a
> Foot; how it came thither, I knew not, nor could in the least
> imagine.[5]

Especially troubling for Crusoe is the footprint's obscure origin. A sign in the sand waiting to be deciphered, it is, Shawn Rosenheim notes, "that rare thing, a true hieroglyph: an Adamic sign, marked by the body that produced it."[6] Yet Crusoe finds himself unable to form a determinate judgment on the print's origins. He cannot read from the mark to an individual body, or from the effect to the cause. Between the footprint's Adamic aspect and Crusoe's earthly existence a great gulf opens. Crusoe, long fallen—having departed his "primitive Condition" by rejecting his father's "excellent Advice" to stay at home, "the Opposition to which, was, *as I may call it,* my ORIGINAL SIN"—now wanders alone in his post-lapsarian wilderness: "I kill'd a large Bird that was good to eat," he says, "but I know not what to call it" (194, 73). Crusoe is no Adam in Eden, able to name "every living creature" (Genesis 2.19–20). This the footprint remarks with particular force. Its presses upon Crusoe his worldly, temporal condition by paradoxically putting that condition in doubt. For while the mark ought to be worldly like himself, it withdraws to present an almost inaccessible margin to that temporal condition—a presentation that in turn distorts the world as Crusoe knows it. "After innumerable fluttering Thoughts," Crusoe continues,

> like a Man perfectly confus'd and out of my self, I came Home to my Fortification, not feeling, as we say, the Ground I went on, but terrify'd to the last Degree, looking behind me at every two or three Steps, mistaking every Bush and Tree, and fancying every Stump at a Distance to be a Man; nor is it possible to describe how many various Shapes affrighted Imagination represented Things to me in, how many wild Ideas were found every Moment in my Fancy, and what strange unaccountable Whimsies came into my Thoughts by the Way. (154)

A clear and distinct mark in the sand, the footprint nonetheless entails a far-reaching obscurity. That the print stands alone immediately worries Crusoe, and his first response is to look for other marks "up the Shore and down the Shore." His search proves fruitless; appearing in no tradition, attached to no context, the footprint defies attribution. Nature's laws, too, have no hold over it. Surviving the tides, the mark refuses to let the sand return to its untouched condition. "All this," Crusoe says, "seem'd inconsistent with the Thing it self" (155). Not only does the footprint

betoken "the mystery of causality itself," as Homer Obed Brown suggests. It patently upsets the law-abiding aspect of nature Defoe invokes else-where: "all Nature most obsequiously obeyes the great Law of Cause and Consequence."[7]

The footprint goes so far as to turn on its head a rethinking of causa-tion as far-reaching as David Hume's, whose skepticism would so force-fully upset the grounds of certain knowledge for Kant among others in the eighteenth century. While Hume admits an unknowable cause, that cause would match the power that produced the impression—not the foot, but whatever hidden force causes the change in the sand's appearance as it and the foot meet. What we can know of cause and effect, Hume argues, follows the "general rule" of "connexion" established by "customary tran-sition." If "in all instances" a given cause produces a given effect, whenever we see the respective cause or effect "we *feel* in the mind, this customary transition of the imagination from one object to its usual attendant." Hence if we see a footprint in sand, we imagine a foot to have caused it. For Crusoe the footprint clearly calls forth this connection and all too obscurely troubles it. The unknowable aspect of causality inserts itself in the place of the cause one ought to know, producing a primitive sign that, insistently, remains singular. Or better, the print becomes less an Adamic sign in the wilderness than merely Adamic, an object of unearthly order. Outside history, it occurs in no series; outside time, it fails to wash away with the tide; and outside culture, it refuses the transition of customary knowledge.[8]

Perhaps Crusoe's greatest fright is the print's pressing upon him the sense of an uncertain primal existence. As he experiences not only terror but fear as well, the footprint shunts Crusoe toward the state of nature as formulated in the tradition running from Hobbes and Pufendorf in the seventeenth century, to Montesquieu and Kant in the eighteenth. For them, it is the fear of other human beings that characterizes the original state. Hobbes famously claimed the state of nature a condition of perpet-ual war and "continual feare." Like "the savage people in many places of *America*" who live in the state of nature, everyone lives acutely aware of everyone else's disposition to war, and so everyone exists in a state of anxious alert to the danger others present to one's self-preservation. Fear means "a certain foresight of future evil." What removes this existential apprehension, Hobbes argues, is civil society. Within a contracted body, one feels awe for the sovereign, but not an anticipatory anxiety generated

by the potentially unpredictable actions of unknown others. When subjects are kept in line by the sovereign's law, one knows how one's neighbor will behave. One's sense of security will be will be bolstered by predictable codes of action. As Jean Starobinski sums up the premise, entry into society makes fear disappear.[9]

Remarkable in Crusoe's case is his prior achievement of a certain distance from the state of nature. The footprint presses him up close to that fearful state within the context of his agricultural and industrial advances. "Reduced," he says, "to a meer State of Nature" upon landing on the island, having "no Weapon either to hunt and kill any Creature for my Sustenance, or to defend my self against any other Creature that might desire to kill me for theirs," Crusoe soon found in the wreck tools to plow the earth and so mark his removal from the absolute natural state (118, 47). What the footprint episode dramatizes so vividly is the incompleteness of Crusoe's removal from the state of nature and hence the state of fear. Just before finding the footprint, Crusoe imagined himself "Lord of the whole Mannor; or if I pleas'd, I might call my self King, or Emperor over the whole Country which I had Possession of" (128). He had instituted on the island's vacant land a certain order and something resembling civil society, even if his list of subjects—cats, goats, and a parrot—suggest a parody of civil society. Yet in boasting that he "has not Competitor, none to dispute Sovereignty or Command with me," Crusoe betrays the precariousness of his situation (128). He has no competitor; he is alone, asocial, and isolated. In this context the footprint presses upon Crusoe his uneven condition. It makes him acutely conscious of "the constant Snare of *the Fear of Man*" that pits him against some other whom he does not know but who he would have to confront alone, beyond any contracted, sovereign authorized law (163).

To conclude this initial summary of Crusoe's encounter with the footprint, let me point out that Crusoe's response will take two sequential forms. Initially he wants to destroy all that he has made—his crops, his goat pens, and so on. Then he turns his industry almost exclusively toward his defense. Feeling under threat, he leaves off producing conveniences for himself, building instead his most substantial fences. The footprint becomes, we can say, the cause of Crusoe's subsequent and prodigious industry—though not the print alone. To varying degrees of success and conviction, Crusoe attempts to link this uncaused primitive thing with something else derived not by logical deduction. By an anxious, even

psychotic, transference, he attaches it to the cannibals he pictures dwelling on the adjacent mainland, trying, in other words, to establish what Hume would call a "customary transition" between the danger suggested by the footprint and that which he attributes to the nearby savages. In this way, he aims to make earthly once more this familiar mark in the sand that appears, paradoxically, so unearthly and unfamiliar.[10]

"I was exceedingly surpriz'd"

So far we have considered Crusoe's encounter with the footprint as an event befalling him. But the encounter is, of course, presented in a narrative context, that is, in a context that orders events as temporally determined actions. The encounter as presented too takes some time, even if it lets loose a force that pushes Crusoe beside time, pressing him, however briefly, into an a state of undifferentiated primal existence. Over the next several pages I will elaborate on the force unleashed by the encounter by examining the encounter's presentation at the narrative level. What we will see is that as the narrative works to produce the event as a blunt exertion of force, it ultimately presents the event as a Longinian exertion of the sublime that pushes the "Thunder-struck" Crusoe beside himself.

We must first note that as Crusoe turns to introduce the footprint episode into his narrative, he pauses, signaling a change in narrative level with a declarative verb: "But now I come to a new Scene of my Life" (153). Foregrounding the extradiegetic level—speaking from his position as author-narrator, on the same level as his potential readers—the narrating Crusoe insists on two temporal planes, the event and its telling.[11] He explicitly frames what he promises to present as something being presented through the narrating self as it exists at the moment of narration. *This* Crusoe turns our attention to the event as he separates himself from it, a detachment he seems to need to present the horrific episode, or that he wants his readers to think he needs—but which also articulates a sense of self-through-time à la Locke (the same Crusoe, then and now, linked by consciousness-through-time), while making historicity the modality of existence according to which Crusoe will encounter the print. All descriptive language, all rhetoric, falls to the narrating Crusoe.

This does, of course, produce a corollary weakening of the mimesis that he paradoxically promises (the "new Scene" he sets out to represent), but what it achieves is significant: the tension between presenting and not

presenting that Crusoe is pointing to itself exemplifies the problem he faces in narrating the event. Encountering midway through his time on the island something that does not easily give over to what Defoe's preface calls *"a just History of Facts,"* Crusoe's island experience realizes an internal, otherwise invisible limit to representation (1). It is for this reason that Crusoe the narrator immediately follows the active, present tense of "I now come to" with a construction we can call passive as its object remains to be presented: "It happen'd one Day about Noon" (153). The unspecified "it" delays naming an event that does not sit well with a direct showing.

The narrator's passive phrasing also removes the historical Crusoe's agency. The event becomes something that happened *to* him—something, as we have seen, that befalls him. What seems no more than a mark in sand the size of man's foot extends to an entirely different order of magnitude. Hence Crusoe's use of a notable, doubly disjoining phrase in describing how the footprint initially confronted him: "I was *exceedingly surpriz'd* with the Print of a Man's naked Foot on the Shore, which was very plain to be seen in the Sand." (153, emphasis mine). The footprint's plainness and apparent passivity hides its remarkable capacity to shock Crusoe, indicated by the hyperbolic phrase, "exceedingly surpriz'd," which implies displacement *(ex-)* as well as subjection. "Surpriz'd" here does not mean excitement or wonder (according to the *OED,* a late nineteenth-century development of the present participle adjective). French in origin, *surprise* (literally "over-taken," *sur-prise*) connotes capture and domination, and the word suggests that the footprint has come upon Crusoe suddenly. It is thus in keeping when Crusoe goes on to say, "I stood like one Thunder-struck, or as if I had seen an Apparition," and, looking and listening, "could hear nothing, nor see any Thing" (153). Presenting his state of utter privation, Crusoe uses alternate similes whose vehicles themselves are nothing tangible. He further presses his troubled state with a parallel modal phrase: "after innumerable fluttering Thoughts, like a Man perfectly confus'd and out of my self, I came Home to my Fortification, not feeling, as we say, the Ground I went on." The narrator's repetition of modal terms *(like, as if)* simultaneously names and evades, announcing a true condition as he forecloses its direct presentation. Detached from the scene, the narrating Crusoe retroactively produces a sense of the encounter's historicity by holding to himself a manifestly figural language that in turn claims the scene's historical literalism: *It happen'd.*

It is significant, then, that the historical Crusoe himself soon succumbs to a loss of literal designation. In this way, the narrator dramatizes the turn from literal to figural as a corollary of the footprint's force. The footprint confounds proper *prescription*, and its confounding force proves dangerously expansive, encroaching upon *designation*. As Crusoe runs home "terrify'd to the last Degree," he looks behind himself "at every two or three Steps, mistaking every Bush and Tree, and fancying every Stump at a Distance to be a Man." Though we are not told when and how Crusoe realizes his misattribution, his mistaking local flora for other men suggests that a model of uncontrolled, deceptive figuration (symptomatic of irrationality here as elsewhere in Defoe) cuts through the historical Crusoe. Of course, *this* Crusoe's apparent immediacy was, in the first place, a retroactive effect of narrative manipulation. And here the significance of such manipulation becomes clear. By producing the historical Crusoe as a mere empirical being stumbling upon this singular thing, the narrating Crusoe allows himself to fully register the footprint's transforming effect. Having first reduced his past self to a kind of tabula rasa, the narrator can then trace out the impressions made upon him by the primitive sign that edges out of history.

Above all, the footprint upsets Crusoe's comprehension of the order of things and his place in it. He falls to a form of radical alienation from a self whose production and development the narrative has to this point carefully articulated.[12] Coded as naïve and wholly sense oriented at the moment of first encountering the footprint, the subsequent instability of Crusoe's empirical attachment to the world takes on a greater significance. Producing a far-reaching experience of anthropological insecurity, the footprint reduces him to that base state and then shatters that state's governing assumption of an empirical self linked directly to, and directly engaged in, the world. Hence the importance of the way that Crusoe's language becomes, after his initial confrontation with the primitive sign, somewhat secondary: "When I came to my Castle, for so I think I call'd it ever after this, I fled into it like one pursued; whether I went over by the Ladder as first contriv'd, or went in at the Hole in the Rock, which I call'd a Door, I cannot remember" (154). Why Crusoe, hurrying home after his fright, thinks right then to name his cave a castle is unclear. What is striking is *that* he calls his dwelling such a thing.

Crusoe's calling "the Hole . . . a Door" and his cave a "Castle" recalls that famous hero of one of Defoe's favorite works, Cervantes's *Don*

Quixote, who mistook the things of quotidian life as grand objects worthy of his chivalrous knight-errantry. The association harbors potential irony, with Crusoe's hopeful naming suggesting that he has become as deluded in his own way as poor Don Quixote was in his. Of course, one could claim that if there is irony here, its point is a more mundane expression of self-awareness: Crusoe's saying one thing (castle) and meaning another (cave) is less a complicated allusion to *Don Quixote* than a straightforward self-mockery or self-effacement. Yet his switch from *cave* and *hole* to *castle* and *door* seems to have occurred at a moment when Crusoe's self-awareness has been sundered, his self more literally (and less voluntarily) effaced: "like a Man perfectly confus'd and out of my self, I came Home to my Fortification, not feeling, as we say, the Ground I went on, but terrify'd to the last Degree." Additionally, his narrating self presents the switch as obscure in origin, implying that it was not a conscious decision ("for so I think I call'd it ever after this"). The suggestion seems to be that at that moment Crusoe experienced something like madness. He is beside himself, *out of* all knowledge of himself.

We have seen that the narrating Crusoe presents an historical self subjected to a reason-sundering anxiety concerning the footprint and its origins, an anxiety bordering on madness. The historical Crusoe appears subject to an event of immense force that comes upon him, that *happens to* a resistless self. But what exactly is the event and its immense force? As indicated, my sense is that the force of the event manifests as a version of Longinus's widely influential notion of the sublime. We should perhaps not be surprised to find *Robinson Crusoe* bearing the marks of a Longinian vocabulary. Weiskel notes that it was in Longinus that early eighteenth-century writers found "a vocabulary for a powerful experience whose origins are obscure."[13] My point, though, will not just be that Crusoe deploys a Longinian vocabulary; rather, I argue that Crusoe's encounter with the footprint centers on an event of sublimity à la Longinus. To get closer to an understanding of the event and its force, I will spend the next few pages outlining Longinus's conception of a sublime event before moving on to draw out the particular implications of the footprint's Longinian force.

Longinus

For us Longinus's virtue lies partly in how he presents the sublime outside the consumption model that we associate with eighteenth-century

aesthetics. The footprint presents an intentional structure closer to Longinus's than to eighteenth-century treatments of the sublime. I will focus on the peculiar power the sublime presents in Longinus's account by following and extending Neil Hertz's influential account of the Greek critic's treatise, *On the Sublime*.[14] Before Hertz, discussions of Longinus considered references to power in the treatise as marginalia or as corruptions of the original text—the outcome, Hertz shows, of a misplaced demand for thematic coherence.[15] Hertz argues instead that Longinus works to exemplify the sublime through a practice of citation ("the play of the text with quotation and of quotations with one another"), and he finds the performative play of citation to produce force through resonance.[16] What interests us is the dynamic of that force.

Longinus splices, Hertz suggests, seemingly disparate quotations to issue a cumulative repetition that produces a swelling performative movement. "One quotation will suggest another but not necessarily because each illustrates the rhetorical topic at issue; both might, but the effective links between them seem at once flimsier and subtler than that. A single word—'light' or 'Ajax'—will provide a superficial connection between passages that then turn out to be suggestively resonant" (3). The procedure does not follow a linear movement progressing neatly from one topic to another; rather, it is "in certain ways cumulative," so that at various points "one becomes aware of a thickening of texture"—a thickening Longinus engenders by selecting and arranging materials "so as to bring them into interesting juxtaposition" (8, 13). It is in the lurking, seemingly concealed quality of resonance, that Hertz unearths the sublime. For him, Longinus generates sublimity in between the repetition of citations. The juxtapositions reverberate to produce a flash of "figurative reconstitution" from the apparent "disintegration" of disparate citations, constituting what Hertz calls the "sublime turn" (6, 14). Through this poetic activity, the force of submerged continuity effects a "transfer of power" akin to what Longinus describes as the movement of Homer's sublime oratory, namely, in Hertz's words, "the turning away from near-annihilation, from being 'under death' to being out from under death" (6). At the moment of reconstitution the sublime turn squeezes power out of the imminent crash of annihilation-by-fragmentation.

We need to qualify the status of what Hertz calls the "sublime turn." Longinus formulates the move "from being 'under death' to being out from under death" more precisely as one's being shunted aside oneself—what

Crusoe would call being "like a Man perfectly confus'd and out of my self." For this reason, Longinus reworks the conventional emphasis on disguising one's figures to foreground the sense that the subject of the sublime does not consciously reconfigure the fragments. The sublime flash is as illuminating as it is blinding. This itself points to the sublime's distinctive paradoxical power: its ability to conceal any view of the citation's concealment. Sublimity, in other words, obscures its origins. While "Figures," Longinus says, in William Smith's popular eighteenth-century English translation, "naturally impart assistance to, and on the other side receive it again in a wonderful manner from sublime Sentiments," the sublime disfigures its figures.[17] Or better, sublimity follows a double disfiguration: on the one hand, a figure itself defaces a prior literal meaning (hence what Longinus notes is the tendency to suspect figures of "Artifice, Deceit and Fraud"), and on the other, a sublime utterance removes all traces of the first disfiguring. Longinus describes the movement as a gaining of priority:

> For as the Stars are quite dim'd and obscur'd, when the Sun breaks out in all his blazing Rays, so the Artifices of Rhetoric are entirely overshadowed by the superior Splendor of sublime Thoughts. A parallel illustration may be drawn from Painting. For when several Colours of Light and Shade are drawn upon the same Surface, those of Light seem not only to rise out of the Piece, but even to lie much nearer to the Sight. So the Sublime and Pathetic either by means of a great Affinity they bear to the Springs and Movements of our Souls, or by their own superlative Lustre, always outshine the adjacent Figures, whose Art they Shadow, and whose Appearance they cover in a Veil of superior Beauties. (§17, pp. 51–52)

Distinguishing the sublime from rhetoric as traditionally understood, Longinus does not suggest that sublimity hides its figures to support rational disputation ("figures," says Quintilian, for example, "make what we say probable, and penetrate imperceptibly into the mind of the judge").[18] The sublime occurs in the absence of judgment; it obscures everything around it.

Hertz's account, by emphasizing the mechanics of citation, reduces the doubled disfiguration to a subterranean strand. Though this is to be expected—he is, after all, unmasking the principle gambit of Longinus's

own rhetorical mastery—Hertz risks doing something more: inscribing the reduction into the treatise itself so as to bury the sublime's power once more. Hence he suggests that Longinus, through the cumulative movement of his text, "too is drawn into the sublime turning, and what he is moved to produce is not merely an analysis illustrative of the sublime but further figures for it" (8). For Hertz, figures never become concealed, a conclusion at odds with the sublime's distinctive power, which Longinus says annihilates all possible resistance such as would emerge if one could read sublime figures.[19]

Prosaically considered, Hertz's claim is not wrong. Longinus's analogy between the priority of figures and that of light in painting only underscores Hertz's point: Longinus does not appear able to present the sublime directly, leading him to cite further figures. Furthermore, Hertz makes the crucial point that Longinus observes a distinction between figures and figuration. As Hertz puts it, echoing the figure Longinus uses to describe grandeur's effect on the artifice of rhetoric, "Surrounded by brilliance, the lesser light (the artifice) disappears from sight. But what is it that disappears? Not the particular figure . . . but 'the fact that it is a figure'—its figurativeness, so to speak" (17). Blindness to the presence of figures does not mean the figures are absent. We can add that Longinus himself often inserts explicit rhetorical gestures in various passages. Consider his mention of the *fiat lux*, which for him exemplifies the sublime: "*And God said*—What?—*Let there be Light, and there was Light*" (§9, p. 23). Citing Moses citing God, Longinus inserts his own dialogic marker ("What?"), "drawing attention," Jonathan Lamb points out, "to himself, and to his own rhetorical manipulation of the language of power."[20] Moreover—and especially important for us—the passage indexes heterogeneity in sense and in self: it makes the *fiat lux* a repeatable rhetorical figure; it presents an interlocutory "what?" that comes on as it were sideways; and by piggybacking citations, it inscribes each speaker as insufficient to himself (Longinus needs Moses who needs God who needs Moses).

Even so, we need to acknowledge how the sublime repudiates the subject's ability to consciously reconcile "figurative reconfiguration." Longinus allows no transcendent unification; sublimity does not align the self with itself but marks in it a radical heterogeneity. Through the sublime, the slave resists the power of the master by turning the tables on him, making both other to themselves, though in a way that does not simply cancel their respective original identities. The master becomes both master and

slave. Longinus commonly gives examples where an orator, under sentence of death or some other danger, overwhelms someone invested with great authority—"a Judge . . . a Tyrant, a Monarch, or any one invested with arbitrary Power or unbounded Authority" (§17, p. 50)—hence Hertz's gloss on the sublime as a "turning away from near-annihilation, from being 'under death' to being out from under death" (6). By achieving sublimity, the orator enslaves or enthralls (δουλοῦται, *douloutai*) the one in authority.[21] Yet it does not follow that the master becomes only a slave. He maintains his institutional authority, and for this reason, the orator must remain careful to keep her figures hidden. The master, still designated institutionally as the one in possession of power, would not look kindly upon one who tried to enslave him by artifice. Now as noted, it is the sublime's great strength to hide its figurative origins. The "sublime turn" comes as if from nowhere, an effect of rhetoric that overtakes its causal agency. Here, cause and effect do not obey the law, or rather the sublime usurps the processes of law, instituting an alternative regime. Breaking with the order of things, sublimity short-circuits judgment, hiding all rhetoric, all manipulation, upsetting all expected causation (or, in Hume's terms, "customary transition"). "In most Cases," Longinus says, "it is wholly in our Power, either to resist or yield to Persuasion. But the Sublime, endued with Strength irresistible, strikes home, and triumphs over every Hearer." "With the rapid force of Lightning," he continues, the sublime "[bears] down all before it"; it is a "Force we cannot possibly withstand" (§1, p. 3). Sublimity, in short, unleashes immense violence. It stamps, strikes, enslaves, transports; it "immediately sinks deep, and makes such Impressions on the Mind as cannot easily be worn out or effaced" (§7, p. 15).

Eighteenth-century readers tended to underplay the unsettling violence of Longinus's sublime. They typically ignored the irreversible scaring of the mind we might call a trauma or puncturing of consciousness. This too Hertz risks disavowing—even as he enables us to recognize it— by emphasizing the play of citation. When he examines Longinus's discussion of mastery and slavery, for example, he only hints at the connection between that theme and the mastery achieved with sublimity's power. It is, he says, one of those "interestingly resonant" moments in Longinus's text. But for Longinus sublimity leads the listener into ecstasy (εἰς ἔκστασιν, *eis ekstasin*). At least since the French poet Boileau's influential translation of 1674, what I gloss as *ecstasy* is typically rendered *transport* ("Car il ne

persuade pas proprement, mais il ravit, *il transporte*"). That term misses something important signaled in Longinus's paradoxical conjoining of *eis* ("into") and *ek-* ("out of"); while *transport* suggests the relationship of motion indicated by the accusative ekstasin, it obscures that motion's peculiar force. Most literally, *eis ekstasin* means to lead one into outsideness. One is not merely moved by sublimity but shunted aside oneself.[22]

The reader might object to the idea that Longinus presents the listener's absolute subjection. Does he not claim that in being subject to sublimity one gains the impression the words are one's own production? "For the Mind is," Longinus writes, "naturally elevated by the true Sublime, and so sensibly affected with its lively Strokes, that it swells in Transport and an inward Pride, as if what was only heard had been the Product of its own Invention" (§7, p. 14). The eighteenth-century emphasis on aesthetic reception would tend to align Longinus's claim with a sense of self-mastery and self-extension. However, Longinus himself suggests that the listener's sense of producing what she hears proves her absolute subjection. The sentence in question appears in the context of a discussion of ornamentation: "whatever is veil'd over with a theatrical Splendor, and a gawdy Out-side"—"Riches, Honours, Titles, Crowns"—wards off any actual impression of grandeur (§7, p. 14). Words, if they are to produce sublimity, need to come closer than this, minus the interfering screen of trapping and ornament. So if it seems "as if what was only heard had been the Product of [one's] own Invention," it is because there is nothing in between to moderate reception. Importantly, Longinus bases his formulation on a further paradox. At the moment sublimity achieves proximity and seeming unity in the subject, it remarks heterogeneity. The qualifying clause "as if" indicates clearly that one did not in actuality produce the sublime oratory; what one feels is the *as if,* inserting into the sublime sensation a disjunctive experience of self. One is led, in short, into outsideness. Longinus's sublime does away with mediation and, by its unmodified immediacy, the listener's own imaginative agency, even as it kindles the simulacrum of agency precisely at the moment of dispossession in ironic testimony to the listener's utter subjection.

Thrown into Ecstasies

The footprint produces a far-reaching cognitive disturbance in the historical Crusoe. It presents a radically asymmetrical intrusion into Crusoe's

world, with a forceful insistence, as we have seen, on the obscurity of its origins. It asserts nonidentity as such, silently refusing to give itself up to a code Crusoe could decipher; singular, it neither fits into a series of prints, coming before or after another, nor forms an ordinal or cardinal unit. The mastery of things through mathematical deduction that Crusoe advocates—"as Reason is the Substance and Original of the Mathematicks, so by stating and squaring every thing by Reason, and by making the most rational Judgment of things, every Man may be in time Master of every mechanick Art" (68)—will not work here. Sundering reason, the footprint works up Crusoe's imagination, a faculty that, for Defoe more widely, one cannot control. This is why Longinus proves important: the footprint takes Crusoe, as he puts it, "out of my self."

How the footprint connects with Longinus's rhetorical sublime needs initial elaboration for several reasons. On the one hand, while we can call the footprint a figure (it presents the form of a foot), we cannot call it a rhetorical trope. Indeed, insofar as it appears an Adamic sign, it would be antirhetorical. On the other hand, while the mark's status as a phenomenological object seems crucial, we cannot say it has an intentional structure that makes it the agent of someone's resistance to Crusoe's mastery. To these two main points we can add that the qualities the footprint possesses as an object suggest a further divorce from Longinian conceptions of sublimity. It is small, just a little larger than Crusoe's own foot; it is beneath him; it is in itself almost nothing—brush the sand and it disappears. Objects of nature cited by Longinus—objects that evidence a human desire for excess, which for him indicates humanity's affinity for the sublime—prove noticeably different: prodigious rivers and the ocean, "celestial Fires" and volcanoes spewing "Rocks from their labouring Abyss." For Longinus it is their contrariety to expected forms that produces in the viewer a sense of wonder (§35, pp. 85–86).

If the contrary aspect of Longinus's objects start to suggest a connection with Crusoe's recalcitrant footprint, we are still left to ask how a nonrhetorical, diminutive mark could produce an event of Longinian sublimity. To understand how, we need to realize that Defoe has switched the medium of sublimity from rhetoric to the imagination—or more accurately, the imagination operates in *Robinson Crusoe* as a rhetorical medium à la Longinain sublimity. The move from a rhetorical sublime (a sublime style evidenced in the use of certain tropes and figures) to a subjective sublime (a sublime experience produced by the individual's faculty of

imagination) has long been considered the sublime's trajectory through the eighteenth century. At midcentury, it is commonly claimed, aesthetic theorists drop Longinus's rhetorical emphasis in favor of the subject-based experience of natural forms like exploding volcanoes and expansive oceans.[23] However, within that tradition, the Longinus in question is one already turned over to a subjective vocabulary of reception: throughout the eighteenth century, Longinus's poetics is recast as an aesthetics, concerned less with how one makes sublime figures and more with how one experiences those figures, through the reception of sublime language.[24] However, the footprint does not fit that model. It works upon an imagination that, at its extreme, suspends and potentially obliterates the self. In *Robinson Crusoe* we are dealing with a sense of the imagination that does not suggest a psychologically complex or deep concept. The particular way that Defoe develops a theory of the imagination *as a rhetorical medium* explicitly connects the footprint with what we might call the preaesthetic Longinus.

The Imagination

To gain a full sense of Defoe's theory of the imagination in *Robinson Crusoe,* it will help to look more widely at all three of the Crusoe novels. After the success of the first Crusoe novel (the one we know as *Robinson Crusoe*), Defoe quickly published *The Farther Adventures of Robinson Crusoe* later in 1719 and *Serious Reflections During the Life and Surprising Adventures of Robinson Crusoe* in 1720. The third installment includes an explicit discussion of the imagination, where Crusoe distinguishes "meer imagination" and "imagination rais'd up to disease."[25] While the former would be irrational insofar as it is based in fantasy, it does not confound reason; indeed, it may even further reason, enabling one to extend one's understanding beyond the merely visible world. However, the latter, heightened by disease, does confound reason. This sort of imagination steps wildly beyond its own sphere, causing all sorts of problems for the understanding. Notably, the latter sense dominates in Crusoe's presentation of his various adventures. "Meer imagination" features hardly at all. From an historical perspective this means that Crusoe holds to just one of the two common ways of understanding what the imagination does, which themselves more or less correspond to Crusoe's own distinction between mere and heightened imagination: as a faculty that may augment or endanger reason respectively.[26]

Crusoe's favoring of the heightened view must be underscored. Patricia Meyer Spacks and James O. Foster, who have respectively provided the fullest treatments on the topic, merely assume the presence of the two versions of the imagination (that is, mere and heightened). Doing so, they take *reflection* to be a use of the imagination in the service of understanding. But when Defoe's protagonist reflects on his experiences, on the operation of Providence, and so forth, he engages in a wholly rational activity. As in Descartes, Locke, and others, here reflection is a modality of reason. We might call Crusoe's reflection a private use of reason, but even so, it must not contradict anything one could deduce by a public reason. The rules of reason tout court underwrite reflection. (To give a simple example: if reason dictates that A cannot equal not-A, then one cannot contradict that premise, publicly or privately, without succumbing to unreason.) When reason is upset, it tends to be because a diseased imagination intrudes, which then becomes what reflection must reduce to reestablish itself.[27]

Let me elaborate further by turning to Crusoe's extended account of the imagination's power at the beginning of the *Farther Adventures.* In retirement at home in England, Crusoe feels a driving desire to go abroad once again, in particular to go and see his island plantation and "the colony I left there." He could not, he says, employing a Longinian locution, "resist the strong inclination I had to go abroad again"—a sentiment his wife quickly reiterates ("There is no resisting it"), as does Crusoe again after her death ("an irresistible force upon me," "an irresistible desire to the voyage").[28] What produces the desire is the force of the imagination. That force worked, he says, "so steadily and strongly upon" the notion of visiting his island "that I talk'd of it out of sleep; in short, nothing could remove it out of my mind; it even broke . . . violently into all my discourses." Subject to his fancy, Crusoe even feels as if on his island: "My imagination work'd up to such a height, and brought me into such extasies of vapours, or what else I may call it, that I actually suppos'd my self, oftentimes upon the spot . . . and this I did, till I often frighted my self with the images my fancy represented to me" (3). Echoing Longinus, Crusoe's imagination takes him out of himself, "into . . . extasies."

In its settled state the self is, for Crusoe, equivalent to its rational capacity. When the imagination intrudes, it adds something, taking the self outside itself. "My imagination," he says, "*brought me* into such extasies"; it pulls him into the ecstasies it creates, as if standing outside him even as it

appears to belong to him. Instructively, though Crusoe avoids possessive phrasing when invoking reason, he does so consistently when addressing the imagination ("*my* imagination," "*my* fancy"). The faculty is alienable, which is to say, not primitive; it is something added on and hence not essential. The imagination's separable aspect underscores its ability to divide the self, adding to it something both alienating and alienable. The danger the imagination presents is its ability not only to be in-addition-to the self, but to take-the-place of what it adds itself to.[29]

Reason alone appears able to resist the imagination. In his battle with fancy in the *Farther Adventures,* it is by rational reflection that Crusoe gains, though temporarily, the upper hand. "I struggled with the power of my imagination, reason'd myself out of it . . . in a word, I conquer'd it; compos'd myself."[30] Elsewhere Defoe associates the ability to resist with preserving individual liberties against sovereign tyranny. In the Preface to *Jure Divino* (1706), his most sustained treatment of natural law and government, Defoe argues "that Kings who invade their Peoples Liberties, break in upon Constitutions, and the Sacred *Postulata* of Government; that oppress their Subjects, and impose unjust and intolerable things upon them, MAY BE RESISTED."[31] In other words, Defoe codes the resistance to force as an act founded in reason's rejection of infringements upon one's rightful autonomy. To preserve the self one must maintain the ability to resist incursions upon it, such as those, we can say, presented by the imagination.

Fear

What commonly makes Crusoe's imagination overrun him is fear.[32] Later in the *Farther Adventures,* for example, Crusoe, his merchant partner, and his crew sit off the coast of China, far north of the Dutch and the English ships that believe them pirates. While rationally, Crusoe says, their immediate situation may present little danger, "fear, that blind useless passion, work'd another way, and threw us into vapours; it bewildered our understandings, and set the imagination at work, to form a thousand terrible things, that perhaps might never happen."[33] Their sense of fear follows from a realization that the Chinese coast is more or less ungoverned. Crusoe et al. can appeal to no intervening authority to mediate between themselves and the European ships, who want to hang them and thereby enact a form of law from outside law. While Crusoe does not find himself here

in the state of nature, aspects of the situation approximate it a certain version of it—specifically the fear of others in the absence of law, as argued most famously by Hobbes.

When Crusoe does come upon the state of nature, or at least of lawlessness, in *Robinson Crusoe,* fear of other human beings characterizes the experience. He marks this clearly twice when crossing from lawful to unlawful domains. First, after escaping slavery in *"Sallee,"* he and Xury sail south along the coast of Africa, beyond the "Dominions . . . of any . . . King thereabouts" (24). There he fears being overtaken by "Canoes with *Savages,*" for it is "the truly *Barbarian* Coast, where whole Nations of Negroes were sure to surrounds us with their Canoes, and destroy us; where we could ne'er once go on shoar but we should be devour'd by savage Beasts, or more merciless Savages of humane [that is, human] kind" (26, 23). Second, the storm that ultimately lands Crusoe on his island blew him and his crew "so out of the very Way of all humane Commerce, that had all our Lives been saved, as to the Sea, we were rather in Danger of being devoured by Savages" (42). Beyond "humane Commerce" devouring savages lie in wait, signaling a dark, Hobbesian state of nature, outside regular and so ruled mechanisms of exchange, be they linguistic or mercantile. There, one always risks being given up, with no possible return, to what he calls "the worst kind of Destruction, *viz.* That of falling into the Hands of Cannibals, and Savages, who would have seiz'd on me with the same View, as I did of a Goat, or a Turtle" (197). The cannibals would enforce another sense of ecstasy, sundering body and soul.

"Into Outsideness"

It is in part as a danger to self-preservation that Crusoe understands the footprint. Yet how he formulates that danger does not follow a coherent logic. The distinct mark—"very plain to be seen in the Sand," "exactly the very Print of a Foot, Toes, Heel, and every Part of a Foot"—entails great confusion (153–54). Finding a determinate judgment on the print impossible, Crusoe goes back and forth over various explanatory possibilities. The respective terms that Crusoe uses contradict and rework those of other explanations in startling ways. What does prove certain is the initial fright and sense of danger he experiences upon seeing the mark in the sand. The world around him distorts; he feels the shore lose distinction ("it was all one"); he runs home "not feeling, as we say, the Ground I went

on"; he mistakes "every Bush and Tree . . . to be a Man" (154). Certainly other events—hurricanes, earthquakes, cannibal feasts—produce like effects. After an earthquake, for example, Crusoe says, "I was like one dead or stupify'd" (80). But Crusoe responds to that event energetically and productively. Coding it as a providential intervention (a sign of "the invisible Power which alone directs such Things"), he sets about altering his dwelling to ensure he will not be buried alive should another earthquake strike (90). The footprint works on Crusoe quite differently. His inability to adequately frame the mark means that the footprint episode is neither one more case of Crusoe's confronting the contingency of an accident, divinely ordained or not, nor one more version of his experiencing the fear of others in a place beyond law. Once again, the footprint is, precisely, singular.

Crusoe does achieve a degree of calm by turning to Providence and recalling his own "unquestion'd Duty to resign my self absolutely and entirely to his Will" (157). Even so, Crusoe's submission does not explain the cause of the print, which continues to prove unreadable and to augur ill will. Out of his mind with fear, Crusoe considers destroying his dwelling and means of subsistence: "The first Thing I propos'd to my self, was, to throw down my Enclosures, and turn all my tame Cattle wild into the Woods . . . Then to the simple Thing of Digging up my two Corn Fields . . . then to demolish my Bower, and Tent, that they might not see any Vestiges of Habitation" (159). As Homer Brown notes, Crusoe's destructive urge suggests a practical desire "to disappear, to be invisible, to see without being seen."[34] Notably, the projected effects of that desire align Crusoe with the savages as he posits them—that is to say, both Crusoe and the savages desire Crusoe's disappearance:

> terrible Thoughts rack'd my Imagination about their having found my Boat, and that there were People here; and that if so, I should certainly have them come again in greater Numbers, and devour me; that if it should happen so that they should not find me, yet they would find my Enclosure, destroy all my Corn, carry away all my Flock of tame Goats, and I should perish at last for meer Want. (155)

Transposing, in his "rack'd . . . Imagination," the single and singular print into "greater Numbers," Crusoe attributes to savagery the same impulse

to destroy the products of his hard work that, pressed by fear, he himself will experience.

The print produces in Crusoe an overwhelming fear of others that, uniquely, makes his apprehensive projections increase. "The farther I was from the Occasion of my Fright," he says, "the greater my Apprehensions were, which is something contrary to the Nature of such Things, and especially to the usual Practice of all Creatures in Fear" (154). In calling his reaction "contrary . . . to the *usual* Practice of all Creatures in Fear," he designates it precisely "Fear," while suggesting it is a specific kind, continual and ever pressing. This is no ordinary fear; it suggests contrariety, adding to the contrariety of the supposed other against him, the paradox of a contrary reaction. Symptomatic is the perversion of reason contrarity produces, reason becoming the subaltern to his imagination: "I was so embarrass'd with my own frightful Ideas of the Thing, that I form'd nothing but dismal Imaginations to my self, even tho' I was now a great way off of it. Sometimes I fancy'd it must be the Devil; and Reason joyn'd in with me upon this Supposition: For how should any other Thing in human Shape come into the Place?" (154). Leading Crusoe into outsideness, the footprint obliterates all but the imagination ("I form'd nothing but dismal Imaginations to my self"), which in turn submits reason to its own service ("Reason joyn'd in with me upon this Supposition").

Crusoe's recourse to reason is not a reversal. Here reason does not correct imagination but helps further it; no longer equivalent to self, reason must now join in, he says, "with *me*." Finding that his mental turmoil only increases, the "Terrors and Apprehensions" of Crusoe's mind deny him the use of soothing prayer and "the Use of those Means which Reason offers for . . . Relief" (159). However, Crusoe does regain some access to the powers of reasoning by conducting conversations with himself in an attempt to tighten the circle of explanation around the obscure footprint, framing it in various ways. Dismissing the possibility that the footprint is a trick of the devil's, he thinks it may have been made by "Savages of the main Land over-against me" (155). As we have seen, reason itself denies this possibility, and Crusoe seems to move on to dismiss it: he soon wonders whether he himself might not have left the footprint getting in and out of his boat, though his hopes here are dashed when he measures his foot against the print but finds his foot "not so large by a great deal" (159).

By this point it should be clear that the common tendency to assume that the print was in fact left by a cannibal, and that Crusoe believes this

too, is mistaken. The text supports neither position—or rather, it supports and undermines both without clearly settling the matter. If at certain points Crusoe attributes the print to a visiting savage, the narrative also makes that conclusion problematical. After Crusoe realizes that he himself could not have left the mark, for example, he describes how "these Things fill'd my Head with new Imaginations, and gave me the Vapours again, to the highest Degree . . . I went Home again, fill'd with the Belief that some Man or Men had been on Shore there; or in short, that the Island was inhabited" (159; see also 196). Here, Crusoe not only repeats the unwarranted transposition from singular to plural; he also uses a loose parallelism ("fill'd my Head with new Imaginations . . . And I went Home again, fill'd with the Belief") to indicate how it is by means of the imagination that he attaches the print to "some Man or Men." The novel consistently phrases the footprint's attribution to cannibals in such unwarranted, metaleptic terms.

Crusoe, in his struggle to gain composure, takes recourse to a variety of means. As with his metalepses, they tend to offer only a precarious and provisional calm. Consider the equanimity Crusoe gains several days after first seeing the footprint after waking from a sound sleep: "now I began to think sedately; and . . . Debate with my self" (160). Doing so, he lessens the perceived threat to himself by inscribing the possible encounter with another within the logic of an accident that befalls both him and the other: "That the most I cou'd suggest any Danger from, was, from any such casual accidental Landing of straggling People form the Main, who, as it was likely if they were driven hither, were here against their Wills" (160). By suspending the savages' agency, Crusoe reassures himself. If he were to accidentally encounter cannibals on the shore, it would be because they themselves were there by accident, the currents carrying them "against their Wills." And yet Crusoe's disavowal harbors the dialectical point that the suspension of the savages' agency requires that they *have* agency, a will to go against. When Crusoe recognizes this potential will, he is driven to prepare his defenses against whomever might be blown onto the island.

Characteristic of Crusoe's oscillating mental state, his image of helpless savages reiterates an earlier statement that led him to a quite different conclusion. When, terror-stricken, he first considered the footprint as a mark left by savages, he used the same terms: "it must be some of the Savages of the main Land over-against me, who had wander'd out to Sea in their *Canoes;* and either driven by the Currents, or by contrary Winds

had made the Island" (155). Despite the savages' loss of agency here, as in the first version, Crusoe imagines them the utmost danger to his self-preservation. Each version of the statement—the savages arrive on Crusoe's island by accident—recasts the other. On the one hand, the second version indexes Crusoe's gain in composure and in turn suggests the first especially symptomatic of his unease: his fear having "banish'd all [his] religious Hope," even the force of accident harbors him ill will (156). As Crusoe's paranoia overtakes him, everything appears intentionally against him. On the other hand, the first version undercuts the confidence later suggested by the second. It shows how the same statement can serve opposite ends precisely because their relation to the world around Crusoe is so tenuous.

A similar pattern is at work in Crusoe's strongest claim to equanimity. Right before he discovers something more solid than fancy's intimations, namely the remains of a cannibal feast, Crusoe expresses a sense of relief from what he continues to feel as the footprint's pressing uncertainty:

> When I was come down the Hill, to the End of the Island, where indeed I had never been before, I was presently convinc'd, that the seeing the Print of a Man's Foot, was not such a strange Thing in the Island as I imagin'd; and but that it was a special Providence that I was cast upon the Side of the Island, where the Savages never came: I should easily have known, that nothing was more frequent than for the *Canoes* from the Main, when they happen'd to be a little too far out at Sea, to shoot over to that Side of the Island for Harbour; likewise as they often met, and fought in the *Canoes,* the Victors having taken any Prisoners, would bring them over to this Shore, where according to their dreadful Customs, being all *Cannibals,* they would kill and eat them. (164)

Here, Crusoe makes clear that two years after encountering the print, he is still trying to come to terms with it; that, in his efforts, he continues to oscillate from terror to calm and—a possibility his use of "presently" suggests—back again. The passage also shows that Crusoe's efforts to gain relief turn on disavowing the footprint's singularity. It is one mark left by potentially any number of savages stepping ashore at a place where Crusoe would never see them. They would, he says, leave "Foot-steps" (166).

Once placed in the wider context of Crusoe's narrative, the passage reveals the astonishing depth of Crusoe's uncertainty concerning the footprint's origins. It is of a piece with two gestures Crusoe makes, whose recurrence makes the passage in question seem markedly rhetorical. First, Crusoe frequently sets up a shocking event by emphasizing immediately beforehand his sense of calm and sense of security (this was the case with the footprint episode, for example). This gesture, reiterated several times, starts to look like a deliberate setup and hence expressly artificial. Second, Crusoe's imagining the coming of cannibals with victims in tow to this part of the island, followed by his finding the remnants of such an act, corresponds to an unrealistic gesture that he repeats. Here, Crusoe imagines cannibals coming ashore to eat victims, then suddenly finds the remains of such victims, just as elsewhere in the novel there are various examples of such marked coincidence, most notably when he dreams of gaining a savage for a friend, then shortly after finds Friday (198–99).

Crusoe's moments of self-possession move him closer to Weiskel's third phase of the sublime. Having been overtaken, Crusoe starts to overcome the pain and difficulty that fear produces. For Weiskel, the difficulty in question "is the affective correlative of a semiotic discontinuity in the inexplicable passage between one order or discourse and another."[35] One gains the third phase by constituting a new relation through symbolizing the difficulty in question. Note that this does not cancel the difficulty: "Should there be a reversion to habitual perception, the sublime moment subsides or collapses into something else. For it is precisely the semiotic character of the sublime moment which preserves the sublimation necessary to the sublime" (24). Most clearly, Crusoe's metalepses cover over as they uncover a certain "inexplicable passage." And in several ways his fence building presents an attempt at sublimation: the fences serve to screen Crusoe from certain dangers, hiding the singularity of the footprint from himself and hiding himself from the multitude of ferocious savages.

Beyond physical separation, Crusoe's fences form a putative symbolic marker of his difference from those dangers that he feels pressed too close. In his efforts to leave behind his ambivalent condition between nature and civil society, Crusoe's fences would exhibit his industry and thereby align him with a civil state. In this way, his fences help him shore up his self. But any assurance Crusoe could take from his industry would be undercut insofar as it proves to be a simulacrum of autonomous industry, its cause being the fear of others. As in Longinus, such simulated agency

betrays subjection. "All this Labour," Crusoe says of his fence building, "I was at the Expence of, purely from my Apprehensions on the Account of the Print of a Man's Foot which I had seen" (162). Laying "in Expectation every Night of being murther'd and devour'd before Morning," living "in the constant Snare of *the Fear of Man*," he becomes dominated by a drive to self-preservation (163). All this he does, of course, in the absence of others, the cause of his industry being in turn the outcome of Crusoe's mental leap from the footprint to other human beings. "I foresaw nothing at that Time, more than my meer Fear suggested to me" (162).

It is not long before Crusoe does find something more solid than fancy's suggestions:

> I was perfectly confounded and amaz'd; nor is it possible for me to express the Horror of my Mind, at seeing the Shore spread with Skulls, Hands, Feet, and other Bones of humane Bodies; and particularly I observ'd a Place where there had been a Fire made, and a Circle dug in the Earth, like a Cockpit, where it is suppos'd the Savage Wretches had sat down to their inhumane Feastings upon the bodies of their Fellow-Creatures. (164–65)

Despite the scene's horrific nature, Crusoe finds relief in it. His initial bewilderment recalls his response to the footprint, but the difference between the two episodes quickly becomes apparent. Upon discovering the footprint, Crusoe felt the world around him distort, then from fear fled into his home "like one pursued." But here Crusoe records the scene in vivid detail: "and then," he says, "recovering my self, I look'd up with the utmost Affection of my soul, and with a Flood of Tears in my Eyes, gave God Thanks." And in a remarkable phrase, Crusoe notes how "*In this Frame of Thankfulness,* I went home to my Castle, and began to be much easier now, as to the Safety of my Circumstances, than ever I was before" (165, my emphasis). He has, it seems, realigned himself.

How could a scene confirming Crusoe's worst fears prove mollifying? At this point, Longinus can no longer help us. We find something at work beyond the exercise of an external power or the sensation of mere terror. We find a subjective operation that, though not based on the exercise of reason, entails a specific form of agency located in Crusoe's self, an agency and a self closer to home in certain developments commonly thought to be characteristically eighteenth century in origin. We can best see that

agency and that self, which is in *Robinson Crusoe* more specifically an aesthetic self, by turning to Edmund Burke's theorization of the sublime in his *Philosophical Enquiry into the Origin of our Ideas of the Sublime and Beautiful* (1757/59).

Edmund Burke

For our purposes, it is most immediately significant that Burke aligns the sublime with self-preservation. Arguing that "all our passions" support either sociability or self-preservation, Burke claims beauty furthers the former and the sublime the latter.[36] Whereas beauty, in its different forms, inclines us to either *"particular"* or *"general society"* by producing a sense of pleasure that leads, respectively, to a desire for *"generation"* or for company, the sublime incites us to self-preservation by "[exciting] the ideas of pain, and danger" (39). Burke associates the sublime with a resistance to what, in its most extreme form, threatens annihilation; by intimating death ("this king of terrors"), the sublime stimulates a drive to extend life (40). This premise leads Burke to his strongest formulation of sublimity:

> The passion caused by the great and sublime in *nature*, when those causes operate most powerfully, is Astonishment; and astonishment is that state of the soul, in which all its motions are suspended, with some degree of horror. In this case the mind is so entirely filled with its object, that it cannot entertain any other, nor by consequence reason on the object which employs it. Hence arises the great power of the sublime, that far from being produced by them, it anticipates our reasonings, and hurries us on by an irresistible force. (57)

Here, Burke comes closest to Longinus and thus to the footprint episode, isolating a suspension of the self and its rational faculties. However, an important difference distinguishes Burke's formulation. For him the threat to the subject is only an apparent threat. "The passions which belong to self-preservation," Burke argues, "are simply painful when their causes immediately affect us; they are delightful when we have an idea of pain and danger, without being actually in such circumstances" (51). This degree of distance does not obtain in Longinus or in Crusoe's experience of the footprint.

For Burke an object's aesthetic status primarily indexes a subjective sensation. Whether we can call something sublime or beautiful depends on the perceptual effects the object has in and for the subject. In fact, an object as it were *becomes* sublime or beautiful through the execution of a speech act following a subjective determination: "Whatever excites this delight, I call *sublime*"; "beauty . . . is a name I shall apply to all such qualities in things as induce in us a sense of affection and tenderness."[37] Whereas Longinus focused on how one can use sublimity to enthrall others, Burke attends to how one consumes the sublime. Whatever there would be in the way of struggle for Burke would occur within the subject, as a modification of some pain or difficulty, an action that attributes to the subject a certain capacity for resistance. In other words, Burke configures the subject of a sublime experience as one who exercises agency, for otherwise she fails to experience sublimity: "The passions which . . . turn on pain and danger . . . are simply painful when their causes immediately affect us" (51). However, this is not to say that Burke finds the experience to be compatible with reason. He analyzes what the subject of a sublime experience feels and how their senses react, all prior to any reasoning (46).

In Burke's account, then, the sublime requires a certain distance to enable the modification of whatever pain or danger one perceives. If an object appears to press too closely one needs to reduce the strength of the apparent threat (by realizing, for example, that one is not in any actual danger), a reduction that in turn produces a sensation Burke calls delight (51)—and whatever excites delight, we call sublime (32–37). Burke's understanding of distance is especially clear in his account of sympathy. Though he introduces sympathy as a social passion, it can either produce a feeling of the beautiful or of the sublime, depending on whether it attends to one's sense of sociability or self-preservation. "Sympathy must be considered," he says, "as a sort of substitution, by which we are put into the place of another man, and affected in many respects as he is affected" (44). As "a *sort of* substitution," sympathy involves a hypothetical skip along the "chain of society" to the place of another person— most famously, in the case of sublime sympathy, another person about to be executed. Though to get the full effect of the sublime one needs to approach the object of sympathy, one must not actually be in the place of the other; then one would be too close to the source of terror. "When danger or pain press too nearly, they are incapable of giving any delight, and are simply terrible; but at certain distances, and with certain modifications,

they may be, and they are delightful, as we every day experience" (40). The spectator viewing an execution, who is therefore *not* in the place of the object of sympathy, feels a kind of relief in her distance.

The differentiation that underwrites Burke's account of sympathy proves crucial for his understanding of the sublime. Sympathy shifts from a syntagmatic relation of contiguity (links in a chain) to a paradigmatic one of substitution (in the place of the other) only insofar as the latter remains hypothetical, governed by the nonalignment marked by the former (one after another, never in the same place). Of course an experience of sympathy based on beauty obeys the same logic. However, whereas the sublime merely insists on separation, the beautiful leads to action, to the desire to relieve the other in distress. Sympathy founded on the sublime leads to no such exchange. Most important, it suggests identity on the basis of a difference that must be simultaneously suspended and maintained, even demanded, an ambivalence central to Burke's notion of sublime experience. It is the total suspension of difference that threatens annihilation—that is, death as a state of absolute nondifferentiation. Anything absolute for Burke proves only terrifying, including total darkness without intermission of light, or "absolute and entire *solitude* . . . [which] is as great a positive pain as can almost be conceived" (43). Without a glimpse of difference, there can be no distance and hence no modification.[38]

Indifference, Difference

We could say that Crusoe's problems with the footprint follow from its startling, and hence paradoxical, indifference. The print—itself barely anything, almost nothing—offers Crusoe little more than its naked form. Beyond marking an alteration in the sand in the outline of a foot, it withholds any determinate content and thus any identity by which to know it as different (from other footprints, from someone who made it). As Peter Hulme suggests, the footprint is "more like a pure trace of the idea of otherness than the actual track of another human being."[39] Discovered at noon, time of no shadows, the print seems as if only shadow, ungraspable, almost insubstantial. In this light, consider the pun Crusoe makes on *one,* implying that the print obliterates difference and hence identity: "I went up the Shore and down the Shore, but it was all one, I could see no other Impression but that one." For this reason, Crusoe's difficulties do not stem from simple ignorance on his part. A blockage inheres in the

footprint: *that it is* does not lead to *what it is*. Crusoe's inability to divine a passage from *quod* to *quid* causes him, as we have seen, great anxiety, even, in Longinian terms, casting himself beside himself. None of his industrious endeavors proves capable of properly reducing the force of what *merely is* and the anxiety it generates. If the self's dumbfounding can in other contexts spur aggressive self-assertion, the footprint offers Crusoe nothing to assert himself against. He can bolster his defenses but they remain, in purpose, hypothetical. The mark is, in itself, almost nothing; kick the sand, and it disappears.

Burke himself articulates a like logic. "It is," he says, "our ignorance of things that causes all our admiration, and chiefly excites our passions" (61). He also offers a darker formulation of the same principle: "uncertainty is so terrible, that we often seek to be rid of it, at the hazard of a certain mischief" (83). What separates ignorance and uncertainty is their respective relation to self-preservation. One can know that one is ignorant of the full extent of the universe without feeling a sense of danger to self, but uncertainty, as Burke presents it, augurs a threat to the self, real or perceived. Burke's rationalization of a potentially violent response to uncertainty ("the hazard of a certain mischief") corresponds to an ethics of colonial violence or so-called defense that we find in *Robinson Crusoe*. There, as in Burke, uncertainty derives from a deeper certainty, the certainty marked by anxiety. Crusoe *knows* the cannibals would eat him and so is uncertain of his future—a complex sensation that leads him to entertain and enact various measures for his self-defense. But how to perform "mischief" in the total absence of cannibals? What we begin to see is that Crusoe, by having savages to kill, finds the opportunity to reduce his anxiety. They would present him the chance to annihilate anxiety's apparent source by enabling him to assert his self over others.

Crusoe's need for savages helps explain why he feels relief in finding the unmistakable tracks of their presence. Though the remains of the cannibal feast are like the footprint in being remnants of a previous, unseen action, the evidence it presents Crusoe is of a different order. The remains suggest a clear motive missing in the footprint. Most important, they offer solid ocular proof, so to speak. This, it seems, stops him from being overwhelmed by the fear of others. "I was so astonish'd with the Sight of these Things," he says, "that I entertain'd no Notions of any Danger to my self from it for a long while; All my Apprehensions were bury'd in the Thoughts of such a Pitch of inhuman, hellish Brutality, and the Horror of

the Degeneracy of Humane Nature; which though I had heard of often, yet I never had so near a View of before" (165). Whereas the footprint struck Crusoe with great fear, evidence of an actual cause for fear produces "no Notions of any Danger to [his] self."

Crucially, the two events and Crusoe's respective reactions to them form a chiasmus. On the one hand, Crusoe's response to the print seems contrary to expectations: rather than wanting "to sink into the Ground at but the Shadow or silent Appearance of a Man's having set his Foot in the Island," he ought to have felt blessed by the prospect of seeing "one of his own Species," which, he says, "would have seem'd to me a Raising me from Death to Life" (156). On the other hand, the arrival of savages leads not to fear but to relief and, though he later checks his enthusiasm, an eagerness to meet them in battle. Through the chiastic structure Crusoe assigns the footprint to a place predetermined by the rhetorical device. The mark becomes, as it were, an "X"—a placeholder within a larger cross-shaped structure.

The "Frame of Thankfulness" in which Crusoe's walks home after discovering the cannibal remains arguably references not just Providence but the four corners of the chiasmus (165). The chiastic frame helps him mentally set a border between himself and the savages, while enabling him to link the footprint to a determined structure of apparently empirical experience. The mark in the sand made clear to him his overproximity to the state of nature, whereas the remains of the cannibal feast show him what he is not: a savage in the state of nature where people eat one another. He thus gives thanks to God "that [he] had cast my first Lot in a Part of the World, where I was distinguish'd from such dreadful Creatures as these" (165); and he observes that "all these Things tended to shewing me more and more how far my Condition was from being miserable, compar'd to some others" (167). The frame, in short, facilitates a certain modification. The experience of that modification Crusoe the narrator represents as the experience of his historical self. Yet the experience articulates, at both historical and narrative levels, a retroactive bracketing and so modifying of the in-itself implacable footprint. No longer beside himself, Crusoe is "*In* this Frame," structured, bordered, relieved.

As with Longinus's rhetorical sublime, Burke's subjective sublime does not offer a perfect fit with Crusoe's experience. Crusoe discovers a strong impulse to action missing in Burke's formulation. Specifically, Crusoe wants to kill savages—his "certain mischief." We can say that his passion

for destroying "these Monsters" (168) derives from a kind of monomania whereby, in Burke's terms, his "mind is so entirely filled with its object" that "the great power of the sublime . . . anticipates [his] reasonings, and hurries [him] on by an irresistible force." Crusoe's desire is, he goes on to say, the product of "my Imagination" (169). But he does not labor long under the force of such passion. Departing from Burke, he looks to establish a rational foundation for further action. Crusoe appears to realize that if he did murder all the savages, the action would align him with the state of nature; he would be acting à la brute, given to murdering whomever he meets. Thus, holding "a Discussion . . . in [his] Thoughts" (170), Crusoe posits an international law of rights to which he links his and, by implication, the savages' respective situations. "These People," he says, "had done me no Injury" (171). "As to the Crimes they were guilty of towards one another, I had nothing to do with them; they were National" (173). In the absence of a wrong perpetrated against him, Crusoe has no right to attack and kill anyone—a proposition whose observance Crusoe represents to himself as a characteristic that would distinguish him from another form of brutishness, namely "the conduct of the *Spaniards* in all their Barbarities practis'd in *America*" (171).

By deductive reasoning, Crusoe proposes a higher symbolic level—a law of nations to supply the means to mediate between himself and the savages. By "National," Crusoe means something like *kind,* not nation-state (173). But what is important for him is the ability to conceive himself, in earthly terms, in a relation to the savages where one party could wrong the other. This would suggest his separation from the state of nature and his ascension to law as such. As Hobbes put it, "injustice against men presupposeth human laws, such as in the state of nature there are none."[40] What we see emerging in *Robinson Crusoe,* then, is a hierarchical chain. The primitive footprint, the savages, the law of nations, and, finally, Providence (175–76)—each represents a higher articulation of the former that produces in Crusoe's mind some sense of stability. So following the distortion and blanking of his world upon seeing the footprint ("it was all one"), Crusoe institutes from the ground up, so to speak, a hierarchy of world ordering along the lines of a Great Chain of Being.

What we find by following the two versions of the sublime through Defoe's novel is that Crusoe attempts to establish, by a genre of linkage, a determinate structure following upon an indeterminate judgment. Crusoe makes clear, however, that despite the paradigmatic structure of the

Great Chain of Being, following its foundation in earthly terms requires the temporal unfolding of syntagmatic form. Between the historical Crusoe and Crusoe the narrator, there lies the task of binding things in their unfolding. While Defoe's occasional eschatology would provide a strong determinate binding agent, in *Robinson Crusoe* Providence becomes a link itself. Though Crusoe defers to Providence as the mode of linkage—the creator of all things—his deferral in turn makes Providence one more link. For this reason, a higher level does not negate the previous level but rather is bound to it. The linking that Crusoe establishes may suggest order, yet it does not remove what troubled order to begin with. Disorder becomes order's internal limit, demanding a response that cannot be naïvely empirical. Thus Crusoe's positing of international law is, like the chiasmus, a kind of abstracting from the impulse to murder other human beings. He as it were scales the chain that he posits so as to reach a level at which he can, if not erase, then at least bind the previous link to a symbolic determination. However, that determination soon becomes symbolic in a quite different sense, hollowed out by the repetitions and elisions of Crusoe's narrative. Under these circumstances, we see how Crusoe's attempt to link the primitive and the savage shows up their prior categorical separation without presenting the means to overcome that separation.

Indian Mounds in the
End-of-the-Line Mode

O NCE AGAIN I WILL BE ADDRESSING the attempt to recast something
singular as something historical by way of a certain aesthetic logic—
though not, in this case, a logic of the sublime but rather a logic I suggest
we call one of serendipity. More concretely, I will be discussing North
American Indian mounds and the far-reaching problems late eighteenth-
and early nineteenth-century Europeans had in coming to terms with their
existence. Like Robinson Crusoe's footprint, the mounds edge out of time
and confound comprehension, though they produce a sense of insecurity
less on the egoistical level explored in Daniel Defoe's novel and more on
the grand, world-historical level of nations, territories, and peoples. The
mounds of the Mississippi and Ohio valleys recast the earth as radically
unfamiliar and perpetually unpredictable, an encounter whose dynamics,
as I hope to show, are brought out with particular force and clarity by the
notion of serendipity, first formulated in the mid-eighteenth century by
Horace Walpole.

Before the North American earthworks could shake history and earth,
there was a basic problem of recognizing, let alone comprehending, the
mounds. Once recognized, mounds might usher in all sorts of disorienta-
tion and wild surmises in a manner akin to Crusoe's footprint. But whereas
Crusoe was never in doubt as to what he saw—that indexical print of
a human foot on the shore—Europeans in North America struggled to
establish whether or not they stood before an earthwork or a natural devi-
ation in the land. The profound confusion the mounds would induce thus
follows an initial and successful act of cognition. Reversing the logic of
Crusoe's sublime reassertion of mastery, those encountering a mound
need to first produce, by way of the understanding, a determinate concept
of mound qua earthwork with which to successfully perceive an unexpected
feature of the landscape. Only then do we witness the onrush of confu-
sion and disorientation, as Europeans confront this thing that solicits an
unknown, alien past that seems to beckon from beyond time. For reasons

I will develop below, the initial act of cognition required for recognizing a mound, and the shaking of one's relation to earth and history that follows, casts the encounter with them as a form of serendipity.

I should say a few words about this chapter's organization. Unlike the previous three chapters this chapter is not centered on a single text. It moves through numerous texts that arguably belong to numerous—and, for experts in the respective fields, incommensurable—contexts. Such experts will perhaps find the attention paid to their particular field insufficient. However, the apparent shortcomings are not entirely my own. They are in some sense symptomatic: if the evidence I present seems an assemblage of shreds and patches of heterogeneous origin, it is because that is the form of the available evidence. There is no disciplinary or field-specific context that governs writing on the mounds. I will, though, offer ways of understanding the obscure dynamics that orient encounters with mounds late in the eighteenth and into the nineteenth centuries. For what we are dealing with is less the structure of disciplines and fields and more the event of a reiterated encounter that exhibits a logic of serendipity. Hence my inclusion, as an appendage of sorts to the chapter's primary object (the mounds), of a secondary aim (an account of serendipity) that requires spending some time establishing what serendipity might actually mean. As will become clear, we no longer appreciate serendipity's full range and force, from which follows its significance vis-à-vis the mounds. *Serendipity* as we use the word today is a pale and mild-mannered version of its eighteenth- and nineteenth-century incarnation.

With such caveats in mind, the trajectory of this chapter is roughly as follows. After first discussing the difficulty of seeing the mounds and establishing why this engenders a kind of sublime in reverse, I turn to elaborate in some detail Walpole's notion of serendipity (a word, I should note, of exotic coinage, derived from Serendip, one of the many variant European spellings used to translate the Arabic and Persian names for what the eighteenth-century English called Ceylon, or present-day Sri Lanka). As it turns out, serendipity's close relation to archaeology and the subject of ruins brings out with especial clarity the highly wrought dynamics of an encounter with what appears in the end-of-the-line mode. This phrase, which I borrow from Neil Hertz (who borrowed it from Kenneth Burke), highlights the paradoxical aspect of mounds that, on the one hand, can barely be seen, and, on the other hand, are singularly opaque; the minimal difference between a mound of earth and the land surrounding it

makes looking at a mound akin to perceiving, in Hertz's terms, "black against black."[1] The problem becomes one of determining whether the rising earth reflects only itself or an act of human labor. As we will see, late in the eighteenth century a determination on the side of art rather than nature starts to rattle the understanding. At this point, I turn to North American archaeology's birth in destroying mounds, an action aimed at binding the mounds to a stabilizing vision of history through what T. H. Huxley, late in the nineteenth century, called "retrospective prophecy"— his recasting of serendipity as the necessarily allegorical structure of archaeological knowledge.

Seeing Mounds

"Standing before the Miamisburg mound," the abstract expressionist painter Barnett Newman asks "what difference if the shape is on a table, a pedestal, or lies immense on a desert?" Though he puts the question rhetorically, Newman nonetheless goes on to mark a profound difference between such earthworks ("perhaps the greatest art monuments in the world") and other kinds of artworks and artifacts. A mound is, he says, "nothing that can be shown in a museum"; it is "a work of art that cannot even be seen, so it is something that must be experienced there on the spot." Site specific and, in offering little to the view, indifferent to institutional display, mounds refuse museological archiving and exhibiting practices. Certainly mounds can be destroyed (most have been), but they cannot, as the economy of the archive requires, be destroyed and preserved at once. A mound of earth cannot be cut from its original context (the act of destruction) and resituated within the new context of the museum archive (the act of preservation), available for study or exhibition. Its covering of grass and trees would fall away; it would come apart, lose its shape; it would no longer cut into the wide Midwestern sky.[2]

One might say that the Miamisburg Mound is itself an archive, that it forms a potential gathering place for various objects, like the bones of the deceased, which would be the archive's content. However—and this is crucial—the mound as such, the mound *as a mound,* exists only by denying access to whatever it contains. It hides its contents from view such that one cannot tell, looking at a mound, whether it contains anything more than mere earth. As Ephraim G. Squier and Edwin H. Davis put it in their foundational work, *Ancient Monuments of the Mississippi Valley* (1848),

what a mound holds, and so what it holds out for a certain knowledge, is only "disclosed by the mattock and the spade."[3] Otherwise a mound gives little to notice, especially the classically conical mound like that at Miamisburg. Whereas one may at least organize effigy mounds within a taxonomy of animal types (alligators, bears, birds, serpents), what those mounds exhibit—bends and lines, specific and varied characteristics—the conical mound does not. That mound's form appears at best simply characteristic of what it is. As a largely blank surface of earth, presenting few if any isolatable features that one could describe, the conical mound differs from the surrounding landscape only by a certain angle of incline.

The mounds' minimal difference from the landscape may help to explain why the full range of known sixteenth- and seventeenth-century European comment on the earthworks amounts to a few passing references in the chronicles of Hernando de Soto's expedition (1539–43). In June 1541, for example, the expedition came upon "some very high mounds [cerros], made by hand." As with the expedition's discovery of the Mississippi River (which "did not," Mark Twain would point out, "excite that amount of curiosity . . . [to] thus move other adventurers to go at once and explore"), its happening upon mounds did not ignite European desire to seek them out.[4] Not until 1750 do we find perhaps the first mention in English of a mound, itself characterized by the earthwork's failure to strike the observer, Thomas Walker, either as awe-inspiring or as an object for further consideration. In his posthumously published *Journal of an Exploration in the Spring of the Year 1750*, Thomas Walker writes: "Below the mouth of this Creek, and above the mouth are the remains of Several Indian Cabbins and amongst them a round Hill made by Art about 20 feet high and 60 over the Top. We went up the River, and Camped on the Bank."[5] Even when Europeans lived in areas dotted by earthen mounds (as did French traders, for example, in what is now the Nashville area), before the 1770s they gave mounds little notice. As Squier and Davis note, "The fact of the existence, within the valley of the Mississippi river and its tributaries, of many ancient monuments of human labor and skill, seems to have escaped the notice of the adventurers who first made known to the world the extent and fertility of that vast region." In other words, early Europeans appear to have traveled through land laced with mounds without seeing them (or at least without recording having seen anything like them), making Newman's claim that a mound "cannot even be seen" one of great historical insight.[6]

Late in the eighteenth century, Euro-Americans start to realize that for the waves of settlers now heading into the Ohio Valley, the earth might not be all that is before them.[7] Not only were there bands of Indians still surviving disease and displacement, there were things in and of the earth itself. While I would not suggest that an age of insight now surpasses one of blindness (most obviously, mounds seem to remain hard to see to this day, just as they remain largely unacknowledged), we do find late in the eighteenth century an especially acute moment of initial, if at best partial, recognition. The questions that nineteenth-century writers would obsessively ask of the earthworks—what are they? and where did they come from?—belie the initial difficulty Europeans had in coming to terms with the surprise of their *being there*. In turn, we today have found it difficult to come to terms with that late eighteenth-century surprise.

The various nineteenth-century accounts of the earthworks have been subject to much scholarly attention, as have the earthworks in and of themselves. We have a large corpus of existent scholarship on both topics.[8] What remains mostly ignored is the particular pressure that the mounds placed upon late Enlightenment thinking. More than merely describing tumuli and other earthworks, like walls and fortifications, late eighteenth- and early nineteenth-century writers struggle to establish the grounds to acknowledge and to think the earthworks. That struggle plays out most vividly, and with the most far-reaching implications, in attempts to understand the conical mounds of the Ohio Valley. For unlike the fortifications, for example—and even, we can add, the platform mounds common to the southern Mississippi Valley—the conical mounds seemed lacking not only in a clear purpose but also in those straight and perpendicular lines suggestive of human invention. When considering early European encounters with these obscure mounds, the relevant questions become: How does a certain deviation in terrain become recognizable as a mound? And what takes place when it does?

The Sublime Reversed

Early accounts of mounds were commonly couched in the idiom of aesthetic appreciation. This is not surprising, given a mound's apparent obscurity and the attendant difficulty of attaching to it a determinate concept. Because the senses barely seem able to show all there is and as reason stumbles in supplying answers, writers and observers often call upon the

imagination as if it remained the one faculty able to extend itself when faced with a mound. Tropes of the sublime, the grand, and the picturesque prove especially abundant in rendering a mound as an object of intuition. William Bartram and H. M. Brackenridge, for example, each favor *stupendous* as the appropriate adjective to express their sense of astonishment: "I observed a stupendous conical pyramid, or artificial mount of earth" (Bartram); "what a stupendous pile of earth!" (Brackenridge). Bartram's and Brackenridge's *stupendous* is already quite an achievement. The degree of obscurity entailed in these early encounters with mounds requires on the part of the observer an initial act of understanding to know whether or not she is—or, more simply still, whether or not she even might be— facing a mound.[9]

The understanding's central role in encountering a mound means that we are not in the realm of the sublime found in *Robinson Crusoe* (or, for that matter, of the beautiful in Kant). For Crusoe the intuition of a mark in the sand confounds his reason, throwing him beside himself, out of all knowledge of himself, anthropologically insecure if not destitute. In Edmund Burke's terms, as we have seen, sublime astonishment is not "produced" by "our reasonings"; rather, it "anticipates our reasonings," hurrying "us on by an irresistible force." Only subsequently does reason regain a foothold, convincing one, say, of one's safety, lessening one's pain to engender the delight characteristic of an aesthetic sublime experience. Hence it is Crusoe's attempt to reinstitute the self-mastery confounded by the encounter with the singular footprint that makes the episode unfold according to the logic of an assertive and extensive sublime.

Generally speaking, things prove quite different for one who comes upon a mound. We find taking place a kind of a sublime in reverse—an act of reason or understanding that leads to an encounter with something excessive vis-à-vis reason or understanding. Realizing that one stands before what A. J. Conant, writing late in the nineteenth century, called the "footprints of vanished races in the Mississippi Valley," one must first assert the understanding, even if that assertion then leads to understanding's suspension. Only by an act of understanding does one bring forth what turns out to be a sharp limit to understanding, a limit that therefore shows up one's ignorance as much as it does one's insight.[10]

A concept formulated in the eighteenth century can help us think through this reversed sublime. The concept, *serendipity*, attends precisely to the understanding's role in what nevertheless remains an aesthetic

experience. This sense of serendipity is distinct from today's sense of an unlooked-for yet pleasant discovery. The word we now know names an entirely positive force, defined in the *OED* as an act of "making happy and unexpected discoveries by accident." However, as Leo A. Goodman points out, uses of the word before the twentieth century "suggest a meaning . . . somewhat different from what now appears to be its present usage."[11] What has changed, Goodman finds, is that whereas serendipity now suggests the happy progress of scientific knowledge, previously it could suggest outcomes more frivolous or more ambiguous and threatening. As I will show, the eighteenth-century notion of serendipity addresses itself to two crucial questions: what happens when certain barely apprehensible marks suddenly solicit the living? And how does one come to know these marks? As such, serendipity concerns less the content of any gained knowledge than the act of unexpectedly recognizing the traces of something about which to posit knowledge. Already we should sense serendipity's relevance to the problem of encountering a mound, which prompts like questions: How does a certain deviation in terrain become recognizable as a mound? What takes place when it does? Before we can begin to take full measure of this resemblance, we need to spend some time establishing the older, outmoded sense of serendipity. As Goodman indicates, to return to the eighteenth- or nineteenth-century understanding of the word is to return to a now unfamiliar sense.

Understanding Serendipity

Serendipity 1: Walpole's "Accidental Sagacity"

Horace Walpole coined the term *serendipity* in 1754, defining it as an act of *"accidental sagacity."* In the letter to Horace Mann where Walpole introduces the word, he initially refers to "a critical discovery" that he had made as "almost of that kind which I call *Serendipity*." The difference Walpole marks with the qualifying *almost* is due to his looking for what he found, namely information on the Italian Capello family's heraldic arms. While what Walpole found altered his knowledge of the Capello arms, that was what he had set out to do: to learn more about the arms. Insofar as Walpole exhibited accidental sagacity, it lay in his going straight to the right book for the information he desired without knowing in advance that this book rather than another contained that information.[12]

As serendipity, accidental sagacity lacks the intentional structure apparent in Walpole's own "*sortes Walpolianae,* by which I find everything I want" (407). While serendipity retains an analogous moment of vatic revelation, what it reveals is nothing one was aware of wanting:

> One of the most remarkable instances of this *accidental sagacity*
> (for you must observe that *no* discovery of a thing you *are* looking
> for comes under this description) was of my Lord Shaft[e]sbury,
> who happening to dine at Lord Chancellor Clarendon's, found out
> the marriage of the Duke of York and Mrs. Hyde, by the respect
> with which her mother treated her at table. (408)

Here Shaftesbury turns from blindness to insight in a movement that entails his being surprised in a weak sense of the term. Suddenly he perceives certain marks that support an otherwise unexpected and unlooked-for knowledge. The act of accidental sagacity therefore proves tethered to a prior ignorance, even if that ignorance is itself only realized at the moment of insight. That is to say, the moment of surprise (the accident) turns on a hinge that binds a necessary blindness to the instant of insight, with the latter taking place as a sudden realization of an unlooked-for discovery ("*no* discovery of a thing you *are* looking for comes under this description").

I should underscore at this point that serendipity's structural dependence on ignorance signals one aspect of its aesthetic provenance, aligning it with contemporary notions of the sublime and original genius. All three terms address an elevated power taken to reside in the human that lies outside of direct human knowledge, a power that—whether as accidental sagacity, transcendence, or unexampled creativity—transcends the formulaic and predicable. Consider how Percy Shelley, writing in 1821, effectively runs all three together as he presents poetry's force of creation: "[Poetry] acts in a divine and unapprehended manner, beyond and above consciousness. . . . It awakens and enlarges the mind itself by rendering it the receptacle of a thousand unapprehended combinations of thought. Poetry lifts the veil from the hidden beauty of the world; and makes familiar objects be as if they were not familiar." The divine and thus nonhuman inspiration that produces poetry; the elevation of thought through a multitude of as yet unknown combinations; the unexpected arrival of all this in a way that makes the familiar unfamiliar—here Shelley casts genius, the

sublime, and serendipity in the same frame, each supporting and drawing power off from the others. In Shelley's formulation, all three entail going beyond the (thus) merely human from within the human.[13]

Shelley's casting of serendipity as a kind of making strange ("makes familiar objects be as if they were not familiar") alerts us to a central feature of its subjective force. Because the occurrence of serendipity, and therefore its cognitive dispensation, cannot be predicted in advance, sagacity's standing under the accidental entails a certain loss of bearings. Serendipity may reveal a logic of development (the progress of the duke of York's and Anne Hyde's relationship, for example), but it itself occurs as a break of sorts— a break that, to differing degrees, transforms the past as one had lived it. Likewise, serendipity may, on one level, involve tying effects (Anne Hyde's mother's behavior) to causes (the marriage of the duke of York and Anne Hyde), yet on another, higher level, it upsets the teleology of cause and effect that would bind one's past actions to a future predicated on those past actions. With serendipity, one suddenly faces the future standing on unfamiliar ground; the particular past orienting one toward the future will have been quite different to what one thought one's past had been.

Obviously the force of surprise attending an act of accidental sagacity could vary greatly. Shaftesbury was far from unsettled by the knowledge that a certain secret had shadowed his interactions with the duke of York. His discovery may even have lent him a welcome degree of power over the future James II, whom Shaftesbury did not entirely trust, and who was not yet acknowledging his marriage to Anne Hyde. But one can recognize in Walpole's notion the potential for more far-reaching revelations. Consider a common reference in discussions of serendipity, Columbus's happening upon the New World when in search of a way west to the (subsequently) East Indies.[14] Though strictly speaking not itself an act of accidental sagacity (Columbus never realized that he had not in fact landed in the East Indies), when the nature of Columbus's so-called discovery is recognized in Europe, the world becomes quite a different entity, no longer what it had seemed. It becomes something unknown but nevertheless there all along, now becomes legible and shifting the grounds of Christian Europe's way of being in the world, as it did of those soon-to-be-decimated populations of the New World. As serendipity makes the once illegible suddenly legible, it enacts a retroactive force that does not leave the past alone. The familiar past and one's assumed experience of it turn into something now unfamiliar.

Serendipity 2: Huxley's "Retrospective Prophecy"

To realize the significance of history's open condition for attempts to cognize the North American mounds, we need to understand serendipity's particular association with ruins. It is the relation with ruins, which is a relation not of identification but of a crucial difference, that most vividly secures serendipity's relevance to the North American mounds, although in a somewhat dialectical fashion. Keep in mind that while we may freely consider the mounds as ruins, they initially proved difficult to think of as such. A ruin is presumably a product of art and not nature. As we will see, serendipity suggests how the mounds could be conceived as ruins and so as monuments once made by human hands, though with an important distinction: while ruins and serendipity both address the appearance of existent traces whose legibility is not guaranteed in advance but whose decipherment would appear to constitute a gain in knowledge, the two part insofar as the ruin constitutes a preexisting, empirically verifiable object, while serendipity addresses situations where, as we shall see, empirical judgments prove far less secure.

Walpole himself implies a relation between serendipity and the ruin when he introduces the neologism in the context of his antiquarian endeavors. T. H. Huxley, late in the nineteenth century, presents the most direct link when he recasts serendipity as *retrospective prophecy*.[15] As a method of positing likely causes of past actions from visible, though often vague, effects, retrospective prophecy recalls serendipity first in being bound to a degree of blindness, and second in marking within itself an aspect of incompletion and insufficiency. Now as Huxley points out, prophecy does not necessarily address the future. It merely concerns our projecting, on the basis of materials that are available and known to us, events and actions that we do not directly know. Hence the prophetic nature of sciences such as archaeology: they "strive towards the reconstruction in human imagination of events which have vanished and ceased to be" (933). Huxley insists on calling such imaginary reconstructions prophetic to underline his sense that what one reconstructs cannot, without subsequent confirmation and often never, be verified. It is, he says, a "process of divination beyond the limits of possible direct knowledge" (931, 934). One looks beyond what one can see.

As with serendipity, retrospective prophecy requires insight and reflection. Though whereas Walpole locates serendipity's gain of knowledge in

an accidental act, Huxley formulates the gain of knowledge as structurally accidental. Due to the problem of verification, one cannot confirm whether the posited causes hold an essential or nonessential (and thus accidental) relation to the effects. If one did manage to make the causes essential to the effects, then one would remove the element of prophecy. That retrospective prophecy should nonetheless prove proximate to serendipity (albeit with the accidental being displaced into the domain of verification) is unsurprising insofar as Huxley founds the concept on a reading of "Le chien et le cheval" from Voltaire's *Zadig ou la destinée* (1748). That chapter constitutes Voltaire's reworking of the same, widely repeated episode from the *Voyages et aventures des trois Princes de Sarendip,* which had suggested to Walpole the idea of serendipity.[16] Walpole presents the episode's basic outline in his letter to Mann:

> I once read a silly fairy tale, called *The Three Princes of Serendip:* as their highnesses travelled, they were always making discoveries, by accidents and sagacity, of things which they were not in quest of: for instance, one of them discovered that a mule blind of the right eye had travelled the same road lately, because the grass was eaten only on the left side, where it was worse than on the right—now do you understand *serendipity?* (407–8)

Such chance and unlooked-for yet virtuosic discoveries enable the princes to inform the muleteer where his lost animal had traveled, though the princes had not themselves laid eyes on the beast. From a series of effects, the princes posit certain causes: they take the fact of grass having been eaten only on one side of the road, when the grass is actually better on the other side of the road, to indicate that a mule blind in its right eye had traveled that road. Here, serendipity lies in recognizing something not looked for or expected (the traces of a mule), while the modality of inquiry conforms to retrospective prophecy's reading of the various *Traces* and *Marks* in the absence of verification (these marks *are* those of a given mule).

If Huxley alerts us to the provisional nature of a serendipitous judgment, he does not suggest that one can imaginatively reconstruct anything at all. Retrospective prophecy works only if one can read the available traces as signs, where the putative referents would occupy the place of probable causes. "Archaeology," Huxley says, "which takes up the thread of history beyond the point at which documentary evidence fails us, could have no

existence, except for our well-grounded confidence that monuments and works of art, or artifice, have never been produced by causes different in kind from those to which they now owe their origin" (935). Accordingly, the archaeologist who aims to explain ancient works cannot accept as causes any apparently nonhuman forms of agency such as miracles or magic. A corollary of this causal limitation is that artifacts need to be historically probable. If we date the steam engine's invention to mid-eighteenth-century England, we would not likely prophesy (in Huxley's quotidian sense of the word) its use in Paleolithic Lascaux. In short, Huxley's gloss of Zadig's "great principle"—"like effects imply like causes"—needs to be qualified. The causes need to be historically likely, according to one's previously settled understanding of history.

We can gain a more nuanced understanding of Huxley's claim and its relation to Walpole's serendipity by asking whether the imperative to present past actions in *historically likely* terms might not close out serendipity. While Walpole's concept suggests the surprise discovery that things are not what one assumed them to be, the proposition "like effects imply [historically likely] causes" would bind the past and the present within a prescribed and thus predicable framework. How, under such circumstances, can a discovery generate the force of a surprise whereby one's faculties could be overtaken? We need to recall that the imperative in question (that one present past actions in historically likely terms) corresponds to a certain moment within the broader structure of serendipity: that of elaboration. Returning to serendipity's general structure, its surprise is the revelation of an apparently coherent cause and effect relation. The three princes perceive various unlooked-for effects that, as all versions of the tale make clear, no one else had seen. Certainly the princes prove virtuosic in postulating likely prior causes, but their great, serendipitous sagacity follows from recognizing the obscure marks of invisible causes—from recognizing, in other words, the presence of signs where everyone else saw a blank desert.

However, Huxley's imperative alerts us to something important that Walpole obscures: the temporal disjunction between the claim and its verification. To propose what is historically likely means precisely to propose something that remains to be verified, just as the hypotheses of Shaftesbury and the three princes await confirmation. Walpole, however, through the economy of his examples, foreshortens out of existence the

time between discovery and confirmation. Shaftesbury may have "found out" the marriage of the duke of York by reading signs, but he did not find out until later that he had read the signs correctly. Likewise, the three princes may have found the tracks of a mule, but they have no means to verify the existence of a mule until they meet the muleteer—which is still not to see the mule. Indeed, the three princes never do see the animal; confirmation of its existence rests on the muleteer's testimony, not on the object itself. Moreover, how the princes gain their knowledge remains unknown until the end of both the adventure and the tale, a deferral that thereby structures the narrative. The plot's emphasis lies less with the re-covery of a lost mule (let alone the pregnant woman it turns out to have been carrying) than with the acts of sagacity that identified the mule. The princes' insights themselves do not even lead to the animal's recovery, it being found by other means. The various and apparently unformed aspects of the narrative coalesce only in the final act of revelation: this is how we, the three princes, divined the mule's features and actions.

If the way Walpole presents his examples draws attention away from the originally nonessential relation between knowledge and object, his insistence on the word *sagacity* nonetheless implies that the initial act of interpretation does take place outside of verification. Serendipity must not be seen to deal in the immediately obvious, and unlike knowledge or judgment, sagacity indicates that one is dealing with obscure matters. Quintilian, widely read and cited in the eighteenth century, presents the distinction with great economy: "Judgment," he says (in William Guthrie's 1756 translation), "does not greatly differ from Sagacity, only we apply the first to the Management of Matters that are already evident, and the latter to the Discovery of Matters that are either obscure, or not found out, or doubtful."[17] With the word *sagacity,* Walpole implies the accidental aspect of serendipity's initial gain in knowledge to which Huxley had directly alerted us. Because serendipity's accidental discovery is structured by a temporal delay or disjunction, serendipity's sagacity is accidental, not only because it follows from chance events, but also because it offers a gain in knowledge that comes as a surprise and remains to be verified. The new knowledge stands unconfirmed as essential to its object. At the moment of serendipitous discovery, the accuracy of one's sagacity remains to be verified—though one already achieves a great deal in perceiving the traces and marks upon which to exercise sagacity.

Serendipity 3: Causes without Discernible Effects

Before we can turn toward the mounds, we need to address one final facet of serendipity. An act of virtuosic sagacity harbors a danger. It can invade more certain knowledge. Insofar as serendipity reveals a cause-and-effect relation in the apparent absence of such a relation, it suggests that while effects may have deducible or at least conjectural causes, causes do not necessarily have readily legible effects. Jean-Jacques Rousseau, in his *Discours sur les sciences et les arts* (1750), suggests that "where there is no effect, there is no cause to discover."[18] But serendipity questions the confidence Rousseau places in being able know that there is an effect about which to posit a cause. It reveals an incomplete world where one cannot be sure that a given cause necessarily has a cognizable effect. The world becomes an estranging force, containing not simply signs one cannot read, but also causes and effects whose marks one might not recognize, let alone convert into signs that might be deciphered. Yet precisely because the world becomes estranged and suspiciously inscrutable, there always remains the possibility of an unexpected and disconcerting history suddenly flashing into legibility.

The sudden flash that an act of serendipity generates does suggest a certain configuration; it is not simply any kind of flashing into legibility. Insofar as serendipity reveals, by chance, that there is something rather than nothing, or rather something where there seems to be nothing in particular, it entails the accidental recognition of a certain unity or ordering in the apparent absence of a unifying principle. That recognition, if we were to phrase it in the language of aesthetic appreciation, would present an apparent unity in the manifold that thereby produces a certain pleasure for the spectator. It is perhaps for this reason that in the *Voyages et aventures des trois Princes de Sarendip* pleasure follows from viewing the act Walpole calls serendipitous: "Les observations de ces trois jeunes princes donnèrent tant de plaisir à l'empereur." The sudden recognition of unity and order where there had been only difference and disorder gives the sovereign spectator "tant de plaisir."[19]

It will help to recall Joseph Addison's claim in "The Pleasures of the Imagination" that a particular pleasure follows from perceiving the meeting of chance and design. For Addison, that pleasure was due to a "double principle" whereby one gains an overplus of pleasure when making out an object of nature that appears as if it were a work of art, and vice versa.

Jonathan Lamb's gloss on the notion is especially telling: "The mind's chief delight is to oscillate as rapidly as possible between the perceptions of the same thing as both natural and artificial." "It rises from the same source," he continues, citing Addison, "when we locate 'the effect of design, in what we call the works of chance.'"[20] Whether or not serendipity leads to the disinterested pleasure that Addison seeks to delineate, his "double principle" helps elaborate the logic of serendipity's striking revelatory force. At bottom, Addison's double principle and Walpole's accidental sagacity formulate modalities of appearing where something becomes different from its familiar form without that familiar form itself being transformed. For Addison as for Walpole, the spectator's pleasure follows from her awareness that the unfamiliar has crossed through, but not crossed out, the familiar. The familiar must remain remarked in the form of what is now unfamiliar, or at least novel. Importantly, the insistence of this double aspect—of the familiar thing crossed through with the unfamiliar—harbors a certain instability. Nature and art may come together, resembling one another, yet only insofar as each secures its heterogeneity from the other—a double bind of identity and nonidentity that means the object's identity will be difficult to secure as long as the double principle remains in effect. The object splits in two incompatible directions.

At this point we can return to the mounds, whose identity proved a notable source of insecurity for late eighteenth-century European observers. No Aristippus, shipwrecked on the Ohio River, stepped ashore, observed a mound, and proclaimed with confidence to his companions, "Rejoice! for I see the signs of men!" Shipwrecked "on the coast of Rhodes," Aristippus had famously found "some geometrical figures there described" in the sand.[21] Those encountering the mounds in the middle of North America made out no unambiguous inscription testifying to human intention. Although the mounds struck some observers as natural formations, many observers thought they presented marks of a potential human intention. Notably, the marks in question tended to reference some form of geometric organization. In certain areas mounds appeared either grouped into apparently artificial patterns or placed next to raised earthen fortifications of various geometrical shapes. However, even here the faint cross of Addison's double principle unsettles a secure cognitive relation with the mounds. As we will see, in the late eighteenth century nature and art awkwardly yet insistently coalesce in a mound, rendering its presentation in a unified intuition extremely difficult. The chiastic crossing of art and

nature marks a void—the point where the "X" of a chiasmus turns—that becomes ever larger and ever more unavoidable. Consequently, knowledge appears less secure and more accidental, even as Europeans obsessively attempt to discover, in the scraps of unsecured knowledge, an as yet unforeseen design.

Recognizing Mounds

Early accounts of the Ohio Valley monuments exhibit less the disinterested presentation of order amid a manifold, and more the vertiginous surprise of serendipity. They register the shock as an imposing pressure placed upon European understanding. The pressure manifests, on the one hand, negatively, in the degree of virtuosity required to recognize the presence of a mound, and on the other hand, in the direct challenge the earthworks present to well-defined expectations. Of course, what European travelers into the Ohio had expected was precisely nothing, *terra nullius*. But for some of those travelers the earth as it were suddenly shifts, soliciting the grounds of knowledge. What stands revealed is the possibility of a past both new and unforeseen. The revelation occurs both at a particular level and at a general level. Europeans have difficulties recognizing not only the existence of particular mounds, but the possibility that such monuments could even exist.

Concerning the earthworks' possibility, their existence did not sit well with the image of North America and its inhabitants common to the dominant strains of Enlightenment political philosophy. As is well known, for Hobbes, Locke, and Montesquieu alike, America was wasteland populated by itinerant savages alone—for Hobbes a place without law, for Locke a place without the institution of property relations, and for Montesquieu a place where people have not united together to form nations. Of the three, Montesquieu proves notable for considering evidence contrary to his conclusions. And that evidence concerns a group of Indians to which his source, the Jesuit père Mathurin le Petit, attributed the production of monumental earthworks. If we can believe such accounts as le Petit's, says Montesquieu, the Natchez of Louisiana formed a centralized, even despotic society, yet they lacked, like other North American Indians, the use of money that would bind them together within a single exchange economy, and, by implication, the means of extensive cultivation that would ordinarily enable such social organization. The absence of a complex

social organization means, for Montesquieu as for others, an attendant absence of monumental architecture. Without a division of labor, how could the necessary and large laboring population be supported?[22]

Accounts that mention the earthworks remain sporadic enough for Montesquieu and his contemporaries to be in no way compelled either to acknowledge or to discount their existence. No great tide of evidence can be said to have yet broken upon European awareness. To the extent that such a tide arises, its material conditions lie largely in new Euro-American settlement patterns after the American Revolutionary wars of 1775–83. Previously, areas of direct and sustained European action in North America were restricted to the Atlantic coast and Hudson Bay (Britain), Florida and Texas (Spain), and the Great Lakes, including the St. Lawrence and Mississippi rivers (France), augmented by travels into other areas by traders, missionaries, and explorers. While some Europeans entered the Ohio Valley (British traders begin passing beyond the Alleghenies in the 1740s), the area remains largely unexamined and unknown.

The Ohio Valley becomes a place of extensive European settlement only after the new United States claims the territory from Quebec. Migration from the Atlantic states puts large numbers of Europeans in close proximity to the valley's numerous and varied monumental earthworks. In some cases, seeing a mound and knowing it to be such becomes unavoidable. Thomas Ashe, who traveled through Cincinnati in 1806, describes the presence there of a "barrow or funeral pile . . . seated in the centre of the upper and lower town on the edge of the upper bank. The principle street leading from the water is cut through the barrow, and exposes its strata and remains to every person passing by."[23] While settlement brings proximity, proximity does not of itself bring closer scrutiny or greater recognition. Problems persist in perceiving and acknowledging the existence of particular mounds. The earthworks do not seem to show themselves, to give themselves to the view, making the difficulty of recognition persist even when the presence of mounds lies beyond doubt—a difficulty that cannot be explained away, then, as a mere lack of information.

Thomas Jefferson, for example, in his *Notes on Virginia* (1787), does not quite seem to know how to acknowledge the mounds, and when he does, he does so reluctantly, with qualifications. Anthony F. C. Wallace argues that Jefferson's reticence is especially notable given that the widely read Jefferson would likely have come across recently published work on aboriginal architecture. Certainly Jefferson appears to have known of

native-built fortifications, and in the *Notes* he mentions, without elaborating, that mounds of "differing sizes" can "be found all over this country." Nonetheless, Jefferson famously claims, writing in the tradition of Montesquieu et al., "to know of no such thing as an Indian monument: for I would not honour with that name arrow points, stone hatchets, stone pipes, and half-shapen images. Of labour on the large scale, I think there is no remain as respectable as would be a common ditch for the draining of lands." "Unless," he adds, "it be the Barrows"—earthen burial mounds, like the one on his estate whose excavation he goes on to describe.[24]

Jefferson makes his admission ("unless indeed it be the Barrows") in a context opened, and so limited, by the question, is there "such [a] thing as an Indian monument"? Much thus depends on what Jefferson understands by *monument*. He uses the term in two distinct ways that we can identify as figural and literal respectively. On the one hand, Jefferson says it would carry an unwarranted honor to diminutive, perhaps rude, objects of use or superstition ("arrow points, stone hatchets, stone pipes, and half-shapen images"). Here Jefferson invests *monument* with a power to do something to the object it names. Serving as an honorific title of sorts, it would not so much describe as dignify the putative object. On the other hand, the particular honor that Jefferson suggests the word would carry to an object derives from the literal use he makes of it to name an object of significant public works ("Of labour on the large scale"). In other words, *monument* properly names for Jefferson a work of great labor and, because it applies only figuratively to small, simple objects, of significant size and complexity.

We should avoid thinking that Jefferson takes the simple fact of an object's size alone to determine its potential monumental status. He does not suggest, for example, that an object forty feet high is necessarily more monumental than one ten feet high, while in a letter to George Wythe dated January 16, 1796, he claims that the past laws of Virginia, existing now only as dispersed and tattered papers, constitute the "precious monuments of our property and our history."[25] What Jefferson finds crucial is the labor's large scale, by which he does not appear to mean Crusoe's solitary and "infinite labour," but labor large on a public scale. Such public-scale labor might be manifested in laborers erecting a large statue or in an assembly drafting state laws. Crucially, both require a certain division of labor. As with Montesquieu, with Jefferson it comes down to social organization, and particularly the Indians' apparent lack of a society complex enough to support a division of labor.

Jefferson does not believe that the twelve-foot-tall mound on his estate required much labor. Nor does he take it to be of astonishing size. If the mound can be called a monument, he implies, it is not because of its shape or its manufacture but because of its basic function. If a simple tomb is to be called a monument, then we have to call the barrow a monument. Jefferson could not, of course, designate the mound a monument in this sense (that is, as a tomb) by simply looking at the shape before him. To establish the mound's apparent function, he first would have to find out what lies inside it by excavating and so destroying it. Apprehending a mound *as a mound* without destroying it involves the more uncertain act of recognizing that *there is* something rather than the expected *terra nullius.*

Here we start to see the importance of large earthworks like the Miamisburg Mound Newman visited, or the similar-sized Grave Creek Mound in present-day West Virginia. Europeans might freely acknowledge small-scale Indian burial grounds where mounds formed a "swelling turf," as the poet Philip Freneau put it in his "Lines occasioned by a visit to an old Indian burying ground" of 1787. Such burial grounds could readily be addressed outside the question of whether there is "such [a] thing as an Indian monument" that is not a simple tomb. But at seventy feet tall, the Miamisburg and Grave Creek mounds make quite different demands. They attain to what Lord Kames (who, according to Henry F. May, was Jefferson's "life long guide in such diverse fields as law and aesthetics") would call grandeur. In fact, Kames sets about explaining grandeur by considering our approach to conical hills of varying size:

> Approaching to a small conical hill, we take an accurate survey
> of every part, and are sensible of the slightest deviation from
> regularity and proportion. Supposing the hill to be considerably
> enlarged, so as to make us less sensible of its regularity, it will upon
> that account appear less beautiful. It will not however appear less
> agreeable, because some slight emotion of grandeur comes in
> place of what is lost in beauty. . . . Hence it is, that a towering hill is
> delightful, if it have but the slightest resemblance of a cone.

According to Jefferson's own understanding of what a monument is, as long as he remains unaware of (or refuses to admit knowledge of) mounds of great size, he can, within the specific context he opens, claim "to know

of no such thing as an Indian monument" in either a literal sense (a work of great labor) or a figural sense (a work not of great labor). If Jefferson had stood, like Barnett Newman, before the Miamisburg Mound, he would have met great difficulty maintaining his sense of "Indian monument" as something of an oxymoron. The point to underscore is that the mounds prove difficult to face up to when they press their claims to grand or monumental status.[26]

Mounds in the End-of-the-Line Mode

Why were the mounds so difficult to recognize and acknowledge? We can best begin to appreciate the particular difficulties by way of Neil Hertz's notion of an end-of-the-line mode, which helps to highlight a vital feature of early encounters with mounds that would otherwise be lost in mere empirical recital of our examples' content.[27] The North American mounds can be said to be in the end-of-the-line mode in the sense that when they initially come into sight, they appear almost at "a point of nonreflective opacity," where one can barely tell whether the earth reflects only itself or the action of human labor. For Hertz that opacity lies at the end of a line of sight where one perceives "the residual tension of minimal difference, of black against black" (218). With the mounds, the "minimal difference" concerns the presence or absence of difference itself: has human labor altered the land and so introduced a certain difference, or does human labor remain absent from a therefore undifferentiated earth? In short, a mound in the end-of-the-line mode makes opaque the difference between difference and indifference. Crucially, that opacity has the potential to invade one's perception of any substantial earthen deviation. The following three examples—two drawn from travel literature and one from what we simply call literature—will make this expansive force of a mound's opacity explicit.

We see the force of the earthworks' opacity at work in William Bartram's claim, recorded in his widely read *Travels through North and South Carolina, Georgia, East and West Florida* (1791), that he saw magnificent mounds like the following:

Not far distant from the terrace or eminence, overlooking the low grounds of the river, many very magnificent monuments of the power and industry of the ancient inhabitants of these lands are

visible. I observed a stupendous conical pyramid, or artificial mount of earth, vast tetragon terraces, and a large sunken area, of cubical form, encompassed with banks of earth; and certain traces of a larger Indian town, the work of a powerful nation, whose period of grandeur perhaps long preceded the discovery of this continent.[28]

Archaeologists have never found these monuments. Apparently what Bartram took as works of ancient "power and industry" were actually objects of natural formation. "The only landmark that seems to fit Bartram's description," writes Robert Silverberg, "is a large wooded hillock of natural origin; a nearby 'sunken area' also appears to be a purely natural feature."[29] However, Bartram's tendency to construe what we might call natural formations as mounds goes much further. The language Bartram uses to describe Indian mounds recurs in his accounts of animals' architectural constructions. He presents a wood rat's "habitation" as a three- to four-foot-tall "conical pyramid," built with "great labor and perseverance" (120), a series of crocodile nests as "a great number of [four-foot-high] hillocks or small pyramids ... ranged like an encampment along the banks" (121), and the earth thrown up from digging by a type of "large ground rat" and by the gopher as "little mounds, or hillocks" (34, 43) much as he writes of Indian earthworks: "conical mounds, or artificial heaps of earth," "conical mounds of earth," a "conical pyramid of earth" (41, 98, 104). Of course, a wood rat's habitation may well take the form of a "conical pyramid." The point of interest for us lies in Bartram's tendency to perceive mounds, whether the result of human or animal labor, wherever he goes, to the degree that when faced with "a purely natural feature," he sees a mound constructed with great "power and industry." With Bartram the mounds' formal proximity to a seemingly natural shape invades the perception of any mound-like appearance, such that what the shape reflects remains—for us in reading Bartram, as it did for him in his travels—uncertain.

James Fenimore Cooper adds a further level of complexity to the question of recognizing mounds when he dramatizes the role of an uncommon sagacity in an accurate recognition in the second of his Leatherstocking Tales, *The Last of the Mohicans* (1826). Pursued through the forest by armed Huron, Hawk-eye and his charges, Heyward, Cora, and Alice, along with the two Delaware, Chingachgook and Uncas, take refuge in a little-known clearing "that surrounded a low, green hillock, which was crowned by [a]

decayed block-house." [30] On this same "secluded spot," Hawk-eye and Chingachgook once fought in a bloody skirmish with Mohawk, over whom their own group, "Mohican" or Delaware, proved entirely victorious. Being "then young, and new to the sight of blood, and not relishing the thought that creatures who had spirits like myself, should lay naked of the ground," Hawk-eye buried the enemy dead "under that very little hillock" (143). In effect, Hawk-eye turned that green hillock into a burial mound, making it mimic the mounds of earth like Jefferson's barrows.[31] Likewise, Heyward and the Munro sisters, Cora and Alice, repeat the actions of many eighteenth-century Europeans, when, unaware and unsuspecting of the mound's origin or function, they settle themselves on "the grassy sepulchre" that, as Hawk-eye points out, makes "no bad seat . . . neither, though it be raised by the bones of mortal men" (143).

Hawk-eye gently dismisses his youthful mound building for an act of unworldly innocence, much as he dismisses his young white charges' expression of "natural horror, when they found themselves in such familiar contact with the grave of the dead Mohawks." "'They are gone, and they are harmless,' continued Hawk-eye, waving his hand, with a melancholy smile, at their manifest alarm; 'they'll never shout the warwhoop, nor strike a blow with the tomahawk again!'" (144). An animated threat soon does present itself, though, forcing the group onto the mound and within the walls of the ruined blockhouse: "restless savages were heard beating the brush, and gradually approaching . . . the little area" (149). But as the Huron enter the clearing, the ruin elicits in them great "surprise and curiosity":

> These children of the woods stood together for several moments, pointing at the crumbling edifice, and conversing in the unintelligible language of their tribe. They then approached, though with slow and cautious steps, pausing every instant to look at the building, like startled deer, whose curiosity struggled powerfully with their awakened apprehensions for the mastery. The foot of one of them suddenly rested on the mound, and he stooped to examine its nature. . . . In discovering the character of the mound, the attention of Hurons appeared directed to a different object. They spoke together, and the sounds of their voices were low and solemn, as if influenced by a reverence that was deeply blended with awe. Then they drew warily back, keeping their

eyes riveted on the ruin, as if they expected to see the apparitions
of the dead issue from its silent walls, until having reached the
boundary of the area, they moved slowly into the thicket, and
disappeared. (150)

If one wanted to locate an instance of serendipity in the scene, strictly
speaking only the Huron conjoin the requisite surprise and sagacity "in
discovering the character of the mound." It is they who detect signs of
what they were not expecting where others see nothing, they who per-
ceive signs whose interpretation apparently leads them to avoid a poten-
tial threat ("apparitions of the dead"). The Huron exhibit the sagacity that
Voltaire had attributed to Zadig, "une sagacité qui lui découvrait mille dif-
férences où les autres hommes ne voient rein que d'uniforme" (a sagacity
by which he discovers a thousand differences where other men see only
uniformity).[32] Of course, within the context of Cooper's novel, what the
Hurons' response serves to highlight is the significance of Hawk-eye's own
act of respect: the initial burial of the dead (151). By reacting with great
deference to the mounds and retreating, the Huron imbue Hawk-eye's
previous act with a sense of cosmic reward for a selfless act and of startling
foresight for the present situation: by it, Hawk-eye and his companions
escape their pursuers. Hawk-eye's imitation of Indian burial practices
itself starts to look serendipitous, an act that in producing unexpected yet
fortunate effects now looks like an act of uncanny genius, or of wholly
accidental sagacity. Moreover, it is an act that brings him and his com-
panions out from under death.

What Cooper highlights is the difficultly of recognizing a mound. To
secure the identity of a mound requires particular attention. Somehow
(and Cooper does not make clear how) one needs to perceive more than
what is readily given to the view. Because of the mound's form, one can-
not tell, when standing in front of a conical elevation of earth, whether
one stands before a work of art or of nature; one has to establish the exis-
tence of each and every mound. Though the conical mounds' shape is
always the same, the shape itself borders on the apparently natural, mak-
ing a patent division of art and nature often doubtful. While the division is
marked most clearly in the larger mounds, it is less clear in the thousands of
mounds that range between five and fifteen feet in height. For this reason,
the apprehension of a mound in the midst of an apparent desert remains
an ever-present possibility. As Cooper suggests, the act of discovering a

mound's character appears shot through with surprise and sagacity because merely looking upon one is not enough. With a mound, the potential for an act of accidental sagacity remains noticeably open.

When the European eyewitness realizes that she stands before an Indian mound, an unexpected history flashes, as it were, into legibility, though the newly legible may itself simply challenge comprehension. That is, even when the European recognizes a mound to the point of being able to draw a line around it or describe it on a map, she does not necessarily reduce the end-of-the-line opacity. The opacity does not give way to crystalline transparency. The earthworks continue to elude and trouble understanding. Specifically, the opacity is displaced, in the process opening a wide field of conjecture. What now looms at the end of the line, as observers try to see in an object of artifice the nature of the artificers, are the mound builders: "the mounds and their contents," write Squier and Davis, "serve to reflect light more particularly upon [the builders'] customs and the condition of the arts among them. Within these mounds we must look for the only authentic remains of their builders."[33] Yet any reflecting light proves as blinding as it does enlightening. The difficulty that attends defining the earthworks means that even when Europeans acknowledge the mounds as objects of human labor and invention (and so as objects of historical knowledge in Vico's sense), that acknowledgment ends up only shifting the "point of nonreflective opacity" from the earthworks' form to their origins and functions.

In his *Views of Louisiana* (1817), Brackenridge registers the displacing of opacity from existence to origins and functions and the surprise it engenders when describing the Cahokia mound complex near St. Louis. In the midst of what was once the largest pre-Columbian city in North America, Brackenridge approaches the one-hundred-foot-tall, platform-shaped Monk's Mound:

> When I reached the foot of the largest mound, I was struck with the degree of astonishment, not unlike that which is experienced in contemplating the Egyptian pyramids; and could not help exclaiming, what a stupendous pile of earth! To heap up such a mass must have required years, and the labours of thousands. . . . Were it not for the regularity and design which it manifests, the circumstances of its being on alluvial ground, and the other mounds scattered around it, we could scarcely believe it the work

of human hands, in a country which we have generally believed
never to have been inhabited by any but a few lazy Indians.

For Brackenridge, the earthworks appear at the edge of comprehension.
Of course, there is the idiom of sublimity suggesting a degree of obscurity.
More important, there is the pressing disjunction between what Bracken-
ridge perceives as the abilities of the supposed inhabitants ("a few lazy
Indians") and the great labor required for the erection of Monk's Mound.
The mound looms on the horizon of what can be retrospectively prophe-
sied because some hitherto unthought agent remains to be known and
explained.[34]

As observers acknowledge the earthworks to be objects of labor, many
start to imagine at the end of the line, where mound and mound builder
would reflect one another, the existence of an unknown, primitive Ameri-
can race. For such observers, the surprise becomes the astonishing revela-
tion that the earthworks were built by a significant number of people who
no longer appear to exist. Distinguished from *les nations sauvages* surviving
them, the primitive American civilization or semicivilization of Mound
Builders were variously thought to descend from one of the Lost Tribes
of Israel, from twelfth-century Welch migrants, from an unknown group
who crossed into North America via Asia, or from other potential sources.
Certainly some observers argued that ancestors of the present-day Indian
populations had built the mounds; at least one claimed that building the
mounds entailed no great feat of labor or of conception, and hence the
Indians could well have built them. But more commonly, writers, includ-
ing Albert Gallatin and Henry Rowe Schoolcraft, suggested that the Indians
had previously lived in large, semicivilized groups but had since declined
to their current state. Gallatin and Schoolcraft were, however, in a dis-
tinct minority. The dominant view held that a different race had built the
mounds. Indeed, it was not until the 1880s that the Smithsonian Institu-
tion published a series of studies that effectively dispelled the myth of an
unknown race of mound builders.[35]

If the recognition that one stood before a mound of human invention
meant that an unknown past flashed into legibility, so too does the posit-
ing of an ancient race or nation of mound builders. Additionally, the lat-
ter displaces the end-of-the-line opacity from existence to origins and
functions. There is accordingly a general shift in the nineteenth century
toward the level of accidental knowledge that Huxley called retrospective

prophecy, one that remains dominant today. Thus, in the nineteenth century, Squier and Davis, discussing a group of five burial mounds near Piketon, Ohio, arranged in a cross formation with the largest in the center, ask rhetorically: "May we not conclude that these groups are family tombs; the principal mound containing the head of the family, the smaller ones its various members?"[36] They nonetheless know of nothing on, in, or around the mounds that might verify the conjecture. Likewise, early in the twenty-first century, a leading authority on the archaeology of mounds, George R. Milner, writing of the three-thousand-year-old earthworks at Poverty Point in present-day Mississippi, notes that "what went on at Poverty Point is . . . unknown. People lived there, but how many of them did so, how long they stayed, and what they did while there are questions that require much more work to answer." Facing the unknown, Milner then gives a textbook example of retrospective prophecy, offering on the basis of contemporary common sense an outline of what was historical likely (even if only in the vaguest possible terms): "It is likely, however, that people from the surrounding area periodically assembled at the site for the kinds of social interactions common to all groups of people, such as finding marriage partners and renewing bonds of kinship and friendship."[37]

Certainly, acts of serendipity à la Walpole remain possible: one can always stumble upon a mound-like shape and with great insight divine that it is an artificial rather than natural formation. But even this will come to require that one frame the encountered earthwork as an object open to something like retrospective prophecy. The mound's mere existence is not the point. Of importance is the story that one will be able to tell about those who built the mound by interpreting the artifacts and remains buried within the earthwork. And that would mean cutting into and destroying the mound—which is to say, archaeology.

Knowing Mounds: Prophetic Archaeology

North American archaeology began with the destruction of mounds. Of particular interest for us is that archaeology's attempt to turn the mounds into signs of human social or cultural action—signs that one can then read or decipher. As we will see, while practitioners of archaeology aim to reduce the speculative dimension that inheres in archaeological knowledge, prophecy maintains a structurally dominant role in accounts of the

mounds. The mound's stubborn singularity eludes the grasp of a more secure knowledge, leaving archaeology, unable to fix its object adequately, to seek resolution elsewhere. Aligning itself with historicism, archaeology reduces a mound's singularity by insisting on its necessarily historical, contextual nature. Above all, this means cutting up the mounds, destroying them in search of objects whose functions and uses may be discerned as reflective of certain social or cultural values and practices. In the marrying of archaeology and historicism, we see emerge an overriding interest not simply in establishing the mounds' origins (their *arche*), but in framing the mounds in terms of their contents taken as representative of certain social or cultural functions.

The question that Brackenridge posed—how could these mounds have been built by "human hands" in a land apparently only ever populated by "a few lazy Indians"?—was of immense interest for many early nineteenth-century Euro-Americans. Albert Gallatin, who would become a founding figure of North American ethnology, suggests that the "origin of the semi-civilization" that built the mounds is a "problem perhaps more interesting" than that of the origin of those who first peopled the Americas—though it is a problem whose "solution . . . is not less difficult to resolve."[38] The problem widely exercises the European imagination, drawing talk of the mounds' origins into a sphere of speculation from which archaeology will try to distance itself. The recognition that there remains, under one's feet, an as yet unfathomable history of the continent engenders numerous responses of varying plausibility, though the mounds themselves refuse to reflect clearly on their origins. Hence it is, in fact, more or less only the imagination that proves able to respond. The imagination has to be called upon to supply what direct observation cannot.

The local Indians' silence on the mounds only reinforces the sense of estrangement produced by the earthworks, the sense that they make the land radically unfamiliar and recalcitrant to available knowledge. Writing as early as 1772, David Taitt suggests that present-day Indians can give no "Account of the Reasons of [the earthworks] being made," while the January 1775 issue of the *Royal American Magazine* includes an anonymously published essay on earthworks in "Shawanese country," where the writer notes that "who the constructors of it were, the Indians who live in neighbourhood to it, have no tradition upon which we many depend. . . . The present Indian inhabitants were not the builders, and they can give no satisfactory account of who were." No longer objects of either memory

or use, the mounds appear as remains of a time long since past, no longer easily accessible. As J. H. McCulloh puts it in his *Researches, philosophical and antiquarian, concerning the aboriginal history of America* (1829), "the utter absence of tradition among the Indians concerning their history, [means] the most ample room is left for conjecture." The mounds remain distant, open to an imagination that they nonetheless hold the potential to surprise.[39]

Arguably, archaeology's first attempt at stepping away from the overly speculative manifests as a departure from the common theologically oriented approach that concerned itself exclusively with the question of who built the mounds. That approach sought an answer that would dovetail with biblical chronology. It required a single group, ideally one mentioned in the Bible. The claim that the mound builders descend from one of the Lost Tribes, for example, installs a primitive American race whose existence can be squared with the biblical account of world history. It is, in other words, an argument in support of a certain Judeo-Christian worldview, one that many early accounts of the earthworks aimed to uphold.[40] In doing so, such accounts recall earlier efforts like John Webb's *Historical Essay,* which I have discussed in previous chapters. As we saw, Webb asks how a civilization like China could exist, largely unknown in Europe until recently and unmentioned in the Bible. In answer to his own question, Webb suggests that Noah settled China after the flood, and—this is Webb's main contention—that some of Noah's descendants remained there, managing to maintain the primitive language spoken in Eden. In a similar way many late eighteenth-century writers feel pressed to ask how a civilization like that of the mounds' builders could have come to exist in North America, given the Bible's silence on this race of people. Accordingly, these writers, like Webb, appear less concerned to historicize the mounds than to determine their place within the Bible's preexisting framework.

Yet a noticeable gap separates Webb's China from the builders of the mounds. For Webb it is beyond doubt that China presents an existent, complex civilization, as is the fact that the Chinese possess written records covering five thousand years. Things are less clear with the mound builders. Though they engaged in monumental architecture and so would seem to constitute a civilization, their apparent lack of written records calls that status into question—as does, of course, their use of packed earth rather than bricks or masonry, which separates them from the "Mexicans" and "Peruvians," to whom Webb does refer. So whereas Webb conceives China

as the ideal version of any social order (which for Webb necessarily means a state-based order), when late eighteenth-century Europeans confront the mounds, they end up approaching the earthworks as products of a social organization markedly different from their own. That the mounds' makers be considered such seemed to be demanded by the questions that the mounds themselves prompted. Understanding the earthworks proved less an issue of finding the truth itself in a single point of origin beyond all contradiction (Webb's primitive language) than of establishing a true account of them, including how particular works were built, and—crucially—in what context, a development that becomes incompatible with a strict biblical framework.

A central work in the turn to context was Caleb Atwater's "A Description of the Antiquities Discovered in the State of Ohio" (1820), which Warren K. Moorehead, writing in 1901, claimed had inaugurated North American archaeology.[41] Atwater, like Webb, believes the Bible to be "the most authentick, the most ancient history of man" (195). However, unlike Webb, Atwater posits the existence of discrete national (today we would say cultural) entities that possess certain characteristics that differentiate them both spatially and temporally from other nations. That is to say, Atwater does not look to locate a single primitive group lodged outside of all temporal corruption. Rather, a nation is a nation for him because it is something formed temporally and differentially. Describing the spatial axis, he notes how the historical Egyptians' "pyramids and temples, medals and monuments, show us a comparatively civilized people" who built great public works at a time when "their neighbours were rude barbarians" (199). For Atwater the Egyptian case suggests that we should not expect all indigenous inhabitants of North America to be *either* civil *or* savage; nor should we expect the same group to have always and only constituted a civilization. Civilized or semicivilized groups producing monumental architecture may well have existed alongside other groups whose way of life bore scant resemblance to a civilized existence, just as that same civilized group may have been, at other moments in its history, entirely savage.

Atwater adds a further level of complexity to his historical outlook by maintaining that the mounds were not likely built by the same group. "Our Antiquities belong," he writes, "not only to different eras, in point of time, but to several nations" (111). This means that a given earthwork potentially belongs to any number of ancient nations, a situation that demands of archaeologists a highly contextualizing methodology. Potentially, every

earthwork that they consider could be different in its origins than any other known earthwork. Of course, that difference is to be revealed by cutting into the earthwork and finding objects in whose reflection one might trace their makers. But then, following the demands of his contextualizing methodology, Atwater extends to each object his contextualizing premises, insisting that a given object may have various functions for various groups at various times: "those articles belonging to the same era and the same people, were intended by their authors to be applied to many different uses" (111). At bottom, then, Atwater's broadly historicist methodology requires that one have access to specific human-produced objects that can be understood to have several national purposes—that is to say, artifacts intended for various uses. Understanding those uses will in turn enable one to build an account of the object's users, suggesting features of their way of life, modes of reproduction, and so forth.

For Atwater the interest in cutting a mound open is not to reveal the origins of humanity itself or some analogous grand truth. Certainly the tendency continues to consider the mounds as the work of a single primitive social or racial entity, and hence the notion of the Mound Builders, or differently, the belief held by George Catlin, among others, that the descendents of the Welch prince Madoc, who left Wales in 1170, built the mounds as they migrated along the Ohio, up the Mississippi, to the northern end of the Missouri River. Yet that tendency becomes more and more unworkable, more or less only taking place *as* a constant response to contradictory information. The demand that one produce an account of historical, contextual change will ultimately undermine the notion of a single primitive group.[42]

The historical–contextual approach advanced by Atwater faced a significant problem: how to comprehend the mounds historically when they appear to remove themselves from an historical understanding? Or rather, how to meet the demands of historiography and render in a narrative form these things that do not easily give over to narration? For added to the mounds' minimal difference from the surrounding environment is their perceived lack of difference over time. As Squier and Davis note, mounds do not appear subject to the losses of time: "When covered with forests, and their surfaces interlaced with the roots of trees and bushes, or when protected by turf, the humble mound bids defiance to the elements which throw down the temple and crumble the marble into dust."[43] The mounds' singularity, their recalcitrance vis-à-vis the spatial and temporal

axes, signify for Atwater and those who followed him that they could gain access to potentially functional and thus representative objects only by cutting mounds open.

Atwater's attention to a mound's own context rather than the context supplied by the biblical narrative might be considered an advance in knowledge generally (it certainly resembles our own practices today, which value the historical and the contextual). It might also suggest an increase in regard for the earthworks themselves in their respective historical specificity. Above all, it means that the archaeologist needs to cut up an earthwork, either sinking a shaft into it to remove a cross section of earth, or conducting a full excavation or removal of the mound. In other words, for historicists to find what they need to produce an historicist account of a mound, they must cut into it, altering or destroying the earthwork.

The simple destruction of a mound will not, of course, serve historicist aims. Moreover, they will need to locate a certain sense of historical agency in the mound and its context, the apparent obscurity of which works to foreground their own act of temporal alteration, which they introduce with the slice of the cutting, altering the mound in time in a bid to turn it into an object that exhibits a temporal reference. How, then, can the historicist find the source or agency of history in the object rather than in their own act of cutting, and do so in a way that procures order from an action of destruction? It is to obviate the force of such problems that early archaeologists adopted the stratigraphic principle developed by geologists in the early nineteenth century.

The principle that layers of strata are built up over time enabled a degree of conceptual framing hitherto unavailable. The archaeologist could now perceive unfolding layers of time by strong analogy with the likewise temporal—and apparently natural and so indisputable—process of natural sedimentation. They borrow from nature a principle of stability otherwise unavailable in the products of nonnatural activities, including their own actions. Indeed, even cases where one finds the layers of sedimentation disturbed indicate the mound's historical existence: at this point in the mound's history it was broken up, perhaps for the purpose of making new deposits. Squier sums up the stratigraphic principle's virtues: "It is in this view, that the fact of stratification is seen to be important, as well as interesting; for it will serve to fix, beyond all dispute, the origin of many singular relics." What that fixing enables is the reframing of the singular relic as a representative object.[44]

The great strength of the stratigraphic principle is its ability to allow a degree of plotting. Upon excavating a series of representative objects, one can begin to frame a mound as an historical production. If whoever made or used the objects made the earthwork, then one can examine the different types of objects discovered at different layers to determine the context or contexts of the mound's use and construction. The representative objects, indexed stratigraphically, begin to facilitate a certain telling. That is to say, excavation makes a form of narrative possible, even if in cutting up the mound one destroys the referent of what one wants to preserve in the telling (Figure 5). By cutting up a mound and binding one's findings in a narrative form, one can thus frame a mound *as historical*—as, therefore, laden with history and thus with determinate content. If, as Gordon M. Sayre points out, the mounds proved amenable to various narratives, we can add the point that they only appear amenable at all to European thought once they are rendered as objects that can be narrated.[45]

Bearing History

I have so far remained silent on what the mounds might mean for Native American groups, and thereby risk replicating what we might call the late Enlightenment's silencing of Native voices. Certainly the various earthworks that remain are proving significant today in the wider context of North American Indian efforts to regain stolen material objects and to claim recognition for long-ignored or disparaged sacred sites. But what stands out in the accounts that have been my focus is a common claim of Indian silence concerning the earthworks. The perceived silence arguably shapes the European understanding of the earthworks in crucial ways, positioning them as ancient but above all helping to augment the mounds' indifference to comprehension. The resulting situation—the augmenting of European incomprehension by apparent Indian silence—might mean that any effort to recover lost indigenous voices in those early debates on the mounds requires (at least in part, if not in whole) that we attend to the force that a perceived silence can exert. In other words, what might be the significance, vis-à-vis the debates on the mounds, of someone or something taking a stand at a marked remove from the demands of a historical understanding?[46]

To begin to answer this question, we need to return to the issue of how early Europeans tried to establish an historical understanding of the

FIGURE 5. Knowledge as destruction: to disclose what a mound holds, excavators destroy the mound itself. Depicted is the excavation of the Carriage Factory Mound, located northwest of Chillicothe, Ohio, and so called because the land on which the mound then stood was owned by the Carriage Factory Company. Warren K. Moorehead, in his account of the mound's excavation, notes that before archaeological work began in 1897, local settlers had already hauled away "much of the rich, black soil for lawns and gardens." The mound itself stood "thirty-five feet high" with "a diameter at the base of two hundred and twenty-five feet." Moorehead, "Report of Field Work in Various Portions of Ohio," *Ohio Archaeological and Historical Quarterly* 7 (1899): 127–27. Photograph of the "Carriage Factory Mound during excavation, Ross County, Ohio, 1897" courtesy of the Ohio Historical Society, Columbus.

mounds. As we saw, in making a mound over as an object of narration, Atwater and other early archaeologists produced something of a tautological object, one that served as a cipher for historical functions of which it in turn appeared as the product. Of importance in this view is not the mound but what it is taken to testify to or to speak of: an historical context. Or rather, the approach requires an initial determination of two planes, one for the mound-cum-cipher and one for historical context, with a successful

historical account being one that brings about the two planes' rapprochement, combined to form a single plane that is properly the domain of only one of the initial two planes: historical context. Notably the synthesis, in establishing itself and its object, obscures a crucial component of the historicizing operation. In framing a mound as an object embedded in an historical context, one must make the earthwork itself stand for something else no longer present or operative, such as forms of social organization, certain social functions, or what we would call a culture. In short, the mound's physical obliteration facilitates its recasting as an object that tells of what it is not—its recasting, that is, as allegorical. Here we find an attempt to recover a lost voice of sorts, an attempt to make the earthworks speak, albeit to *speak otherwise*.

Of course, put crudely, the aim of nineteenth-century historicism and the related discipline of archaeology is to turn the initially allegoric into the symbolic, flattening the symbol into what it symbolizes or the object into the context. Historical investigation sees the disjunctive nature of allegory as a problem to overcome. Here the concept of serendipity proves especially enlightening. What it suggests is that the gap that inheres in allegory will be quite difficult to close or suture. Because serendipity's initial judgment is, as we have seen, structured by a temporal disjunction, its mode of representation remains allegorical, failing to pass into the symbolical. This is particularly apparent with Huxley's retrospective prophecy in the production of archaeological knowledge. We must, Huxley notes, use what can be described to invoke what cannot yet, and possibly never, be directly presented. Additionally, as we have seen, an aspect of retrospective prophecy inheres in Walpole's serendipity, which suggests that the like allegorical mode organizes the act of accidental sagacity. When the flash of legibility occurs, the mode of representation appropriate to the sagacity that traces its delineations would thus be allegory. This means that the three princes and Zadig, echoing Crusoe in his encounter with the footprint in the sand, find marks in the sand that they try to read as either iconic or symbolic but that function more like writing or inscription— marks that can never quite be read because they always remain *to be* read. They never coalesce with that of which they tell.

Crucially for us, insofar as a mound *as a mound* continues to fall outside all adequate historicization, a mound does not, as Newman suggested, allow for the initial separation of putative object and context needed for its subsequent symbolization. For this reason, I suggest in conclusion that

the mounds remain for nineteenth-century European observers things that force thought into a certain open-ended allegorical operation. (This, perhaps, is the place where a silenced voice of sorts may be recoverable, a silence that, with great *prévoyance,* forcefully interrupts the discourse of the other—the discourse, that is, of another on their other, in this case, North American Indians.) By "open-ended allegorical operation," I do not mean to suggest that a mound becomes a signifier forever in pursuit of a signified. The opening in question enters into the allegorical sign in a way that blocks one from easily perceiving the mound as a signifier. In the terms I have used throughout, the mound holds off attempts to reduce it to a reflective object. It refuses to take (its) place as an object that reflects an absent concept (as signified) whose recovery would complete the allegory—accomplish it, finish it off, put an end to it.

Certainly an allegorical sign presupposes a disjunctive temporal dimension (it tells of something that it necessarily does not coincide with in time) from within a temporal movement (it *tells* of something, narrating it and thus unfolding in time). But as archaeologists begin to make dissected mounds out as objects of narration, the need to translate a mound into narratable and therefore temporal terms by way of its destruction proves symptomatic of how time is also what mounds trouble. How can there be a signified to come when the putative signifier edges out of time? Before being cut into (or analyzed, recalling that word's etymological derivation) a mound does not even exhibit, as does a more or less decayed Egyptian pyramid, the sequence of its construction—the placing of one stone upon another. In themselves, mounds can be said to obey duration but not succession; they endure, but they do not succeed along a line of differing historical contexts.

Perhaps better than anyone, Newman recognized the mound's open challenge to time, even as he saw that the Miamisburg Mound's reference was to time and not to space. What strikes Newman is the way the mound did not give over to a sense of succession, to being, in his terms, one object among others within the landscape. Insistently and indifferently, the mound remains. Newman takes this to mean that the mound stands forth as if a sublime pulsation in time: "Suddenly one realizes that the sensation is not one of space or [of] an object in space. It has nothing to do with space and its manipulations. The sensation is the sensation of time—and all other multiple feelings vanish like the outside landscape." Like Crusoe's footprint, the mound obliterates one's sense of everything else ("all other

multiple feelings vanish like the outside landscape"). The only remaining sensation is that of the instant *("here")*, of the time-outside-of-time, the time that does not take (its) place within the anthropologically secure model of a supposed human historical consciousness unfolding in a succession of before, during, and after.[47]

Crusoe, of course, had tried to gain a cognitive grasp of the singular footprint by linking the primitive sign to the savage hordes of the mainland. In contrast, early nineteenth-century European observers on the mounds sought to establish a like grasp of the "foot-prints of vanished races" by separating out a primitive race of mound builders from the surviving savage races of North America. Though like Crusoe's attempted linking, the Europeans' attempted disjoining occurs largely in absence of evidence, which might be taken to suggest that what is in evidence is the force of a desire on the part of the European observers. That the force of a desire is in effect indicates that it is not enough to note apparent contradictions in content when considering the wide-ranging debate over the earthworks. Given the dearth of certain knowledge to ground statements concerning the mounds—writing of the "ancient earthworks" in 1894, Lindesay Brine noted that "nothing definite ... [was] yet ... determined"—we should not be surprised that both one thing and the other was said of the mounds.[48] But writing unceasingly in the face of nothing definite or determined, the insistence upon a separate race of mound builders is also symptomatic of an overwhelming impulse to avoid something whose threat seems almost of the order of Crusoe's troubling footprint. Above all, the insistence means that one will not have to alter one's understanding of the Indians, whether one sees them as noble, lazy, or not lazy enough—that is, as inveterate scalpers. One is also left to populate the scene with all the reassuring charm of an antiquarian's dream. The separating out of mound builders and Indians shores things up, helps secure one's existing knowledge on one level (of Indians), even as one's knowledge is called into question on another level (of mound builders). It is an avoidance, a swerving, but also a recuperation, facilitated by the figure of the savage. The primitive race begins as the savage's negation. The savage falls out of history, or rather stands beside history, inaugurating it yet not being part of it.

. . . As If Europe Existed

DESCARTES ENDS HIS PREFATORY SYNOPSIS to the *Meditations on First Philosophy* (1641) by restating his claim that the world of body and extension exists. Descartes may have famously separated soul and body, subject and object, but he does not reduce the latter (body, object) as a merely imagined or intentioned product of the former (soul, subject). The two orders differ in substance—one is divisible and mortal, the other indivisible and immortal—which is to say they are both, in their respective ways, substantial.[1] I can imagine objects that do not exist, certainly, yet not all objects are things that I have imagined. Some things exist apart from me, material or corporeal things; we have arguments that prove this. Among the topics Descartes says he will bring forward in the sixth and final Meditation are precisely "all the arguments which enable the existence of material things to be inferred." To give an example, Descartes will suggest that because God does not deceive, God would not have made us to believe that we can understand material things objectively if no such things could exist: "It follows that corporeal things exist."[2]

However, Descartes values the arguments he will bring forward less for what they may prove directly about the external world of extension, and more for what they show indirectly about another set of arguments:

> The great benefit of these arguments is not, in my view, that they prove what they establish—namely that there really is a world, and that human beings have bodies and so on—since no sane person has ever seriously doubted these things. The point is that in considering these arguments we come to realize that they are not as solid or as transparent as [*non esse tam firmas nec tam perspicuas quàm*] the arguments which lead us to knowledge of our own minds and of God, so that the latter are the most certain and evident of all possible objects of knowledge for the human intellect.[3]

Descartes' point is that arguments for the existence of material and cor-
poreal things always prove less secure than arguments by which we arrive
at "knowledge of our own minds and of God"—that is, of what is immor-
tal and indivisible—and therein lies their value. The virtue of arguments
for the reality of body apart from us turns out to be their relative lack of
certainty. They put us on the path, by contrast or negation (non *esse* tam
firmas nec tam *perspicuas quàm*), by which we can arrive at the more
secure knowledge.

What I have called the Enlightenment problematic might be said to
begin when Descartes' more secure knowledge gets folded into the less
secure, worldly knowledge. This was obviously the case with Kant, for
whom the existence of God is far less important than the role that "God"
as a regulative idea ought to play in orienting human thought and action.
For Kant, God is, in the famous phrase, "a postulate of pure practical rea-
son."[4] Hence the aim of the Critical Philosophy: to determine reason,
both pure and pure practical, along with the other primordial and given
human faculties of understanding and judgment. The example of Kant
suggests that the Enlightenment problematic reverses Descartes' order of
emphasis. The most important concern, the primary point of departure
for knowledge, becomes the human in the world, a reversal that I have
suggested occasions a certain insecurity. Arguments for the existence of
a world apart from the human no longer prove, as they did for Descartes,
a more secure knowledge (of God and Self). These arguments take their
place in a context marking the human's place in and relation to the world
as uncertain. This is, after all, why Kant calls upon God as a regulating idea
to get beyond the peculiar problem he made for himself: it is the human
alone who must give itself its own law, and yet the human alone appears
an inadequate foundation for a properly ethical program.[5]

As we have seen, the central question that thinking the primitive comes
to pose is precisely one of understanding how the immortal and indi-
visible manifests in the world, on the same plane of worldliness as body,
object, or extension. We saw the question and the difficulties it entails
played out across the variegated and incomplete field we call eighteenth-
century aesthetics, as exemplified in the work of Joseph Addison, Imman-
uel Kant, Daniel Defoe, and the serendipitous encounters with North
American Indian mounds. As I noted in chapter 2, aesthetic theory itself
rejected Cartesian "clear and distinct" knowledge in favor of what Alexan-
der Baumgarten initially formulated as "clear and confused" knowledge.

Above all, thinking the aesthetic means thinking the as it were other-worldly presentation of a primitive human faculty in a now unsecured world, one without God and as yet without History, one known at best through a self-grounding human reason. Any challenge to anthropological security therefore becomes a challenge to any secure knowledge at all, clear, confused, or otherwise.

What could possibly usher in such a breach in anthropological security? I have argued the vital importance of a certain cause, namely the New World (the Americas first of all, but also China and the South Pacific). We might call that certain cause an absent one in two senses, the first empirical, the second theoretical and historical. In the first sense, the cause is absent because it is unacknowledged in our scholarship; it has been largely ignored. In the second sense—the one I find the more impor-tant—the cause is absent because it is not present at any one determinant point. The mode of its causality is not one cause to one effect, the effect of one element on another element within a limited temporal frame defined by the duration of a necessary proximity—for example, the flame of *this* fire (cause) which produces the heat I feel *now* on my hand (effect). Rather, the cause's force traverses and structures the Enlightenment problematic, con-stituting, bending, and altering it, but above all demanding the problem's iteration without end. The New World, as I have suggested, profoundly recast the known world to include an immense, unknown realm, such that the world one exists in and in relation to proves to be marked by uncer-tainty. Yet as we have seen, the New World's exoticism also provided the apparent means for suturing the deep-running challenge to anthropo-logical security running specifically through eighteenth-century aesthetics (again, whether the aesthetic is the object or the modality of inquiry).

I have argued, then, for a certain understanding of the New World's role in what we call eighteenth-century European thought. But what do we mean by a "thought" that is "European" if it really is, as I have suggested, structured by the New World? The understanding I have presented, put in its strongest form, holds the thought in question to be properly neither European nor the product of a sovereign consciousness, individual or collective. In between the Old World and the New, in the encounter that also and paradoxically made each possible, there occurred something closer to an event of thinking: the unsettling, unpredictable encounter recalcitrant to a thought intent on settling the matter within a predicable framework. The model of an event of thinking is not one whereby Europe

constitutes a preexisting individual subject that either subsequently over-
comes, or is overcome by, an external object or Other. Put differently, it
is not a case of reducing the encounter of Europe and the New World to
the order of an historical phenomenology. The action of Europe's over-
coming does not obey the law of a phenomenology whereby the exotic
enabled European self-recognition, even if only to disable it. In its more
sophisticated form the phenomenological model of overcoming is broadly
Hegelian: with the successful version, the self would comprehend an other
through the dialectic's sublating process, vanquishing the other and any
force of alienation it may have presented. Thus, as Alexandre Kojève pres-
ents the Hegelian model in his widely influential treatment, the self "cre-
ates and preserves its own reality by the overcoming of a reality other than
its own, by the 'transformation' of an alien reality into its own reality, by
the 'assimilation,' the 'internalization' of a 'foreign,' 'external' reality." The
other becomes an expropriated object of knowledge by being incorpo-
rated within the self and its world view (its "reality"). The other becomes
the other of the self, the self's (own) other.[6]

Of course, the Hegelian model of self-consciousness (rather than of
History) does articulate a phenomenological process that, as Robert Young
puts it, "uncannily simulates the project of nineteenth-century [European]
imperialism." Much as the self is consolidated in the act of negating the
other *as other,* a European expansionist capitalism consolidated itself in
the act of negating other, noncapitalist groups. Though one might also be
tempted to note that even in the absence of an overarching project such
as nineteenth-century European imperialism (whether on the continen-
tal or national level), the Hegelian model, stood on its head, might well
be said to carry an explanatory force on the level of world-historical vio-
lence. Thus Pierre Clastres succinctly notes, "Since 1492, a machine of
destruction of Indians was put into gear." The statistics are staggering and
the sheer violence of imperial action in the New World appalling. We
could say that from an Amerindian perspective, a perspective increasingly
and literally erased, becoming barely recognizable on terms that would
be its own, the inexorable acts of annihilation after 1492 obey an all-too-
Hegelian logic—negations upon negations.[7]

My emphasis has not been on the physical, life-annihilating violence of
European expansion, whether imperialist or colonialist, mercantilist or
capitalist, mercenary or missionary.[8] My emphasis has been on the episte-
mological and even rhetorical force of an encounter that made it possible

to conceive, among other things, an Old World and a New World. I followed that force through the singular events of thinking that presented themselves in the works of Addison, Kant, Defoe, and others. What became apparent in the eighteenth century was that Europe's apparent discovery of the New World had occasioned a kind of anacoluthon in knowledge and existence. By ordering in advance an impossible syntax of self-articulation, the encounter at once offered and upset the self-identity of what we would call the respective subjects of "New World" and "Europe." Each comes to exist *as if* it exists, in a mode of virtuality that posits each as self-identical and immemorially *there*—as if, for example, the advent of Europe was simply the use of new name to designate what was once self-identified as Christendom.[9]

While "Europe" represents an inheritance of sorts for the eighteenth century, a hand-me-down not two hundred years old, the identity and stability of such an active hallucination was obviously subject to continual restatement and reassertion. In chapter 7 we came across the closely related attempt, late in the eighteenth century, to produce an immemorial existence for the new United States of America. Strikingly, the notion of an immemorial Europe or Republic reiterates important aspects of the desire to determine primitive human faculties, which, as we have seen, took place in the face of a proliferation of humankinds. In this sense both the retrospective immemorial and the primitive would constitute responses to like problems. From the morass of mere existence and contingency, how is one to garner the necessity of one's own existence? Between God's withdrawal from the world and History's arrival, *entre Descartes et Hegel,* a determination of necessity beyond time (through retrospective immemorial or primitive human faculty) would thus serve to secure a degree of stability. And yet such determination proves hard to achieve.

The difficulty of achieving determination in the absence of God or History suggests why it is that the New World's unhinging of self-articulation proved most forceful in the Enlightenment, between Descartes and Hegel. It was then, in the face of a New World now made truly immense and multiple (the Americas joined with the South Seas), that we find the problem of anthropological security press most forcefully in what we call European thought. As we saw in the cases of Addison and Kant, Defoe and the Indian mounds, the exotic and the savage demand the perpetual rethinking of the human's place in and relation to the world, and for two main reasons: first, because the savage's ungovernable proliferation (its allegorical

force) upset any adequate understanding of the human's relation to world; and second, because the positing of a unifying category beyond time (for example, the primitive, which formed the primary strategy pursued in response to problems ushered in by the savage) failed to adequately substitute for a withdrawing Deity, a substitution that would be made, historically speaking, only after Hegel, once History came to order and explained the human's place in the world.

I want to conclude this study by suggesting how my own emphasis on the New World's epistemological force in the eighteenth-century conjuncture relates to—and may in some way revise—more familiar models of economic impact. It is in the realm of economic history that we have the strongest tradition of thinking the New World's impact on the Old, and certainly it is this economic history that initially shaped my own sense of the world that is our inheritance and that, unfortunately, we continue to reproduce and reassert in the most uncritical fashion on a daily basis. Epistemological or rhetorical force may not be physical violence in any commonsensical way, but nor is it entirely alien to violence. As I hope to have shown, this force does not belong merely to a realm of representation or static thought. I offer my concluding remarks on economic history to give a context that shows the pertinence of the question of violence to be all too clear.

That the New World forced a certain deviation upon an apparently already existing Europe has long been acknowledged on the economic level. In the eighteenth century itself, the likes of Adam Smith and the Abbé de Raynal described the late fifteenth-century discoveries of the New World and of the passage to the East Indies via the Cape of Good Hope as momentous, world-historical developments, whose major consequences were, on the one hand, the catastrophic devastation of Amerindian populations, and on the other, the further expansion of commerce, which in turn enabled great improvements in Europe.[10] However, for Smith and Raynal, what I called "a certain deviation in Europe's historical trajectory" would be simply the greater expansion of something Europe was already familiar with: commerce. The dual discoveries worked more or less to enhance rather than conjure up Europe *(as if . . .)*. Only the Amerindians proved subject to a force of radical alteration—that is, toward nonexistence. Bear in mind that neither Smith nor Raynal lived to witness the full-fledged advent of industrial capitalism. Insofar as capitalism existed as a mode of production in the eighteenth century, it was

as mercantile capitalism—hence the emphasis on commercial exchange rather than on the dialectical operations of production and consumption.[11] The degradations of industrial capitalism, which would destroy not only those far-off populations in the New World but those at home in Western Europe, casts 1492 in a rather different light. Insofar as the immense wealth accumulated through overseas commerce supplied the capital needed to get capitalism going, we start to see, economically, the disaster that Europe brings upon itself with its two so-called discoveries. As has often been noted, the intensely exploitative action of industrial capitalism represents, in a very real sense, the turning of European colonization upon Europe itself.

At this point it might useful to recall the terms of J. M. Blaut's polemic, "Fourteen Ninety-two," published to coincide with the quincentennial celebrations of Columbus's arrival in the New World. Blaut begins with the familiar argument that without the gains resulting from the discovery of the New World, Europe would not have become the dominant site of world capitalism. Various complex means contributed to that end, including the massive increase in bullion from New World mines brought to Europe, and the plantation system that radically reduced the cost of labor necessary for the production of certain foodstuffs. As Blaut goes on to insist, the effects of 1492 came upon what we call Europe as an imposition; that is to say, the effects of the extra-European world upon Europe appear as "forces suddenly impinging" upon it:

> Novel forces *intrude* into the European system, as *impinging* boundary processes, because of the conquest and the other extra-European events, *intruding* processes which consist mainly of capital and material products (and of course the dead labour embedded in these things). These [then] intersect with the ongoing evolving economic, technological, demographic, etc., changes.[12]

Here Blaut counters the commonplace image of Western Europe as engaged in a process of rationally ordered progress toward mercantile and ultimately industrial capitalism merely supported by its supposed discoveries in the New World. Recalling E. J. Hamilton's foundational work of the 1920s, Blaut points out that the advent of capitalism in Europe followed from the far-reaching destabilization of various European economies by

the influx of immense wealth from the New World. Capitalism's advent in Europe turns out to derive from Europe's inability to protect itself and maintain itself in the face of the New World's imposition upon it.[13]

I might say that in addressing the epistemological and rhetorical force of the New World upon Europe in the Enlightenment, I am trying to bring intellectual and literary history in line with a certain economic history while calling into question the continuous existence of a Europe as supposed by economic history. Hence my attempt to isolate ways that the exotic, and the savage in particular, might be said to have inaugurated, or at least forced, certain deviations upon, what we have come to call European thought. One thing I take the impact of the New World on the Old to mean is that we cannot continue the practice of producing what Dipesh Chakrabarty describes as the unselfconscious insertion of Europe as history's sovereign subject, whereby Europe becomes the "silent referent in historical knowledge."[14] The refusal to unselfconsciously promote Europe into the place of sovereign, governing subject means no longer reading mentions of Amerindians, for example, as only references or flat figures. Often, they are figures for thought and figures that carry or inaugurate thought—but they also become figures of thinking without a subject, pushing thought up against itself, showing up its limits, even disabling it—(the act of) thinking, that is, as the forceful introduction of alterity into (what is) thought.

We must not forget that an exotic figure not only imparts knowledge but brings with it the unfamiliar and unknown. Recall the example of Lessing's Hottentots discussed in Chapter 2. For Lessing they serve to show that when one adds a supposed dignity to what is disgusting, the dignity softens the force of one's disgust to produce an image ridiculous and humorous. Yet however well "we know how dirty the Hottentots are," their taste for what disgusts the European remains, in Lessing account, an unknown taste, incompatible with a European sensibility. The European may find the image of the Hottentots humorous, but the Hottentots' taste for rubbing goat fat over their bodies and entwining their limbs with fresh entrails remains alien. We may expand from Lessing's example to note that wherever one stands, an exotic figure both faces one and points away—and it will only be exotic for as long as it continues to do so. With an exotic figure, one necessarily gestures toward a limit to understanding.

Central to my study has been the question of what is at stake in the appearance of a figure that expressly imparts knowledge as it hides knowledge. Can such a figure be controlled so that the knowledge it hides does

not in fact disturb the knowledge it imparts? That control is even at issue underscores my deeper sense that figural language, and exotic figures in particular, have a certain energy or force about them. That an exotic figure may exert a certain force was, of course, a lesson to be drawn from Kant's example of Maori facial tattooing in his *Critique of Judgment*. The notion that Kant merely drew on a preexisting, stable archive of exotic tropes when referencing Maori facial tattooing misses the live, active forces that they may unleash in a text such as the third *Critique*. It assumes that Kant's example is the end product, on the one hand, of a deliberate, controlled decision on his part, and on the other hand, of an historically and culturally determined representation defined by its separation from a putative referent—assuring, in turn, the sovereignty of a European subject engaged in entirely European modes of representation.

My aim in suggesting that the tattooed New Zealanders in some sense write the third *Critique* was to begin rethinking the now well-worn practices of a colonial discourse analysis that has not, in my estimation, faced up to the challenge of a thinking beyond Europe-as-sovereign-subject. To conclude, I would say that what I hope to have at least intimated over the course of this book is the possibility of thinking through the way that exotic figures, and especially the figure of the savage in its New World iterations (the Americas and the South Seas), deface Europe as sovereign subject. They are not simply the contents of a stable thought, such as one might find in the documents of an archive (institutional, discursive, or historical). Rather, they think—or, at the very least, they step into the realm of thinking, a realm of perpetually incomplete action taking place on the verge of *nothing rather than something*.

Notes

Preface

1. Herman Melville, *Typee: A Peep at Polynesian Life,* ed. Harrison Hayford, Hershel Parker, and G. Thomas Tanselle (Evanston, Ill.: Northwestern University Press, 1968), 50–75.

2. On the emergence of modern historicism, see James K. Chandler, *England in 1819: The Politics of Literary Culture and the Case of Romantic Historicism* (Chicago: University of Chicago Press, 1998); Michel Foucault, *Les mots et les choses: une archéologie des sciences humaines* (Paris: Gallimard, 1966), 229–33, 378–85; Reinhart Koselleck, *Futures Past: On the Semantics of Historical Time,* trans. Keith Tribe (New York: Columbia University Press, 2004); Friedrich Meinecke, *Historism: The Rise of a New Historical Outlook,* trans. J. E. Anderson (London: Routledge and Kegan Paul, 1972); and Hayden V. White, *Metahistory: The Historical Imagination in Nineteenth-Century Europe* (Baltimore: Johns Hopkins University Press, 1973). For readers familiar with White's account the dominant forms of historical consciousness remain today what they were in the nineteenth century, being ordered by Formist (or antiquarian) and Contextualist (or historicist) modes of formal argument. White's other two modes, the Organist (e.g., Hegelian) and Mechanist (e.g., Marxian), continue to be marginalized as overly abstract hence insufficiently empirical, with officially legitimate historical work remaining almost exclusively Formist or Contextualist. Valuable accounts of historical thought prior to nineteenth-century historicism can be found in Ernst Cassirer, *The Philosophy of the Enlightenment,* trans. Fritz C. A. Koelln and James P. Pettegrove (Princeton: Princeton University Press, 1951), 197–233; R. G. Collingwood, *The Idea of History,* ed. W. J. van der Dussen, rev. ed. (Oxford: Oxford University Press, 1993); Anthony Grafton, *What Was History? The Art of History in Early Modern Europe* (Cambridge: Cambridge University Press, 2007); George H. Nadel, "Philosophy of History before Historicism," *History and Theory* 3, no. 3 (1964): 291–315; and Krzysztof Pomian, *L'ordre du temps* (Paris: Gallimard, 1984). Finally, for a brief overview of recent scholarship critical of historicism's current hegemony, see Cary Wolfe, *What Is Posthumanism?* (Minneapolis: University of Minnesota Press, 2010), 100–108; see also Tom Cohen, *Ideology and Inscription: "Cultural Studies" after Benjamin, de Man, and Bakhtin* (Cambridge:

Cambridge University Press, 1998); and the discussion of historical explanation in Mark Cousins, "The Practice of Historical Investigation," in *Post-structuralism and the Question of History,* ed. Derek Attridge, Geoffrey Bennington, and Robert Young (Cambridge: Cambridge University Press, 1987), 126–36.

3. Jacques Derrida, *Limited Inc.* (Evanston, Ill.: Northwestern University Press, 1988), 136–37. Derrida is responding to the incessant misreading of his well-known phrase, *il n'y a pas de hors-texte,* from *De la grammatologie* (Paris: Minuit, 1967), 227.

4. Cleanth Brooks, *The Well Wrought Urn: Studies in the Structure of Poetry* (New York: Harcourt, 1975), x; Paul de Man, *Allegories of Reading: Figural Language in Rousseau, Nietzsche, Rilke, and Proust* (New Haven, Conn.: Yale University Press, 1979), 3.

5. The best book on the topic remains Bill Readings, *The University in Ruins* (Cambridge, Mass.: Harvard University Press, 1996).

6. On recent work approaching the Americas as a hemisphere, see Ralph Bauer, "Hemispheric Studies," *PMLA* 124 (January 2009): 234–50.

7. David E. Mungello reviews the challenges posed by China in "European Philosophical Responses to Non-European Culture: China," in *The Cambridge History of Seventeenth-Century Philosophy,* ed. Daniel Garber and Michael Ayers (Cambridge: Cambridge University Press, 1998), 1:87–100.

8. Arthur O. Lovejoy and George Boas, *Primitivism and Related Ideas in Antiquity* (Baltimore: Johns Hopkins University Press, 1997); Boas, *Primitivism and Related Ideas in the Middle Ages* (Baltimore: Johns Hopkins University Press, 1997); Gilbert Chinard, *L'Amérique et le rêve exotique dans la littérature française au XVIIe et XVIIIe siècle* (Paris: Droz, 1934); Margaret T. Hodgen, *Early Anthropology in the Sixteenth and Seventeenth Centuries* (Philadelphia: University of Pennsylvania Press, 1964); Roy Harvey Pearce, *Savagism and Civilization: A Study of the Indian and the American Mind* (Berkeley: University of California Press, 1988); and Lois Whitney, *Primitivism and the Idea of Progress in English Popular Literature of the Eighteenth Century* (Baltimore: Johns Hopkins University Press, 1934). On the "unit-idea" as organizing object of study for the History of Ideas, see Lovejoy, *The Great Chain of Being: A Study of the History of an Idea* (Cambridge, Mass.: Harvard University Press, 1936), 3–23.

9. The classic account is J. H. Elliott, *The Old World and the New, 1492–1650* (Cambridge: Cambridge University Press, 1970). See also—and for reasons of space restricting myself here and in the notes to follow to work available in English—Christopher Bracken, *Magical Criticism: The Recourse of Savage Philosophy* (Chicago: University of Chicago Press, 2007); Susan Buck-Morss, *Hegel, Haiti and Universal History* (Pittsburgh: University of Pittsburgh Press, 2009); Enrique Dussel, *The Invention of the Americas: Eclipse of "the Other" and the Myth of Modernity,* trans. Michael D. Barber (New York: Continuum, 1995); Johannes Fabian,

Time and the Other: How Anthropology Makes Its Object, 2nd ed. (New York: Columbia University Press, 2002); Paul Gilroy, *The Black Atlantic: Modernity and Double Consciousness* (Cambridge, Mass.: Harvard University Press, 1993); Sanjay Krishnan, *Reading the Global: Troubling Perspectives on Britain's Empire in Asia* (New York: Columbia University Press, 2007); Fuyuki Kurasawa, *The Ethnological Imagination: A Cross-Cultural Critique of Modernity* (Minneapolis: University of Minnesota Press, 2004); Jonathan Lamb, *Preserving the Self in the South Seas, 1680–1840* (Chicago: University of Chicago Press, 2001); Franklin Perkins, *Leibniz and China: A Commerce of Light* (Cambridge: Cambridge University Press, 2004); and Gayatri Chakravorty Spivak, *A Critique of Postcolonial Reason: Toward a History of the Vanishing Present* (Cambridge, Mass.: Harvard University Press, 1999).

10. See the representative work of Srinivas Aravamudan, *Tropicopolitans: Colonialism and Agency, 1688–1804* (Durham, N.C.: Duke University Press, 1999); Laura Brown, *Fables of Modernity: Literature and Culture in the English Eighteenth Century* (Ithaca, N.Y.: Cornell University Press, 2001); Suvir Kaul, *Poems of Nation, Anthems of Empire: English Verse in the Long Eighteenth Century* (Charlottesville: University Press of Virginia, 2000); Robert Markley, *The Far East and the English Imagination, 1600–1730* (Cambridge: Cambridge University Press, 2006); Felicity Nussbaum, *The Limits of the Human: Fictions of Anomaly, Race, and Gender in the Long Eighteenth Century* (Cambridge: Cambridge University Press, 2003); and Roxann Wheeler, *The Complexion of Race: Categories of Difference in Eighteenth-Century British Culture* (Philadelphia: University of Pennsylvania Press, 2000). See also the following recent collections: Felicity Nussbaum, ed., *The Global Eighteenth Century* (Baltimore: Johns Hopkins University Press, 2003); and Daniel Carey and Lynn M. Festa, eds., *The Postcolonial Enlightenment: Eighteenth-Century Colonialism and Postcolonial Theory* (Oxford: Oxford University Press, 2009).

11. Edward W. Said, *Orientalism* (New York: Pantheon, 1978).

12. See Aijaz Ahmad, "*Orientalism* and After: Ambivalence and Metropolitan Location in the Work of Edward Said," in *In Theory: Classes, Nations, Literatures* (London: Verso, 1992), 159–220; and James Clifford, "On *Orientalism*," in *The Predicament of Culture: Twentieth-Century Ethnography, Literature, and Art* (Cambridge, Mass.: Harvard University Press, 1988), 255–76. See also Robert J. C. Young, *Colonial Desire: Hybridity in Theory, Culture, and Race* (London: Routledge, 1995), 159–82.

13. Rodolphe Gasché, "Hegel's Orient or the End of Romanticism," in *History and Mimesis,* ed. Irving J. Massey and Sung-won Lee (Buffalo: Department of English, State University of New York, Buffalo, 1983), 17–29.

14. Samuel Richardson, *Clarissa, or The History of a Young Lady,* ed. Angus Ross (Harmondsworth: Penguin, 1985), 609; see also 574.

15. Derrida, *De la grammatologie,* 147. A recent special issue of *Eighteenth-Century Studies* does make the case for Derrida's importance in the journal's titular field. See "Derrida's Eighteenth Century," ed. Jody Greene, *Eighteenth-Century Studies* 40 (Spring 2007): 367–472.

16. René Descartes, *Meditations on First Philosophy,* trans. John Cottingham, in *The Philosophical Writings of Descartes* (Cambridge: Cambridge University Press, 1984), 2:37–43. On Hegel's expressive causality, see Louis Althusser and Étienne Balibar, *Reading Capital,* trans. Ben Brewster (London: Verso, 1997), 186–87.

Introduction

1. Voltaire, *Dictionnaire philosophique* (Paris: Flammarion, 1964), 63.

2. Louis Althusser, *Montesquieu, la politique et l'histoire* (Paris: Presses Universitaires de France, 2003), 50. I derive the notion of a problematic more widely from Althusser and Étienne Balibar, *Reading Capital,* trans. Ben Brewster (London: Verso, 1997), 24–30. On the nonsubjective aspect of a problematic, see Gilles Deleuze, *Logique du sens* (Paris: Minuit, 1969), 69–70.

3. For an overview of eighteenth-century primitivism, see Maximillian E. Novak, "Primitivism," in *The Eighteenth Century,* vol. 4 of *The Cambridge History of Literary Criticism,* ed. H. B. Nisbet and Claude Rawson (Cambridge: Cambridge University Press, 1997), 456–69.

4. G. W. F. Hegel, *Aesthetics: Lectures on Fine Art,* trans. T. M. Knox (Oxford: Clarendon Press, 1975), 1:1; Francis Hutcheson, *An Inquiry into the Original of Our Ideas of Beauty and Virtue in Two Treatises,* ed. Wolfgang Leidhold (Indianapolis, Ind.: Liberty Fund, 2004), 27. Note that Hutcheson characterizes the human faculty of taste as a sense because the pleasures it produces are immediate and precognitive, with *cognitive* understood as entailing a mental deliberation: "This superior Power of Perception [i.e., the internal perception of beauty] is justly called a Sense, because of its Affinity to the other Senses in this, that the Pleasure does not arise from any Knowledge of the Principles, Proportions, Causes, or of the Usefulness of the Object; but strikes us at first with the Idea of Beauty" (25). On aesthetic theory's turn away from an interest in natural beauty, see Rodolphe Gasché, "The Theory of Natural Beauty and Its Evil Star: Kant, Hegel, Adorno," *Research in Phenomenology* 32 (2002): 103–22.

5. G. W. Leibniz, *Monadologie,* in *Discours de métaphysique, suivi de Monadologie et autres textes,* ed. Michel Fichant (Paris: Gallimard, 2004), §14, p. 222.

6. Jean-Jacques Rousseau, *Les Confessions,* in *Œuvres complètes,* ed. Bernard Gagnebin and Marcel Raymond (Paris: Gallimard, 1959), 1:152; translated by Angela Scholar as *Confessions,* ed. Patrick Coleman (Oxford: Oxford University Press, 2000), 148.

7. Edward Young, *Conjectures on Original Composition, in a letter to the author of Sir Charles Grandison* (London, 1759), 12.

8. J. H. Elliott, *The Old World and the New, 1492–1650* (Cambridge: Cambridge University Press, 1970). See also Nicholas P. Canny, "England's New World and the Old," in *The Origins of Empire: British Overseas Enterprise to the Close of the Seventeenth Century,* vol. 1 of *The Oxford History of the British Empire,* ed. Canny (Oxford: Oxford University Press, 1998), 148–69; Fredi Chiappelli, ed., *First Images of America: The Impact of the New World on the Old* (Berkeley: University of California Press, 1976); Michèle Duchet, *Anthropologie et histoire au siècle des lumières* (Paris: Albin Michel, 1995), 65–66; Jean-Paul Duviols, *Le miroir du Nouveau Monde: images primitives de l'Amérique* (Paris: Presses de l'Université Paris-Sorbonne, 2006), 9–57; Karen Ordahl Kupperman, ed., *America in European Consciousness, 1493–1750* (Chapel Hill: University of North Carolina Press, 1995); Anthony Pagden, "The Impact of the New World on the Old: The History of an Idea," *Renaissance and Modern Studies* 30 (1986): 1–11; and Michael T. Ryan, "Assimilating New Worlds in the Sixteenth and Seventeenth Centuries," *Comparative Studies in Society and History* 23 (Fall 1981): 519–38.

9. Christian Marouby, "From Early Anthropology to the Literature of the Savage: The Naturalization of the Primitive," *Studies in Eighteenth-Century Culture* 14 (1985): 290. See also Marouby's *Utopie et primitivisme: essai sur l'imaginaire anthropologique à l'âge classique* (Paris: Seuil, 1990).

10. Michèle Duchet, "Aspects de l'anthropologie des Lumières," in *Essais d'anthropologie: espace, langues, histoire* (Paris: Presses Universitaires de France, 2005), 215: "one can situate the origin of anthropological discourse at that moment of European thought when, with the great discoveries and the end of the theological era, the human endowed with reason and infinite powers *[pouvoirs infinis]* becomes the most interesting being of creation." As we will see in chapter 2, the *pouvoirs infinis* to which Duchet refers would include the aesthetic faculty. I should note that secularization does not, of course, mean secular: it names an ongoing action, not a completed process or condition. Accordingly, when I refer to God's withdrawal from the world I do not mean the end of belief in God. I mean something closer to the sense that a fully enchanting Deity is fading, departing. Secularization, in and beyond the Enlightenment, has long been a topic of intense debate. Relevant foundational studies that deal with the undoing of theological dominance in seventeenth- and eighteenth-century thinking include, in addition to Duchet: Michel Foucault, *Les mots et les choses: une archéologie des sciences humaines* (Paris: Gallimard, 1966); Peter Gay, *The Enlightenment: An Interpretation,* 2 vols. (New York: Norton, 1977); Georges Gusdorf, *Dieu, la nature, l'homme au siècle des Lumières,* vol. 5 of *Les sciences humaines et la pensée occidentale* (Paris: Payot, 1972); Paul Hazard, *La pensée européenne au xviiie siècle* (Paris: Fayard, 1963); and Charles Taylor, *A Secular Age* (Cambridge, Mass.:

Harvard University Press, 2007). See also Hans W. Frei, *The Eclipse of Biblical Narrative: A Study in Eighteenth and Nineteenth Century Hermeneutics* (New Haven, Conn.: Yale University Press, 1974); Jonathan Israel, *Radical Enlightenment: Philosophy and the Making of Modernity, 1650–1750* (Oxford: Oxford University Press, 2001); Alexandre Koyré, *From the Closed World to the Infinite Universe* (Baltimore: Johns Hopkins Press, 1957); and Stephen Toulmin, *Cosmopolis: The Hidden Agenda of Modernity* (Chicago: University of Chicago Press, 1992). Cf. Carl L. Becker, *The Heavenly City of the Eighteenth Century Philosophers* (New Haven, Conn.: Yale University Press, 1932); and David Sorkin, *The Religious Enlightenment: Protestants, Jews, and Catholics from London to Vienna* (Princeton: Princeton University Press, 2008).

11. Umberto Eco, *The Search for the Perfect Language* (Oxford: Blackwell, 1995), 238.

12. John Wilkins, *An Essay Towards a Real Character, And a Philosophical Language* (London, 1668), 3, 2. For a full account of Wilkins's project, see Eco, *Search for the Perfect Language,* 238–59. See also Hans Aarsleff, *From Locke to Saussure: Essays on the Study of Language and Intellectual History* (Minneapolis: University of Minnesota Press, 1982), 239–77; Murray Cohen, *Sensible Words: Linguistic Practice in England, 1640–1785* (Baltimore: Johns Hopkins University Press, 1977), 1–42; and Robert Markley, *Fallen Languages: Crises of Representation in Newtonian England, 1660–1740* (Ithaca, N.Y.: Cornell University Press, 1993), 63–94.

13. Johann Georg Hamann, *Aesthetica in nuce: A Rhapsody in Cabbalistic Prose,* trans. J. M. Bernstein, in *Classic and Romantic German Aesthetics,* ed. Bernstein (Cambridge: Cambridge University Press, 2003), 3.

14. Julien Offray de la Mettrie, *L'Homme-Machine,* ed. Paul-Laurent Assoun (Paris: Denoël-Gonthier, 1981), 183.

15. La Mettrie, *Histoire naturelle de l'âme* (Paris, 1747), 131.

16. La Mettrie, *L'Homme-Machine,* 186.

17. La Mettrie, *Man a Machine, and Man a Plant,* ed. Justin Leiber, trans. Richard A. Watson and Maya Rybalka (Indianapolis, Ind.: Hackett, 1994), 54.

18. La Mettrie, *L'Homme-Machine,* 189/54.

19. La Mettrie, *L'Homme-Machine,* 198. Descartes famously argues that non-human animals are automatons in part 5 of the *Discours de la méthode* (1637).

20. La Mettrie, *L'Homme-Machine,* 198/64 (translation modified); Paul-Laurent Assoun, in La Mettrie, *L'Homme-Machine,* 270n132.

21. Jean-Jacques Rousseau, *Discours sur l'origine et les fondements de l'inégalité parmi les hommes,* in *Œuvres complètes,* ed. Bernard Gagnebin and Marcel Raymond (Paris: Gallimard, 1964), 3:134.

22. Jean-Jacques Rousseau, *Essai sur l'origine des langues, où il est parlé de la mélodie et de l'imitation musicale,* ed. Jean Starobinski (Paris: Gallimard, 1990), 64; see also 89–112.

23. Jacques Derrida, *De la grammatologie* (Paris: Minuit, 1967), 357. See also Duchet, *Anthropologie et histoire,* 337–38. Recall that in the *Discours sur l'inégalité* Rousseau locates no beginning to the time of dispersal. On the opening of abyssal time more broadly in the eighteenth century, see Paolo Rossi, *The Dark Abyss of Time: The History of the Earth and the History of Nations from Hooke to Vico,* trans. Lydia G. Cochrane (Chicago: University of Chicago Press, 1984); and Taylor, *Secular Age,* 322–51.

24. Rousseau, *Essai,* 99; translated by Victor Gourevitch as *Essay on the Origin of Languages,* in *The Discourses and Other Political Writings,* ed. Gourevitch (Cambridge: Cambridge University Press, 1997), 272–73.

25. See Rousseau, *Essai,* 101. On Rousseau and the finger of God, see Jean Starobinski, "L'inclinaison de l'axe du globe," in Rousseau, *Essai,* 165–89. See also Derrida, *De la grammatologie,* 361–78.

26. This is, of course, the lesson learned from Vico. See Erich Auerbach, "Vico and Aesthetic Historism," in *Scenes from the Drama of European Literature* (Minneapolis: University of Minnesota Press, 1984), 183–98.

27. J. G. A. Pocock, *Narratives of Civil Government,* vol. 2 of *Barbarism and Religion* (Cambridge: Cambridge University Press, 1999), 7.

1. The Primitive

1. Jean Starobinski, *Jean-Jacques Rousseau: la transparence et l'obstacle, suivi de Sept essais sur Rousseau* (Paris: Gallimard, 1976), 26. On the Enlightenment's interest in origins as it relates specifically to questions of epistemology and aesthetics, see Catherine Labio, *Origins and the Enlightenment: Aesthetic Epistemology from Descartes to Kant* (Ithaca, N.Y.: Cornell University Press, 2004).

2. A valuable account of the term *primitive* as a category of thought can be found in Stanley Diamond, *In Search of the Primitive: A Critique of Civilization* (New Brunswick, N.J.: Transaction Books, 1974), 116–75.

3. Margaret T. Hodgen, *Early Anthropology in the Sixteenth and Seventeenth Centuries* (Philadelphia: University of Pennsylvania Press, 1964), 361.

4. Voltaire, *Micromégas. L'Ingénu,* ed. Jacques Van den Heuvel, Frédéric Deloffre, and Jacqueline Hellegouarc'h (Paris: Gallimard, 2002), 22; Macpherson, *The Poems of Ossian and Related Works,* ed. Howard Gaskill (Edinburgh: Edinburgh University Press, 1996), 216–17; Rochester, *The Works of John Wilmot, Earl of Rochester,* ed. Harold Love (Oxford: Oxford University Press, 1999), lines 4–6, p. 46.

5. Bulwer, *Anthropometamorphosis: Man Transform'd: Or, the Artificial Changling,* 2nd ed. (London, 1653), 534; Swift, *Gulliver's Travels,* ed. Paul Turner (Oxford: Oxford University Press, 1998), 36. On Bulwer, see Mary Baine Campbell, *Wonder and Science: Imagining Worlds in Early Modern Europe* (Ithaca, N.Y.: Cornell University Press, 1999), 225–56.

6. Plato, *Theaetetus,* ed. Bernard Williams, trans. M. J. Levett and Myles Burnyeat (Indianapolis, Ind.: Hackett, 1992), 82; Plutarch, *Plutarch's Lives,* trans. Bernadotte Perrin (London: Heinemann, 1914), 1:2–5; Saussure, *Course in General Linguistics,* ed. Charles Bally, Albert Sechehaye, and Albert Riedlinger, trans. Roy Harris (LaSalle, Ill.: Open Court, 1986), 110–11; Heidegger, *Being and Time,* trans. Joan Stambaugh (Albany: State University of New York Press, 1996), 1–12, 341–69; Colin McGinn, "How You Think," review of *The Stuff of Thought: Language as a Mirror onto Human Nature,* by Steven Pinker, *New York Review of Books,* September 27, 2007, 37–40; Meillassoux, *After Finitude: An Essay on the Necessity of Contingency,* trans. Ray Brassier (London: Continuum, 2008), 10, 21–22, 26–27; John Milton, *Poetical Works,* ed. Helen Darbishire (Oxford: Clarendon Press, 1952), 1:149–50; Thomas Aquinas, *A Summary of Philosophy,* ed. and trans. Richard J. Regan (Indianapolis, Ind.: Hackett, 2003), 49.

7. See, for example, Buffon's extended attempt to imagine the very first movements, sensations, and judgments of "le premier homme au moment de la création," in *Œuvres,* ed. Stéphane Schmitt (Paris: Gallimard, 2007), 302–6.

8. Rochester, *Works,* 46–48. Further references to this text are to line numbers and included in text.

9. Aristotle, *On the Parts of Animals,* trans. William Ogle, in *The Basic Works of Aristotle,* ed. Richard McKeon (New York: Modern Library, 2001), 644b, p. 656. For the Greek text, see Aristotle, *Parts of Animals,* trans. A. L. Peck (Cambridge, Mass.: Harvard University Press, 1937), 96.

10. Edward Grant, *A History of Natural Philosophy: From the Ancient World to the Nineteenth Century* (New York: Cambridge University Press, 2007), 44.

11. See Jacques Derrida, *De la grammatologie* (Paris: Minuit, 1967), 328–29.

12. John Webb, *An Historical Essay Endeavoring a Probability That the Language of the Empire of China is the Primitive Language* (London, 1669), 111, 99; Rachel Ramsey, "China and the Ideal of Order in John Webb's *An Historical Essay . . . ,*" *Journal of the History of Ideas* 62 (July 2001): 492. Webb's sources include standard texts by Samuel Purchas and Sir Walter Raleigh, but also recent works by Jesuit missionaries who had lived in China, including Alvaro Semedo, Athanasius Kircher, and Martino Martini.

13. See on this point Ramsey, "China," 484–87.

14. See the detailed accounts in David E. Mungello, *Curious Land: Jesuit Accommodation and the Origins of Sinology* (Stuttgart: F. Steiner Verlag Wiesbaden, 1985); and Virgile Pinot, *La Chine et la formation de l'esprit philosophique en France, 1640–1740* (Paris: Paul Geuthner, 1932), esp. 189–279. See also David Porter, *Ideographia: The Chinese Cipher in Early Modern Europe* (Stanford, Calif.: Stanford University Press, 2001).

15. Benedictus de Spinoza, *Theological-Political Treatise,* ed. Jonathan Israel, trans. Michael Silverthorne and Israel (Cambridge: Cambridge University Press, 2007), 43–56.

16. Paolo Rossi, *The Dark Abyss of Time: The History of the Earth and the History of Nations from Hooke to Vico,* trans. Lydia G. Cochrane (Chicago: University of Chicago Press, 1984), 52.

17. Jean-Luc Marion, "The Idea of God," trans. Thomas Carlson and Daniel Garber, in *The Cambridge History of Seventeenth-Century Philosophy,* ed. Garber and Michael Ayers (Cambridge: Cambridge University Press, 1998), 1:265.

18. Reiner Schürmann, *Heidegger on Being and Acting: From Principles to Anarchy,* trans. Christine-Marie Gros (Bloomington: Indiana University Press, 1987), 107, 112.

19. G. W. Leibniz, *Nouveaux essais sur l'entendement,* in *Die Philosophischen Schriften,* ed. C. I. Gerhardt (Berlin, 1882), 5:65. Jonathan Israel gives a concise review of Leibniz's major points of resistance to Spinoza in *Radical Enlightenment: Philosophy and the Making of Modernity, 1650–1750* (Oxford: Oxford University Press, 2001), 502–14.

20. G. W. Leibniz, *Monadologie,* in *Discours de métaphysique, suivi de Monadologie et autres textes,* ed. Michel Fichant (Paris: Gallimard, 2004), §47, p. 231.

21. Leibniz, *Monadologie,* 227.

22. See, for example, Michel Foucault, *Les mots et les choses: une archéologie des sciences humaines* (Paris: Gallimard, 1966), 60–91.

23. Etienne Bonnot de Condillac, *Traité des sensations,* in *Œuvres de Condillac* (Paris, 1798), 41–42.

24. Jean-Jacques Rousseau, *Discours sur l'origine et les fondements de l'inégalité parmi les hommes,* in *Œuvres complètes,* ed. Bernard Gagnebin and Marcel Raymond (Paris: Gallimard, 1964), 3:134; translated by Victor Gourevitch as *Discourse on the Origin and the Foundations of Inequality among Men,* in *The Discourses and Other Political Writings,* ed. Gourevitch (Cambridge: Cambridge University Press, 1997), 134.

25. Starobinski, *Rousseau,* 40.

26. On knowing a stone *as* a stone, see Martin Heidegger, *The Fundamental Concepts of Metaphysics: World, Finitude, Solitude,* trans. William McNeill and Nicholas Walker (Bloomington: Indiana University Press, 1995), 197–98.

2. The Aesthetic

1. Alexander Pope, *An Essay on Criticism,* in *The Poems of Alexander Pope,* ed. John Butt (New Haven, Conn.: Yale University Press, 1963), 143–68. Further references to this text are to line numbers.

2. Alexander Baumgarten, *Reflections on Poetry,* trans. Karl Aschenbrenner and William B. Holther (Berkeley: University of California Press, 1954), §116, p. 78; William K. Wimsatt Jr. and Cleanth Brooks, *Literary Criticism: A Short History* (New York: Vintage, 1957), 261; Immanuel Kant, *Critique of Pure Reason,* ed. and

trans. Paul Guyer and Allen W. Wood (Cambridge: Cambridge University Press, 1998), 156, 173. Notably Baumgarten formulates his own notion of poetry as the combination of clear and confused ideas (§15, p. 42). For a detailed reading of Baumgarten's *Reflections on Poetry* relevant to my own discussion, see Rodolphe Gasché, "Of Aesthetic and Historical Determination," in *Post-structuralism and the Question of History,* ed. Derek Attridge, Robert Young, and Geoff Bennington (Cambridge: Cambridge University Press, 1987), 139–61; and for an account of eighteenth-century German aesthetics as it emerges in Baumgarten and his immediate contemporaries, see David E. Wellbery, *Lessing's "Laocoon": Semiotics and Aesthetics in the Age of Reason* (Cambridge: Cambridge University Press, 1984). There is an abundant critical literature on the history of aesthetics. See, in particular, Andrew Bowie, *Aesthetics and Subjectivity: From Kant to Nietzsche,* 2nd ed. (Manchester, U.K.: Manchester University Press, 2003); Ernst Cassirer, *The Philosophy of the Enlightenment,* trans. Fritz C. A. Koelln and James P. Pettegrove (Princeton: Princeton University Press, 1951), 275–360; Howard Caygill, *Art of Judgement* (Oxford: Blackwell, 1989); Frances Ferguson, *Solitude and the Sublime: Romanticism and the Aesthetics of Individuation* (New York: Routledge, 1992); Paul Guyer, *Values of Beauty: Historical Essays in Aesthetics* (Cambridge: Cambridge University Press, 2005); Walter John Hipple Jr., *The Beautiful, the Sublime, and the Picturesque in Eighteenth-Century British Aesthetic Theory* (Carbondale: Southern Illinois University Press, 1957); Hans Reiss, "The Rise of Aesthetics from Baumgarten to Humboldt," in *The Eighteenth Century,* vol. 4 of *The Cambridge History of Literary Criticism,* ed. H. B. Nisbet and Claude Rawson (Cambridge: Cambridge University Press, 1997), 658–80; and David E. Wellbery, "Aesthetic Media: The Structure of Aesthetic Theory before Kant," in *Regimes of Description: In the Archive of the Eighteenth Century,* ed. John Bender and Michael Marrinan (Stanford, Calif.: Stanford University Press, 2005), 199–211.

3. Immanuel Kant, *Prolegomena to Any Future Metaphysics,* trans. Gary C. Hatfield, in *Theoretical Philosophy after 1781,* ed. Henry Allison and Peter Heath (Cambridge: Cambridge University Press, 2002), 103, 95n.

4. Cassirer, *Philosophy of the Enlightenment,* 275–360, esp. 300–301.

5. Aristotle, *Poetics,* trans. Ingram Bywater, in *The Rhetoric and Poetics of Aristotle* (New York: Modern Library, 1984), 1458a, p. 253.

6. I am not suggesting that one cannot be the object of another person's aesthetic experience, as certain women are thought to be for certain men. I am suggesting that an aesthetic experience, as something that happens, does not constitute an attribute of the individual human in the sense, for example, that "extension" is an attribute of "body."

7. Howard Caygill, *A Kant Dictionary* (Oxford: Blackwell, 1995), 190.

8. Ephraim Chambers, *Cyclopedia: Or, an Universal Dictionary of Arts and Sciences* (London, 1728), 1:5; Jean-Jacques Rousseau, *Essai sur l'origine des langues,*

où il est parlé de la mélodie et de l'imitation musicale, ed. Jean Starobinski (Paris: Gallimard, 1990), 92.

9. Montesquieu, *Essai sur le goût,* in *Essai sur le goût, précédé de Éloge de la sincérité* (Paris: Armand Colin, 1993), 30.

10. John Locke, *An Essay Concerning Human Understanding,* ed. P. H. Nidditch (Oxford: Clarendon Press, 1975), 305, 296; see also 95, 175, 305; Kenneth Burke, *A Grammar of Motives* (Berkeley: University of California Press, 1969), 23, 24.

11. As will become apparent in chapter 5 this is a version of the problem of the *parergon.* On dialectic and irony, see Burke, *Grammar of Motives,* 503–17.

12. Locke, *Essay,* 175; see also 296.

13. From the extensive literature on modernist primitivism, see in particular James Clifford, "Histories of the Tribal and Modern," in *The Predicament of Culture: Twentieth-Century Ethnography, Literature, and Art* (Cambridge, Mass.: Harvard University Press, 1988), 189–214. See also Marianna Torgovnick, *Gone Primitive: Savage Intellects, Modern Lives* (Chicago: Chicago University Press, 1990).

14. Anthony Pagden surveys the literature in "The Savage Critic: Some European Images of the Primitive," *Yearbook of English Studies* 13 (1983): 32–45.

15. Baumgarten, *Reflections on Poetry,* §21, p. 45.

16. Roland Barthes, "Le dernier des écrivains heureux," in *Candide et autres contes,* ed. Frédéric Deloffre and Jacques Van den Heuvel (Paris: Gallimard, 1992), 384.

17. Gotthold Ephraim Lessing, *Laocoön: An Essay on the Limits of Painting and Poetry,* trans. Edward Allen McCormick (Baltimore: Johns Hopkins University Press, 1984), 132–33. For the German text, see *Lessings Laokoon,* ed. Hug Blümner (Berlin, 1876), 282.

18. Horace, *On the Art of Poetry,* trans. T. S. Dorsch, in *Classical Literary Criticism* (London: Penguin, 1965), 79. For an overview of the eighteenth-century understanding of *ut pictura poesis,* see David Marshall, *"Ut pictura poesis,"* in Nisbet and Rawson, *Eighteenth Century,* 681–99.

19. Sir Joshua Reynolds, *Discourses on Art,* ed. Robert R. Wark (New Haven, Conn.: Yale University Press, 1997), 117–42.

20. Michel de Montaigne, "Des cannibales," in *Essais,* ed. Pierre Michel (Paris: Gallimard, 1965), 1:303; translated by Donald M. Frame as "Of Cannibals," in *The Complete Essays* (Stanford, Calif.: Stanford University Press, 1958), 152.

21. David Hume, *Essays, Moral, Political, and Literary,* ed. Eugene F. Miller (Indianapolis, Ind.: Liberty Fund, 1985), 227; Reynolds, *Discourses,* 137. John Barrell gives a full account of Reynolds's notion of custom in *The Political Theory of Painting from Reynolds to Hazlitt: "The Body of the Public"* (New Haven, Conn.: Yale University Press, 1986), 136–58.

22. Reynolds does not name a specific Tahitian practice, but as Harriet Guest has shown, it is their tattooing he has in mind. Guest, "Curiously Marked: Tattooing, Masculinity, and Nationality in Eighteenth-Century British Perceptions of the South Pacific," in *Painting and the Politics of Culture: New Essays on British Art, 1700–1850,* ed. John Barrell (Oxford: Oxford University Press, 1992), 110.

23. Paul Ricœur, *The Rule of Metaphor: Multi-disciplinary Studies of the Creation of Meaning in Language,* trans. Robert Czerny with Kathleen McLaughlin and John Costello (Toronto: University of Toronto Press, 1977), 46–47. Ricœur identifies a purely rhetorical tradition of tropology that is based on the premise that "if an exhaustive paraphrase of the metaphor (and of tropes in general) can be given, then the metaphor says nothing new.... The trope, teaching us nothing, has a merely decorative function."

3. The Savage

1. Extended studies of the savage's place in Enlightenment thought include Michèle Duchet, *Anthropologie et histoire au siècle des lumières* (Paris: Albin Michel, 1995); Ter Ellingson, *The Myth of the Noble Savage* (Berkeley: University of California Press, 2001); Ronald L. Meek, *Social Science and the Ignoble Savage* (Cambridge: Cambridge University Press, 1976); Anthony Pagden, *European Encounters with the New World: From Renaissance to Romanticism* (New Haven, Conn.: Yale University Press, 1993); J. G. A. Pocock, *Barbarians, Savages and Empires,* vol. 4 of *Barbarism and Religion* (Cambridge: Cambridge University Press, 2005); and David J. Weber, *Bárbaros: Spaniards and Their Savages in the Age of Enlightenment* (New Haven, Conn.: Yale University Press, 2005).

2. See Margaret T. Hodgen, *Early Anthropology in the Sixteenth and Seventeenth Centuries* (Philadelphia: University of Pennsylvania Press, 1964), 295–430; and Jorge Cañizares-Esguerra, *How to Write the History of the New World: Histories, Epistemologies, and Identities in the Eighteenth-Century Atlantic World* (Stanford, Calif.: Stanford University Press, 2001), 11–59.

3. Voltaire, *Candide et autres contes,* ed. Frédéric Deloffre and Jacques Van den Heuvel (Paris: Gallimard, 1992), 53: "mais des montagnes, des fleuves, des précipices, des brigands, *des sauvages,* étaient partout de terribles obstacles.... Ils se nourrirent un mois entier *de fruits sauvages*" (my emphasis).

4. Bruce Mazlish, in *Civilization and Its Contents* (Stanford, Calif.: Stanford University Press, 2004), gives an intellectual history of the concept of civilization. On the complexity of the Enlightenment concept of nature, specifically in aesthetics, see Arthur O. Lovejoy, "'Nature' as Aesthetic Norm," in *Essays in the History of Ideas* (Baltimore: Johns Hopkins University Press, 1948), 68–77. See also Clarence J. Glacken, *Traces on the Rhodian Shore: Nature and Culture in*

Western Thought from Ancient Times to the End of the Eighteenth Century (Berkeley: University of California Press, 1967).

5. Buffon, *Œuvres,* ed. Stéphane Schmitt (Paris: Gallimard, 2007), 382.

6. Michel de Montaigne, "Des cannibales," in *Essais,* ed. Pierre Michel (Paris: Gallimard, 1965), 1:305, translated by Donald M. Frame as "Of Cannibals," in *The Complete Essays* (Stanford, Calif.: Stanford University Press, 1958), 153.

7. Amerigo Vespucci, *Letters from a New World: Amerigo Vespucci's Discovery of America,* ed. Luciano Formisano, trans. David Jacobson (New York: Marsilio, 1992), 49–50; John Webb, *An Historical Essay Endeavoring a Probability That the Language of the Empire of China is the Primitive Language* (London, 1669), 120. On Vespucci's New World career, see David Abulafia, *The Discovery of Mankind: Atlantic Encounters in the Age of Columbus* (New Haven, Conn.: Yale University Press, 2008), 241–61.

8. Immanuel Kant, *Anthropology from a Pragmatic Point of View,* trans. Robert B. Louden, in *Anthropology, History, and Education,* ed. Günter Zöller and Louden (Cambridge: Cambridge University Press, 2007), 231.

9. Pocock, *Barbarians,* 4:176. On the proliferation of travel accounts and their tendency to generate a perceived need to grapple with the difficulties presented by the New World savage, see P. J. Marshall and Glyndwr Williams, *The Great Map of Mankind: British Perceptions of the World in the Age of Enlightenment* (London: Dent, 1982), 45. On understanding Europe as a unified continent, see Wilcomb E. Washburn, "The Meaning of 'Discovery' in the Fifteenth and Sixteenth Centuries," *American Historical Review* 68 (October 1962): 2–4; and, more recently, Roberto M. Dainotto, *Europe (in Theory)* (Durham, N.C.: Duke University Press, 2007), 41–42.

10. Tzvetan Todorov, *Life in Common: An Essay in General Anthropology,* trans. Katherine Golsan and Lucy Golsan (Lincoln: University of Nebraska Press, 2001), 12. Major studies in the intellectual history of the Western self include Jerrold E. Seigel, *The Idea of the Self: Thought and Experience in Western Europe since the Seventeenth Century* (New York: Cambridge University Press, 2005); Charles Taylor, *Sources of the Self: The Making of the Modern Identity* (Cambridge, Mass.: Harvard University Press, 1989); and Dror Wahrman, *The Making of the Modern Self: Identity and Culture in Eighteenth-Century England* (New Haven, Conn.: Yale University Press, 2004).

11. Todorov, *Life in Common,* 12. See also Charles Taylor, "The Politics of Recognition," in *Multiculturalism: Examining the Politics of Recognition,* ed. Amy Gutmann (Princeton: Princeton University Press, 1994), 23–73.

12. See Thomas Hobbes, *Leviathan,* ed. Richard Tuck (Cambridge: Cambridge University Press, 1991), 86–90. On America's role in Hobbes's life and thought, see Srinivas Aravamudan, "Hobbes and America," in *The Postcolonial*

Enlightenment: Eighteenth-Century Colonialism and Postcolonial Theory, ed. Daniel Carey and Lynn M. Festa (Oxford: Oxford University Press, 2009), 37–70.

13. Jean-Jacques Rousseau, *Émile ou de l'éducation,* in *Œuvres complètes,* ed. Bernard Gagnebin and Marcel Raymond (Paris: Gallimard, 1969), 4:503. See also Jacques Derrida, *De la grammatologie* (Paris: Minuit, 1967), 203–34.

4. Joseph Addison's China

1. Joseph Addison's "Pleasures of the Imagination" comprise ten *Spectator* papers (411–21), with an introductory paper (409) typically included. All references to the *Spectator* are to Richard Steele and Joseph Addison, *The Spectator,* ed. Donald F. Bond, 5 vols. (Oxford: Clarendon Press, 1965).

2. Addison, *Spectator,* 3:549.

3. Anthony Ashley Cooper, Third Earl of Shaftesbury, *Characteristics of Men, Manners, Opinions, Times,* ed. Lawrence E. Klein (Cambridge: Cambridge University Press, 1999), 321, 62, 323. A fuller account of the relation between Addison's and Shaftesbury's aesthetics can be found in David Marshall, "Shaftesbury and Addison: Criticism and the Public Taste," in *The Eighteenth Century,* vol. 4 of *The Cambridge History of Literary Criticism,* ed. H. B. Nisbet and Claude Rawson (Cambridge: Cambridge University Press, 1997), 633–57. See also Ronald Paulson, *The Beautiful, Novel, and Strange: Aesthetics and Heterodoxy* (Baltimore: Johns Hopkins University Press, 1996), 23–75.

4. See Jerome Stolnitz, "On the Origins of 'Aesthetic Disinterestedness,'" *Journal of Aesthetics and Art Criticism* 20 (Winter 1961): 134. Stolnitz correlates the extent of Shaftesbury's influence on eighteenth-century aesthetics to the influence of his notion of disinterestedness.

5. I use the translation by W. H. D. Rouse and Martin Ferguson Smith, in Lucretius, *De rerum natura,* 2nd ed. (Cambridge, Mass.: Harvard University Press, 1992), 1.927–28.

6. Hugh Blair, *Lectures on Rhetoric and Belles Lettres,* ed. Linda Ferreira-Buckley and S. Michael Halloran (Carbondale: Southern Illinois University Press, 2005), 24–25; Lucretius, *De rerum natura,* 1.926–28 and 4.1–3. I should note that Addison's innovation is as often questioned as asserted. The debate turns specifically on the question of Longinus's and Locke's respective influence, and to a lesser extent Hobbes's and Newton's. See, for example, Walter John Hipple Jr., *The Beautiful, the Sublime, and the Picturesque in Eighteenth-Century British Aesthetic Theory* (Carbondale: Southern Illinois University Press, 1957), 13; and Lee Andrew Elioseff, *The Cultural Milieu of Addison's Literary Criticism* (Austin: University of Texas Press, 1963), 161–88.

7. The claim is found in William H. Youngren, "Addison and the Birth of Eighteenth-Century Aesthetics," *Modern Philology* 79 (1982): 267–83. Cf. Neil

Saccamano, "The Sublime Force of Words in Addison's 'Pleasures,'" *ELH* 58, 1 (1991): 83–106.

8. Samuel Holt Monk, *The Sublime: A Study of Critical Theories in XVIII-Century England* (Ann Arbor: University of Michigan Press, 1960), 57, 59.

9. René Descartes, *Meditations on First Philosophy*, trans. John Cottingham, in *The Philosophical Writings of Descartes* (Cambridge: Cambridge University Press, 1984), 2:50–51.

10. John Dennis, *The Grounds of Criticism in Poetry*, in *The Critical Works of John Dennis*, ed. Edward Niles Hooker (Baltimore: Johns Hopkins Press, 1967), 1:337, 335; Albert O. Hirschman, *The Passions and the Interests: Political Arguments for Capitalism Before Its Triumph* (Princeton: Princeton University Press, 1997), 20–31. On Dennis's understanding of enthusiasm and affective discourse, see Shaun Irlam, *Elations: The Poetics of Enthusiasm in Eighteenth-Century Britain* (Stanford, Calif.: Stanford University Press, 1999), 53–82.

11. Dennis, *Grounds of Criticism*, 361.

12. Ernest Lee Tuveson, *The Imagination as a Means of Grace: Locke and the Aesthetics of Romanticism* (Berkeley: University of California Press, 1960), 94.

13. Aristotle, *Physics*, trans. R. Hardie and R. K. Gaye, in *The Basic Works of Aristotle*, ed. Richard McKeon (New York: Modern Library, 2001), 194b, p. 241.

14. John Locke, *An Essay Concerning Human Understanding*, ed. P. H. Nidditch (Oxford: Clarendon Press, 1975), 324.

15. Maurice Blanchot, "The Novel, Work of Bad Faith," trans. Arthur Goldhammer, in *Literary Debate: Texts and Contexts*, ed. Denis Hollier and Jeffrey Mehlman (New York: New Press, 1999), 418.

16. Dennis, *Grounds of Criticism*, 328.

17. Addison, *Spectator*, 2:126–30.

18. Addison, *Spectator*, 3:537. See Locke, *Essay*, 105. James Sambrook compares Locke and Addison in detail on this point in "The Psychology of Literary Creation and Literary Response," in Nisbet and Rawson, *Eighteenth Century*, 618–22.

19. Arthur O. Lovejoy, "The Chinese Origin of a Romanticism," in *Essays in the History of Ideas* (Baltimore: Johns Hopkins University Press, 1948), 113. For a fuller, recent account of a specifically English taste in things Chinese, see David Porter, *The Chinese Taste in Eighteenth-Century England* (Cambridge: Cambridge University Press, 2010).

20. Blair, *Lectures*, 219–52.

21. Alexander Pope, *Epistle IV to Richard Boyle, Earl of Burlington*, in *The Poems of Alexander Pope*, ed. John Butt (New Haven, Conn.: Yale University Press, 1963), 586–95; Addison, *Spectator*, 3:552–53. By midcentury the natural taste advocated by Addison and Pope is arguably commonplace, though it is not recognized as Chinese. On the scope of English writing about landscape gardening,

see the invaluable anthology edited by John Dixon Hunt and Peter Willis, *The Genius of the Place: The English Landscape Garden, 1620–1820* (Cambridge, Mass.: MIT Press, 1988); see also the comprehensive account of landscape's literary trajectory in John Barrell, *The Idea of Landscape and the Sense of Place, 1730–1840: An Approach to the Poetry of John Clare* (Cambridge: Cambridge University Press, 1972), 1–63.

22. William Temple, "Upon the Gardens of Epicurus; or of Gardening in the Year 1685," in *Miscellanea: The second part in four essays* (London, 1692), 131.

23. Temple, "Gardens of Epicurus," 132.

24. William Empson, *The Structure of Complex Words* (Cambridge, Mass.: Harvard University Press, 1989), 346–47. Angus Fletcher develops Empson's claim in a broadly historical direction in *Allegory: The Theory of a Symbolic Mode* (Ithaca, N.Y.: Cornell University Press, 1964), 70–146.

25. Gordon Teskey, *Allegory and Violence* (Ithaca, N.Y.: Cornell University Press, 1996), 98, 105. See also Neil Saccamano, "Knowledge, Power, Allegory: Swift's *Tale* and Neoclassical Literary Criticism," in *Enlightening Allegory: Theory, Practice, and Contexts of Allegory in the Late Seventeenth and Eighteenth Centuries,* ed. Kevin L. Cope (New York: AMS Press, 1993), 299–322.

26. Accounts of how major empiricist philosophers understand language, paying special attention to the question of rhetoric, include Cathy Caruth, *Empirical Truths and Critical Fictions: Locke, Wordsworth, Kant, Freud* (Baltimore: Johns Hopkins University Press, 1991); and Jules David Law, *The Rhetoric of Empiricism: Language and Perception from Locke to I. A. Richards* (Ithaca, N.Y.: Cornell University Press, 1993). See also Paul de Man, "The Epistemology of Metaphor," in *Aesthetic Ideology,* ed. Andrzej Warminski (Minneapolis: University of Minnesota Press, 1996), 34–50; and Geoffrey Bennington, "The Perfect Cheat: Locke and Empiricism's Rhetoric," in *Legislations: The Politics of Deconstruction* (London: Verso, 1994), 119–36.

27. John Hughes, *An essay on allegorical poetry, &c.,* in *Critical Essays of the Eighteenth Century, 1700–1725,* ed. W. H. Durham (New York: Russell & Russell, 1961), 100–101.

28. See Teskey, *Allegory and Violence,* 105. In suggesting Bunyan's allegory "self-sufficient"—that it can be read for its surface narrative alone—I follow Michael McKeon, *The Origins of the English Novel, 1600–1740* (Baltimore: Johns Hopkins University Press, 1987), 295–314.

29. Tuveson, *Imagination,* 73.

30. Paul de Man, *Allegories of Reading: Figural Language in Rousseau, Nietzsche, Rilke, and Proust* (New Haven, Conn.: Yale University Press, 1979), 198.

31. de Man, *Allegories of Reading,* 205.

32. Commentators have gone to great lengths in search of a Chinese source. See, for example, S. Lang and N. Pevsner, "Sir William Temple and Sharawadgi,"

Architectural Review 106 (December 1949): 391–93. See also Ciaran Murray, *Sharawadgi: The Romantic Return to Nature* (San Francisco: International Scholars Publications, 1998), 34–39.

33. Paul de Man, "The Rhetoric of Temporality," in *Blindness and Insight: Essays in the Rhetoric of Contemporary Criticism* (Minneapolis: University of Minnesota Press, 1983), 203.

34. *Spectator* 293 serves as a warning against too quickly associating Addison's position with Gratian's. There, Addison cites a precept of Gratian's and suggests that it is base "to an honest Mind," though perhaps useful for those governed by self-interest (3:42).

35. Claude Lefort, "L'image du corps et le totalitarisme," in *L'invention démocratique: les limites de la domination totalitaire* (Paris: Fayard, 1981), 172; translated by Alan Sheridan as "The Image of the Body and Totalitarianism," in *The Political Forms of Modern Society: Bureaucracy, Democracy, Totalitarianism,* ed. John B. Thompson (Cambridge, Mass.: MIT Press, 1986), 303.

36. de Man, "Rhetoric of Temporality," 207. Addison's China unveils what de Man calls allegory's "authentically temporal destiny": "The meaning constituted by the allegorical sign can then consist only in the *repetition* . . . of a previous sign with which it can never coincide, since it is of the essence of this previous sign to be pure anteriority" (206, 207).

37. Rodolphe Gasché, *The Tain of the Mirror: Derrida and the Philosophy of Reflection* (Cambridge, Mass.: Harvard University Press, 1986), 16.

5. Kant's Tattooed New Zealanders

1. Howard Caygill, *A Kant Dictionary* (Oxford: Blackwell, 1995), 352; Philippe Lacoue-Labarthe and Jean-Luc Nancy, *The Literary Absolute: The Theory of Literature in German Romanticism,* trans. Philip Barnard and Cheryl Lester (Albany: State University of New York Press, 1988), 31. On Kant's understanding of reflection in the Critical Philosophy, with particular attention to its role in the *Critique of Judgment,* see Jean-François Lyotard, *Lessons on the Analytic of the Sublime,* trans. Elizabeth Rottenberg (Stanford, Calif.: Stanford University Press, 1994), 1–49.

2. Immanuel Kant, *Critique of Pure Reason,* ed. and trans. Paul Guyer and Allen W. Wood (Cambridge: Cambridge University Press, 1998), 110, 100. See also Kant, *Correspondence,* ed. and trans. Arnulf Zweig (Cambridge: Cambridge University Press, 1999), 198.

3. See Andrew Bowie, *Aesthetics and Subjectivity: From Kant to Nietzsche,* 2nd ed. (Manchester, U.K.: Manchester University Press, 2003), 17.

4. Immanuel Kant, *Kritik der Urteilskraft,* in *Kants gesammelte Schriften,* ed. Königlich-Preußischen Akademie der Wissenschaften zu Berlin (Berlin: G. Reimer,

1913), 5:175; translated by Paul Guyer and Eric Matthews as *Critique of the Power of Judgment,* ed. Guyer (Cambridge: Cambridge University Press, 2000), 63. Further references are to the Akademie edition only as the corresponding page numbers are included in the margins of the English translation. Although the translators of the Cambridge edition insist, rightly, on translating *Urteilskraft* in the title of Kant's work as "power of judgment," I follow the conventional practice and use *Critique of Judgment* throughout.

5. Jacques Derrida, *La vérité en peinture* (Paris: Flammarion, 1978), 123; translated by Geoff Bennington and Ian McLeod as *The Truth in Painting* (Chicago: University of Chicago Press, 1987), 107–8. After the publication of Kant's anthropology lectures in 1997, the place of anthropology in both Kant's aesthetic theory and his Critical Philosophy has become a prominent focus in Kant scholarship. Kant, *Vorlesungen über Anthropologie,* vol. 25 of *Kants gesammelte Schriften,* ed. Berlin-Brandenburgische Akademie der Wissenschaften and Akademie der Wissenschaften zu Göttingen (Berlin: W. de Gruyter, 1997). See Brian Jacobs and Patrick Kain, eds., *Essays on Kant's Anthropology* (Cambridge: Cambridge University Press, 2003).

6. "Man würde vieles unmittelbar in der Anschauung Gefallende an einem Gebäude anbringen können, wenn es nur nicht eine Kirche sein sollte; eine Gestalt mit allerlei Schnörkeln und leichten, doch regelmäßigen Zügen, wie die Neuseeländer mit ihrem Tettawiren thun, verschönern können, wenn es nur nicht ein Mensch wäre; und dieser könnte viel feinere Züge und einen gefälligeren sanftern Umriß der Gesichtsbildung haben, wenn er nur nicht einen Mann, oder gar einen kriegerischen vorstellen sollte." Kant, *Kritik der Urteilskraft,* §16, p. 230.

7. Philip Mallaband, "Understanding Kant's Distinction between Free and Dependent Beauty," *Philosophical Quarterly* 52 (January 2002): 74. In view of the discussion to follow, it is perhaps worth noting that Kant expressly endorses what we would call armchair anthropology, in *Anthropologie in pragmatischer Hinsicht,* in *Kants gesammelte Schriften,* ed. Königlich-Preußischen Akademie der Wissenschaften zu Berlin (Berlin: G. Reimer, 1907), 7:120.

8. Kant, *Kritik der Urteilskraft,* 225.

9. Kant will also go on to address questions of physiognomic characteristics in a footnote to §17, "On the Ideal of Beauty" (235), and later still indicate his familiarity with, and support of, the work of the well-known comparative anatomists Johann Friedrich Blumenbach and Pieter Camper (§81, p. 424; §82, p. 428). See also John H. Zammito, *The Genesis of Kant's "Critique of Judgment"* (Chicago: University of Chicago Press, 1992), 201. Kant's only extensive use of *Gesichtsbildung* to address physiognomic questions appears in the late *Anthropologie* (1798). Kant, *Anthropologie,* 7:285–334.

10. Jacob Grimm and Wilhelm Grimm, *Deutsches Wörterbuch,* ed. Deutschen Akademie der Wissenschaften zu Berlin (Leipzig: Hirzel, 1956), 12.1:1143–44.

On Kant's complicated understanding of *die Negers,* see Ronald A. T. Judy, *(Dis)forming the American Canon: African-Arabic Slave Narratives and the Vernacular* (Minneapolis: University of Minnesota Press, 1993), 105–46. See David Bindman's discussion of race and aesthetics in *Ape to Apollo: Aesthetics and the Idea of Race in the 18th Century* (Ithaca, N.Y.: Cornell University Press, 2002).

11. The main English-language entries into the debate, arranged chronologically, include: Geoffrey Scarré, "Kant on Free and Dependent Beauty," *British Journal of Aesthetics* 21 (1981): 351–62; Paul Crowther, "The Claims of Perfection: A Revisionary Defense of Kant's Theory of Dependent Beauty," *International Philosophical Quarterly* 26 (1986): 61–74; Ruth Lorand, "Free and Dependent Beauty: A Puzzling Issue," *British Journal of Aesthetics* 29 (Winter 1989): 32–40; Robert Stecker, "Lorand and Kant on Free and Dependent Beauty," *British Journal of Aesthetics* 30 (January 1990): 71–74; Ruth Lorand, "On 'Free and Dependent Beauty'—A Rejoinder," *British Journal of Aesthetics* 32 (July 1992): 250–53; Robert Wicks, "Dependent Beauty as the Appreciation of Teleological Style," *Journal of Aesthetics and Art Criticism* 55 (1997): 387–400; Paul Guyer, "Dependent Beauty Revisited: A Reply to Wicks," *Journal of Aesthetics and Art Criticism* 57 (1999): 357–61; Paul Guyer, "Free and Adherant Beauty: A Modest Proposal," *British Journal of Aesthetics* 42 (October 2002): 357–66; and Mallaband, "Understanding Kant's Distinction," 66–81.

12. For a full treatment of related issues, see Jean-Luc Nancy, *The Discourse of the Syncope: Logodaedalus,* trans. Saul Anton (Stanford, Calif.: Stanford University Press, 2008). On the example and the exemplar in the third *Critique* from the perspective of pedagogical theory—asking what and how Kant is trying to facilitate knowledge through his use of examples—see David Lloyd, "Kant's Examples," *Representations* 28 (Autumn 1989): 34–54.

13. Rodolphe Gasché, *The Idea of Form: Rethinking Kant's Aesthetics* (Stanford, Calif.: Stanford University Press, 2003), 66; Derrida, *La vérité en peinture,* 104–5/92–93.

14. Kant, *Kritik der Urteilskraft,* §51, p. 323.

15. William Marsden, *The History of Sumatra, Containing An Account of the Government, Laws, Customs, and Manners Of the Native Inhabitants, With A Description of the Natural Productions, And a Relation of the Ancient Political State of that Island,* 2nd ed. (London, 1784), 103–32, iii, 113.

16. Kant, *Kritik der Urteilskraft,* 243.

17. Gasché, *Idea of Form,* 67; Kant, *Observations on the Feeling of the Beautiful and the Sublime,* trans. Paul Guyer, in *Anthropology, History, and Education,* ed. Günter Zöller and Robert B. Louden (Cambridge: Cambridge University Press, 2007), 52.

18. Derrida, *La vérité en peinture,* 96–97/85.

19. "Für sich allein würde ein verlassener Mensch auf einer wüsten Insel weder seine Hütte, noch sich selbst ausputzen, oder Blumen aufsuchen, noch

weniger sie pflanzen, um sich damit auszuschmücken; sondern nur in Gesell-
schaft kommt es ihm ein, nicht bloß Mensch, sondern auch nach seiner Art ein
feiner Mensch zu sein (der Anfang der Civilisirung): denn als einen solchen beur-
theilt man denjenigen, welcher seine Lust andern mitzutheilen geneigt und
geschickt ist, und den ein Object nicht befriedigt, wenn er das Wohlgefallen an
demselben nicht in Gemeinschaft mit andern fühlen kann. Auch erwartet und
fordert ein jeder die Rücksicht auf allgemeine Mittheilung von jedermann, gleich-
sam als aus einem ursprünglichen Vertrage, der durch die Menschheit selbst
dictirt ist; und so werden freilich anfangs nur Reize, z.b. Farben, um sich zu bema-
len (Rocou bei den Caraiben und Zinnober bei den Irokesen), oder Blumen,
Muschelschalen, schönfarbige Vogelfedern, mit der Zeit aber auch schöne For-
men (als an Canots, Kleidern u.s.w.), die gar kein Vergnügen, d.i. Wohlgefallen
des Genusses, bei sich führen, in der Gesellschaft wichtig und mit großem Inte-
resse verbunden: bis endlich die auf den höchsten Punkt gekommene Civil-
isirung daraus beinahe das Hauptwerk der verfeinerten Neigung macht, und
Empfindungen nur so viel werth gehalten werden, als sie sich allgemein mitthei-
len lassen; wo denn, wenn gleich die Lust, die jeder an einem solchen Gegen-
stande hat, nur unbeträchtlich und für sich ohne merkliches Interesse ist, doch
die Idee von ihrer allgemeinen Mittheilbarkeit ihren Werth beinahe unendlich
vergrößert." Kant, *Kritik der Urteilskraft,* §41, p. 297.

20. For a detailed exploration of "the narrative of development" embedded in
the passage, see David Lloyd, "The Pathological Sublime: Pleasure and Pain in
the Colonial Context," in *The Postcolonial Enlightenment: Eighteenth-Century
Colonialism and Postcolonial Theory,* ed. Daniel Carey and Lynn M. Festa (Oxford:
Oxford University Press, 2009), 70–102.

21. See, for example, H. Ling Roth, "Maori Tatu and Moko," *Journal of the
Royal Anthropological Institute of Great Britain and Ireland* 31 (1901): 51.

22. H. G. Robley, *Moko, or Maori Tattooing* (London, 1896), 2; Bernard
Smith, *Imagining the Pacific: In the Wake of the Cook Voyages* (New Haven, Conn.:
Yale University Press, 1992), 81; Nicholas Thomas, "Kiss the Baby Goodbye:
Kowhaiwhai and Aesthetics in Aotearoa New Zealand," *Critical Inquiry* 22
(Autumn 1995): 93. John Hawkesworth's *An Account of the Voyages Undertaken
by the Order of his Present Majesty for making Discoveries in the Southern Hemi-
sphere* (London, 1773) included a narrative in the first person of Cook's first
Pacific voyage (1768–71) based on Cook's and Joseph Banks's journals. It was
immediately translated into German by Johann Friedrich Schiller as *Geschichte
der See-Reisen und Entdeckungen im Süd-Meer,* 3 vols. (Berlin, 1774), and then
again by Johann Heinrich Merck as *Geschichte der See-Reisen nach dem Südmeer,* 3
vols. (Leipzig, 1775). On Cook's three Pacific voyages, see the excellent accounts
in Anne Salmond, *The Trial of the Cannibal Dog: The Remarkable Story of Captain
Cook's Encounters in the South Seas* (New Haven, Conn.: Yale University Press,

2003); and Nicholas Thomas, *Cook: The Extraordinary Voyages of Captain James Cook* (New York: Walker, 2003). On Maori tattooing, see Peter Gathercole, "Contexts of Maori *Moko*," in *Marks of Civilization: Artistic Transformations of the Human Body*, ed. Arnold Rubin (Los Angeles: Museum of Cultural History, 1988), 171–77; Dave Simmons, *"Moko,"* in *Art and Artists in Oceania*, ed. Sidney M. Mead and Bernie Kernot (Palmerston North, New Zealand: Dunmore, 1983), 226–43; Dave Simmons, *"Ta Moko": The Art of Maori Tattooing* (Auckland, New Zealand: Reed Methuen, 1986); and Ko Te Riria and Dave Simmons, *Maori Tattoo* (Auckland, New Zealand: Bush, 1989). See also Stephen Pritchard's recent work on Maori tattooing, which draws it into relation with contemporary debates on intellectual property rights and questions of identity: "Essence, Identity, Signature: Tattoos and Cultural Property," *Social Semiotics* 10, no. 3 (2000): 340–41; and "An Essential Marking: Maori Tattooing and the Properties of Identity," *Theory, Culture and Society* 18, no. 4 (2001): 27–45. Alfred Gell, *Wrapping in Images: Tattooing in Polynesia* (Oxford: Clarendon Press, 1993), provides a comprehensive treatment of tattooing throughout Polynesia. See also Juniper Ellis, *Tattooing the World: Pacific Designs in Print and Skin* (New York: Columbia University Press, 2008); Simon Schaffer, "'On Seeing Me Write': Inscription Devices in the South Seas," *Representations* 97 (Winter 2007): 90–122; and Nicholas Thomas, Anna Cole, and Bronwen Douglas, eds., *Tattoo: Bodies, Art, and Exchange in the Pacific and the West* (Durham, N.C.: Duke University Press, 2005).

23. In England, images of three of the four Indian kings who visited London in 1710 (to whom, as we saw in the previous chapter, Addison addressed a *Spectator* paper) showed them as having facial tattooing. See Eric Hinderaker, "The 'Four Indian Kings' and the Imaginative Construction of the First British Empire," *William and Mary Quarterly* 53 (July 1996): 487–526. See also Juliet Fleming, *Graffiti and the Writing Arts of Early Modern England* (London: Reaktion, 2001), 79–112; Michael Gaudio, *Engraving the Savage: The New World and Techniques of Civilization* (Minneapolis: University of Minnesota Press, 2008), 1–43; and Gordon M. Sayre, *Les Sauvages Américains: Representations of Native Americans in French and English Colonial Literature* (Chapel Hill: University of North Carolina Press, 1997), 165–79.

24. Georg Forster, *A Voyage Round the World*, ed. Nicholas Thomas and Oliver Berghof (Honolulu: University of Hawai'i Press, 2000), 1:211, 265; Joseph Banks, *The Endeavour Journal of Joseph Banks, 1768–1771*, ed. J. C. Beaglehole (Sydney: Angus and Robertson, 1962), 2:13–14; Bernard Smith, *European Vision and the South Pacific*, 2nd ed. (New Haven, Conn.: Yale University Press, 1985), 13.

25. Georg Forster, *Reise um die Welt*, in *Werke in vier Bänden*, ed. Gerhard Steiner (Frankfurt am Main: Insel, 1967), 1:349. The first recorded instances of *tattow* can be found in James Cook, *The Explorations of Captain James Cook in the*

Pacific, as Told by Selections of His Own Journals, 1768–1779, ed. A. Grenfell Price (New York: Dover, 1971), 37; and Banks, *Endeavour Journal,* 1:309.

26. George Lillie Craik, *The New Zealanders* (London, 1830), 142.

27. In *Moby-Dick,* for example, Ishmael glosses New Zealand as "the Tattoo Land," while Victor Segalen, in his 1907 novel *Les Immémoriaux,* explains the pronunciation of the Maori *u* by using the example of *tatu,* as if a quintessential marker of Maori language ("Dans tous les mots Maori *u* doit se prononcer *ou; atua* comme 'atoua,' *tatu* comme 'tatou,' etc."). Herman Melville, *Moby-Dick, or The Whale,* ed. Harrison Hayford, Hershel Parker, and G. Thomas Tanselle (Evanston, Ill.: Northwestern University Press, 1988), 205; Victor Segalen, *Les immémoriaux,* in *Œuvres complètes,* ed. Henry Bouillier (Paris: Laffont, 1995), 1:107.

28. Banks, *Endeavour Journal,* 2:14. For a fascinating and suggestive account of the naturalist Banks's naming practices, especially as they contrast to Cook's, see Paul Carter, *The Road to Botany Bay: An Exploration of Landscape and History* (New York: Knopf, 1988).

29. Craik, *New Zealanders,* 143; H. Ling Roth, "On Permanent Artificial Skin Marks: A Definition of Terms," *Journal of the Anthropological Institute of Great Britain and Ireland* 30 (1900): 117. Elsdon Best gives a valuable account of Maori tattooing implements in "The Uhi-Maori, or Native Tattooing Instruments," *Journal of the Polynesian Society* 13 (1904): 166–72.

30. Smith, *Imagining the Pacific,* 10.

31. Kant, *Kritik der Urteilskraft,* 195.

32. Derrida, *La vérité en peinture,* 44/37.

33. Cited in Robley, *Moko,* 18.

34. Jean-Jacques Rousseau, *Essai sur l'origine des langues, où il est parlé de la mélodie et de l'imitation musicale,* ed. Jean Starobinski (Paris: Gallimard, 1990), 73–74. Tzvetan Todorov provides a brief but clear account of mythographic writing and its differentiation from forms of logographic writing in Oswald Ducrot and Todorov, *Encyclopedic Dictionary of the Sciences of Language,* trans. Catherine Porter (Baltimore: Johns Hopkins University Press, 1979), 193–98.

35. Samuel Marsden cited in Roth, "Maori Tatu and Moko," 47; Talyor, *Te ika a Maui,* cited in Robley, *Moko,* 19; Samuel Johnson, *A Dictionary of the English Language* (London, 1755). It is also worth noting that several chiefs signed Aotearoa/New Zealand's founding document, the Treaty of Waitangi (1840), in this fashion. For a reproduction of the treaty that shows the use of moko as signature, see Thomas Lindsay Buick, *The Treaty of Waitangi: How New Zealand Became a British Colony,* 3rd ed. (New Plymouth, New Zealand: Thomas Avery, 1936), facing 352.

36. On Kant's distinction between the mechanical and beautiful arts as one between doing *(facere)* and acting or making *(agere),* see Gasché, *Idea of Form,* 179–201.

37. As Lacan playfully sums up his differentiation of "natural symbolism" and "symbolism as structured in language": *"To read coffee grounds is not to read hieroglyphics."* Jacques Lacan, *The Psychoses, 1955–1956,* vol. 3 of *The Seminar of Jacques Lacan,* ed. Jacques-Alain Miller, trans. Russell Grigg (New York: Norton, 1993), 195.

38. Kant, *Kritik der Urteilskraft,* §1, p. 203.

39. Michel de Certeau, *L'écriture de l'histoire* (Paris: Gallimard, 1975), 254–55. On the aligning of the savage with orality, see as well as de Certeau; Jacques Derrida, *De la grammatologie* (Paris: Minuit, 1967), 149–202; and Nicholas Hudson, *Writing and European Thought, 1600–1830* (Cambridge: Cambridge University Press, 1994), 39–41.

40. Gell, *Wrapping in Images,* 237.

41. Derrida, *La vérité en peinture,* 63. By emphasizing the role of the *parergon* and the *parergonal* in Kant's text, I am, or course, following Derrida's lead. Many critics have made reference to Derrida's account to different ends. See in particular Gayatri Chakravorty Spivak, *A Critique of Postcolonial Reason: Toward a History of the Vanishing Present* (Cambridge, Mass.: Harvard University Press, 1999), 9–37. Spivak follows Derrida in a direction relevant to my discussion. See also David Wills's wonderfully insightful account, "Derrida and Aesthetics: Lemming (Reframing the Abyss)," in *Jacques Derrida and the Humanities: A Critical Reader,* ed. Tom Cohen (Cambridge: Cambridge University Press, 2001), 108–31.

42. Kant, *Kritik der Urteilskraft,* §14, p. 226.

43. Immanuel Kant, *Die Metaphysik der Sitten,* in *Kants gesammelte Schriften,* ed. Königlich-Preußischen Akademie der Wissenschaften zu Berlin (Berlin: G. Reimer, 1907), 6:473; translated by Mary J. Gregor as *The Metaphysics of Morals,* in *Practical Philosophy,* ed. Gregor (Cambridge: Cambridge University Press, 1996), 588.

44. Derrida, *La vérité en peinture,* 63–66/54–56.

45. See Derrida, *La vérité en peinture,* 79–81/68–69.

46. Kant, *Kritik der Urteilskraft,* 219, 236.

47. Kant, *Kritik der Urteilskraft,* §16, p. 230 (translation modified).

48. Aristotle, *Politics,* trans. Benjamin Jowett, in *The Basic Works of Aristotle,* ed. Richard McKeon (New York: Modern Library, 2001), 1252b–1253a, p. 1129 (translation modified).

49. "Es giebt zweierlei Arten von Schönheit: freie Schönheit *(pulchritude vaga),* oder die bloß anhängende Schönheit *(pulchritudo adhaerens).* Die erstere setzt keinen Begriff von dem voraus, was der Gegenstand sein soll; die zweite setzt einen solchen und die Vollkommenheit des Gegenstandes nach demselben voraus. Die Arten der erstern heißen (für sich bestehende) Schönheiten dieses oder jenes Dinges; die andere wird, als einem Begriffe anhängend (bedingte

Schönheit), Objecten, die unter dem Begriffe eines besondern Zwecks stehen, beigelegt." Kant, *Kritik der Urteilskraft*, §16, p. 229 (translation modified).

50. See Derrida, *La vérité en peinture*, 100–104.

51. "Man könnte wider diese Erklärung als Instanz anführen: daß es Dinge giebt, an denen man eine zweckmäßige Form sieht, ohne an ihnen einen Zweck zu erkennen; z.b. die öfter aus alten Grabhügeln gezogenen, mit einem Loche als zu einem Hefte versehenen steinernen Geräthe, die, ob sie zwar in ihrer Gestalt eine Zweckmäßigkeit deutlich verrathen, für die man den Zweck nicht kennt, darum gleichwohl nicht für schön erklärt werden. Allein, daß man sie für ein Kunstwerk ansieht, ist schon genug, um gestehen zu müssen, daß man ihre Figur auf irgend eine Absicht und einen bestimmten Zweck bezieht. Daher auch gar kein unmittelbares Wohlgefallen an ihrer Anschauung. Eine Blume hingegen, z.B. eine Tulpe, wird für schön gehalten, weil eine gewisse Zweckmäßigkeit, die so, wie wir sie beurtheilen, auf gar keinen Zweck bezogen wird, in ihrer Wahrnehmung angetroffen wird." Kant, *Kritik der Urteilskraft*, 236n.

52. "Sieht z.B. ein Wilder ein Haus aus der Ferne, dessen Gebrauch er nicht kennt: so hat er zwar eben dasselbe Objekt wie ein Anderer, der es bestimmt als eine für Menschen eingerichtete Wohnung kennt, in der Vorstellung vor sich. Aber der Form nach ist dieses Erkenntnis eines und desselben Objekts in beiden verschieden. Bei dem Einen ist es *bloße Anschauung,* bei dem Andern *Anschauung* und *Begriff* zugleich.

"Die Verschiedenheit der Form des Erkenntnisses beruht auf einer Bedingung, die alles Erkennen begleitet, auf dem *Bewußtsein.* Bin ich mir der Vorstellung bewußt: so ist sie *klar;* bin ich mir derselben nicht bewußt, *dunkel.*" Immanuel Kant, *Logik,* in *Kants gesammelte Schriften,* ed. Deutsche Akademie der Wissenschaften zu Berlin (Berlin: G. Reimer, 1923), 9:33; translated by J. Michael Young as *Lectures on Logic,* ed. Young (Cambridge: Cambridge University Press, 1992), 544–45. See the discussion of this passage in Paul de Man, "Phenomenality and Materiality in Kant," in *Aesthetic Ideology,* ed. Andrzej Warminski (Minneapolis: University of Minnesota Press, 1996), 81–82.

53. Kant, *Kritik der Urteilskraft*, §83, p. 429. On this point, see Derrida, *La vérité en peinture*, 122–23/107.

54. G. W. F. Hegel, *Vorlesungen über die Ästhetik,* in *Werke: Auf der Grundlage der Werke von 1832–1845,* ed. Eva Moldenhauer and Karl Markus Michel (Frankfurt am Main: Suhrkamp, 1969), 13:522–23; translated by T. M. Knox as *Aesthetics: Lectures on Fine Art* (Oxford: Clarendon Press, 1975), 1:407–8. For examples of the European and Euro-American perception of Polynesian facial tattooing as a disfiguring or defacing, see Forster, *Voyage Round the World,* 2:613; and Herman Melville, *Typee: A Peep at Polynesian Life,* ed. Harrison Hayford, Hershel Parker, and G. Thomas Tanselle (Evanston, Ill.: Northwestern University Press, 1968), 255–56.

55. Immanuel Kant, "Review of J. G. Herder's *Ideas for the Philosophy of the History of Humanity, Parts 1 and 2*," trans. Allen W. Wood, in *Anthropology, History, and Education*, ed. Günter Zöller and Robert B. Louden (Cambridge: Cambridge University Press, 2007), 138. On Kant's relation to rhetoric, see Robert J. Drostal, "Kant and Rhetoric," *Philosophy and Rhetoric* 13 (Fall 1980): 223–44; and Gasché, *Idea of Form*, 202–18.

56. Quintilian, *Institutes of oratory; or, Education of an orator*, trans. John Selby Watson (London, 1875), 2:138; Northrop Frye, *Anatomy of Criticism: Four Essays* (Princeton: Princeton University Press, 1957), 91–92; Angus Fletcher, *Allegory: The Theory of a Symbolic Mode* (Ithaca, N.Y.: Cornell University Press, 1964), 7; Paul de Man, "The Rhetoric of Temporality," in *Blindness and Insight: Essays in the Rhetoric of Contemporary Criticism* (Minneapolis: University of Minnesota Press, 1983), 222, 207.

57. Paul de Man, "The Concept of Irony," in *Aesthetic Ideology*, 178. For a valuable discussion of philosophy's relation to the literary, see Rodolphe Gasché, *Of Minimal Things: Studies on the Notion of Relation* (Stanford, Calif.: Stanford University Press, 1999), 285–308.

58. Friedrich Schlegel, "Zur Philosophie," cited in de Man, "Concept of Irony," 179n20.

59. Friedrich Schlegel, "On Incomprehensibility," in *Friedrich Schlegel's Lucinde and the Fragments*, trans. Peter Firchow (Minneapolis: University of Minnesota Press, 1971), 267; de Man, "Rhetoric of Temporality," 215.

6. Adding History to a Footprint in *Robinson Crusoe*

1. Herman Melville, *Typee: A Peep at Polynesian Life*, ed. Harrison Hayford, Hershel Parker, and G. Thomas Tanselle (Evanston, Ill.: Northwestern University Press, 1968), 44. See also, for example, Nathaniel Hawthorne, "Foot-prints on the Sea-shore," in *Twice-Told Tales*, ed. Rosemary Mahoney (New York: Modern Library, 2001), 353–62; and Walter Scott, *Rob Roy*, ed. Ian Duncan (Oxford: Oxford University Press, 1998), 208. In *Marius the Epicurean* (1885), Walter Pater gives an especially apt gloss on Crusoe's encounter with the footprint: "A sudden suspicion of hatred against him, of the nearness of 'enemies,' seemed all at once to alter the visible form of things, as with the child's hero, when he found the footprint on the sand of his peaceful, dreamy island." Pater, *The Works of Walter Pater* (London: Macmillan, 1900), 2.1:170.

2. Robert N. Essick, *William Blake and the Language of Adam* (Oxford: Clarendon Press, 1989), 33. On the indexical sign, see Charles S. Peirce, *Philosophical Writings*, ed. Justus Buchler (New York: Dover, 1955), 107–11; and on the mark's necessary iterability, see Jacques Derrida, *Limited Inc.* (Evanston, Ill.: Northwestern University Press, 1988).

3. To my knowledge, only two critics have addressed the sublime in *Robinson Crusoe* in any detail, though in terms quite different to my own: Gary Hentzi, "Sublime Moments and Social Authority in *Robinson Crusoe* and *A Journal of the Plague Year*," *Eighteenth-Century Studies* 26 (Spring 1993): 419–34; and Maximillian E. Novak, *Realism, Myth, and History in Defoe's Fiction* (Lincoln: University of Nebraska Press, 1983), 23–46.

4. Thomas Weiskel, *The Romantic Sublime: Studies in the Structure and Psychology of Transcendence* (Baltimore: Johns Hopkins University Press, 1986), 23–24.

5. Daniel Defoe, *The Life and Strange Surprizing Adventures of Robinson Crusoe,* ed. J. Donald Crowley (Oxford: Oxford University Press, 1998), 153–54.

6. Shawn Rosenheim, *The Cryptographic Imagination: Secret Writing from Edgar Allen Poe to the Internet* (Baltimore: Johns Hopkins University Press, 1997), 58. See also Essick, *William Blake,* 28–103.

7. Homer Obed Brown, *Institutions of the English Novel from Defoe to Scott* (Philadelphia: University of Pennsylvania Press, 1997), 73; Defoe, *Giving Alms No Charity* (1704), cited in Maximillian E. Novak, *Daniel Defoe: Master of Fictions* (Oxford: Oxford University Press, 2001), 247.

8. David Hume, *An Enquiry Concerning Human Understanding,* ed. Tom L. Beauchamp (Oxford: Oxford University Press, 1999), 144–45. See Immanuel Kant, *Prolegomena to Any Future Metaphysics,* trans. Gary C. Hatfield, in *Theoretical Philosophy after 1781,* ed. Henry Allison and Peter Heath (Cambridge: Cambridge University Press, 2002), 57–58. On notions of causation in the eighteenth century, see J. L. Mackie's classic account, *The Cement of the Universe: A Study of Causation* (Oxford: Clarendon Press, 1974).

9. Thomas Hobbes, *Leviathan,* ed. Richard Tuck (Cambridge: Cambridge University Press, 1991), 89; Hobbes, *The Citizen,* in *Man and Citizen: De Homine and De Cive,* ed. Bernard Gert (Indianapolis, Ind.: Hackett, 1991), 113; Jean Starobinski, "Surmonter la peur," in *La peur au XVIIIe siècle: discours, représentations, pratiques,* ed. Jacques Berchtold and Michel Porret (Geneva: Droz, 1994), 90. On the importance of Hobbes in Defoe's thought, see Maximillian E. Novak, *Defoe and the Nature of Man* (London: Oxford University Press, 1963); and Carol Kay, *Political Constructions: Defoe, Richardson, and Sterne in Relation to Hobbes, Hume, and Burke* (Ithaca, N.Y.: Cornell University Press, 1988), 66–75.

10. Peter Hulme highlights the psychotic dimension of Crusoe's experience in *Colonial Encounters: Europe and the Native Caribbean, 1492–1797* (London: Routledge, 1986), 194–96.

11. On narrative levels and Crusoe's extradiegetic position, see Gérard Genette, *Narrative Discourse: An Essay in Method,* trans. Jane E. Lewin (Ithaca, N.Y.: Cornell University Press, 1980), 227–31.

12. Or this at least is a common reading of the novel, i.e., that it presents Crusoe's self-production. See, for example, John Bender, *Imagining the Penitentiary: Fiction and the Architecture of Mind in Eighteenth-Century England* (Chicago: University of Chicago Press, 1987), 56–61.

13. Weiskel, *Romantic Sublime*, 13.

14. Neil Hertz, "A Reading of Longinus," in *The End of the Line: Essays on Psychoanalysis and the Sublime* (New York: Columbia University Press, 1985), 1–20.

15. Frances Ferguson, "A Commentary on Suzanne Guerlac's 'Longinus and the Subject of the Sublime,'" *New Literary History* 16 (Winter 1985): 291.

16. Hertz, "Reading of Longinus," 2.

17. Longinus, *Dionysius Longinus on the Sublime,* trans. William Smith (London, 1739), §17, p. 50.

18. Quintilian, *Institutes of Oratory; or, Education of an Orator,* trans. John Selby Watson (London, 1875), 2:148.

19. See also Jonathan Lamb's account Hertz's obscuring of power relations, in "Longinus, the Dialectic, and the Practice of Mastery," *ELH* 60 (Autumn 1993): 551.

20. Jonathan Lamb, "The Sublime," in *The Eighteenth Century*, vol. 4 of *The Cambridge History of Literary Criticism*, ed. H. B. Nisbet and Claude Rawson (Cambridge: Cambridge University Press, 1997), 398.

21. Longinus, *Longinus on the Sublime: The Greek Text Edited after the Paris Manuscript,* ed. W. Rhys Roberts (Cambridge: Cambridge University Press, 1935), §15, p. 88. My transliteration.

22. Hertz, "Reading of Longinus," 8–13; Longinus, *Longinus on the Sublime: The Greek Text,* §1, p. 42; Longinus, *Le traité du sublime ou du merveilleux,* trans. Nicolas Boileau-Despréaux (Paris, 1674), 5 (my emphasis). See also Lamb, "Longinus," 547. For Longinus's discussion of mastery and slavery, see *On the Sublime,* §§15–17. I thank Shaun Irlam for drawing my attention to the odd phrasing of *eis ekstasin.*

23. See M. H. Abrams, *The Mirror and the Lamp: Romantic Theory and the Critical Tradition* (New York: Oxford University Press, 1953), 72–78; and Samuel Holt Monk, *The Sublime: A Study of Critical Theories in XVIII-Century England* (Ann Arbor: University of Michigan Press, 1960), 10–28.

24. On this point, see Marjorie Hope Nicolson, *Mountain Gloom and Mountain Glory: The Development of the Aesthetics of the Infinite* (Seattle: University of Washington Press, 1997), 31.

25. Daniel Defoe, *Serious Reflections during the Life and Surprising Adventures of Robinson Crusoe: With His Vision of the Angelick World* (London: Constable, 1925), 265.

26. See Donald F. Bond, "'Distrust' of Imagination in English Neo-classicism," *Philological Quarterly* 14 (January 1935): 54–69.

27. Patricia Meyer Spacks, "The Soul's Imaginings: Daniel Defoe, William Cowper," *PMLA* 91 (May 1976): 420–35; James O. Forster, *"Robinson Crusoe and the Uses of the Imagination," Journal of English and German Philology* 91 (April 1992): 179–202. On reflection as a modality of reason, see Rodolphe Gasché, *The Tain of the Mirror: Derrida and the Philosophy of Reflection* (Cambridge, Mass.: Harvard University Press, 1986), 13–22.

28. Daniel Defoe, *The Farther Adventures of Robinson Crusoe, Being the Second and Last Part of His Life* (London: Constable, 1925), 2, 5, 7, 11.

29. The danger here of course recalls that which Jacques Derrida locates in Rousseau's notion of the supplement, in *De la grammatologie* (Paris: Minuit, 1967), 203–34.

30. Defoe, *Farther Adventures,* 5. Crusoe dominates the imagination only temporarily for, he says, "one blow from unforeseen Providence"—his wife dying—"unhing'd me at once; and not only made a breach upon me inevitable and incurable, but drove me, by its consequences, into a deep relapse of the wandering disposition" (6–7). He subsequently departs England on a voyage with his nephew.

31. Daniel Defoe, *Jure Divino: A Satyr* (London, 1706), xiv.

32. See, for example, Defoe, *Robinson Crusoe,* 159.

33. Defoe, *Farther Adventures,* 254.

34. Brown, *Institutions of the English Novel,* 61.

35. Weiskel, *Romantic Sublime,* 17.

36. Edmund Burke, *A Philosophical Enquiry into the Origin of Our Ideas of the Sublime and Beautiful,* ed. James T. Boulton (Notre Dame: University of Notre Dame Press, 1958), 38.

37. Burke, *Philosophical Enquiry,* 51; see also 32–37. However, see Frances Ferguson, *Solitude and the Sublime: Romanticism and the Aesthetics of Individuation* (New York: Routledge, 1992), 40–42, where she complicates Burke's understanding of the role of language in designating an object sublime or beautiful.

38. Jean-François Lyotard offers the strongest formulation of Burke's sublime along these lines: "One feels [in the Burkean sublime] that it is possible that soon nothing more will take place. What is sublime is the feeling that something will happen, despite everything, within this threatening void, that something will take 'place' and will announce that everything is not over. That place is mere 'here,' the most minimal occurrence." Lyotard, *The Inhuman: Reflections on Time,* trans. Geoffrey Bennington and Rachel Bowlby (Stanford, Calif.: Stanford University Press, 1991), 84. Arguably Lyotard downplays too much the role of distance in Burke's account, but his emphasis on the significance of a "minimal occurrence" is of great importance. It is such an occurrence that the cannibals inaugurate after the void presented by the footprint (i.e., the inability to distinguish self and other). For a detailed account of Burke's understanding of the relation between

sympathy and the sublime, see Luke Gibbons, *Edmund Burke and Ireland* (Cambridge: Cambridge University Press, 2003), 83–120.

39. Hulme, *Colonial Encounters*, 201.

40. Hobbes, *Citizen*, 116n.

7. Indian Mounds in the End-of-the-Line Mode

1. Neil Hertz, "Afterword: The End of the Line," in *The End of the Line: Essays on Psychoanalysis and the Sublime* (New York: Columbia University Press, 1985), 218.

2. Barnett Newman, "Ohio, 1949," in *Selected Writings and Interviews*, ed. John P. O'Neill (New York: Knopf, 1990), 174. The Miamisburg Mound, in southwest Ohio, measures nearly seventy feet in height and more than eight hundred feet in circumference at its base. On the archive's double orientation toward destruction and preservation, see Jacques Derrida, *Mal d'archive: une impression freudienne* (Paris: Galilée, 1995).

3. Ephraim G. Squier and Edwin H. Davis, *Ancient Monuments of the Mississippi Valley*, ed. David J. Meltzer (Washington, D.C.: Smithsonian Institution Press, 1998), 139. On Squier's contribution to American archaeology and to the understanding of the mounds, including his work with Davis, see Terry A. Barnhart, *Ephraim George Squier and the Development of American Anthropology* (Lincoln: University of Nebraska Press, 2005).

4. Luys Hernández de Biedma, "Relation of the Island of Florida," trans. John E. Worth, in Lawrence A. Clayton, Vernon J. Knight, and Edward C. Moore, eds., *The De Soto Chronicles: The Expedition of Hernando de Soto to North America in 1539–1543* (Tuscaloosa: University of Alabama Press, 1993), 1:239; Mark Twain, *Life on the Mississippi*, in *Mississippi Writings* (New York: Library of America, 1982), 231.

5. Thomas Walker, *Journal of an exploration in the spring of the year 1750* (Boston, 1888), 49. Robert Silverberg locates a slightly earlier reference, from Cadwallader Colden, *The history of the Five Indian nations of Canada, which are dependent on the province of New-York in America, and are the barrier between the English and French in that part of the world* (London, 1747), 113, which I here quote in full: "Their funeral Rites seem to be formed up on a Notion of some Kind of Existence after Death: They make a large round Hole, in which the Body can be placed upright, or upon its Haunches, which after the Body is placed in it, is covered with Timber, to support the Earth which they lay over, and thereby keep the Body free from being pressed; they then raise the Earth in a round Hill over it" (16). See Robert Silverberg, *Mound Builders of Ancient America: The Archaeology of a Myth* (Athens: Ohio University Press, 1986), 28. I would suggest there remains an important difference between Colden's and Walker's respective

mentions of "a round Hill" that places Walker's reference more firmly in the tradition of subsequent mound observation. Colden attends to a localized burial practice governed by largely pragmatic concerns (how to bury a certain person in the most appropriate way). Walker, in contrast, observes an existing and prodigious earthwork "made by Art," whose existence was unexpected and whose purpose and origin remain unapparent.

6. Roger G. Kennedy, *Hidden Cities: The Discovery and Loss of Ancient North American Civilization* (New York: Free Press, 1994), 3; Squier and Davis, *Ancient Monuments*, xxxi. On French activities in North America, see Louise Phelps Kellogg, "France and the Mississippi Valley: A Resume," *Mississippi Valley Historical Review* 18 (June 1931): 3–22; John F. McDermott, *The French in the Mississippi Valley* (Urbana: University of Illinois Press, 1965); and Alan Taylor, *American Colonies: The Settling of North America* (New York: Viking, 2001), 363–95. William Y. Adams describes how the particular way the French inhabited North America limited their ethnographic output, in *The Philosophical Roots of Anthropology* (Stanford, Calif.: CSLI Publications 1998), 202–3, 205, 213. A valuable summary of late seventeenth- and early eighteenth-century writing on French Louisiana can be found in John R. Carpenter, *Histoire de la littérature française sur la Louisiane de 1673 jusqu'à 1766* (Paris: A. G. Nizet, 1966), esp. 175–210.

7. I use *European* to indicate something or someone of European origin or descent. When wanting to highlight the American aspect of something or someone of European origin or descent, I use *Euro-American*. In the case of Euro-Americans beginning to notice mounds in the Ohio Valley, I wish to draw attention to the fact that the people in question were of European descent but also citizens of the new United States.

8. In addition to those works already cited, see especially Gordon M. Sayre, "The Mound Builders and the Imagination of American Antiquity in Jefferson, Bartram, and Chateaubriand," *Early American Literature* 33, no. 3 (1998): 225–49; and Steven Conn, *History's Shadow: Native Americans and Historical Consciousness in the Nineteenth Century* (Chicago: University of Chicago Press, 2004), 116–53. For a nicely illustrated and thorough account of archaeological research into the mounds, see George R. Milner, *The Moundbuilders: Ancient Peoples of Eastern North America* (London: Thames and Hudson, 2004).

9. William Bartram, *The Travels of William Bartram* (New York: Dover, 1955), 57; H. M. Brackenridge, *Views of Louisiana; containing geographical, statistical and historical notices of that vast and important portion of America* (Baltimore, 1817), 173.

10. See A. J. Conant, *Foot-prints of vanished races in the Mississippi Valley: being an account of some of the monuments and relics of pre-historic races scattered over its surface, with suggestions as to their origin and uses* (St. Louis, 1879).

11. Leo A. Goodman, "Notes on the Etymology of Serendipity and Some Related Philological Observations," *MLN* 76 (May 1961): 457.

12. Horace Walpole, *Horace Walpole's Correspondence with Sir Horace Mann*, ed. W. S. Lewis, Warren Hunting Smith, and George L. Lam (New Haven, Conn.: Yale University Press, 1960), 20:407.

13. Percy Bysshe Shelley, "A Defence of Poetry," in *The Major Works*, ed. Zachary Leader and Michael O'Neill (Oxford: Oxford University Press, 2003), 480–81.

14. See, for example, Umberto Eco, *Serendipities: Language and Lunacy*, trans. William Weaver (New York: Columbia University Press, 1998), 6–7.

15. T. H. Huxley, "On the Method of Zadig: Retrospective Prophecy as a Function of Science," *Nineteenth Century* 8 (January–June 1880): 929–40.

16. Voltaire, *Zadig ou la destinée*, in *Zadig et autres contes*, ed. Frédéric Deloffre, Jacques Van den Heuvel, and Jacqueline Hellegouarc'h (Paris: Gallimard, 1979), 91–94. The editors of Walpole's *Correspondence* note that Walpole "read the fairy tale in the Amsterdam, 1721, edition, *Voyage . . . des trois Princes de Serendip*" (20:407n3). The 1721 edition reprinted the original 1719 edition of the Chevalier de Mailly's translation "du Persan."

17. Quintilian, *M. Fabius Quinctilianus his Institutes of eloquence, or The art of speaking in public in every character and capacity*, trans. William Guthrie (London, 1756), 2:77.

18. Jean-Jacques Rousseau, *Discours sur les sciences et les arts*, in *Œuvres complètes*, ed. Bernard Gagnebin and Marcel Raymond (Paris: Gallimard, 1964), 3:33.

19. *Voyages et aventures des trois Princes de Serendip. Traduits du Persan; par le Chevalier de Mailli*, in *Voyages imaginaires, songes, vision, et romans cabalistiques* (Amsterdam, 1788), 25:238.

20. Jonathan Lamb, *Sterne's Fiction and the Double Principle* (Cambridge: Cambridge University Press, 1989), 27–28. For Addison's account of the double principle, see Richard Steele and Joseph Addison, *The Spectator*, ed. Donald F. Bond (Oxford: Clarendon Press, 1965), 3:548–53.

21. Vitruvius, *The architecture of M. Vitruvius Pollio: translated from the original Latin, by W. Newton, architect* (London, 1791), 2:123.

22. See Thomas Hobbes, *Leviathan*, ed. Richard Tuck (Cambridge: Cambridge University Press, 1991), 89–90; John Locke, *Two Treatises of Government*, ed. Peter Laslett (Cambridge: Cambridge University Press, 1988), 285–302; and Montesquieu, *The Spirit of the Laws*, trans. and ed. Anne M. Cohler, Basia Carolyn Miller, and Harold Samuel Stone (Cambridge: Cambridge University Press, 1989), 285–94. Montesquieu cites as his source on the Natchez a letter written by Mathurin le Petit from New Orleans on July 12, 1730, and published in *Lettres édifiantes et curieuses, écrites des missions étrangères par quelques missionnaires de la compagnie de Jésus* (Paris, 1731), 20:106–13.

23. Thomas Ashe, *Travels in America, performed in 1806, for the purpose of exploring the rivers Alleghany, Monongahela, Ohio, and Mississippi, and ascertaining*

the produce and condition of their banks and vicinity (Newburyport, Mass., 1808), 207–8.

24. Anthony F. C. Wallace, *Jefferson and the Indians: The Tragic Fate of the First Americans* (Cambridge, Mass.: Harvard University Press, 1999), 131–43; Thomas Jefferson, *Notes on the State of Virginia,* ed. William Harwood Peden (New York: Norton, 1972), 97–98. See also Kennedy, *Hidden Cities,* 125–51.

25. Thomas Jefferson, *Extract of a Letter from Thomas Jefferson to George Wythe* (Richmond, 1796).

26. Philip Freneau, "Lines occasioned by a visit to an old Indian burying ground," in *The miscellaneous works of Mr. Philip Freneau containing his essays, and additional poems* (Philadelphia, 1788), 188; Henry F. May, *The Enlightenment in America* (Oxford: Oxford University Press, 1976), 293; Henry Home, Lord Kames, *Elements of Criticism: The Sixth Edition,* ed. Peter Jones (Indianapolis, Ind.: Liberty Fund, 2005), 1:293.

27. Hertz, "Afterword," 217–39.

28. Bartram, *Travels,* 56–57.

29. Silverberg, *Mound Builders,* cited in Sayre, "Mound Builders," 239.

30. James Fenimore Cooper, *The Last of the Mohicans,* ed. John P. McWilliam (Oxford: Oxford University Press, 1990), 142.

31. Cooper's narrator signals his awareness of Indian mounds earlier in the novel: "The Indian had selected for this desirable purpose, one of those steep, pyramidal hills, which bear a strong resemblance to artificial mounds, and which so frequently occur in the valleys of America." Cooper, *Last of the Mohicans,* 114.

32. Voltaire, *Zadig,* 91–92.

33. Squier and Davis, *Ancient Monuments,* 139.

34. Brackenridge, *Views of Louisiana,* 173.

35. See Silverberg, *Mound Builders,* 125–67. On Albert Gallatin, see Kennedy, *Hidden Cities,* 23–39; and on Henry Rowe Schoolcraft, see Silverberg, *Mound Builders,* 77–79.

36. Squier and Davis, *Ancient Monuments,* 171.

37. Milner continues: "But why haul dirt to build mounds and ridges? All we can say for sure is that it was necessary to create a space within which socially and ritually significant events could be conducted." Milner, *Moundbuilders,* 45.

38. Albert Gallatin, "A Synopsis of the Indian Tribes of North America," *Archæologia Americana* 2 (1836): 143.

39. "Journal of David Taitt's Travels," cited in Donald A. Ringe, *The Pictorial Mode: Space and Time in the Art of Bryant, Irving, and Cooper* (Lexington: University Press of Kentucky, 1971), 134; "A Plan of a Fort and Intrenchment in the Shawanese country," *Royal American Magazine,* January 1775, 29; J. H. McCulloh Jr., *Researches, philosophical and antiquarian, concerning the aboriginal history of America* (Baltimore, 1829), 501. There are, of course, the early eighteenth-century

Jesuit accounts of the Natchez building and using mounds. The Natchez seem to be the last practicing Mississippian group encountered by Europeans—that is, until the French largely annihilated them in 1731. See Colin G. Calloway, *One Vast Winter Count: The Native American West before Lewis and Clark* (Lincoln: University of Nebraska Press, 2003), 103–4. Beyond any question of whether local Indians deliberately withheld information on the mounds, we should note several reasons why local groups might have had little to say about the earthworks: some Indian groups continued to build and/or use mounds into the seventeenth and, in the case of the Natchez, eighteenth centuries, but they suddenly ceased to exist in numbers that could support their previous activities. Possible reasons for the cessation of activity with the mounds include a changing climate, Indian warfare and movement, and the decimating force of European diseases, which traveled well in advance of the Europeans themselves. On climate change and disease, see Calloway, *One Vast Winter Count,* 98–108. Richard White notes how the "huge area between the Ohio River and the Northern shores of the Great Lakes [had been] emptied of inhabitants by the Iroquois," who had carried on an extended war with the Algonquian-speaking groups of the Ohio Valley in the first half of the eighteenth century. Richard White, *The Middle Ground: Indians, Empires, and Republics in the Great Lakes Region, 1650–1815* (Cambridge: Cambridge University Press, 1991), 11.

40. On this point, see Conn, *History's Shadow,* 118, 123–24. Perhaps the best account of early theories on how the New World was populated is that of Giuliano Gliozzi, *Adamo e il nuovo mondo: la nascita dell'antropologia come ideologia coloniale: dalle genealogie bibliche alle teorie razziali (1500–1700)* (Firenze: La nuova Italia, 1977), which remains unavailable in English.

41. Caleb Atwater, "Description of the Antiquities discovered in the State of Ohio and other Western States," *Archæologia Americana* 1 (1820): 105–267; Moorehead, "A Century of American Archaeology," cited in Conn, *History's Shadow,* 119–20. While Atwater's act of cutting into a mound was not original (Jefferson had done so fifty years before him), what Atwater did differently, following the methodological framework he adopted, was to perform and write up his excavation with an entirely new level of detail.

42. George Catlin, *Letters and notes on the manners, customs, and conditions of the North American Indians; written during eight years' travel (1832–1839) amongst the wildest tribes of Indians in North America* (New York: Dover, 1973), 259–61. See also George Burder, *The Welch Indians, or, A collection of papers respecting a people whose ancestors emigrated from Wales to America, in the year 1170, with Prince Madoc (three hundred years before the first voyage of Columbus), and who are said now to inhabit a beautiful country on the west side of the Mississippi* (London, 1797).

43. Squier and Davis, *Ancient Monuments,* 139.

44. Ephraim G. Squier, "Observations on the Aboriginal Monuments of the Mississippi Valley," *Transactions of the American Ethnological Society* 2 (1848): 163. See also Conn, *History's Shadow*, 125–26. For an overview of geological stratigraphy, see Patrick Wyse Jackson, *The Chronologers' Quest: Episodes in the Search for the Age of the Earth* (Cambridge: Cambridge University Press, 2006), 119–53.

45. Sayre, "Mound Builders," 226.

46. On mounds as scared sites, see Peter Nabokov, *Where the Lightning Strikes: The Lives of American Indian Sacred Places* (New York: Viking, 2006), 35–51. See also Tamara L. Bray, ed., *The Future of the Past: Archaeologists, Native Americans, and Repatriation* (New York: Garland, 2001); Michael F. Brown, *Who Owns Native Culture?* (Cambridge, Mass.: Harvard University Press, 2003); Rosemary J. Coombe, *The Cultural Life of Intellectual Properties: Authorship, Appropriation, and the Law* (Durham, N.C.: Duke University Press, 1998); and Barbara Alice Mann, *Native Americans, Archaeologists and the Mounds* (New York: Peter Lang, 2003).

47. Newman, "Ohio, 1949," 174–75. See Jean-François Lyotard, *The Inhuman: Reflections on Time*, trans. Geoffrey Bennington and Rachel Bowlby (Stanford, Calif.: Stanford University Press, 1991), 90; see also 78–88.

48. Lindesay Brine, *Travels amongst American Indians, their ancient earthworks and temples* (London, 1894), 55. Brine was an amateur historian who also served as vice admiral in the Royal Navy, from which he retired in the same year his *Travels* appeared in print.

Conclusion

1. "All the things that we clearly and distinctly conceive of as different substances *[substantiae diversae]* (as we do in the case of mind and body) are in fact substances *[substantias]* which are really distinct one from the other *[se mutuò distinctas]*." René Descartes, *Meditationes de prima philosophia*, in *Œuvres de Descartes*, ed. Charles Adam and Paul Tannery (Paris: Vrin, 1983), 7:13; translated by John Cottingham as *Meditations on First Philosophy*, in *The Philosophical Writings of Descartes* (Cambridge: Cambridge University Press, 1984), 2:9.

2. Descartes, *Meditationes*, 7:15, 80/2:11, 55.

3. Descartes, *Meditationes*, 7:15–16/2:11.

4. Immanuel Kant, *Critique of Practical Reason*, in *Practical Philosophy* trans. and ed. Mary J. Gregor (Cambridge: Cambridge University Press, 1996), 239–46.

5. See Paul Guyer, "From a Practical Point of View: Kant's Conception of a Postulate of Pure Practical Reason," in *Kant on Freedom, Law, and Happiness* (Cambridge: Cambridge University Press, 2000), 333–71; and Terry P. Pinkard, *German Philosophy, 1760–1860: The Legacy of Idealism* (Cambridge: Cambridge University Press, 2002), 59–60, 226–27.

6. Alexandre Kojève, *Introduction to the Reading of Hegel: Lectures on the Phenomenology of Spirit*, trans. James H. Nichols Jr. (Ithaca, N.Y.: Cornell University Press, 1980), 4. I pass over the more simplistic form of self-recognition by reflection found, for example, in Bruce Mazlish, *Civilization and Its Contents* (Stanford, Calif.: Stanford University Press, 2004): "Seeing itself in the mirror of the other, the West could reflect upon itself and its identity" (48). As we saw in the case of Joseph Addison's aesthetic theory, this model of reflection, with its implied subjective coherence and rationality, proves inadequate both historically and conceptually.

7. Robert Young, *White Mythologies: Writing History and the West* (London: Routledge, 1990), 3; Pierre Clastres, *Archaeology of Violence,* trans. Jeanine Herman (New York: Semiotext(e), 1994), 44. On the "great dying," see Eric R. Wolf, *Europe and the People without History* (Berkeley: University of California Press, 1982), 58–71, 131–57; Francis Jennings, *The Invasion of America: Indians, Colonialism, and the Cant of Conquest* (New York: Norton, 1976); and Tzvetan Todorov, "The Conquest as Seen by the Aztecs," trans. Alyson Waters, in *The Morals of History* (Minneapolis: University of Minnesota Press, 1995), 17–33. An overview of nineteenth-century developments can be found in Patrick Brantlinger, *Dark Vanishings: Discourse on the Extinction of Primitive Races, 1800–1930* (Ithaca, N.Y.: Cornell University Press, 2003). For a suggestive attempt to recreate an Amerindian perspective in British North America, see Daniel K. Richter, *Facing East from Indian Country: A Native History of Early America* (Cambridge, Mass.: Harvard University Press, 2001).

8. I address the structural role of violence in capitalism elsewhere. See Tony C. Brown, "The Time of Globalization: Rethinking Primitive Accumulation," *Rethinking Marxism* 21 (2009): 571–84.

9. On this point, see Roberto M. Dainotto, *Europe (in Theory)* (Durham, N.C.: Duke University Press, 2007), 11–51. J. G. A. Pocock notes how the terms *Christendom* and *Europe* are not symmetrical. Whereas Europe would be one continent among others (Africa, Asia, North America, and South America), Christendom inserted itself into an opposition between lands properly Christian and lands not Christian, namely the eastern Mediterranean and North Africa. J. G. A. Pocock, *Narratives of Civil Government,* vol. 2 of *Barbarism and Religion* (Cambridge: Cambridge University Press, 1999), 20.

10. Adam Smith, *An Enquiry into the Nature and Causes of the Wealth of Nations,* ed. R. H. Campbell and A. S. Skinner (Oxford: Oxford University Press, 1976), 2:626; and Abbé Guillaume Thomas François de Raynal, *Histoire philosophique et politique des deux Indes,* ed. Yves Benot (Paris: La Découverte, 2001), 13.

11. See Karl Marx, *Capital: A Critique of Political Economy,* trans. David Fernbach (London: Penguin, 1981), 440–55. Marx addresses the dialectical nature of

production and consumption under capitalism with great clarity in his Introduction to the *Grundrisse*. See Karl Marx, *Grundrisse: Foundations of the Critique of Political Economy (Rough Draft)*, trans. Martin Nicolaus (London: Penguin, 1973), 83–111, esp. 88–100.

12. J. M. Blaut, "Fourteen Ninety-two," in *1492: The Debate on Colonialism, Eurocentrism, and History* (Trenton, N.J.: Africa World Press, 1992), 49, 48 (my emphasis).

13. Blaut, "Fourteen Ninety-two," 40–41. See E. J. Hamilton, "American Treasure and the Rise of Capitalism," *Economica* 9 (1929): 338–57. See also the fuller historical, political, and economic treatments in Giovanni Arrighi, *The Long Twentieth Century: Money, Power, and the Origins of Our Times* (London: Verso, 1994); Immanuel Wallerstein, *Mercantilism and the Consolidation of the European World-Economy, 1600–1750*, vol. 2 of *The Modern World-System* (New York: Academic Press, 1980); Wolf, *Europe and the People without History;* and Peter Worsley, *The Three Worlds: Culture and World Development* (Chicago: University of Chicago Press, 1984). Blaut gives an extended statement of his argument in *The Colonizer's Model of the World: Geographical Diffusionism and Eurocentric History* (New York: Guilford Press, 1993).

14. Dipesh Chakrabarty, *Provincializing Europe: Postcolonial Thought and Historical Difference* (Princeton: Princeton University Press, 2000), 27–28. See also Jack Goody, *The Theft of History* (Cambridge: Cambridge University Press, 2006).

Index

Adam: direct knowledge of creation impossible, 28; primitive language, 11, 16, 27, 32, 33, 36; *Robinson Crusoe*, 151. *See also* Adamic

Adamic: inheritance, 34; sign (footprint as), 148, 151, 152, 163

Addison, Joseph, 19–20, 47, 75–103; absence of transcendental authority, 76–77; aesthetic experience, 75–80 *passim*, 82–83, 85, 87–88, 92, 94–95, 98–100; aesthetic faculty, 75–76, 79–84, 88–92, 98; allegory, 95–103; Blair on, 80; the beautiful, 78, 79, 94–95, 97; China, 92–95, 99–103; delimitation, 75, 76, 82–84 *passim*, 92, 95, 99, 101; Dennis, as responding to, 84–85, 88–90; "double principle," 194–95; efficient cause, 76, 85–88 *passim*, 90; example, 92; exotic, 75, 76, 97, 98, 99; figural language, 90, 93, 95–100; final cause, 85–87; God, 85, 86, 88, 92; imagination, 79–95, 90–100; immediacy of aesthetic, 78, 79, 92, 94, 97–100 *passim*; "infinite variety," 76–79, 84, 92, 95, 99–100; Kant and, 105, 112–13, 138, 141, 141–42; landscape gardening, 92–95 *passim*, 97, 112; noncognitive, 87, 87–88, 98; pleasure, 76–79, 83–84, 85, 90–91; primary and secondary, 80, 81, 90–91, 100;

primitive, 75–76, 80, 82, 87–91, 105, 147; problematic and, 75–76, 103; reflection, 88, 99, 101, 102–3, 105; said vs. saying, 20, 95, 99; self as incomplete, 84, 90, 100, 101–3; Shaftesbury, First Earl of, divergence from, 77, 78; subject-object, 76, 79, 83; tain, 102; temporal in, 75–76, 97–98, 101, 102; unconditioned in, 75, 76, 87, 88, 90, 92; understanding, the, 76, 78, 79, 81–83, 90, 98

aesthetic, aesthetics, ix–xviii *passim*, 1, 2, 3, 19–22, 45–61, 71, 149, 164, 218–19; aporetic structure, 46; Baumgarten, 47–48, 218; beyond cognition, 4–5, 47 (*see also* Addison, noncognitive; nonreflective); Cassirer on, 49–50; "clear and confused," 47, 50, 71, 98, 218; distinct from poetics and rhetoric, 50; exotic in, 56–61, 65, 123, 124; immediacy (Addison), 78, 79, 92, 94, 97–100 *passim*; immediacy (Kant), 127, 136; judgment, 45–46, 48, 159, 161; Kant, 105–18 *passim*, 128, 134, 139, 143–44; nature and, 3, 45–46, 49, 76, 77–78, 113–14, 194–96, 203–4; as otherworldly, 3–6; problematic and, 8, 45, 53; reason and, 47–48, 92; self, 21, 148, 174; Smith (Bernard) on, 123;

footprint *(Robinson Crusoe)*, 21, 147–
58, 162–64, 167–74, 176–79, 181,
186, 214, 215–16, 251n1; as
almost nothing, 163, 176–77;
cannibals and, 149, 153–54, 169–
70; causality, 152; nonrhetorical,
163; otherworldly, 154; primitive
sign, 148–49, 152, 156; repetition,
148; as singular, 21, 148–50 *passim*,
152, 163, 168, 170, 216; time,
outside of, 152, 156. *See also* Defoe;
Robinson Crusoe
Forster, Georg, 119, 122
four causes, the, 85. *See also* cause;
efficient cause; final cause
Freneau, Philip, 199
Frye, Northrop, 142

Gallatin, Albert, 205, 207
Garden of Eden, 27; human fallen
from, 56, 89; language in, 33, 151,
208
Gasché, Rodolphe, xiv, 112, 115
Gell, Alfred, 128–29
global expansion (European), xiii, xvi,
220, 222
God, xvi, 29, 32, 38, 66, 77; Addison,
85, 86, 88, 92; anthropomorphic,
36–37; Descartes, xvii, 106, 217–
18; as final cause (Addison), 85,
86; as first cause (Leibniz), 39;
Hamann, 12; La Mettrie, 13; New
World puts in question, 8; as regu-
lative idea (Kant), 218; Rousseau,
15–17 *passim*, 41; Spinoza, 36, 39;
Webb, 33–36 *passim*; Wilkins, 9–
13 *passim*; 32; withdrawal of, xvii, 2,
9, 17, 19, 38, 44–46 *passim*, 219,
221, 231n10; Word of, 8, 34. *See
also* Creation; *fiat lux*; *Robinson
Crusoe*, Providence; theology;
transcendence

Goldsmith, Oliver, 56
Goodman, Leo A., 187
Grave Creek Mound, 199
Guest, Harriet, 238n22

Hamann, Johann Georg, 12, 17
Hamilton, E. J., 223–24
Hamilton, Elizabeth, 56
Hawkesworth, John, *Account of the
Voyages*, 119, 120, 246n22
Hegel, G. W. F., xvi, 221; aesthetics, 3;
figural language, 138; *Geist*, xvii, 19,
45; history, xvii, 45, 221, 222,
227n2; Kojève on, 220; self and
other, 220
Heidegger, Martin, 28
Herder, xvii, 12, 17, 69; Kant on,
141
Hertz, Neil: "end-of-the-line mode,"
182–83, 200; Longinus, 158, 159–
60, 161
Heywood, Eliza, 56
Hippocrates, 14, 15
Hirschman, Albert O., 84
history or historical, ix–x, 1–2;
causation, x, 18; consciousness,
216, 227n2; explanation, xvi, 192,
210; framing, 147, 181; human
destiny as, xvi, 18; mounds and,
210–16; naturalized, xii, 18; outside
of, xviii, 10, 11, 20, 34, 41, 52, 71;
primitive and, 18–19, 35, 36, 71;
problematic and, 2, 3, 17, 18, 35;
savage and, 22, 67, 69, 215;
serendipity and, 192; understand-
ing, ix–xi, xviii, 17, 18, 43, 204, 212.
See also cause; historicism; tempo-
ral; time; world
historicism, x, xi–xii; anthropological
security and, xvi–xvii; archaeology
and, 207, 210, 211, 214; dominance

TONY C. BROWN teaches literary theory and philosophy at the University of Minnesota, Twin Cities.